Ideas and Art
in Asian
Civilizations

This book is also available in a
full-color ebook edition

Ideas and Art in Asian Civilizations

India, China, and Japan

Kenneth R. Stunkel

An East Gate Book

M.E.Sharpe
Armonk, New York
London, England

An East Gate Book
Consulting Editor: Doug Merwin

Cover photos (clockwise, starting top left) from: Shanghai Museum; Mahesh Telkar; Freer Gallery,
Smithsonian Institute; http://en.wikipedia.org/wiki/File:Kali_Devi.jpg; http: en.wikipedia.org/wiki/
File: Loupan.jpg; Makiko Parsons.

Library of Congress Cataloging-in-Publication Data

Stunkel, Kenneth R.
 Ideas and art in Asian civilizations : India, China, and Japan / by Kenneth R. Stunkel.
 p. cm.
 Includes bibliographical references and index.
 "An East Gate book."
 ISBN 978-0-7656-2540-3 (cloth : alk. paper)—ISBN 978-0-7656-2541-0 (pbk. : alk. paper)
 1. Asia—Civilization. 2. India—Civilization. 3. China—Civilization. 4. Japan—Civilization.
5. Civilization, Oriental. I. Title.

CB253.S76 2011
950—dc22 2010034502

Printed in the United States of America

IBT (c) 10 9 8 7 6 5 4 3 2 1
IBT (p) 10 9 8 7 6 5 4 3 2 1

Contents

PART V: A SUMMING UP • 261

Introduction

This volume brings together ideas and selected works of art associated with Buddhism, Jainism, Hinduism, Taoism, Confucianism, and Shintoism within the geographical and historical scope of traditional India, China, and Japan. The goal is to provide a concise account of core ideas in the three traditional literatures, supported by brief historical and social background and enlivened by works of art and architecture as they relate to those ideas. Complementing the description and analysis is the assumption that Asian ideas and the works of art expressing them are not merely relics of a vanished past but still have a living presence and relevance in the modern world.

The strategy for making sense of so much history, thought, and creative effort within relatively few pages is to bring each civilization into focus by concentrating on symbols, styles, and meanings in eight categories: historical overview, dominant social forms, beliefs about nature, ideas in select works of literature, formal traditions of thought, ideas in religion and myth, characteristic way of thinking, and ideals of beauty. Applying the eight sections to each of the civilizations yields a common framework for comparison. Some discussion of historical settings and the kinds of societies that arose from them is necessary because ideas and art do not exist and interact in a historical and social vacuum. Since art in Asia brings imagination and skill to bear on materials such as wood, stone, metal, clay, silk, paper, and ink, some comments about craftsmanship are necessary to sustain the narrative.

With air travel ubiquitous, millions of people travel annually to Asian countries from every part of the globe in a matter of hours. Many take in the sights with the help of tour guides and usually take pictures with high-tech cameras. Accessibility to such sites is one thing—understanding them is quite another. Behind the artifacts are coherent ideas about man, society, nature, and beauty that arose and flourished centuries ago.

Forces of change driven by technology, industrialization, and mass consumer societies have swept away much of the past in less than two hundred years, but the best it has to offer can be recovered by putting ideas and art together to restore connections between meaning, symbol, and style. Firsthand experience is usually preferable, but its absence is not fatal to understanding or intensity of experience, both of which are attainable through the power of words and images. With the help of philosophy, literature, and art, an inquiring mind can travel across thousands of miles and reach far into the past.

The three Asian traditions cultivated ideals of meaning and aesthetics that survive to this day. Millions of people are Hindus and Buddhists. Confucianism lives on in the family and educational ideals of many contemporary Chinese—in all parts of the world and increasingly in China itself, despite Maoist attempts to eradicate it there—to promote harmony and stability among a large segment of the world's population. More recently, Taoism has undergone a revival, partly to confront ruinous environmental damage from unrestrained industrialization and urbanization. Shintoism and Buddhism still have an audience in modern Japan, and not just for marriages and funerals, respectively. Even if one does not share or live by these South Asian and East Asian points of view, it is worth knowing what they are and how they once served and still support the needs of life. Ideas expressed in literary, religious, and philosophical texts were translated into works of art and architecture that embody high standards of craftsmanship and aesthetics that can still touch the imagination and excite the aesthetic wonder of the viewer.

The artworks selected to complement the ideas in this volume are few compared to the vast storehouse of artifacts that exists, but they are representative of that treasure. Several examples of Hindu temples to illustrate basic styles, out of hundreds available, are enough to explain the rudiments of structure, aesthetics, and iconography. Chinese landscape paintings abound for a period of some nine hundred years, but a handful will do to illustrate materials, technique, principles, meaning, and broad changes in style. In the case of Japanese art, basic principles and meanings can be addressed with a judicious selection of painting, sculpture, buildings, gardens, and ceramics. The reader who wishes to do so can easily survey riches of the three cultures more extensively by consulting works in the annotated bibliography or visiting recommended websites. *for more*

Language Barriers

Partly because of geography, the languages and histories of India, China, and Japan are strikingly different, although China and Japan have had cultural affinities since Chinese civilization reached Japan in the sixth and seventh centuries. Classical Sanskrit, the Indo-European language of India's sacred literature, has nothing in common with Mandarin and Cantonese, the two main dialects of China, which belong to the Sinitic group of languages. None of the Chinese dialects are related to Japanese, which is an Altaic language related to Turkish. Chinese writing is complicated because its written form is basically ideographic rather than phonetic. Someone reading a text aloud in Mandarin would not be understood in Cantonese, but both parties would "see" roughly the same meaning in the written characters. Japanese is more complicated because the written language borrowed from China is altogether unsuited to the spoken language. Two phonetic systems, hiragana and katakana, in addition to a stock of Chinese characters, referred to as kanji, are needed to make the written language work, which makes Japanese one of the most difficult of all written languages to master.

A problem in a book like this one is how to decide how much alien vocabulary to impose on a reader—that is, how many Sanskrit, Chinese, and Japanese words will suffice. Names and terms from original languages are indispensable. Without them, the experience of confronting another civilization is shallow, diminished, or simply unintelligible. Non-Western civilizations can be understood only superficially without access to

a specific, usable vocabulary. For India, one cannot dispense with Atman-Brahman, the lofty formulation of Hindu monism. For China, one needs chun-tzu (zhunzi), the name Confucius gave to his "superior man" of high character. For Japan there is no substitute for shibui, a word whose meanings embrace ideas of simplicity, naturalness, understatement, and unobtrusive beauty, an idea derived mainly from Zen Buddhism.

For the untutored reader, no doubt there can be too many such words. A thicket of Sanskrit terminology to clarify Indian thought and art can be disconcerting, so it is kept to a minimum. In this volume, diacritical marks in Sanskrit words, and the contractions they usually entail, are left out (e.g., moksha rather than mokśa, Shiva rather than Śiva). Digressions into the etymology of words can be instructive about deeper meanings of ideas, but they are mostly avoided.[1] Coping with Chinese terminology is a problem because there are two dominant systems for transliteration of words in alphabetic form. In this book, the Wade-Giles system is used for all terms, including place names. The rationale is that traditional China is our subject, and most literature on old and modern China in English used Wade-Giles before the second system, called pinyin (spelling sound), and based on the dialect spoken in Peking (Beijing), was adopted by the People's Republic in 1959. The International Organization for Standardization accepted pinyin in 1979.

China scholars have for the most part rushed to use pinyin even when writing about premodern China, although there is no consistency in practice. The result has been less than helpful for general readers consulting literature on China in English before pinyin came into use. Now both systems of transliteration must be used, one for older, another for newer scholarship. Instead of simply including a conversion chart in this book, I have used both Wade-Giles and pinyin together the first time a Chinese word is used so readers have access to both transliterations; thereafter the Wade-Giles system prevails. Occasionally, for purposes of clarity, the pairing of transliterations is repeated. It is not always necessary, however, to adhere strictly to this procedure when citing Chinese words from bibliographical sources.

Where terms have multiple meanings, which is common in Sanskrit and Chinese, the practice here is to settle on the most plausible central meaning. Common usage is also the criterion for place names—for example, Benares, a holy city on the Ganges in India, rather than the alternative names Kashi and Varanasi. The same policy applies to Japanese terms where appropriate.

Clarifying Geography

Talking about "Asia" is an abstract, unfortunate convenience that needs qualification. Many books refer broadly to Asia, or even to the Far East, without geographical clarification. Strictly speaking, there is no such thing as "Asia" or the "Far East" if one expects to find cultural unity and a single point of view (fig. 1.1).

India belongs to South Asia. My use of the term "India" includes the entire subcontinent. China and Japan belong to East Asia, which includes Korea, a culture included only peripherally in this volume. Lying between South and East Asia are mainland and island Southeast Asia, regions not among our subjects. North of India and west of China is the vast expanse of Central Asia, occupied historically by nomadic peoples whose cultures fell short of civilization defined by agriculture, metallurgy, writing systems, a literature,

Figure 1.1

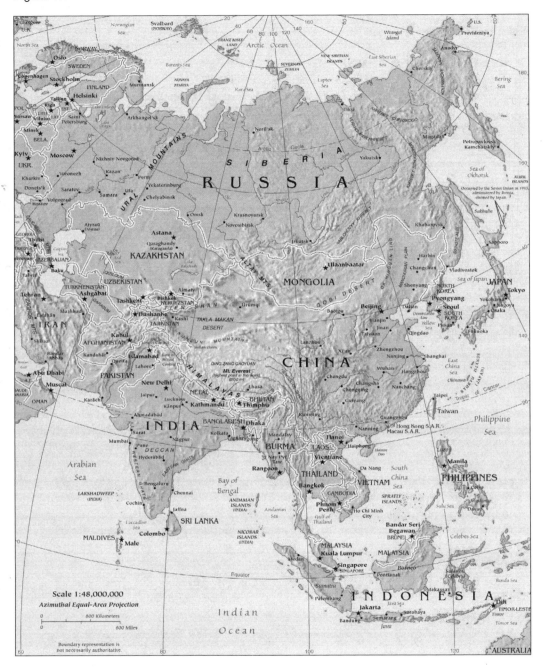

monumental architecture, and cities. India is set off historically from China and Japan; chief transmissions from the former to the latter were the thought, institutions, and art of Buddhism. China and Japan have much in common because the Japanese acquired the beginnings of their civilization from China mainly through Korea, a cultural satellite of imperial China in the sixth and seventh centuries C.E.

Note

1. Browsing in Heinrich Zimmer's *Philosophies of India*, edited by Joseph Campbell (Princeton, NJ: Princeton University Press, 1956) can be daunting. He devotes much attention to the multiple meanings of Sanskrit words and offers a compelling reason for doing so: "By reviewing the whole range of values covered by any Sanskrit term one can watch Indian thought at work, as it were from within. This technique corrects the unavoidable misinterpretations that arise, even in the best intended translations, as a result of the vastly differing range of associations of our European terms" (43). Be that as it may, too much etymology causes eyes and mind to glaze over, so we resort to it sparingly.

PART I
JOURNEY TO THE EAST

The traditional civilizations of India, China, and Japan developed complex ideas about man, society, nature, and the proper ends of life, many of which were expressed in art and architecture. The deepest commitments of those civilizations to what gives direction, purpose, and meaning to life can be read in painting, sculpture, architecture, and often in the minor arts as well. All three traditions have a long tenure in the historical record—more than 3,000 years for India and China, some 1,500 years for Japan. In all three cases there are visible continuities across time into the present. Many temples, palaces, pagodas, and other structures built long ago survive and can still be seen. Some revered arts, such as calligraphy in China and Japan, are still practiced. Ancient beliefs and practices, especially in India, have not been swept away completely by the modern world. Almost anyone receptive to non-Western perspectives on the human condition and its possibilities will find worthy possibilities in the ideas and art of India, China, and Japan.

Those perspectives are not easily brought into focus. In the case of Hinduism, the tradition is ancient and continuous, its myths are numerous, its literature is immense, and, despite many gaps and much destruction across the ages, its surviving artifacts, especially sculpture and architecture, are abundant. Even more than for conventional histories, the problem for this book is judicious selection. A great deal is left out or compressed. It is not possible to march through the centuries and review many of the details of origin, stages of development, and specific influences. Chronologies are telescoped so a complex historical phenomenon like Hinduism can be viewed as more or less complete, although in fact it emerged slowly over many centuries of growth and accretion. Much the same is true of Confucianism in China. From the time of Confucius to the Sung (Song) dynasty, a stretch of some 1,500 years, his original teachings underwent many changes and interpretations, including the creation of specific institutions to transmit and apply them. Only hints of that complexity are given here. In Japan the movement of ideas and art was not quite as intricate as in India and China, but substantial compression is unavoidable.

Because the study of any subject should never be taken for granted, the question "so

what?" is blunt but justified. After all, time and energy that could be directed elsewhere are being asked of a reader. Non-Western cultures present undeniable difficulties for study, not least of which is achieving familiarity with alien vocabularies needed to understand ideas and art. Usually a valuable subject catches hold after an initial period of good faith immersion. Once an intrinsically valuable landscape comes more fully into view, and when some of its mystery is dispersed, there may be more inclination to push on and discover what lies over the next hill. An inducement to keep walking is also a promise that satisfactions await a patient explorer. Learning about other civilizations for their own sake has its virtues, but the emphasis in this volume is on durability through time of ideas and their expression in art that can enhance thought and feeling in the modern world.

1
Learning from Unfamiliar Cultural Traditions

Immersion in the great traditions of India, China, and Japan expands one's awareness, knowledge, and sensibility. Awareness means seeing or grasping something previously hidden from view. Knowledge means accurate recognition of ideas and images supplemented by critical understanding. Sensibility means receptiveness to unfamiliar standards of excellence, meaning, and beauty.

Obviously mere exposure is not enough to produce these results. Active participation in a quest for experience, knowledge, and sensibility yields the choicest fruits. If this condition is met, the results can be surprising, gratifying, and lasting. The high cultures of India, China, and Japan will not disappoint an attentive explorer and observer. No doubt much that is unpleasant and universal in human history and experience—wars, corruption, poverty, natural disasters, brutality, incompetent rulers, class divisions, ignorance, and repression (especially of women)—disfigures these civilizations like all others. Their enduring contribution to the store of human wisdom and beauty, however, can be acknowledged despite such excesses, lapses, and misfortunes.

Ideally everyone could travel to and experience other civilizations firsthand, but not being able to do so is not a barrier to understanding. Travel can broaden one's perspectives, but only if one's eyes and mind are open and alert. Many foreigners who have been fortunate enough to live in India, China, or Japan, sometimes for extended periods, come away without much understanding and appreciation, and with garbled, impoverished notions of all that these cultures have to offer. While teaching oriental philosophy and Chinese history to military personnel in Japan, I encountered men and women with no curiosity about the country or its culture. They did not travel to Kyoto and other historical places; ignored famous gardens, temples, and museums; knew nothing of the literature, traditional or modern; and acquired only a smattering of the language, usually hello and

goodbye and such. One army wife said she preferred the officer's club and went into Tokyo only now and then to shop.

On the other hand, there are people who have a great appreciation for the cultures of Asia without having been there. Intellect and imagination, combined with study and research, can supply an intimate, vivid sense of the essential mind and spirit of another civilization. For example, Arthur Waley, one of the leading twentieth-century students of Chinese and Japanese literature, thought, and art, and a prolific translator of works from both languages, never visited either country. Thought, imagination, and sensibility can be nurtured by reading poetry and philosophy and contemplating images of sculpture, painting, and architecture—in short, selective exposure to the a vast domain of ideas and art that have survived over the past three thousand years.

Discovering Cultural Universals

Civilizations coping with the imperatives of life have produced works of intellect and imagination that resonate with generally educated men and women everywhere. Ideas and art can reach across historical divides. Human beings are agents for the creation of values and the varied artifacts that embody them. Most human needs and questions about the self and the world are universal, even though the means of satisfying needs and working out answers to big questions vary and change from one historical setting to the next.

The need for food, shelter, health, work, companionship, enjoyment, beauty, and purpose in life is intrinsically human. So are questions about human nature, conduct, social order, the supernatural, the past, and how humans fit into the realm of nature. No society is without responses to these questions in the form of myth, legend, theology, or philosophy. The most direct response, however, is in works of art, which are visual manifestations of perception and understanding shared within a civilization.

Political, military, economic, and social matters are largely ephemeral, albeit ubiquitous, in the perspective of time, although a requisite context for ideas and art. Subjects like literature, philosophy, and art are less transitory and can reverberate in the present. They represent attempts by human beings in often remote times and places to make sense of existence and give it expression; making sense is the work of philosophy and religion, while giving it expression is the task of literature and art, which also define canons of beauty.

No one escapes what the Buddha identified as signs of impermanent existence—illness, old age, and death—in a world perpetually subject to change and decay. The freshness of youth lasts the wink of eye and quickly flickers out. Buddha's solution to the riddle of life in a sea of impermanence and the suffering it brings is a regimen of mind culture that secures detachment from the flux, a state of spiritual freedom he called Nirvana. The Buddha's analysis of the human condition and its prospects is a direct challenge to those religions that feature immortality as their centerpiece.

Hindu philosophy aims at achieving closure between the human self, or soul (Atman), and unchanging, indestructible Brahman, the cosmic soul, which is held to be the ultimate ground of all being. The purpose of life in all its stages is for society, education, and family to regulate belief and action to prepare for that state of oneness and escape forever the consequence of endless rebirths. In the West, it is simply taken for granted that

development and satisfaction of individual personality is what life is about. In traditional India, the opposite is true. What matters is that an ephemeral individual selflessly play a role defined by tradition and sacred texts, whose purpose is to transcend individuality altogether.

For Confucius, one of China's first teacher-philosophers, the overriding problem of man and society was a redefinition of humanity to harmonize the world's equilibrium by ending war, violence, and injustice. His means was a process of education that would release the "true man" by cultivating qualities of benevolence, integrity, righteousness, and reciprocity. These "superior men" (chun-tzu, or zhunzi), firm in a knowledge of right and wrong and possessing internal moral harmony, would be available to guide rulers in the direction of ethical government.

Clearly his ideal was not democratic. Leaders, he believed, are made by education and must be judged by standards of character and knowledge. Had Confucius known about Athenian democracy in the fifth century B.C.E., the immediate ancestor of all contemporary democratic institutions and ideas, he probably would have scoffed and asked where order and systematic control exists in such a loose, even chaotic system of government. While in the United States there may be something to the belief that anyone can become president, in the Confucian view the candidate would first have to be a morally superior person.

In the same period of disunity, Taoists (Daoists) proclaimed a route to harmony through personal identification with spontaneous forces of nature, called Tao (Dao), the Way, which entailed abandonment of conventional social and political life. In the Taoist view, government and moral virtue contribute to the problem of divisiveness and factionalism. The essence of assertive government and moral self-righteousness is a tendency to meddle, perhaps with good intentions, but most often with bad results. For the Taoist it was always best to leave well enough alone, a philosophy of laissez-faire in full bloom 2,400 years before Adam Smith and Herbert Spencer. In traditional China, the Confucian point of view became the doctrinal basis of the world's most systematic, effective bureaucracy before the West caught up in early modern times. Generations of Chinese officials, steeped in values of duty, study, and propriety, often turned to Taoism in private life for release from schedules, obligations, worries, and tension. The effects on art and poetry were profound. Anyone who seeks relief from routines, rules, and responsibilities in solitude, unplanned activity, or excursions of the imagination has entered the realm of Tao.

In traditional Japan, a thread running through centuries of historical change was a reverence for nature, a readiness to attribute extraordinary dignity and significance to rocks, trees, creatures, and places of undeniable beauty, and the development of ritual observances to express wonder and gratitude. Nature worship was central Japan's native religion, Shintoism, but was reinforced by major Buddhist sects that chose to find Buddhahood in impermanence. Many Western architects and artists have been enchanted with Japanese models of beauty expressive of oneness between man and the natural world. There is nothing in nature that is not good, including earthquakes and tsunamis. In traditional Japanese thought it is proper for man to bow in the presence of natural phenomena. In Zen Buddhism, enlightenment can be inspired by the humblest physical objects.

Modern men and women can easily spot counterparts in seventeenth-century Japanese urban life. Commoners living in towns, unburdened by political obligations, created a

unique culture that was hedonistic, materialistic, and secular, with literature and art designed for the masses—in short, a concentrated form of popular culture based on commerce that was a forerunner of modern market-driven culture. A love of money, entertainment, consumption, fast living, and volatile relationships are not inventions of the materialistic West. All the trappings of hard-driving, unsettling secular culture were well developed in premodern Japan, associated with a sense of uncontrollable impermanence—the "floating world."

Men and women in the twenty-first century, swept along in the fuss, turmoil, and uncertainties of modern life, are not so remote from these ideas. They were given symbolic meaning in sculpture, painting, architecture, and literature, so that the possibilities and travails of life become visible. Buddhist sculpture invites meditation on perennial issues of life and death. Hindu temples express faith in celestial powers, a mythical structure of the universe, and the complex relations of both with the human condition.

Chinese landscape painting offers a vision of man and nature in harmony that is markedly ecological in its implications; any one thing is connected to everything else in a web of mutual influence. The harmony expressed is cosmic, social, and personal, all associated with a discipline and aesthetic based on skilled manipulations of animal-hair brushes, black ink, a stone for grinding ink, and paper or silk.

An ancient Shinto shrine located in a place of remote, evocative beauty concentrates the mind on the numinous relations between man and nature. Japanese painting and architecture of the fifteenth and sixteenth centuries embody an aesthetic of simplicity and contemplation called shibui, which derived from the convergence of Zen Buddhism with Shinto nature-worship and was applied with a sense of frugality to the humblest surroundings and objects of life—a perfect antidote to a modern culture overstuffed with disposable things. It is ironic that modern industrial Japan would do well to recapture these aspects of its own historical tradition.

With this much said, a qualification is needed about the passage of ideas between cultures. India and China produced intellectual traditions that were adopted wholesale by other peoples without overt proselytizing. Hinduism and Buddhism spread easily to mainland and island Southeast Asia. Buddhism flowered in Tibet, China, Korea, and Japan. Confucianism made its way effortlessly to North Vietnam, Korea, and Japan. The situation with Japanese religion and ideas was markedly different. Shintoism never had appeal outside of Japan.

In the case of Buddhism and Confucianism, both were Japanized so thoroughly as to be nearly unrecognizable. Even if recognizable, ideas from those traditions in their Japanese form had no attraction outside the country. A number of Japanese thinkers scorned or repudiated borrowed traditions and talked narrowly about "the Way of Japan." The point is that ideas without a universal reach will not attract a wide audience. Buddhism and Confucianism offered a universal platform on which all people could stand. Japan did not.[1]

How, then, shall we address ideas in Japan? Some discussion of Shinto, Buddhism, and Confucianism is necessary to explain what they became in the hands of Japanese thinkers, and why they were more local and parochial than open and universal in their implications. Then we shall argue that one set of ideas did have universal possibilities—specifically those embodied in self-conscious aesthetic theory defining standards of

beauty. Shintoism and Buddhism, even if narrow in other respects, contributed notably to Japanese aesthetics, and, in that guise, reached beyond the narrow confines imposed on them by Japanese thinkers.

Understanding Historical Uniqueness

The deepest understanding of one's own cultural tradition comes through experience of "the other," that which is truly unfamiliar and even mysterious. The shock of contrast can sharpen knowledge, appreciation, and criticism of beliefs and practices normally taken for granted. While bridges can be built and points of convergence can be found, all great cultural traditions are sui generis because their distinctive achievements appear in one place and time and not in others, a result of dissimilar historical circumstances and experiences. The Temple of Heaven in Peking could not have been erected in ancient India, nor could a Hindu temple have been built in medieval Japan. Style in art and architecture is specific to historical moments of time and place. The uniqueness of artifacts in our three Asian cultures confirms the variety and richness of human imagination.

The study of history, art, philosophy, and religion across cultural boundaries has two main objectives. One is to isolate unique elements that give a civilization its substance and contours, which is a necessary condition for understanding and contemplating it with empathy and detachment. One way of pursuing this goal is historical and philosophical inquiry supplemented by attention to art—a union of ideas with relevant images.

The second is to locate points of convergence with common human experience so portions or facets of an unfamiliar and distant civilization can be assimilated to contemporary interests and needs. In the meantime, it is well to reflect with some humility that what is happening now is not necessarily "better" in a comprehensive sense than what happened in India, China, and Japan a thousand years ago.

2
Symbols, Styles, and Meanings

The works of art and architecture discussed and illustrated in this volume are understood and discussed as embodiments of symbols, styles, and meanings. These three ideas are normally intertwined, and appear and work together, but are best clarified separately. They are bridges between ideas and art.

Symbols

"Symbol" comes from the Greek "symbolon," which means a sign. On the simplest level, symbols stand for something else.[2] Words are used to stand for things, conditions, and

ideas. Objects can be symbolic of other objects or of immaterial things. A work of art may have within it numerous symbols, as in the beautifully carved sandstone lion capital of the Mauryan king Ashoka, who was converted to Buddhism and spread its teachings throughout his extensive empire (fig. 2.1).

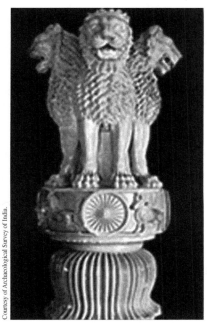

Four lions represent the Buddha roaring his message of enlightenment and compassion to the four cardinal directions. The lions are partly supported by an inverted lotus, a flower of white spotlessness that flourishes in muddy water, symbolizing the purity of Buddha emerging and finding enlightenment in the flux of impermanent existence. The wheel (chakra) has a dual meaning—the wheel of the law (the Four Noble Truths) set in motion by the Buddha's Fire Sermon and a symbol of royal authority adopted by Ashoka.

The best-known symbol from Chinese civilization is the circle divided into light and dark surrounded by the eight trigrams of the Classic of Changes (*I Ching*, or *Yi Ching*) one of the Confucian classics (fig. 2.2).

The symbol originated in the Sung (Song) dynasty as the Diagram of the Great Ultimate (see the section on Neo-Confucianism in Chapter 15). A spot of white is visible in the dark area, and a spot of black in the white area, the two areas divided by the S-shaped line symbolizing the yin and yang, which are the negative and positive sides of existence—male and female, light and dark, right and left, up and down, dry and moist, young and old, life and death, and so on. The two sides are not exclusive opposites, or rigidly dualistic, but rather complementary and interdependent. They move back and forth and alternate in dominance and subordination. In the traditional Chinese view, there are no absolutes of good and evil. Without the interplay of opposites, there would be no world.

The oscillation of yin and yang into and out of one another is one of two principles (the other is a cycle of the Five Elements) that account for change in the experienced world. Both are necessary to the fullness and operation of the universe. The broken lines in the eight trigrams that surround the yin-yang symbol represent the yin, the unbroken lines the yang. Exhaustive pairs of these eight trigrams make up sixty-four hexagrams, which are various combinations of yin and yang that correlate with phenomena of nature and the social world of man. Originally used for purposes of divination, the trigrams later took on deep philosophical significance.

Fig. 2.1 Lion capital for Ashokan pillar, Mauryan, Chunar sandstone, ca. 250 B.C.E.

Courtesy of Archaeological Survey of India.

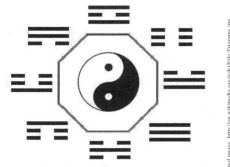

Edited image. http://en.wikipedia.org/wiki/File:Trigrams.jpg

Fig. 2.2 Yin and yang and eight trigram symbol (the Supreme Ultimate).

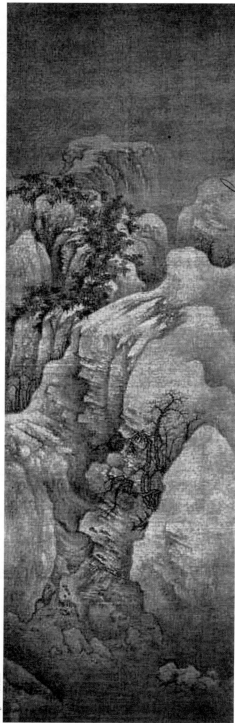

Shanghai Museum.

Fig. 2.3 A landscape by Kuo Hsi (Guo Xi), *Deep Valley*, Northern Sung (Song) dynasty.

While individual symbols abound, a work of art can be symbolic of reality in a holistic sense, which is different from viewing its constituent parts, as in a Sung dynasty landscape painting symbolizing the harmony and unity of the cosmos as well as the virtue and composure of the painter. A landscape painting attributed to Kuo Hsi (Guo Xi) from the eleventh century C.E. conveys a vision of nature as an organic oneness conceived in the painter's mind and spontaneously transferred to silk by his inspired brush (fig. 2.3).

The painting reflects simultaneously ideas of Confucianism, Taoism, and Buddhism and represents the universe as a self-operating organism. Viewed as a holistic symbol, it is "presentational."[3] Discursive symbols have an analytical purpose, as when words are used to dissect a poem or a painting. Presentational symbols function to create forms as a totality. In great works the result is the artist's organic response to experience, which, in turn, can elicit an organic response from a viewer or listener. A presentational rather than an analytical experience with art or architecture means an initial experience unmediated by names, subject matter, medium, technique, and interpretation. A spontaneous act of seeing or hearing initially provides an unfettered intensity usually hard to recapture. The initial sense of spontaneous wonder tends to diminish with successive viewings and yields to maturity of judgment and response conditioned by familiarity and reflection.

Styles

Awareness and analysis of style are central to art historical thinking. Without the concept of style, there would be chaos in the profusion of artifacts thrown up by every civilization and no way of relating them to one another, to their makers, to their environments, or to past and present. One should try to imagine Chinese landscape paintings from the Sung through the Ch'ing (Qing) dynasties piled up without any assignment to period or creator. The spectacle

would be a meaningless heap. Stylistic analysis defeats the chaos and brings the order needed for study and understanding. The reality of style is a key to the meaning and continuity of art.

Style means a consistency of form, content, and expression in the art of a person, group, or historical period, all of which is subject to change in fresh historical circumstances. Through stylistic analysis the art historian aims to establish motives and patterns that can locate a work in space and time, identify forms expressive of outlook in artists and groups, compare established patterns in art with other aspects of a culture (e.g., literature, philosophy, institutions), and marshal evidence of historical and cultural unity in a civilization through the existence and coherence of styles.

Two useful principles for assessing cultures have emerged from stylistic analysis. First, similarities of style found in many art forms constitute evidence that a culture is highly integrated; that is, all constituent parts are working together, more or less, to promote a coherent vision of beauty or truth.[4] Unity of style is a necessary condition for shared public consciousness and ceremony. Ideas of Taoism and Confucianism in traditional China appear in painting, architecture, and poetry as stylistic motifs that reflect definite ideas. For example, the Taoist emphasis on spontaneity—or Tao, the Way of Nature—as the painter puts brush and ink to silk or paper, and the Confucian stress on tradition, as poets and artists strive to honor the spirit of past masters in their work, are examples of this unity. Disconnected stylistic patterns, or the absence of patterns, suggest a culture that is disoriented, fragmented, and in decline from a previous level of integration. Mixed messages from a proliferation of contesting styles tend to undermine social cohesion and aesthetic coherence.

Second, great styles are unique, and uniqueness is confirmed by their coherence, a condition for spotting uniqueness to begin with. Great styles can be imitated but not duplicated. As observed earlier, they belong to one place and time and could not have been produced elsewhere at another time. Kuo Hsi's landscape in Figure 2.3 could not have appeared as a wall painting in an Egyptian tomb, and the subtle Japanese tea ceremony (chanoyu) could not have been practiced by Greek philosophers in the Athens of Pericles. An Indian, Chinese, or Japanese religious building projects different meanings and represents dissimilar styles that arose under widely separated historical circumstances to express unique meanings (figs. 2.4, 2.5, 2.6). A purely visual analysis suggests three different worlds of meaning respectively in a Hindu Temple at Khajuraho, India; the main Shinto shrine

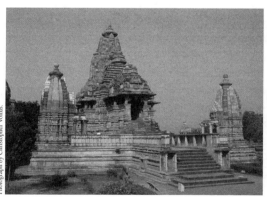

Fig. 2.4 Lakshmana Temple, Khajuraho, tenth century C.E.

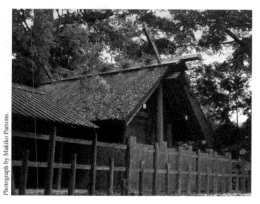

Fig. 2.5 Shinto, Ise Naiku, pre-Buddhist.

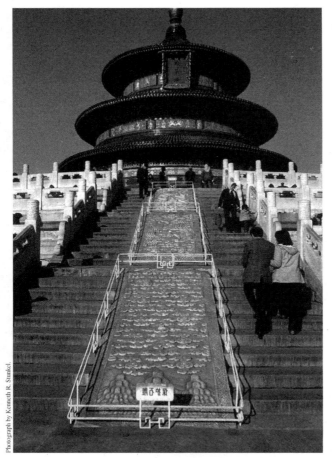

Photograph by Kenneth R. Stunkel.

Fig. 2.6 Hall of Annual Prayers, Temple of Heaven Complex, Peking.

at Ise, Japan; and the Confucian Temple of Annual Prayers, part of the Temple of Heaven, in Peking, China. This is true "diversity." The sad reality is that unique styles are increasingly diluted or lost as they are homogenized by the global influence of Western technology and popular culture. The most dramatic examples of such debasement are the pseudo-historical monuments in Las Vegas and the various Disneylands around the world.

Style is the medium of visual "literacy," which means an ability to "read" visual images, to detect and interpret similarities and differences, to compare and contrast objects unlike one another, and to locate works in space and time. Every artist and architect of any note is associated with a style. While a response to art by direct inspection does not require knowledge of stylistic issues, it is indispensable to appreciation and understanding at deeper levels.

Meanings

No one can live or act without beliefs. Even a philosopher skeptical of all belief holds a belief and wishes it to be taken seriously. The grounds on which beliefs are held may be doubtful, but there is no doubt that beliefs are needed to get through life and that people who hold them think they are meaningful and not just random or arbitrary. The content of all civilizations—government, social life, art, religion, science, and philosophy—aims to express and embody meaning and purpose in systems or structures of belief. Meaning has to do with making sense out of existence, giving it definition, form, direction, and purpose. If a large number of people share the same general belief system and it is reflected in what they say and do, the historian can detect consensus, as well as dissent, in surviving artifacts of literature and art.

Early Buddhist scriptures say the great problem of life is suffering caused by clinging to the impermanence of existence, and it can be solved only by an individual journey, the ideal of the Arhat who goes to the end of the Eight-Fold Path on his own. Mahayana

would the reader know what ?

Buddhism acknowledges the same problem but claims that "salvation" comes from dependence on the merit of an enlightened being (Bodhisattva). For the Buddha there is no survival of personality in Nirvana. For devotees of a Bodhisattva, the promise is individual bliss and survival in a paradise.

In the pre-imperial world of ancient China, the acknowledged problem was to end disunity, war, corruption, and insecurity in order to harmonize the world. The official philosophy of Ch'in (Qin), the state that unified China in 221 B.C.E., was Legalism, which affirmed the natural evil of man and the need for strict laws enforced by rewards and punishments, and defined the meaning of "right" as the ruler's point of view. The Confucian philosophy that replaced (and predated) Legalism in later dynasties affirmed the natural goodness of man, and the need for virtuous men in government who would rule according to moral principles, and the meaning of "right" as a cosmic principle binding on the ruler. Complementing this moral philosophy calling for social action was the philosophy of Taoism, which called for spontaneous behavior, disregard for convention, and a quest for oneness with the flow of nature.

In Japanese civilization, there were always strong individuals, including women, who stood out from the crowd, but the common belief was in the superiority of men over women, old over young, and groups over individuals. Life's meaning was associated with discharging traditional duties and obligations (to parents, teachers, elders, lords). Deviation from that path of duty resulted in shame that could be wiped away in extreme cases only by ritual suicide. These beliefs could lead to knotty contradictions and troublesome choices. In early eighteenth-century Japan, for example, forty-seven samurai warriors went into seclusion after their lord was ordered to commit suicide by the shogun for drawing a weapon within the palace and wounding an official who had insulted him. A samurai had a double obligation, one to the shogun who ruled Japan, another to the lord he served directly. Forty-seven of the lord's retainers now became ronin, or masterless samurai, and decided to avenge their lord and kill the man who had insulted him. When they succeeded, the shogun, in turn, ordered all forty-seven men to commit seppuku (disembowelment) for violating shogunal law.

The cross-cultural lesson from these examples is that Western ideas of freedom, individualism, civil liberty, and legal rights do not apply to the traditional civilizations of India, China, and Japan. Their cultural premises and options had different historical roots, and resulted in works of art expressive of meanings that clash with those of the West. To understand the art of any civilization, one must have access to its meanings, which is achieved by symbolic, or iconographic, analysis of individual works and groups of works in their historical settings.[5]

Notes

1. Hajime Nakamura, *Ways of Thinking of Eastern Peoples: India, China, Japan, Tibet,* edited by Philip Wiener (Honolulu: East-West Center Press, 1964), 396–399.

2. The idea of symbol in its broadest philosophical meaning can be explored in Ernst Cassirer's *Philosophy of Symbolic Forms,* translated from German by Ralph Manheim (New Haven: Yale University Press, 1953, 1955, 1957), which is available in a shorter form as *Essay on Man* (New Haven: Yale University Press, 1944).

3. Suzanne Langer, *Philosophy in a New Key: A Study in the Symbolism of Reason, Rite, and Art* (Cambridge, MA: Harvard University Press, 1942), Chapter 4.

4. The discipline of art history was a German invention, known as *Kunstgeschichte* (literally "art history"), which deals with architecture, sculpture, painting (the three referred to as "fine art"), minor arts like ceramics, and applied or industrial art. Apart from analyzing art as style, what is visible to the eye, artifacts may be studied in other ways—e.g., in their cultural-historical contexts, in relation to subject matter and iconography, or as an integral expression of a people's outlook on life and the world. All of these approaches find uses in this book. On various meanings of style, see Meyer Schapiro, "Style," in Melvin Rader (ed.), *A Modern Book of Esthetics: An Anthology* (New York: Holt, Rinehart and Winston, 1962), 336–337.

5. Panofsky defines iconography as "that branch of the history of art which concerns itself with the subject matter or meaning of works of art as opposed to their form." Erwin Panofsky, *Studies in Iconology: Humanistic Themes in the Art of the Renaissance* (New York: Harper & Row, 1962), 3.

PART II
INDIA

3
India's Historical Foundation

India is a vast country, 2,500 miles in breadth, 1,500 miles in length, endowed with the world's highest mountains, two great river systems, deserts, and rain forests. Its history is long and complex, reaching back perhaps to 2500 B.C.E. Over the centuries numerous peoples, tribes, languages, and religions have arisen, competed, and jostled one another. Over time, for example, there were some two hundred languages, fourteen of them major. Four major invasions influenced Indian culture and institutions, and all but one (the British in the seventeenth century) entered from the northwest through the Khyber Pass. The Aryans came through in about 1500 B.C.E., Alexander the Great in the fourth century B.C.E., and the Muslims in the tenth century. Long stretches of India's past—especially the period from 1500 to 500 B.C.E.—are mostly a blank for lack of a written record. Archeological analysis of surviving remains can take the story only so far, and that kind of evidence is limited in quantity as well. In short, India does not have a continuous history that can be traced through time without serious breaks, especially in the period before the Muslim invasions.

Islam was well established in the north by the thirteenth century, and much of central India as well fell to Mughals from Akbar to Aurangzeb from 1526 to 1707 C.E. The general effect of Islam was to obliterate Buddhism, drive Hinduism into a state of rigidity, and impose cultural apartheid on Indians under Mughal rule, despite the exceptions of enlightened toleration, such as that of the emperor Akbar in the late sixteenth century. In the realm of ideas and art, there were nodal points where Hinduism and Islam met, compromised, and even fused, creating a unique Indo-Muslim cultural fabric.

Muslims in India, however, are not within the purview of this book; nor are we con-

cerned with India's experience with the British. Our exploration of Indian ideas and art runs from the Aryan invasion of 1500 B.C.E. to India's medieval era, ca. 1000–1300 C.E., when Hinduism was in full swing—there was much temple building, and a multitude of religious cults centered on worship (bhakti) flourished. By that time, Sanskrit literature was codified and included the two great epics, *Mahabharata* and *Ramayana,* various law books, the six classical systems of philosophy, and texts associated with the Hindu four ends and four stages of life. From roughly 300 B.C.E. to 1300 C.E. a tradition of architecture and sculpture centered on Buddhist and Hindu themes is evident.

Is this a theme?

Indus Valley Prelude

The foundation of ideas in India was laid between 1500 and 500 B.C.E. The Indus River Valley civilization of Harrapa and Mohenjo Daro (c. 2500–1500 B.C.E.), about which little is known, is—along with Sumeria on the Tigris-Euphrates, Egypt on the Nile, and China on the Yellow River (Huang ho / Huang he)—one of the world's earliest river valley civilizations. Some archeological remains point to later continuities, such as the figure on a seal resembling a yogi in meditation, possibly an early version of the god Shiva, an apparent "priest" with a tri-foil robe covering the left shoulder, and images of

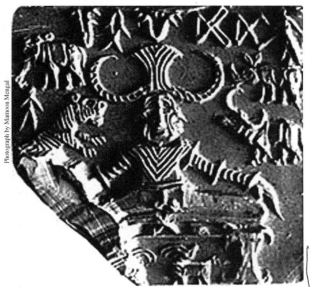
Photograph by Mamoon Mengal

Fig. 3.1 "Yogi" figure from Mohenjo-Daro, 2000–1500 B.C.E.

cows and bulls on seals, anticipating widespread cow worship in later history that continues today in modern India—one cow per hundred people in a population of more than a billion (figs. 3.1, 3.2, 3.3). In Figure 3.1 note the symbols of a language that remains undeciphered.

The yogi figure, prefiguring the god Shiva, and suggesting transcendental meditation, represents an indigenous substratum of religious belief and practice that interacted with the polytheism and ritualism of the Aryan invaders and was linked to later modifications of Vedic authority in the Upanishads, or outright departure in the unorthodox movements of Jainism and Buddhism.

The Aryan Overlay

Would readers know Vedic authority?

Around 1500–1400 B.C.E., the Harappan civilization was overrun by nomadic Indo-Iranian invaders called Aryans (Arya), who spoke early Sanskrit, an Indo-European language that became the classical tongue of ancient India. Arya means "high born and noble," but refers to language rather than class or race. These warlike nomads, riding chariots and using bronze weapons, worshiped a host of gods associated with natural

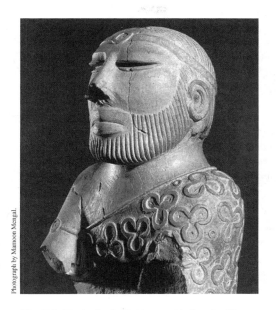

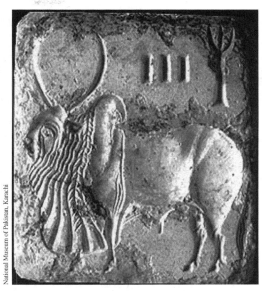

Fig. 3.2 Bust of priest, king, or deity, steatite, Harrapa, 2000–1500 B.C.E.

Fig. 3.3 Bull seal with script from Mohenjo-daro, 2000–1500 B.C.E.

forces, such as Indra for the sky and Agni for fire. Most Vedic gods survived into later times and became part of the Hindu pantheon. In return for ritual sacrifices, the Aryans wanted material advantages and favors from the gods, so their religion was very much a quid pro quo arrangement—in effect, we'll do something for you if you do something for us.

The Aryans composed an extensive literature called the Vedas, four collections (*Rig, Yajur, Sama, Artharva*) consisting of stately hymns, ritual instructions for communicating with the gods, and speculative treatises about the soul. The Vedas formed the basis of later Brahmanical culture, which emphasized a priestly monopoly of the Vedas and the elaborate rituals they controlled to commune with the gods and influence events. In due time, this Brahmanical culture was interpenetrated by beliefs and ideas from the conquered Indus River civilization.

The Long Silence

From 1500 to about 500 B.C.E., mostly a thousand-year historical blank, Aryans moved into the Gangetic plain of north India, conquered it, and settled down. This period gave rise to kingdoms from 1000 to 500 B.C.E., probably inspired by those of Babylonia, Assyria, and Persia. Around 500 B.C.E. Buddhism and Jainism were founded as heterodox movements that denied the authority of the Vedas. They shared some ideas in common, and in their respective scriptures each is clearly aware of the other's existence. By the time of the Mauryan Empire (326–184 B.C.E.), the tradition of a universal king (chakravartin) was established. The Mauryans Empire was a watershed event, as India's first imperial unification, which followed the invasion of Alexander the Great in the mid-fourth century.

Ways of Kingship

The most celebrated Mauryan king was Ashoka, named the "Sorrowless." He called himself raja (suggesting "he who pleases") and also took the title "beloved of the gods." After bloody military campaigns, in which he conquered most of India, provoked a surge of remorse, he converted to Buddhism. It was Ashoka who established the Brahmi script to write Sanskrit and spread Buddhism throughout his empire—some three-quarters of India, a larger area than any other power was able to unite before the British. Numerous Buddhist monuments, stupas, and great halls (chaitya) for worship were cut from living rock. Many tall, polished pillars were erected across India with inscriptions praising Buddha with sculptural forms adorning the crowns, such as a Brahman bull. The bull was prominent on Indus Valley seals and later was the favored mount of the god Shiva, but it also perched on an inverted lotus symbolizing Buddha (fig. 3.4).

In Mauryan times, the voluminous epics the *Mahabharata* and *Ramayana*—whose mythological themes provided endless motifs and figures, divine and human, for art—were consolidated. The Brahmanical reaction to unorthodox movements such as Buddhism that rejected the Vedas began to take shape as Hinduism.

In medieval times (1000–1300 C.E.), those who thought of themselves as universal kings had semi-divine status and took the title maharaja, or great king. The king was supposed to bring peace and order to the world in its last and most corrupt time cycle, kali yuga (see below under India's cosmology). Reform and legislation were not considered issues. The prospect of disorder and anarchy was universally dreaded. Various Hindu writings address the need for monarchs and their many duties. Kings were created to maintain order and prevent evil. They were autocrats restrained by custom, law, brahman priests, and ministers. Their chief role was that of protector rather than lawmaker, and the people always came first, at least in theory: "In the happiness of his subjects lies the happiness of the king in their welfare, his own welfare. The welfare of the king does not lie in the fulfillment of what is dear to him; whatever is dear to the subjects constitutes his welfare."[1] Kingship belongs to the kshatriya class of defenders and rulers, whose self-effacing duties are spelled out as an imperative of dharma, the sacred law or duty whose violation leads to destruction.

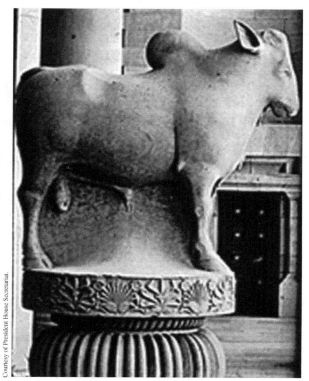

Courtesy of President House Secretariat.

Fig. 3.4 Bull capital from Rampurva, c. 260 B.C.E., sandstone.

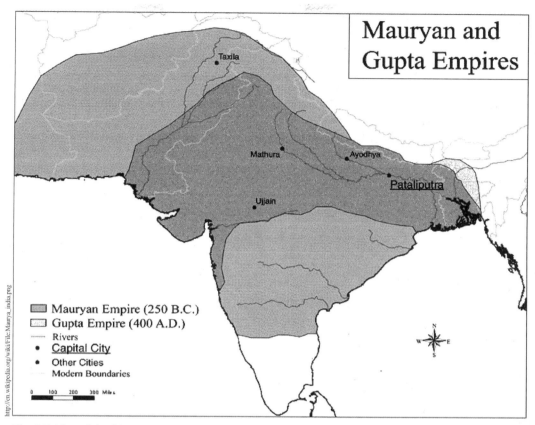

Fig. 3.5 Map of the Mauryan empire.

A Cultural Summit

The high point of classical Indian civilization was the Gupta Empire (320–600 C.E.). This is when the social, religious, and philosophical basis of Hinduism was largely established; Sanskrit literature flourished in poetry and drama; the six classical systems of philosophy were formulated; mathematicians contrived the zero and the decimal place; and much spectacular temple building was undertaken, including the earliest surviving structures. In the early history of Buddhism, there were no direct representations of the Buddha in sculpture, but after the first century C.E. a rich tradition of sculpted Buddha images is evident with sophisticated iconography that distinguished Buddhas from Bodhisattvas.

Society and Thought Stabilize

By Gupta times, the Hindu class system (varna) and the caste system (jati) were fully visible in the cultural landscape, and the ideas of karma and reincarnation had become central to most religious and philosophical points of view. Five stages of religious and philosophical development are discernible, but there is overlap and no tidy succession of doctrines and practices.

A provisional sequence would be:

- Vedic polytheism, with its elaborate rituals to win the favor of the gods.
- Brahmanism, dominated by priests as keepers of the Vedas and sacred rituals.
- Monism of the Upanishads, late additions to the Vedas, which reflect the dissatisfaction of forest sages with the power of the brahman priests and a desire for direct contact and union with ultimate reality, or Brahman.
- New religions derived from an indigenous, non-Vedic base, notably Buddhism and Jainism, which rejected the authority of the Vedas and Brahmanism and sought independent means of enlightenment. For early Buddhism, the ideal was personal discipline and mind culture leading to Nirvana, which means the cessation of clinging to impermanence and release from the wheel of karmic rebirth. For Jainism, the ideal was a life that minimized harm to souls so that bad karmic matter could be expelled from the body and an untrammeled soul could escape rebirth and rise to the top of the universe in eternal bliss.
- Hinduism, a reaction to anti-Vedic teachings such as Buddhism and Jainism, which attempted a comprehensive synthesis of religious ideas and practices that would preserve the status of brahmans and authority of the Vedas while allowing a structured option for achieving personal "enlightenment."

In the midst of this religious diversity, Hinduism emerged not only as body of religious beliefs, practices, literary forms, and philosophical systems, but also as a distinctive web of social arrangements that touched life at all points from birth to death.

4

India's Social Net

The Hindu way of life emerged as an amalgam of related and disparate beliefs, aims, methods, attitudes, and social arrangements. Hindu social ideals and practices did not lend themselves to Buddhism and Jainism. As Aryans settled in the north, four classes (varna) emerged and gradually spread to the south. Because varna means "color," the class system was probably based originally on a racial distinction between light-skinned invading Aryans and dark-skinned indigenous Dravidians. Among the four classes, brahmans sacrificed, studied, taught, and gave and received gifts; kshatriyas sacrificed, studied, and provided protection as warriors, rulers, and administrators; vaisyas (merchants and artisans), sacrificed, studied, traded, and lent money; shudras (farmers and laborers) served the other three classes and were denied contact with the Vedas. The first three groups were "twice born" (dvija)—first at birth and a second time at the coming of age, when they were invested with a sacred thread over the left shoulder and under the arm.

An elaborate ceremony, called upanayana, guided by exactly prescribed steps and words, was a major family rite that sanctified males as full members of class and society and initiated the first stage of life (ashrama), that of a student in total submission to a qualified teacher (guru). The most holy verse from the *Rig Veda* was whispered into the initiate's ear: "Let us think on the lovely splendor / of the god Savitr (the solar god), / that he may inspire our minds." Under his guru, the student was bound by a "vow (of studying) the three Vedas . . . for thirty-six years, or for half that time, or for a quarter, or until the (student) has perfectly learnt them."[2]

The caste system (jati) appeared along with the class system. Caste was linked to occupation and involved strict limitations on individuals, who were required to confine all social intercourse, including marriage and meal taking, to members of his or her caste. Movement and social intercourse between classes was less strict, but applied more strictly to women than to men. The difference between class and caste is that the former was permanent while the latter changed as occupations came and went. At present there are some 3,000 shifting castes in India tied to various occupations, but the four classes are still in place. At the very bottom of the social scale, outside of class and caste, are the chandalas (outcasts). These unfortunates performed "unwholesome" tasks like cleaning latrines, slaughtering animals, and burning the dead. They were required to wear a noisemaker around their necks and use it to warn others of their approach lest they spread spiritual pollution and make rites of purification necessary.

Social underpinning of the class and caste systems is the family. Whatever the class or caste, the traditional Indian family is extended, patriarchal, patrilinear, and the basic unit of the social system. A family group is united in the three upper classes by a rite commemorating ancestors that go back to Vedic times. In all the social groups, the father's power is considerable but limited by sacred law (dharma) and custom. The importance of family in general is codified as the second of the Hindu four stages of life. Without the family, the individual is a helpless leaf blowing in the wind, and in the family socialization into the duties and expectations of class or caste is inevitable.

The rationalization and explanation of class and caste status is karma and reincarnation. For Hindus, good karma comes from obeying the dharma of one's class or caste. Dharma can mean duty, law, right behavior, or proper action. Suitable behavior depends on social status. Dharma for a brahman is not the same as dharma for a shudra. Bad karma comes from neglecting dharma and produces the reverse effect, rebirth at lower levels of status or consciousness, even as an insect or a weed. Karma is always a matter of conscious acts, not accidents or unintended acts, whether good or bad. *The Law of Manu* warns: "Better one's own dharma, done imperfectly, than another's well performed."[3] If dharma is observed faithfully, the next life can see a shudra elevated by good karma to the status of a vaisya. In the Hindu view of life, everyone plays a fixed but necessary role in the cosmic scheme of things. Staying faithfully within the confines of an assigned role, as defined by class or caste affiliation, requires discipline, vigilance, and sacrifice.

The ideal is to fulfill obligations without complaint or ambition to do otherwise. Since individual lives are as brief and insecure as flecks of foam, social and spiritual goals are united—individuals accept with tranquility the situation into which they are born. More is needed than simply making the best of one's social position like a good stoic schooled in resignation and apathy. Men and women are expected to immerse themselves actively

and selflessly in the roles assigned by their previous karma and the social framework. Lying behind the masks everyone must wear as social beings are cosmic cycles of creation and dissolution and the prospect of numerous reincarnations before reaching the final goal—absorption into Brahman, the ultimate reality, or some state of bliss associated with worship of a deity. Wearing the mask with joyous acceptance is the goal. A despised chandala who performs duties serenely has a better chance of favorable reincarnation in the direction of final release from karma than if he broods over his lot, behaves erratically, or yearns to climb the social ladder and become a brahman.

This elaborate system of social guidance and restraint was framed within an equally complex vision of what the universe is and how it functions.

5

India's Cosmology

Hinduism absorbed an elaborate conception of time and space that had roots in Jain thought and also influenced Buddhism.[4] In the way to "enlightenment" of all three, ideas of time and space are intimately associated with karma and reincarnation. Survival through numerous lifetimes is conditioned by karma and takes place through repetitive cycles of time. Not only does a person have more than one life, there can be millions of them at various levels of consciousness and social status.

The mature Hindu cosmology consists of expansive cycles measured in the days of wakefulness and sleep of Brahma, the creator god. The cosmic process is 100 days of Brahma awake and another 100 days of Brahma asleep. One day is a kalpa, whose duration is 4,320,000,000 years. A kalpa consists of 1,000 mahayugas, and each mahayuga consists of four yugas, each weaker than the one before and lasting a shorter period of time. Thus a krita yuga lasts 1,728,000 years, has four legs, and stands for perfection, cosmic order, and effortless realization of dharma; a treta yuga lasts 1,296,000 years, has three legs, and stands for moral decline in which dharma must be learned with effort; a dvapara yuga lasts 864,000 years, has two legs, and stands for further decline into lust, greed, and false pride; a kali yuga lasts 432,000 years, has one leg, and stands for the triumph of materialism, ignorance, and ego.

In this last stage humans are small, weak, corrupt, and deficient compared to the heroic stature, flawless virtue, and spiritual power they have in the first stage. The discrepancy explains why Jain images are remarkably tall and powerfully built. They represent stages of human existence when things were decidedly better. The names of the four ages, or yugas, are derived from an Indian dice game in which krita is the winning throw and kali the losing throw, with the other two lying between them.

The universe is currently in the last phase and awaiting its dissolution, which will last a century, each day a kalpa, after which the cycle shifts once more to creation. The full

cycle of creation and dissolution is a huge number—200,000 kalpas, or 311,040,000,000 years. This mythical cosmology with its "oceans of millions of years" supports the Hindu idea of maya, in which the universe is an illusion endlessly coming and going, appearing and passing away, and the Buddhist idea of sunyatta, or emptiness, wherein existence is an endless flux within which karma and reincarnation operate. Meditation on these cycles of creation and destruction that never end, within which the empirical self is continually reborn as the consequence of karma's remorseless action, prompts the insight that release from the wheel of rebirth is the ultimate purpose of life. Because the prospect of endless, repetitive reincarnations becomes unbearable, the time comes when insight pours in and one is ready for disciplines that can provide release from further rebirths.

Modern cosmology in the West is in striking contrast to the Jain-Buddhist-Hindu view of the universe. Time and space are confined to an expanding cosmos some 14 billion years old, originating in a "Big Bang," encompassing some 120 billion galaxies, each composed of billions of stars, and separated from one another in space by millions of light years. Earth's nearest galactic neighbor is Andromeda, some 2 million light years away. A message sent to Andromeda would take 2 million years to arrive (light travels at 186,000 miles a second, a cosmic limit) and another 2 million years for a response to return. Yet the Indian view of time and space dwarfs the cosmic vision of modern astronomy and astrophysics.

What is the difference? The Indian view is linked mythically to religious and philosophical ideas about karma, reincarnation, illusion (maya), and salvation, while the modern view derives from an objective scientific quest for testable knowledge that has no connection directly with personal hopes, fears, or dreams. Nevertheless, there is a parallel of sorts between myth and science. Meditation on the position of the earth (a "pale blue dot" from the remote orbit of the planet Neptune), and on man in a universe measured in billions of light years and containing innumerable star systems emerging and dying, can inspire humility and a sense of transience no less powerful than the thought of Indian kalpas succeeding one another in eternal cycles of creation and destruction. Hubble telescope images of a space crowded with galaxies billions of light years away bring individual egos into a humbling perspective.

In the Christian tradition, the goal of salvation is resurrection and immortal life for the individual soul, and for some Christians, even the body survives for eternity. In the Indian tradition (with the exception of Jainism), the opposite goal is sought—an end to personal existence and release from the wheel of rebirth. For Christians, there was a single moment of creation by one God followed in due time by original sin committed by the first man and woman (Adam and Eve), a one-time divine incarnation (Jesus), a sacrifice (crucifixion of the man-god to redeem original sin), a last supper with disciples and resurrection of the dead Jesus (the promise of redemption and immortality), and a day of judgment, after which souls would be saved or damned through eternity and the material universe would become irrelevant, having served its temporary purpose as a stage for the drama of salvation.

Thus the Christian view of time is linear with a beginning (creation), middle (incarnation), and end (judgment). Before the creation, there was no time; after judgment day, time is displaced by eternity. This linear sequence is what time and history are all about. The Jain-Buddhist-Hindu view is that time runs in cycles without end, although for Jains it is the world that never changes. The purpose of life is to escape both cosmic cycles and

individual existence, whether temporal or eternal. The cosmological settings for these world religions could hardly be more different in their conceptions of life and salvation in the midst of impermanence and death.

The social world of man and the cosmic world of nature collaborated to provide a richly moral and mythical setting for sacred, imaginative, and philosophical literature.

6

Ideas in Hindu Literature

The classical literature of Hinduism is written in Sanskrit. It varies in form and is not always religious in substance, but it is seldom less than religious in spirit. Poetry and drama are mostly secular but have religious themes and overtones. This body of literature is classified by Hindus as divine, like the Vedas, or traditional, like the epic *Mahabharata*. Common themes of poetry and drama are love, nature, praise of the gods and great men, and moral lessons. Storytelling has a central place, as it often does in sculptural groups. Noticeable in all forms and themes is the absence of political and social criticism. Rather than faulting the social order, authors reflect on it affectionately or reverently in their work without distaste or controversy.

Elaborate aesthetic effects are highly valued and have spiritual overtones. The language tends to be sonorous, with rhyme schemes and ornamentation (alamkaras) expected of poets, dramatists, and storytellers. Ornamentation includes literary devices like rhyme (poetic lines ending with a common sound), simile (saying one thing is like another), metaphor (saying one thing is identical with another), alliteration (repetition of successive sounds), and punning (use of a word to suggest the meaning of another word or words).

Language is crafted to simulate flavors or sympathies (rasas), of which there are eight: love, courage, loathing, anger, mirth, terror, pity, and surprise. A great poet or dramatist is judged also by reverberations (dhvani) in his work, which means the use of words with meanings and suggestiveness beyond their primary connotation or denotation. An example of all these devices in full play are the writings of Kalidasa (fl. 375–455 C.E.). Three of his plays have survived, the most renowned of which is *Shakuntala,* a love story whose plot and characters (a hermit, a king, and a young beauty living in a hermitage) are drawn from a legend found in the first book of the epic *Mahabharata*.

The dominant feeling (rasa) of the play is love, which is presented in a number of flavors from the erotic to the spiritual. Love appears in many guises, such as love of a monarch for a lovely girl he spies in a forest hermitage while hunting, the girl's love for the hermit who protects her, and love for the divine, however it may appear. The reader tastes many possible flavors of love in Kalidasa's use of poetic imagery and devices. Here are some examples of the literary devices used in *Shakuntala:*

Rhyme: *How could you fail to linger / On her soft tapering finger*, and in the waterfall? / Things lifeless know not beauty / But I—I scorned my duty, / The sweetest task of all.

Simile: *The mind of age is like a lamp* / Whose oil is running thin; / One moment it is shining bright, / Then darkness closes in.

Metaphor: *One tree bore fruit, a silken marriage dress / That shamed the moon* in its white loveliness; / Another gave us lac-dye for the feet; / From others, fairy hands extended, sweet / Like flowering twigs, as far as the wrist / And gave us gems, to adorn her as we list.

Alliteration: All servants owe success in enterprise / To honor paid before the great *deed's done*; / Could *dawn defeat the darkness* otherwise / Than resting on the chariot of the sun?[5]

When Kalidasa's work was performed, the circumstances were private, or semiprivate, or his work was performed in temples during festivals. There was no theater as such and no scenery. Theatrical "entertainment" always conveyed a religious message. Dances were used to convey subtle meanings and created atmosphere through the vocabulary of "flavors" translated into movements of head, hand, eyes, and limbs, a system of ornamentation applied to movement. Such ornamentation as an aesthetic and expressive ideal is also a pervasive characteristic of Hindu sculpture and architecture—in short, a way of thinking about aesthetic fitness on all levels.

Other than in poetry and drama, Hindu ideas of life, society, nature, and human destiny are included in an exhaustive classification of texts written or compiled by Gupta times. In these collections an attempt was made to account for everything of significance in writing. Two great divisions were officially recognized—texts coming from divine revelation (shruti) and texts coming from human tradition (smriti).

A second division was between orthodox (astika) and unorthodox (nastika) writings, which distinguished sacred Hindu texts from those of Jainism and Buddhism, but also from skeptical texts of Charvaka (atheists and materialists), whose radical ideas had virtually no impact on traditional Indian religion but did influence philosophical speculation. Hindu literature is as much alive today as it was a thousand years ago. It is a vibrant tradition that has lost none of its force with the passage of time. Modernization has not dimmed its influence. In its pages are the stories, myths, gods, and goddesses that turn up in art, poetry, festivals, domestic worship, movies, and innumerable activities of daily life in modern India. The mythological content of Indian art comes directly from these ancient texts.

Shruti includes Vedic literature. There are four Vedas—Rig, Sama, Yajur, and Artharva—each divided into Brahmanas, Aranyakas, and Upanishads. Brahmanas and Aranyakas are prose commentaries on the ritualism of metrical hymns in the Vedas. The later Upanishads elaborate hints in the early Vedas concerning the soul. The Vedas are the oldest body of religious texts in world history. Their great antiquity explains in part why most religious and philosophical doctrines in India acknowledged their authority. Given their sacred status, there were severe restrictions on who could read, recite, or study Vedic literature. Smriti, supposedly based on shruti, includes texts that appeared between 500 B.C.E. and 500 C.E. This body of writings was available to the ordinary person. They include:

Manu Smriti (Law of Manu) is a major source for dharma, including Vedic ritual, ethical conduct, custom, caste rules, criminal and civil law, foundations of class (varna), and stages of life serving its proper ends. *Manu* is a metrical work of 2,685 verses that provides detailed instructions for the development of individuals and their relationships to other social groups. The class system is explained and justified as a structure of social cooperation that serves the common good. The four ends and four stages of life are praised as a means of ordering the lives of individuals and serving all the major interests of human life. These ideals were rehearsed and dramatized in literature, art, and thought as well as practice. There was no escape.

Manu gives women a seemingly high place: "Women must be honored and adorned by their fathers, brothers, husbands, and brothers-in-law who desire [their own] welfare." On the other hand, "Day and night women must be kept in dependence by the males (of) their (families), and if they attach themselves to sensual enjoyments, they must be kept under one's control." Again: "Her father protects (her) in childhood, her husband protects (her) in youth, and her sons protect (her) in old age; a woman is never fit for independence." In addition to lifelong submission to male authority, women are denied a second birth: "For women no (sacramental) rite (is performed) with sacred texts, thus the law is settled."[6] *Manu* makes clear the foundation for these rules of dharma: " . . . with whatever disposition of mind (a man) performs any act, he reaps its result in a (future) body endowed with the same quality."[7] Man or woman, living by the rules or flouting them earns good or bad karma. Despite all these qualifications and restrictions, women were considered vessels of cosmic energy and were often depicted by sculptors as individual figures and on external temple walls.

Arthashastra (Treatise on Worldly Gain) is a handbook of government and administration that reached its present form in the fourth century C.E. The book is attributed traditionally to a minister of the first Mauryan emperor. The *Arthashastra* deals with artha (material prosperity), the second of Hinduism's four ends of life. Wealth is held to be the foundation of everything else, whether religion, philosophy, art, society, or government. The author is openly materialistic and offers practical discussions of what does and does not work in the world of power and ambition. Topics reviewed include administration; military affairs; law; economic issues such as coinage, commerce, and taxation; orderly succession on the throne and the duties of kings; and principles of effective government. This early version of hardheaded "political science" was part of a tradition nevertheless hedged in and tempered by religious teachings and expectations.

Monarchy is defended as the best form of government. The existence of the state, embodied in the king, is explained as a bulwark of the weak against the strong: "The king who is well educated and disciplined in sciences, devoted to good government of his subjects, and bent on doing good to all people will enjoy the earth unopposed."[8] This same king, however, is supposed to defend and enforce tradition. The stability of the universe depends on everyone keeping to a divinely assigned place: "The observance of one's own duty leads one to . . . [heaven] and infinite bliss. When it is violated, the world will come to an end owing to confusion of castes and duties."[9]

Mahabharata (The Great Bharata) is a martial epic of 100,000 Sanskrit couplets filled with religious, mythological, and theological material. To this day, gifted storytellers recite

the great epic from memory for eager listeners. It is said that everything of consequence can be found in the *Mahabharata*. The epic contains, among other things, an account of the four classes (brahman, kshatriya, vaisya, shudra), the four ends of life (dharma, artha, kama and moksha), and the four stages of life (student, householder, hermit, and homeless wanderer). The story is complex and teems with characters and events. Two families of cousins, the Pandavas and Kauravas, end up fighting because the latter want to usurp the rightful kingdom of the former after winning it in a game of dice.

The losers go into exile and are promised restoration of the kingdom when they return after thirteen years, but upon returning, the promise is broken and their heritage is illegitimately withheld. The five aggrieved Pandava brothers, of whom the most prominent is Arjuna, a princely warrior, assemble an army to settle the dispute on the battlefield. The decision to go to war is not an easy one for Arjuna. Among the Kauravas are many esteemed relatives of the Pandavas, but the war must be fought because principles of honor and chivalry have been violated. The Pandavas launch into battle and destroy their offending rivals, but initially their leader, Arjuna, is plagued with doubt and indecision.

Bhagavad-Gita (Song of the Lord) is a long episode in the *Mahabharata* and perhaps the most influential and treasured of Hindu religious documents. The *Gita's* importance is its bold synthesis of apparently conflicting ideas that arose earlier—Vedic theism and sacrifice, the dualism of Jainism, Sankhya, and Yoga (i.e., spirit versus matter), and the monism of the Upanishads (the Atman-Brahman doctrine). The *Gita* also makes extensive use of the three gunas (sattvas, rajas, and tamas) to distinguish three kinds of knowledge, action, and happiness. Ultimate release from all attachment to the world is the ultimate goal of man, but prior to release one has no choice but to act in the world.

Before the battle between the Pandavas and Kauravas commences, Arjuna is reluctant to take violent action against so many kinsmen lined up on the other side. He engages in a philosophical dialogue with his charioteer, who is none other than Krishna, an incarnation of the god Vishnu, who announces: "I am the origin of all; from Me all [the whole creation] proceeds. Knowing this, the wise worship Me, endowed with meditation."[10] Krishna's advice to Arjuna comes from Vishnu, who reveals himself when a cosmic cycle reaches a downward swing and evil threatens to overturn good.

The *Gita* spells out in detail the powers of the supreme Lord, who is creator, preserver, and destroyer. Krishna explains that no one ever truly dies (karma and reincarnation): " . . . Wise men do not grieve for the dead or for the living." As the imperishable soul passes from childhood to youth to old age, so it passes from one body to another, from one social mask to another, in the round of incarnations mandated by karma:

> Know thou that that by which all is pervaded is indestructible. Of this immutable being, no one can ever bring about destruction . . . He who thinks that this slays and he who thinks that this is slain; both of them fail to perceive the truth; this one neither slays nor is slain. He is never born, nor does he die at any time, nor having once come to be does he again cease to be. He is unborn, eternal, permanent, and primeval. He is not slain when the body is slain. . . . Just as a person casts off worn-out garments and puts on others that are new, even so does the embodied soul cast off worn-out bodies and take others that are new . . . The dweller in the

body of everyone, O Bharata (Arjuna), is eternal and can never be slain. Therefore, thou shouldst not grieve for any creature.[11]

This is the insight Arjuna lacks as he struggles with his conscience on the eve of physical battle. Krishna continues to explain that he must act because action of some kind is unavoidable. If he chooses not to fight in order to spare lives and injuries, he is acting contrary to dharma (his obligation) as a kshatriya: "Further, having regard for thine own duty, thou shouldst not falter; there exists no greater good for a kṣhatriya (warrior) than a war enjoined by duty . . . But if thou doest not this lawful battle, then thou wilt fail thy duty and glory and will incur sin . . . Treating alike pleasure and pain, gain and loss, victory and defeat, then get ready for battle. . . ."[12]

What matters is to fulfill with detachment the dharma associated with social position in the cosmic scheme of things. If action is pursued without regard to self, it becomes a form of disciplined meditation, the portal to identification with the ultimate source of all being. The temporary mask Arjuna wears is that of a kshatriya, whose role and duty is to fight. Not to take up arms and do his best regardless of the consequences is to violate the divine order, leave society in a state of confusion, and pay a price with unfavorable karma.

The *Gita* distinguishes three paths to release from the wheel of rebirth, all of them called yogas, or disciplines. The path for Arjuna is karma yoga, the discipline of detached action. Single-minded devotion to a deity like Krishna, without regard to gains or losses, is bhakti yoga, the discipline of worship. A quest for illumination in the practice of yogic austerities (meditation) is jnana yoga, or the discipline of knowledge. All three options are spiritually legitimate and adaptable to varied conditions of life.

Ramayana (Tale of Rama), a second great epic, comprises 24,000 Sanskrit couplets containing material central to dharma, especially the conduct of women and the relations of man and wife. The central figures are Rama, a prince of noble character, and Sita, his newly acquired wife. Through a series of unfortunate circumstances, Rama is exiled to the jungle for fourteen years instead of taking his rightful place on the throne. Sita goes with him and is subsequently abducted by the demon Ravana. The leader of the monkey-people, Hanuman, discovers her whereabouts on an island and helps Rama in a successful rescue. A battle between Rama and Ravana is the climax of the epic. The years of exile end and Rama returns to his kingdom with Sita to ascend the throne. Notable in this story is Sita's willingness to accept a test of fire to demonstrate her loyalty and purity while a prisoner of Ravana, an incident that served as inspiration for wives to join their dead husbands on a funeral pyre. Sita is in every respect the model of an ideal Hindu wife— obedient, faithful, virtuous, and self-sacrificing. Rama and Sita became popular subjects in temple sculpture.

The best-known *Kamashastra* (Treatise on Pleasure) is the *Kama Sutra,* a text devoted to kama (pleasure, delight), the third end of life. Kama is the god of pleasure. One plausible explanation for this manual of sexual postures and methods is the uncertainties and frequent hardships of marriage. Young married couples usually had no sexual experience, had no prior social contact with each other, and were thrust into marriages arranged by their parents, sometimes agreed on while the prospective bride and groom were still young children. The wedding night must have been fraught with tension for both parties.

A woman's role was to gratify her husband and treat him as a god, which must have been very difficult for a girl of twelve or fourteen. They would need all the help and advice they could get to make the physical relationship pleasing or tolerable for what amounted to a lifetime of marital commitment.

Puranas (Ancient Stories) are some thirty-six in number, of which eighteen are considered major; they are the most popular literature, revered by ordinary people. Gods and stories of their exploits in the world are the main subjects. The most important is the *Bhagavata Purana* (Purana of the Lord), which features Vishnu establishing good and fighting evil with serene detachment as a model of karma yoga, the yoga of selfless action. The *Puranas* prominently feature Krishna, who is not only one of Vishnu's incarnations but also the object of a major cult. These texts are at the heart of theistic devotional (bhakti) worship and generated a number of cults, each with its own doctrines, ritual instructions, shrines, temples, sculpture, dance, and music. The word "god" does not mean to Hindus what it means to Jews, Christians, and Muslims. The latter are monotheists, insisting on one god; the former are polytheists, accepting many gods, sometimes interchangeable, sometimes capable of merging with one another.

A Hindu who worships one god does not condemn as false a different god revered next door: "That devotee who, in a harmful manner, with vanity and intolerance, goes about ostentatiously making distinctions between one being and another, and practices devotion is of the lowest type, impelled by ignorance"[13] All the gods, major and minor, are considered manifestations, or incarnations, of a higher reality, so the *Puranas* have something for everyone in the realm of divinity. Selfless devotion and surrender to a particular deity is a path to salvation and deliverance: ". . . with charity and honor and with friendship toward all and nondifferentiating outlook, one should worship Me, the Soul of all beings, as enshrined in all beings . . . Honoring them, one should mentally bow to all the beings, realizing that the Lord the Master has entered them with an aspect of His own being."[14]

The six classical systems of philosophy emerged in the period from the first century C.E. to the Gupta period three hundred years later. All have the names of apocryphal authors and were collective efforts by people whose names have vanished. The likely exception is Shankara Acharya, who is associated with the Vedanta system. The authors were not content with revelation and wished to speculate freely about questions of space, time, causation, logic, matter, spirit, change, permanence, and other matters not taken simply on faith.

The six systems can be viewed as sutras (threads) to be elaborated on by gurus for the purpose of instructing students rather than works of philosophy by single authors. All the systems acknowledge authority of the Vedas, even if they have nothing to do with Vedic teachings, all include disciplines (sadhanas) of one kind or another, and all insist that a guru is needed to do philosophy. Although several are straightforward in their speculations, after bowing to the Vedas, all take the view that ultimate enlightenment and release from the wheel of rebirth require an understanding of their respective doctrines.

The six schools are classified and linked into three braces of pairs: Sankhya-Yoga, which deal with entanglements of pure spirit (purusha) with inert matter (prakriti) and the means of getting the two untangled; Vaishesika-Nyaya, which address the content of waking consciousness from that limited point of view; and Purva Mimamsa-Vedanta, which

expound the principle of non-dual reality—the Atman-Brahman doctrine. The pairs are represented in Hindu thought as complementing and reinforcing one another even though their doctrines are frequently at odds. The systems have not enjoyed equal authority. In the end, Vedanta, in its non-dualistic (advaita) form, became the most prestigious.

Compared to philosophy in the West, the philosophies of India have divergent features and objectives. Among these are a strong consciousness of authority and tradition; a preference for introspection over empirical study of an objective world that exists in its own right—this is, trust in intuition more than logic as a method of inquiry; an idealistic view of reality, that it is nonmaterial, rather than one based on materialist assumptions; partiality to monism (reality is one thing) rather than pluralism (reality is more than one thing); a leaning toward synthesis, putting things together, rather than analysis, taking things apart (i.e., addressing metaphysics, epistemology, ethics, psychology, and religion all at once rather than separately); indifference to contradictions on the premise that they find resolution in a "higher" reality; and, above all, the view that a true philosopher is known more from practice than theory. In the West, there has been a strong, continuous interplay of empirical science with philosophy, a relationship mostly absent from Indian traditions. Moreover, one could always be a philosopher without necessarily being an admirable person.

Sankhya and Vaishesika texts are full of highly technical language which makes for tough reading, but rarely do the authors engage in extended arguments like those in philosophical works by such Western writers as Plato, Descartes, Kant, and Russell. The reader encounters a great many striking claims but little marshalling of evidence and argument to support them. The appeal is usually to intuition. Yoga is aphoristic in form, essentially a report on how normal operations of body and mind can be controlled to achieve detachment. Purva Mimamsa is a dry work that interprets ritual hymns in the Vedas, which makes little sense without the relevant Vedas at hand. Nyaya is a compressed attempt to explain the basis of believable argument and inference. Vedanta is an extended argument that ordinary experience of the world is an illusion that conceals a single undifferentiated reality; Vedanta is closest to the Western idea of philosophy.

Here are short summaries of the six systems, which are best taken as pairs. We shall add to them the skeptical tradition known as Charvaka, even though it had slight impact in traditional India. In this summary, details about their respective views on technical issues, like the nature of causation and sources of error, will have to be put aside.[15]

Sankhya–Yoga

Sankhya (reasoning) is a form of dualism that claims the universe consists of two incompatible substances, spirit and matter (purusha and prakriti), the former bound and restricted by the latter. The universe of sensory experience evolves out of brute matter and falls back into it. The text is a series of quasi-aphorisms that make a variety of claims loosely connected. Fairly typical is saying 44: "By virtue is obtained ascent to higher planes, by vice descent to the lower; from wisdom results in the highest good, and bondage from the reverse."[16] There is no formal argument and no attempt to supply either logical or empirical demonstrations.

Yoga (yoke, or harness of the body) is chiefly a manual of disciplines for body and mind and has little to do with philosophical speculation; it too is aphoristic in form, as in saying 30: "Disease, languor, indecision, carelessness, sloth, sensuality, mistaken notion, missing the point, instability—these, causing distractions, are the obstacles."[17] The practice of yoga became central to Hinduism and was intended to free the individual from domination of the senses, help him develop special powers, and control mind as well as outer forms to attain direct access to ultimate spiritual reality. Two of the four stages of life—hermit and forest dweller—involve mystical asceticism and yogic disciplines. Sankhya and Yoga together have as their target the seemingly irresistible life force that feeds personality and assures continuous rebirth. The great achievement of this dual system is to view the human condition from a psychological point of view independent of polytheistic Vedic ritual and Jain materialism with regard to karmic matter. Outer events are less important than what is going on in the mind.

In Sankhya, the two opposing constituents of the universe—nonmaterial soul, self, Atman, or life-monad on the one hand, and lifeless matter on the other—unfold themselves through the three gunas—sattva, rajas, and tamas—which hold the life-monad in bondage to continuous reincarnation.[18] A simple way of viewing these three constituents is to think of them as states of the good, the middling, and the bad. Sattva is the quality of goodness and purity possessed by divine beings and morally superior people; it points the way to deliverance from bondage. Rajas is impurity, desire, and passion that bring darkness to the intellect and corrupt moral purpose; it is the force that promotes greed and struggle for advantage and goods in the world. Tamas is illusion and error, a quality of dullness, ignorance, and inertia; it is the force that drives animals to blindly devour one another, and humans to rest stupidly in self-satisfaction. Most human beings are a composite of the gunas, but the composite is seldom balanced, with one of the three usually being more evident. Increasing the power of sattva is to reduce and eliminate the influence of rajas and tamas, the first step toward liberation from the hold of matter and the realm of illusory change (samsara) that it supports.

With this conceptual foundation in place, Yoga steps in with techniques to build on improved sattva and to release the life-monad altogether from its material trammels, to banish the ignorance (avidya) that compels us to cling blindly to existence and all its distractions, to defeat the unconscious drive for life that sustains personality. The three disciplines expounded are asceticism, learning, and devotion. The objective of all three is to strip away the masks of personality and material existence and reveal the transcendent reality behind them.

Unlike Jainism's preoccupation with controlling the flow of karmic matter by limiting external action, Yoga is concerned introspectively with the mind. Asceticism aided by yogic disciplines (breathing, posture) aims to remove attachment to the body as a condition for purging the mind of feelings, thoughts, memories, and reactions. The technique of learning involves memorizing the sacred texts and reciting them so all worldly attachments are broken. Devotion is the technique of pursuing daily activities as a religious ritual without regard to outcomes, thus using mundane actions and commitments as opportunities for sustained meditation that chips away at the hold of egoistic personality.

Vaishesika–Nyaya

Vaishesika (particularity) is a type of realistic pluralism; that is, the material world is paramount, and it consists of more than one thing. While the system starts out by explaining dharma and refers to "the authoritativeness of the Veda," it goes on to develop an elaborate theory of the universe based on invisible atoms that cannot be further subdivided, whose four eternal, irreducible kinds are earth, water, light, and air. Human perception of this atomistic world is classified under six headings: substance, quality, activity, generality, particularity, and inherence, which means inseparable connections between things. The book is replete with classifications, categories of this and that, and fine distinctions, all of which makes for hard reading. A method used by the author of the text on Vaishesika is reminiscent of European medieval scholasticism, in which questions are posed, objections stated, and responses provided. There is a plurality of souls as well as atoms, but souls are not associated with body, sense organs, or mental activities. In this double pluralism of souls and atoms, the souls have different experiences and retain their individuality. There is no original reference to God, Brahman, or any transcendent spiritual reality, but later commentators were unsatisfied that atoms could exist or function without divine assistance, so God was plugged into the system. But Vaishesika is clear enough on this point: "The eternal is that which is existent and uncaused. . . . It is an error to suppose that the ultimate atom is not eternal."[19]

Nyaya (argument) is a form of analytical, logical realism that shares the atomistic pluralism of Vaishesika. Like its analytical partner, the system has nothing to say about God, but there is acknowledgment of the use of logic as a means of purifying knowledge to end pain, "followed by final release, which is the 'highest good.' "[20] Whereas "ignorance" in the Vedanta system is thinking the world of experience is real, for Nyaya ignorance means simply not understanding a proposition about that world. Nyaya is preoccupied with foundations of argument, or means by which a reliable conclusion can be reached, unreliable ones being a source of pain that impede final release.

Nyaya is a system whose chief topic is good reasoning, which includes issues of memory, conditions that arouse doubt, and fallacies that undermine sound argument. There are knowing subjects, known objects, a state of knowing, and finally, the technique of knowing, which includes a five-part syllogism: a proposition to be established, reasons given, examples presented, practical applications, and a conclusion. Truth is best tested in effective action. Intuition as well as sense experience is recognized; thus we have acceptance that knowledge may come from within as well as from without, a view that supports transcendent "knowledge" of the yogi.

Purva Mimamsa–Vedanta

Purva Mimamsa (free inquiry into the Vedas) is the most conservative system and the least speculative, being an interpretation of hymns and formulas in the Vedas with an emphasis on conduct, especially in ritual situations. The school arose to defend the Vedas against heterodox movements like Buddhism. The text is much concerned with the status and use of words, as one might expect from a ritual commentary on the Vedas. There are also theological topics that ask if God created the world and whether the Vedas had

an author. It seems the only reason this system is paired with Vedanta is that both have something directly to do with the Vedas.

Vedanta (goal of the Vedas) includes at least three schools of thought, two of which are theistic in substance and hardly monistic because they both reject the idea that the world is unreal and that souls are absorbed into an undifferentiated Brahman. The school of interest here is Advaita Vedanta, an exposition of uncompromising monism (all is one in Brahman), formalized by Shankara Acharya, a precocious philosopher who died at age thirty-two around 700 C.E. Apparently he was disillusioned by the loose behavior of supposedly virtuous men in his time and unimpressed with their spiritual achievements. He thought deeply about the meaning of human existence, wrote commentaries on various sacred texts, criticized other schools of thought, including Purva Mimamsa's claim to have the only worthy interpretation of the Vedas, concluded there was nothing to the world of sense experience, and decided to take as his premise the formula of the Upanishads: "tat tvam asi" ("that art thou").

Knowledge that Atman (individual soul) is one with Brahman (universal soul), he argues, is the only path to deliverance. Just being good, pious, and learned for billions of lifetimes will do no good: "Men may recite the scriptures and sacrifice to the holy spirits, they may perform rituals and worship deities—but until a man wakes to knowledge of his identity with Atman, liberation can never be obtained; no, not even at the end of many hundreds of ages."[21] Rituals well performed, sincere devotion to a deity, knowledge of sacred texts, and a blameless life lived according to dharma can help prepare the ground for release, but only knowledge can break the hold of illusion (maya) on the mind: "Right action helps to purify the heart, but it does not give us direct perception of the Reality. . . . Certain knowledge of the Reality is gained only through meditation upon right teaching, and not by sacred ablutions, or almsgiving, or by the practice of hundreds of breathing exercises."[22] It appears that for Shankara yogic practices alone were not enough to open the gates of non-discrimination and deliverance.

The Vedas have questionable value as well: "Study of the scriptures is fruitless as long as Brahman has not been experienced. And when Brahman has been experienced, it is useless to read scriptures. . . . What use are Vedas or scriptures, charms, or herbs?"[23] The true Self, the Atman, is trapped and concealed by five sheaths, or layers, a situation caused by ignorance (avidya): "Meditate upon the Atman as indivisible, infinite. . . . Know it to be separate from the body, the senses, the vital energy, the mind and the ego—those limitations imposed upon us by our ignorance."[24] The worst of these sheaths is the gross body driven by its needs and desires: "O fool, stop identifying yourself with this lump of skin, flesh, fat, bones and filth. Identify yourself with Brahman, the Absolute."[25]

Removing the sheaths can be accomplished only with knowledge (vidya), which means direct realization that Atman and Brahman are the same thing. At that point, the world of the senses melts away as the unreality it is. The cosmos is nothing more than a creation of ignorance; in effect, no ignorance, no cosmos: "Because you are associated with ignorance, the supreme Atman within you appears to be in bondage to the non-Atman. This is the sole cause of the cycle of births and deaths."[26]

This feat of detachment from the sheaths is accomplished by continuous meditation on the oneness of Brahman, which means ignoring the body, emptying the mind of anything but thoughts on Brahman, and suppressing any movement of the ego (the sense of

"I," "me," "mine."): "When the mind is completely absorbed in the supreme Being—the Atman, the Brahman, the Absolute—then the world of appearances vanishes."[27] What is this Brahman?: "Brahman is without parts or attributes. It is subtle, absolute, taintless, one without a second, In Brahman there is no diversity whatever. . . . Brahman is indefinable, beyond the range of mind and speech . . ."[28] And what is it that constitutes deliverance from ignorance?: "The state of illumination is described as follows: There is a continuous consciousness of the unity of Atman and Brahman. There is no longer any identification of the Atman with its coverings [i.e., the sheaths]. All sense of duality is obliterated. There is pure, unified consciousness."[29]

Did Shankara experience the "illumination" he describes and praises, or is it just an abstract inference from his premise of non-duality? He does not say anything about personal immersion in the One, and the mere existence of his treatises raises an interesting question. Had he achieved deliverance from the five sheaths into oneness without a second, the concerns of this world would have ceased by his own account, making the composition of texts about deliverance beside the point. His book, however, was duly written and became to this day one of the leading "classics" of Hinduism.

Charvaka (Also Called Lokayata, or "World," Implying Only the World Exists)

Named after its founder, Charvakas, this skeptical, materialist school of thought ranks with Jainism and Buddhism as one of the three leading heterodox systems. Traces of its viewpoint are in the Rig Veda. It is mentioned in the two great epics, in Buddhist texts, and in the *Bhagavad-Gita*. The original text of Charvaka from about 600 C.E. is missing, so its outlook is reconstructed from what mostly hostile critics had to say about it. Thoroughgoing skepticism is rarely encountered in India, China, or Japan. The dominant impulse of most people is to believe uncritically rather than to doubt systematically.

Adherents of Charvaka were not content to deny Vedic authority; nor did they respond to it by proposing an alternative path to salvation or enlightenment. For them, religion itself is a snare and delusion, false and misleading. Hard truth is the sole existence of a material world in which everything passes away without an escape hatch: No protection from gods, no mystical union with some ultimate reality. No gods, heavens, hells, or world spirits. No karma, no reincarnation. Forget about spirituality, for life is governed only by pleasure and pain. Forget about revelation, for all knowledge comes through the senses. Forget about immortality, for there is no survival after death. The only hell is pain inflicted temporarily by the fact of being alive. Souls have no existence apart from bodies, and when the body dies there is nothing to detach itself and go on living. In sum, all religious ideas are illusions and wishful thinking. A rejection of the religious point of view is clearly expressed in sayings attributed to this uncompromising school of thought.

A person is happy or miserable through [the laws of] nature; there is no other cause. . . . The soul is but the body characterized by the attributes signified in the expressions, "I am stout," "I am youthful," "I am grown up," "I am old," etc. It is not something other than that [body] . . . There is no world other than this; there

is no heaven and no hell; the realm of Śiva and like regions are invented by stupid imposters of other schools of thought. . . . The pain of hell lies in the troubles that arise from enemies, weapons, and diseases; while liberation (*mokṣa*) is death which is the cessation of life-breath.[30]

While Hinduism became the dominant framework for life, religion, and thought from the fifth century C.E. on, there was competitive diversity in the options available to men and women, but the diversity was usually bonded in a common view of life and its meaning.

7

India's Traditions of Thought

good section

Indian ideas are suffused with religious terminology and aspirations. Religion can be understood in a general way as a system of beliefs, practices, and organizations developed to address ultimate concerns of human existence. Reason and sensory experience are subordinated to revelation, faith, and intuition. Viewing Jainism, Buddhism, and Hinduism together, we can discern a pattern and unity of ideas that transcends their differences. The purpose of life is to resolve problems of physical, mental, and spiritual suffering. The source of these problems is the impermanence that informs all existence, within which all living things are bound by karma and reincarnation.

Karma, which operates as a moral law of cause and effect, is the accumulated results of behavior in one life that determines social status and level of consciousness for rebirth in the next life. The ultimate goal of life is to escape karma and reincarnation altogether. The Jain solution is to rid the body of karmic matter that results from harming living souls (jiva) so the human soul can rise to a state of eternal bliss at the top of the universe. The Buddhist solution to suffering and karma is the Eight-Fold Path that culminates in Nirvana, and later on salvation in a Bodhisattva's paradise was preferred to rigors of treading the path. For Hindus, release (moksha) from reincarnation at the highest level comes with the mystical realization that Atman (the true individual soul) is one with Brahman, the World Soul, while the more common option is scrupulous devotion to a titular deity such as Shiva or Vishnu on the way to final deliverance.

In all cases, the highest virtue of the individual is self-discipline and controlling one's personal life, which is needed to attain both the good life and release from an eternal round of reincarnations in cosmic cycles of impermanence. Thus philosophy, in the traditional Indian frame of reference, tolerates speculation only if it delivers or illuminates practical solutions to concrete problems of life. In the West, philosophy, invented by the classical Greeks, has always been rational and speculative, attempting, through logic and argument, to resolve problems of reality, knowledge, and conduct. Philosophy for

good comparison of East vs West philosophy

Jainism, Buddhism, and Hinduism is the art of living in control of one's self, which in turn requires self-knowledge. What matters in the end is not belief (whether scientific, philosophical, or religious), but correct, consistent practice in daily life. For Judaism, Christianity, and Islam, monotheistic religions of the Book, belief or "orthodoxy" is what matters most. For Indian philosophers, belief matters less than practice, or "orthopraxy." What a person is counts for more than what a person believes.

The fashionable attention that the West has directed to Indian thought and religion largely misses the point of what ultimately is expected of "mystical consciousness" and disciplines like yoga. Central to Western thinking is the individual personality, which dominates both religious and secular conceptions of meaning and purpose. The idea of personality comes from the Greeks and is related to play-acting in a drama. The tragic or comic mask hides the actor and indicates his *persona*—*per* for through and *sonat* for sound, that is, speaking through a mask. In due time, the distinction between mask and actor was fused. In the Greek underworld, the dead retain their "personalities." In Christianity and Islam, salvation or damnation means survival of individual personalities in heaven or hell, including the body through physical resurrection. Immortality or eternal life means that personality survives indefinitely, supposedly with all the senses intact. In the Muslim heaven, the faithful are promised sensual gratifications, including wine, milk, and honey, and, for men, access to virgins.

In secular societies of the West, rights, well-being, and activities of individuals are central to law and culture. Men and women do not take well to the idea of losing their personalities, the distinctive mask formed by genetics and individual experience. In the Indian view, personality is trivial, ephemeral, burdensome, and dispensable. Everyone must have it, but the task of life is to recognize it and obliterate it. The true actor behind the mask is not a personality. A mask is the role everyone plays in a brief, insignificant life. Behind the mask is the cosmic Self without distinctions of any kind in which personality becomes meaningless. Unlike John Stuart Mill, who philosophized about freedom on the assumption that individual personality is the basic unit of society and meaning, the Indian philosopher views it as an impediment to overcome. The gulf between Western and Indian ways of thinking is dramatically illustrated by the Western cult of celebrity—the glorification of fleeting personalities in athletics and entertainment, known mostly from images, in all forms of mass media in a culture addicted to commercially produced transience.

In the milieu of Indian philosophy and religion, everyone wears a multitude of masks and shifting mantles of personality in the course of numerous reincarnations. Preservation, adornment, indulgence, glorification, and defense of personality are not central issues of life. The Indian philosopher or religious sage has a vision that addresses suffering, rebirth, and limits of existence in time and space. Proof that a true philosopher is at hand is the example of his life. Progress in philosophy is movement from partial to complete truth through self-discipline, which must always have practical consequences for life, whose final goal is release from existence—individual, collective, or otherwise.

The stress on behavior and release from rebirth rather than on doctrine accounts for why Indian thought is so eclectic and syncretic, taking whatever is needed—gods, cults, symbolism, texts—from a variety of sources at any given time without discomfort. Many paths are available for the individual in search of escape from fragile individuality. The

wider outcome is that Indian philosophy and religion have been immensely tolerant and flexible rather than exclusive and rigid.

Vedic Brahmanism

The religion of the Vedas was based on ritual sacrifice and prayers to contact and influence the gods. Attached to each of the Vedas are elaborate ritual texts and a body of "forest" texts, including the Upanishads. Prayers developed into magical spells called bráhmans. The prayer and spell keepers were known as brahmáns (pray-ers,) the difference indicated linguistically by placement of the accent. As described earlier, the Aryans worshiped many gods and expected tangible returns for ritual observances. The Vedic gods do not have human form like the Olympian gods of ancient Greece, who were anthropomorphic, but they do have names and attributes, and they cater to human needs and expectations, which makes them anthropocentric. The power of the brahmáns (the pray-ers) was to control nature and its phenomena by maintaining an exclusive grip on the Vedas as intermediaries between man and gods. In the Vedas, exclusive of the Upanishads, a mythology of salvation, reincarnation, yoga, vegetarianism, and nonviolence is not mentioned. Here are sample hymns from the Rig Veda celebrating three important gods and their significance. Agni: sacrificial fire of the priests and conduit to the gods; Varuna: keeper of cosmic law (rita, dharma); and Indra: the god who slew the serpent holding cosmic waters in a mountain and who is featured in a quarter of the Vedic hymns.

> May that *Agni,* who is to be extolled by ancient and modern seers, conduct the gods here.
>
> O Agni, the sacrifice and ritual which you encompass on every side, that indeed goes to the gods.
>
> Wise are the races of gods and men through the greatness of him who propped apart the two wide worlds. He pressed forth the high, lofty vault of heaven and, likewise, the stars. And he spread out the earth [beneath].
>
> In my own person, I speak together with him: When shall I be in obedience to Varuna. Might betake pleasure in my oblation, becoming free of anger? When shall I look contentedly upon his mercy?
>
> Now I shall proclaim the mighty deeds of Indra, those foremost deeds that he, wielder of the mace, has performed. He smashed the serpent. He released the waters. He split the sides of the mountains.
>
> When you, Indra, smashed the first-born of serpents, you overcame even the tricks . . . of the tricky. Then you brought forth the sun, the heaven, and the dawn, and since then you have never had a rival.[31]

These brief passages show that Vedic polytheism was based on specialization. The idea of one god managing everything has not yet appeared. It is striking that these ancient documents also contain expressions of skepticism and doubt about where things came from and deny the gods a creative role—an anticipation of the skeptical Charvaka philosophy: "Who knows it for certain; who can proclaim it here; namely, out of what was born and wherefrom this creation issued? The gods appeared only later—after the creation of the world. Who knows, then, out of what it has evolved?"[32]

Two of the most profound ideas in the Vedas are that of rita, which anticipates Hindu dharma, an all pervasive cosmic law of righteousness that rules the gods as well as men, and the mystical Atman-Brahman doctrine in the Upanishads, those heretical documents added to each Veda around 600 B.C.E. A historical consequence in the formation of Hinduism was retention of both Vedic polytheism (all is many rather than one), and radical monism (all is one rather than many).

Upanishads

Upanishad means "to sit near," that is, near someone who knows, and represents the mystical views of forest sages (rishis) who chaffed under the authority of Brahman priests and sought a way of communicating with divine powers without rituals and spells.[33] With regard to Vedic rites, on the one hand: "Perform them constantly, O lovers of truth. This is your path to the world of good deeds." On the other hand: "The fools who delight in this sacrificial ritual as the highest spiritual good go again and again through the cycle of old age and death."[34] The rishis did not reject the Vedas, nor did they flatly deny the efficacy of ritual acts for limited purposes, but they claimed direct access to ultimate reality, or Brahman, by means of mystical union.

What the forest sages rejected was Vedic reliance on priests as intermediaries between man and a pantheon of gods. This monistic doctrine that all is one, that Atman, the "true" human soul, is identical with Brahman, the World Soul, promised direct, unimpeded contact with spiritual reality. There are hints in the Vedas of a desire to find the unifying reality behind the multiplicity of ordinary existence, but it was left to the forest sages to strike off decisively in that direction. A distinction is drawn between a changing empirical self, the one seen in the mirror, and the true self, or Atman. The outcome of merging Atman with Brahman is a fusion that eliminates all distinctions of this or that.

The means for merging are austerities to remove distractions of the body, disciplined breathing, and deep meditation to still the mind, summed up in the mystical syllable OM (or AUM). The two syllables are the same, reflecting the way Sanskrit sounds are formed. AUM is a fuller version of OM, which is uttered slowly when a yogi breathes out. "A" is the waking state, the beginning of a breathing cycle. "U" is the dreaming state, the middle of the cycle. "M" is the state beyond dreaming, and beyond M is the outer limit of the cycle (turiya) where distinctions cease and there is oneness with Brahman.

An accomplished yogi can move back and forth at will between the terminal state (turiya) and the waking state. The shortest of the Upanishads, the *Manduka*, describes the state beyond deep sleep: "The Fourth is soundless: unutterable, a quieting down of all the differential manifestations, blissful-peaceful, non-dual. Thus OM is Atman, verily. He who knows thus merges his self in the Self—yea, he who knows thus."[35]

The non-dual conception of ultimate reality is dramatically conveyed in the lengthy *Chandogya Upanishad*. The boy Svetaketu receives instruction from his father about the true self.

> The Self (*atman*) who is free from evil, free from old age, free from death, free from grief, free, from hunger, free from thirst, whose desire is the Real (*satya*), or truth, whose intention is the Real—he should be sought after, he should be desired to be

comprehended. "Bring hither a fig from there." "Here it is, sir." "Break it." "What do you see there?" "These extremely fine seeds, sir." "Of these, please break one." "It is broken, sir." What do you see there?" "Nothing at all, sir." Then he said to Svetaketu. "Verily . . . that subtle essence which you do not perceive—from that very essence . . . does this great fig tree arise. Believe me . . . that which is the subtle essence—this whole world has that essence for its Self; that is the Real (*satya,* truth); that is the Self; that subtle essence art thou, Svetaketu.[36]

"That art Thou" (in Sanskrit, "tat tvam asi") meaning the individual Self—as distinguished from the transitory, empirical self—is at one with the eternal, unchanging, universal World Self.

For these forest sages, the Vedas had their uses, but the knowledge contained in them was considered inferior to mystical knowledge of Brahman acquired through yogic discipline. Sacred texts are like a raft of preliminary wisdom moving the individual across a river from a transitory world to a permanent reality. Once on the other side, the raft can be abandoned, and the river itself disappears. Also left behind are all those things most people think life is about—satisfaction of material needs, enjoyment of pleasures, and performance of moral duties.

Jainism

Further competition for the Vedas came from Jains. Perhaps no other religious sect has such a tightly knit ascetic system. Jainism consolidated several influential ideas and practices, including nonviolence, asceticism, a meatless diet, and a systematic cosmology. Jainism comes from jina, which means "conqueror" or "victor." Jains are followers of the conqueror. The conquest or victory is complete purification of the human life-monad and its release from karmic matter. The preeminent name in Jainism is that of Mahavira ("great hero"), the historical figure who founded the movement in the early fifth century B.C.E. In Jain legend, he was reputedly the last of twenty-four Tirthankaras (crossing makers) stretching into the remote past.

The twenty-third Tirthankara had a presumed life span of some 80,000 years, which puts him well back in the Paleolithic era and makes him, from the Western point of view, a figure of legend rather than history. This mythical line of spiritual crossing makers who broke decisively with ordinary existence was bigger and purer before the onset of the present cosmic age of decay and corruption. Mahavira, the last hero in line, discovered little that was new, but he brought past teachings and practice to perfection. He rejected the authority of the Vedas altogether and claimed a unique route to salvation.

The sacred texts of Jainism number forty-five in prose and verse, all of which changed little over time, once in circulation. As with much Indian religious literature, the texts intersperse passages of poetic beauty with stylized repetition. The texts are not attributed to Mahavira. Jains concede that the earliest texts appeared some 200 years after his death. Since Jains excluded themselves from the occupation of farming, which endangered too many small creatures, they turned to business and became successful merchants. The wealth accumulated was invested in temples and sumptuously decorated manuscripts of Jain scriptures.

For Jains the universe is a living organism teeming with six kinds of life-monads or souls (jiva) that include not only organic life but also inanimate things like stones, fire, wind, and smaller constituents of matter. Jains are materialists for whom the human life-monad (life-monad and jiva are interchangeable) is weighed down by karmic matter that enters the sheath of the body through the five senses and overlays its crystalline purity. Karmic particles of different colors cling to life-monads with a force and quantity that depends on how much damage is being done to other monads. Karmic matter appears in the monad as six colors ranging from white to black and organized into three sets of two, which correspond to the three gunas used to classify human temperament in later Hindu literature.

The mere act of living—drinking, eating, breathing, and moving about—harms other souls. Waving a hand injures souls of the air, and walking causes souls of the earth to cry out in pain. The best strategy is not to move at all, and care must be taken always that the impact of movement on surrounding souls is minimized. Injunctions from Jain scripture are to renounce violence, lying, theft, sensuality, and material possessions. Good will, fasting, and meditation are further requirements, but the underlying injunction of Jainism is to renounce action of any kind, whether good or bad.

The Jain householder who does not embrace more extreme disciplines and denials must abstain from killing, lying, and amassing possessions; vow to go only in certain directions for prescribed distances; avoid pointless talk and behavior; control sinful thoughts; restrict daily pleasures and items of diet; and worship morning, noon, and night at specific times. The universal goal of life is to free the life-monad from particles of karmic matter and prevent any further inflows so the cleansed soul can rise to the summit of the universe for an eternity of bliss and omniscience.

Release from karmic bondage is a task for individual monads, and the reward is individual as well. Once life-monads rise to the summit of the universe, all-conditioned phenomena associated with material existence, such as sensation, perception, and thought, come to an end. Each liberated jiva comprehends all there is outside of time and space and does so separately from other jivas. There are as many "absolutes" as there are liberated jivas. Clearly this is not a monistic view like that of the Upanishads.

The path to liberation is disciplined reverence for life (ahimsa). The worst offense is to kill or harm life, whether intentional or not, although deliberate killing is obviously worse than causing accidental harm, a doctrine that was to have profound influence on Mahatma Gandhi, the father of Indian independence from the British. Jains exercise scrupulous care not to hurt lower forms of life while walking and strain their water to filter out organisms. What and how one eats becomes a problem. Jains are vegetarians, although the consumption of plants is not much help since they too are life-monads.

The literal materialism of Jainism in this respect contrasts sharply with the psychological view of early Buddhism. If a Jain eats a piece of meat without knowing it, karmic matter pours in despite the persons's original intention and how many precautions were taken. If a Buddhist consumes meat unknowingly, there are no consequences, for the emphasis of Buddhism is on inward discipline and mind culture.

Jain practice involves radical asceticism, rigorous denial of bodily actions. To avoid harming life-monads by the mere fact of existing, Mahavira established the ideal of starvation, which affects one's own life-monad but spares others. As we shall see, the

Buddha rejected extreme asceticism as a useless means to enlightenment. Two sects of Jains emerged: those who wear white robes (*Svetambaras*, or "White Clad") and those who go naked (*Digambaras*, or "Space Clad"). *Mahavira* is said to have introduced clothes to overcome social resentments to nakedness in his time. The space-clad Jains considered him a betrayer of the authentic tradition established by his legendary twenty-three predecessors. Nakedness before the world is evidence of detachment and indifference to its values, and is an instance of uncompromising Jain asceticism. One can understand why Jainism had a limited audience and not much success as a movement.

An example of a space-clad saint, the most demanding ideal of Jainism, reputedly stood unmoving for a year (fig. 7.1). As a result of intense inwardness and detachment from all physicality, his legs and arms are entwined with climbing vines. Anthills rise at his feet. The image was cut from a vertical rock formation. It is 56½ feet high and measures 13 feet around the hips. The explanation for these dimensions is that in previous stages of the cosmic cycle human beings were of heroic stature and moral purity.

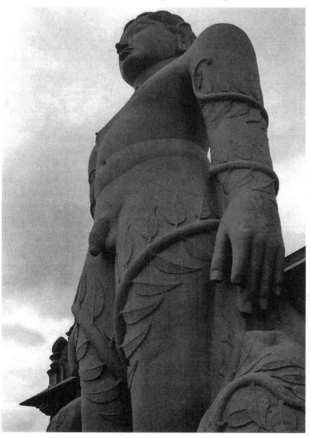

Fig. 7.1 Jain Saint, 983 C.E., Mysore.

Jain saints represented by these images were believed to be sublimely pure as a result of their withdrawal from attachments to material existence. Their blood was white instead of red; their bodies and breath emitted no odor. The ideal material for representing them was alabaster because of its pure color and translucence. The image in Figure 7.1 gets a bath in melted butter every twenty-five years to keep it fresh looking. In Jain philosophy one's mind can be altered by contemplating an image. Vulgar images inspire vulgar thoughts and feelings. Jain images inspire a wish to attain perfection embodied in the image. The image functions as a model for emulation and meditation. This idea had a deep influence on later Indian religion, especially Hinduism, with its rich profusion of sculptured and painted forms of gods, goddesses, and mythological scenes, which are intended to arouse spiritual insight and connect with the gods.

The universe for Jains exists on three major levels, with humans occupying the middle region. The goal of life is for jivas to rise from the lower worlds to the summit of the

highest world. In one account, the universe is anthropomorphic and seen as a giant man. The bottom level is at the feet and the knees, men are at the level of the waist, and the highest level is the crown of the head, which jivas reach when encrustations of karmic matter have been removed and original crystalline purity has been restored. In another account, the world is made up of three concentric rings that are islands separated by oceans. In the center of this circular world is Mt. Meru. The universe conceived in this mythical geography was believed to be eternal.

Given Jainism's rigorous ideal of asceticism, it comes as a surprise that Jain temples were quite glittering affairs with many sculptured images. The Vimala temple in western India, where Jains were numerous and received patronage from local royalty, was built in 1032 C.E. It is dedicated to the first Jain, Titthankara, and sits on Mt. Abu, a 4,000-foot peak believed to be a divine creation in the midst of a flat wasteland. Vimala was the name of the king's minister who undertook construction of the temple complex.

The main building is a courtyard surrounded by fifty-eight smaller shrines. It is plain on the outside but has an interior of white marble with sculptural decoration on every surface, a taste for extravagant ornamentation to please the resident "hero," typical also of Hindu architecture. Three spectacular ceilings simulating the heavens are decorated with lotus buds and beautiful women (fig. 7.2). Jains shared with Buddhists and Hindus the idea that women are favorable signs in religious settings, a source of energy and fertility, a marked contrast to the traditional Christian suspicion of women as instigators of sin, or the Muslim decision to forego any kind of human representation at all.

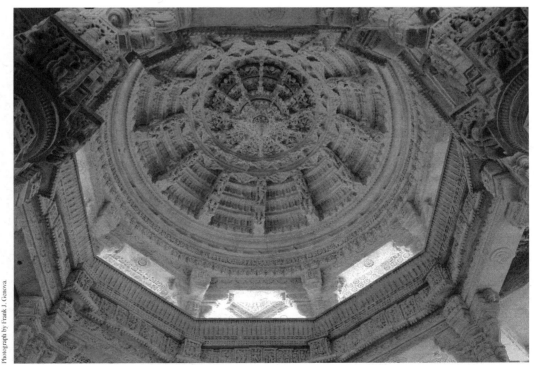

Photograph by Frank J. Genova.

Fig. 7.2 Ceiling of the Jain Vimala Temple, Mount Abu, Rajastan, 1032 C.E., white marble.

Buddhism

The man who became Buddha was Siddhartha Gautama (d. ca. 480 B.C.E.), a prince whose kingdom was in the foothills of the Himalayas. His message of compassion and enlightenment in a suffering world conquered India and spread subsequently to Tibet, Southeast Asia, China, Korea, and Japan. By the ninth century C.E. more than a thousand years later, possibly half the world's people were Buddhists. His legend and teaching became a reservoir of themes and subjects for sculpture, painting, and architecture. Buddhism evolved in different ways, but none of the subsequent sects that arose throughout Asia are intelligible without an understanding of the legend of the Buddha and the earliest teaching.

As a young man, Siddhartha's father sheltered him from experience of sorrow or physical decline, even to the extent of having wilted flowers removed from the gardens at night. Wanting to know what lay outside the palace walls, Siddhartha visited the nearby town in disguise with the help of his tutor. There he encountered four signs of being—an aged person, a sick person, a dead person, and a mendicant begging from door to door. The tutor explained that the first three states would be his fate. He was then inspired to search for the meaning of existence through the mendicant's detachment from worldly ambition and ties.

Distressed by three of the signs and uplifted by the fourth, Siddhartha gave up his kingdom, wife, and newborn son to become a forest-dweller practicing austerities in the quest for enlightenment. After a year or so excelling at self-denial, he decided the path of asceticism was a dead end. A vivid sculpture from the second or third centuries C.E. depicts Siddhartha at the extreme frontier of self-denial, face drawn, rib cage exposed, stomach cavity pulled in—the state of uncompromising withdrawal and deprivation preferred by the Jains (fig. 7.3).

Fig. 7.3 The Fasting Buddha, second or third century C.E.

http://commons.wikimedia.org/wiki/File:FastingBuddhaParis.jpg

Pulling back from that life-denying condition, he bathed, donned fresh robes, and sat beneath a nearby pipal tree (later known as the bodhi tree, or tree of enlightenment) determined not to move until the problem of suffering was solved. For forty days and nights Mara the Tempter, aided by an army of demons, tried to distract him from meditation with fearful threats and offers of power, wealth, and pleasure. He persisted and reached his goal—Nirvana. Now the Enlightened One, he rose and went to a nearby deer park where he encountered several former forest comrades, all of whom had judged him a backslider and quitter for giving up asceticism, but they gathered around and listened as he delivered the Fire Sermon and unfolded the Four Noble Truths.[37]

First, existence itself is suffering (dukkha). Old age, sickness, and death are inevitable consequences. Happiness, contentment, pleasure, and possession will be overwhelmed by misery, disappointment, frustration, and loss. All attachments wither and pass away. The bitter fruits of existence are getting what one does not want and not getting what one wants.

Second, the cause of suffering is clinging (tanha) to existence as though it embodies permanence. But existence is impermanence—a flux that never stands still, whose face is always changing. Any expectation of permanence, whether in fond relationships, worldly good fortune, abundant health, or personal immortality is an illusion. Clinging to existence is like grasping at dreams or the wind.

Third, the end of suffering comes with cessation of clinging to existence. Detachment from impermanence vanquishes the suffering that results from wanting what one does not get and getting what one does not want.

Fourth, cessation of clinging is achieved by treading the Eight-fold Path to the end:[38]

1. Right outlook "is to know suffering, the origin of suffering, the cessation of suffering, and the path that leads to the cessation of suffering." The problem of suffering is stated in the first three Noble Truths. Understanding the problem, however, is mostly intellectual. No change is needed in a person's condition of attachment. In the stage of right outlook one can form an attachment to understanding so that it becomes a distraction from moving along the Path. Such is the case with scholars with knowledge of Buddhist history and philosophy who never practice the mind culture that leads to enlightenment.

2. Right resolve "is the resolve to renounce the world and to do no hurt or harm." At this stage one passes beyond intellectual understanding to positive action that requires an act of will, a movement from thought to commitment. Depth of understanding can help the will exert itself, but what really lies behind resolve, or intention, is weary dissatisfaction with a life of clinging to impermanence, with all its consequences. If a complete journey on the path to enlightment is intended, that decision entails renouncing worldly attachments and the infliction of pain.

3. Right speech "is to abstain from lies and slander, from reviling, and from tattle." Avoidance of harmful, self-indulgent, petty, irrelevant, abusive, gossipy, untruthful talk, while learning the virtue of a "golden silence," is not an easy task, but it is the first moral discipline requiring a change in behavior that binds individuals to impermanence. Discipline imposed on speech is an act of renunciation, or giving up something most people like to do. Nothing is perhaps more ephemeral

than the endless flow of words from billions of people. Modern technology (for example, cell phones) makes the flow of nonstop, idle talk even worse. Controlling speech is not only an act of renunciation; it is a means of controlling and modifying thought. Thought gives birth to the word, and words stimulate thought. Both must be restrained if the mind is to be cleansed and prepared for enlightenment.

4. Right acts "are to abstain from taking life, from stealing, and from lechery." The second moral discipline has two sides—avoiding deeds harmful to living things and the cultivation of deeds that relieve suffering. For the Buddha "living things" means animals as well as humans. An immediate consequence is felt in diet. Slaughtering animals and even catching fish inflict harm on life and are to be avoided. Relief of suffering means helping those in need, which applies to animals as well as humans. Buddhists were the first to establish animal-care centers. In most cultures, people have used violence against one another while rejecting any special status for nonhuman life. At this stage, the Buddha is clearly asking much of individuals preoccupied with themselves at the expense of other life forms. Taking someone else's property and yielding to naked sexual appetite are forms of attachment that cause harm to others and must be severed.

5. Right livelihood "is that by which the disciple of the Noble One supports himself, to the exclusion of wrong modes of livelihood." This moral discipline calls for a benign vocation that does minimal harm to other living things. Obvious examples of "wrong modes" are the professions of the soldier and the butcher. Many professions require willingness to violate steps four and five in the Path, for example, working for a gossip magazine. Perhaps denial of the soldier's profession is the thorniest demand, which means renouncing self-defense as well as aggression. If one's job is to don a uniform and kill men with the sanction of government, the Buddhist Path is impossible to follow. Hinduism got around this dilemma by associating war with fulfillment of an individual's dharma, or sacred duty. Fighting could be accepted with detachment and be viewed as a form of renunciation leading to good karma. This doctrine, however, was not shared by Buddhism, which is one reason its teachings were considered unorthodox (nastika) by Hindus.

6. Right effort means "to stop bad and wrong qualities which have not yet arisen from ever arising, to renounce those which have already arisen, to foster good qualities which have not yet arisen, and . . . to establish, clarify, multiply, enlarge, develop, and perfect those good qualities which are there already." Everyone accumulates bad and good habits in the course of a lifetime. The bad might include heavy drinking and talking compulsively; the good might include courtesy to others and a taste for reading serious books. No one's balance sheet of good and bad tendencies is the same. Each person alone must identify desirable and undesirable traits so the former can be strengthened and increased and the latter eliminated and prevented from arising. Both tasks require concentrated watchfulness.

7. Right mindfulness "realizing what the body is—what feelings are—what the heart is—and what the mental states are. . . ." Referred to here is the transitory

nature of the five grasping groups (body, sensation, perception, mental states, consciousness), which are conditioned and impermanent. The grasping groups (skhandas) add up collectively to the empirical "self" with which people identify themselves. What the groups have in common is that none endures without change. Detachment from existence means distancing oneself from the illusion that the grasping groups constitute a permanent self. Buddhists developed an elaborate system of meditation practices to "watch" the movement of these groups without attachment, a necessary condition for entering the Path's last stage.

8. Right concentration "is when, divested of lusts and diverted from wrong dispositions . . . by laying to rest observation and reflection, he [the disciple] dwells in inward serenity. . . ." The last step on the Path is deep meditation and cultivating a culture of mind leading to Nirvana, which means "blown out," as when a candle is extinguished, a metaphor for an end to craving rather than oblivion or nothingness. At this stage, descriptions and explanations are futile. The end of attachment cannot be discussed rationally. It is a stage in which all distinctions have ceased, including the statement just made. To ask about Nirvana is a question not tending to edification because there is no answer free of distinctions. Nirvana is the commonly used Sanskrit word. Nibbana is the word that appears in early Buddhist texts, which are written in a vernacular dialect of Sanskrit called Pali. Nirvana, or Nibbana, is not a term exclusive to Buddhism. The metaphor of an extinguished flame to signify enlightenment is found in Jain literature as well.

While few may have the will, discipline, and inclination to follow the Path to its end, if enough people went as far as stage five the world would be less afflicted with nastiness, conflict, violence, and distress. Furthermore, the three stages of moral discipline—speech, acts, and livelihood—and the sixth stage of right effort can be practiced without monastic seclusion, although the sixth stage requires more concentration than watching one's words and actions or choosing a harmless profession. Stages seven and eight imply intensive acts of meditation over time. Normal distractions and insistent stimuli of daily life would be serious impediments. The disciplined environment of monastic life is usually a requirement, except for people with exceptionally powerful wills and minds.

The Buddha's former companions were converted by the Fire Sermon and became charter members of the Buddhist Order (the sangha). In due time, Three Treasures were codified—the Buddha (bodhi), the Teaching (dhamma), and the Order (sangha). Women were admitted to the Order and could seek enlightenment on an equal level with men, although the two were segregated in Buddhist monasteries. Buddhism reached out to the masses and was not an exclusive possession of priests. Buddhism's universal appeal accounts for the swiftness with which it won converts. Behind the Buddha's message is a spirit of compassion for all living creatures, animal and human, for all are bound in common on the wheel of rebirth.

While alive, the Buddha was in a state of enlightenment. His death was called para-nirvana, for there was no further rebirth. In effect, he ceased to exist as body and consciousness, and there was no immaterial soul to survive the body unchanged: "The Lord has passed completely away in *Nirvana*. . . . He can only be pointed out in the body of

his doctrines, for it was he who taught it."[39] Rebirth and reincarnation are consequences of grasping after impermanent existence, which continues without relief from one long kalpa to another. Buddha's analysis of the problem and its solution is practical rather than theoretical. His approach can be compared to removing oneself from a burning house rather than asking questions that do not promote a solution, such as figuring out how the house caught fire, how hot the flames are, or which rooms will collapse first. The first priority is to escape the fire that is existence.

Nothing endures except the flux that engulfs all existent things. Buddha does not ask for dogmatic beliefs about god, soul, or salvation. The first step of "right outlook" is provisional and must survive a test of direct experience on the Eight-fold Path. Early Buddhism is not well described as a philosophy or a religion. It is a form of mind culture, a graded series of steps that bring mind to ever higher levels of discipline and detachment, so that it may ultimately transcend ordinary experience and consciousness.

In due time, a scriptural tradition arose after a number of Buddhist councils deliberated what to include and what to reject, and an official canon was arrived at around the third century B.C.E. A body of texts, the Three Baskets, dealt with conduct, rules for the monastic order, and basic teachings and interpretations of doctrine, all written in Pali, the preferred Sanskrit vernacular dialect. Thus, the scriptures reached a wide audience of ordinary people. Ideas and practices contained in these documents are the substance of Theravada Buddhism, or Teaching of the Elders. Its ideal was the Arhat, the resolute individual who sets himself or herself, on the Eight-fold Path and proceeds without deviation to the end.

Once faced in the right direction, the disciple must thereafter find his or her own way. A Buddha can only point the way. Siddhartha's reputed last words to his favorite disciple, Ananda, emphasized the futility of clinging to existence: "All component things must pass away. Strive onward diligently." Moreover, there is no option but self-reliance: "So, Ananda, you must be your own lamps, be your own refuges . . . and do not look for refuge to anything besides yourselves."[40]

Early art forms attempting to convey the spirit and teachings of Buddhism avoid literal representation of the Buddha. Before the first and second centuries C.E., there were no depictions of the man. On his death, he passed into paranirvana and no longer existed. Clinging to existence had ceased permanently. For him, the cycle of karma and reincarnation was over. Art featuring his life and teachings posed a problem. How does one indicate the presence of a being no longer on the wheel of rebirth? The answer was to use indirect symbols marking his presence, such as thrones, umbrellas, pipal trees, stupas, footprints, and the wheel of the law set in motion by the Buddha's teaching. (figs. 7.4, 7.5).

When the Buddha died, he was cremated on a funeral pyre, the usual means for disposing of bodies in India. His ashes were collected and divided into eight portions that were distributed to followers and spread around northern India in local shrines. The Mauryan ruler Ashoka, a Buddhist convert, had monumental structures erected to house an extensive redistribution of Buddha's remains, which became the focus of numerous monasteries. Ashoka reputedly built some 80,000 throughout the empire to contain relics of Buddha. Several of these stupas, or reliquary shrines, have survived and illustrate the sudden emergence of Buddhist myth and symbol. Best known of these early monuments is the Great Stupa at Sanchi (third to first century B.C.E.), with its elaborately carved gates. The original structure was much enlarged in later times.

Photograph by Carol Mitchell.

Fig. 7.4 Buddha-pada (footprint), Bodh Gaya.

Indian Museum, Calcutta, India.

A stupa is a large stone and earthen mound with no interior space to serve as a place of worship. Primarily a reliquary, with vestiges of the Buddha placed in a casket at the center, it also symbolizes Buddha's teaching and his paranirvana and serves as a visible model of the cosmos. The three-stage parasol at the top symbolizes the Three Treasures but also shelters the relics of the Buddha below and intersects with the cosmic axis, a pole that rises through the center of the mound. A protective fence around the parasol is visible. A huge stone railing, originally of wood and twice the height of a man, circles the stupa, identifies it as sacred space, and provides a path, on a gently rising stairway, entered from the south, for ritual circling clockwise by pilgrims to honor the relics and absorb spiritual energy from the stupa. The relics were believed to emanate

Fig. 7.5 King Vidudbha visiting the Buddha. Bharhut Stupa, second century B.C.E.

Fig. 7.6 Great Stupa, Sanchi, ca. 250 B.C.E., enlarged 50–25 B.C.E.

the spiritual substance of Buddha, and circling the stupa was a way of paying direct homage (fig. 7.6).

In other respects, the stupa was a visual encyclopedia of Buddhist lore. The four gates consist of two rising, square pillars connected by three architraves. A profusion of sculpture decorates pillars and architraves reviewing Buddha's life and illustrating colorful tales of his previous lives, called jatakas, which were popular with laymen. The sculptured gates teem with life—worshipers and animals of the forest, villages and cities, and religious processions—all paying homage to Buddha. One way of spreading Buddhist teaching was to tell stories in art that illustrate his royal birth, his departure from the palace, his enlightenment under the bodhi tree, his sermon in the deer park, and his death followed by paranirvana. This practice, intended to guide and instruct potential converts and inspire those already converted, resulted in complex sculptural programs on the stupa's four sandstone gates, which face the cardinal directions. Elephants are prominent, the forest path-breakers clearing away obstructions so other animals can pass; they symbolize the Buddha, the spiritual path-breaker, who cleared away ignorance and opened the way to enlightenment (fig. 7.7).

On the top lintel are stupas, miniature versions of the monument at Sanchi, symbolizing Buddha's paranirvana. The middle panel depicts worshipers gathered around the legendary pipal tree, also called bodhi (meaning enlightenment), under which Buddha meditated, resisted Mara the Tempter, and attained Nirvana. Again, there is no sign of the man, only potent symbols of his previous life. The handling of spatial relationships accords with standard convention. Viewers know that figures near the bottom of a panel are closer than those at a middle or top level. The sculpture testifies that by the second and first centuries B.C.E., the Buddha had become an object of worship, even though acts of devotion repre-

Fig. 7.7 One of four Great Stupa gate carvings, Sanchi, 250 B.C.E., enlarged 50–25 B.C.E.

sented in the sculptured panel are contrary to sayings in the earliest scriptures that a Buddha only points the way and that release from the wheel of rebirth depends on the solitary effort of an individual.

Direct representations of the Buddha were slow in coming— some 500 years after his death. The first Buddha images probably date from the first century B.C.E., and the most accomplished examples appeared in northern India at two different places—Mathura in the Gangetic Plain and Gandhara in northwestern India—in the first and second centuries C.E.[41] The reason for such images was to allow worshipers to earn merit and obtain protection from hard luck and evil forces by honoring and contemplating a visible presence of Buddha. Also important as a stimulus was probably the Jain teaching that images of heroic spiritual achievers are powerful aids to discipline and insight. Already at hand in the first images is a systematic iconography, a repertory of symbols conveying meaning, which became more or less standard for understanding Buddha images, although a uniform iconography never took hold as Buddhism spread across Asia.

A vocabulary of hand gestures (mudras) and leg positions (asanas) was developed (fig. 7.8). The sculpture shows Buddha delivering the Fire Sermon while seated on a lion throne, the lion being a symbol of royalty and his roar conveying the power of Buddha's teaching. Buddha commonly sits on a throne or a flowering lotus. Usually his legs are crossed in a full lotus position, although not in the case of Figure 7.8. His hands are turning the Wheel of the Law. The hair is done in a stylized topknot (ushnisha), symbol of both royalty and wisdom. Usually in the lower forehead just above the nose is a protuberance or tuft of hair (urna), the "eye" of enlightenment. Lobes of the ears are long, another sign of princely status, owing to heavy earrings that stretched the lobes. The right shoulder is usually bare with a simple robe crossing the left that covers a tunic tied around the waist, garments indicating humility. The disc behind him is an aureole that might bear celestial attendants (apsaras) who signify spiritual power.

Buddha images normally sit in a full lotus position to indicate deep meditation. Standing Buddhas are rare, but do appear now and then in Indian, Chinese, and Japanese traditions. Over time the complexity of symbolism grew, all of which could not be easily displayed on a single image. Thus, in Buddhist legend, Prince Siddhartha was visited shortly after his birth by a sage who identified Thirty-two Marks of a Great Man on his body, evidence that he was destined for spiritual greatness or kingship. Among these were long fingers, projecting heels, webbed hands, and skin delicate enough to ward off dust. The Eight Auspicious Symbols included a parasol indicating both royal status and spiritual power;

an endless knot, symbolic of Buddha's infinite wisdom; the lotus, symbolizing purity of mind and heart; and the wheel, symbolizing the Buddha's teaching and its perfection, its eight spokes standing for the Eight-Fold Path.[42]

Excavation of Buddhist cave temples on a small scale as places of worship began in 260 B.C.E., with projects growing in numbers and size around 100 B.C.E. The cave temple continued to thrive until the fifth and sixth centuries C.E., when Hindus adopted Buddhist caves or began excavating their own. Why carve temples out of solid rock, surely a labor-intensive means of creating a space for prayer, ritual, and meditation? First, there was the traditional practice of holy men preferring the seclusion and quiet of a cave. Second, caves were viewed as enclosures sought out by gods because of their intimacy, relative darkness, and mystery. Third, there was the weather—a cave was good for keeping dry in monsoon rains and cool in summer heat.

These worship halls (chaitya), which can be viewed as Buddhist cathedrals, were flanked by monastic residences (viharas) for Buddhist devotees. The plan of the temples is standard—a long hall

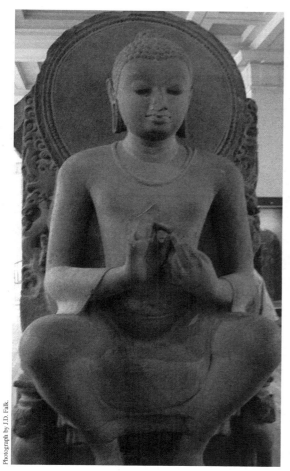

Photograph by J.D. Falk.

Fig. 7.8 Buddha preaching the first sermon, Sarnath, ca. C.E. 465–485, sandstone.

or grotto excavated from the rock cliff with a carved, open entrance and a rounded end for the ritual stupa. In earlier cave temples, as in the 100 B.C.E. cave sanctuary at Bhaja in western India, only the stupa is visible as a symbol of the Buddha until a transition was made to using images. The stupa is set away from the rear wall so worshipers can circumambulate clockwise as they would at Sanchi. At this stage, the exterior gives every appearance of having been executed from wooden models, whose patterns, railings and all, were transferred to stone with extraordinary virtuosity figs. 7.9, 7.10). Six hundred years later at Ajanta, also in western India, where some twenty-six cave temples curve in a great horseshoe on a mountain escarpment overlooking a narrow gorge, the basic plan and stone modeling after wood construction had not changed, but the longitudinal chamber terminates with a standing Buddha image fused with a stupa (fig. 7.11). Buddha has materialized from symbol to physical presence. The columns on either side of a cave temple function to pull the worshipers forward toward the stupa and the Buddha image. The open hall nearer the entrance is for groups of worshipers to assemble.

Carving these temples from solid rock was a stupendous task that merits respect and

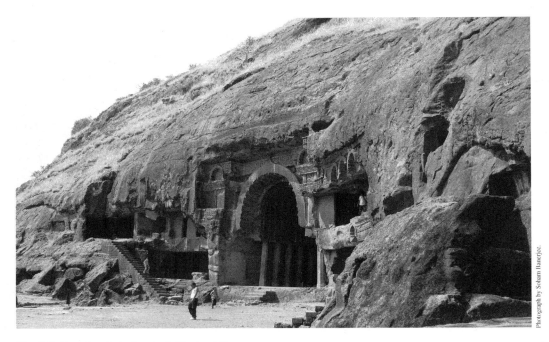

Photograph by Soham Banerjee.

Fig. 7.9 Façade of chaitya hall, Bhaja, 100 B.C.E.

awe. The technique can be understood by inspecting unfinished caves. Ingenious crafts-men who were engineers (not architects) cut a tunnel the height of a man horizontally into the rock face with chisels and iron mallets. The rough work of creating an entry was followed by workers who, after removing the waste material, polished the exposed stone. Once a basic tunnel was hewn out, work would spread to the sides and upward by

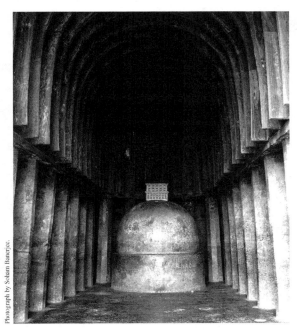

Photograph by Soham Banerjee.

means of carved steps, which could be removed later. Sculptors came next to carve ornamented columns, a ribbed ceiling resembling a barrel vault, and a stupa in the curved apse at the end. Everything was chiseled from the rock. There was no construction as such—that is, bringing in materials and assembling them. Cave temples are more like vast interior sculptures than architecture. By the ninth century C.E., rock-cut temples were discontinued and gave way to their freestanding counterparts.

Early Buddhism was an individu-alistic, monastic ideal that stressed self-reliance. Buddha never expected more than a few at any time to tread the

Fig. 7.10 Interior of chaitya hall, Bhaja, 100 B.C.E.

Path and reach the end. Although he preached to all, his message was not for mass consumption. For that reason, the Theravada ideal was criticized for being exclusive and selfish. Once the Arhat has attained Nirvana, what about others caught in the web of impermanence and rebirth? Must everyone become a monk and renounce the world? Clearly the Arhat ideal could never become universal, since it puts personal enlightenment ahead of mundane responsibilities of family and state.

In economic matters, the monk does not work for shelter or food; nor does he seek wealth or possessions; normally he begs for meals and welcomes charity, while the giver accumulates merit. This ideal is for a handful of tough spiritual athletes. For ordinary men and women attracted to Buddhist teachings of compassion, peace, and good will, it was inevitable that the original teaching would acquire all the trappings of a salvationist religion—savior, heaven, hell, miracle, prayer, and salvation. In the case of Buddhism, these categories were multiplied to include an abundance of savior beings and places of bliss and torment. Rebirth could take place in six domains— humans, beasts, hungry ghosts, warlike demons, ashuras (wrathful, violent beings), or hell.

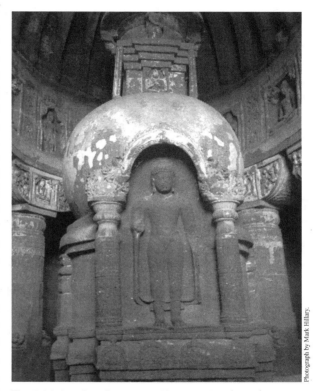

Fig. 7.11 Interior of cave 19, Ajanta, 462–500 C.E.

It was perhaps inevitable that Buddha would be viewed as a god in his own right, possessed of great powers that could be used to relieve the suffering of others if they had faith. The doctrine arose that Siddhartha, prince of the Shakya tribe, was the seventh incarnation of a universal Buddha principle and that six other Buddhas had preceded him in this corrupt stage of kali yuga. Given endless cycles in time and space, there must have been an infinite number of Buddhas in the past as well as countless future enlightened beings. The Buddha of recent vintage, it was argued, cannot be the only one. There were Buddhas before him, and there would be Buddhas after him. The door was opened to limitless prospects for salvation beyond the solitary, demanding ideal of the Arhat, who self-reliantly treads the Eight-Fold Path to the end.

The new sect that offered universal salvation rather than enlightenment after a regimen of individual discipline was called Mahayana (the Great Path, Vehicle, or Raft) to distinguish it from Theravada, which was dismissed as Hinayana (the Small Path, Vehicle, or Raft). The Small Path would lead only a few to salvation; the Great Path was open to all. Instead of the Arhat, Mahayana took as its ideal the Bodhisattva (enlightened being),

a Buddha who had attained enlightenment, dwells in a paradise, and is available to assist and comfort other living beings. The Bodhisattva denies himself or herself ultimate rest in order to engage in a rescue mission that will not end until all living beings have been saved from the dust heap of samsara, the cyclical world of change and rebirth. Instead of enlightenment by one's own strength, Mahayana offered salvation and enlightenment through the strength of another.

Bodhisattvas have accumulated an infinite store of merit that can be shared with the faithful. Merit can be earned by going on a pilgrimage to an important Buddhist site, by providing material assistance for temple building, or by turning a prayer wheel with a sutra (scriptural text) placed inside. The prayer wheel is a metal cylinder with a handle inserted in the bottom by which the cylinder can be rotated. Since a portion of a Buddhist scripture is placed inside, turning the wheel (symbolic of Buddha setting the "wheel of the law," or his teaching, in motion) is considered as good as reading the scripture itself, and multiple turns earn merit. The prayer wheel is obviously a boon to illiterate devotees. Most Buddhist temples have them, always ready to be set in motion. Pilgrims carry portable wheels on their way to a temple, shrine, or holy place to maximize the inflow of merit. Some prayer wheels are large enough to be housed in a small building, a tribute to belief in their efficacy. The prayer wheel had come a long way from the ideal of an arhat who treads the Eight-Fold Path without relying on others.

Faith in a Bodhisattva expressed in worship and prayers would eventually overcome the cycle of reincarnations or offer the faithful an eternity in a glorious paradise. An iconography of Bodhisattvas developed so that the faithful might recognize images of prominent celestial beings like Maitreya, Buddha of the Future; Amitabha, Buddha of Immeasurable Radiance; and Avalokiteshvara, the Lord Who Looks Down. The last of these was also popular as a woman called Kuan-yin (Guanyin—"Goddess of Mercy") in China and Kannon in Japan, reflecting a side of Mahayana Buddhism that is devotional, with the object of worship being one of many Bodhisattvas. These three Bodhisattvas and the Buddha were major figures in later devotional Buddhism, both in India and China.

Along with its promise of salvation through intervention of a Bodhisattva, sometimes in a paradise, sometimes in Nirvana, Mahayana differed from Theravada in a second major way. The door was opened to intricate philosophical speculation about permanence and change, being and non-being, spirit and matter, and all those impractical issues the Buddha warned against. A vast literature eventually arose dealing with the nature of reality and knowledge, questions originally of no interest to Buddha, who never talked about such things. An example is the Mahayana concept of suchness, or emptiness (tathata), a view of appearances in the world of experience considered to be illusions that are totally lost.

> What is meant by . . . knowing in accordance with truth the origin and extinction of form? It means that a bodhisattva . . . knows that when form originates it comes from nowhere and when it is extinguished it goes nowhere, but that though it neither comes nor goes yet its origination and extinction do jointly exist. . . . [43]

To use the raft metaphor in Vedic speculation, there is no shore from which one embarks, there is no river to cross, no farther shore to be reached. Indeed, there is no raft and no one on it. There is only the void in which all distinctions vanish, and, strictly

speaking, even the void does not exist, since it calls up its opposite—non-voidness. Where Hinayana sharply distinguished the phenomenal world from Nirvana, Mahayana teaching identified the two, which meant that salvation was possible in the world with the help of celestial Buddhas and Bodhisattvas. No doubt these puzzles and paradoxes were attractive to philosophically inclined individuals, but it should be clear that they have little in common with issues that persuaded Prince Siddhartha to give up kingdom and family for austerities and the bodhi tree, or his view that personal discipline, not philosophical speculation, is the path to enlightenment.

Like the Buddha, Bodhisattvas lent themselves to image making, which was more complicated than representing the historic Buddha, because one enlightened being had to be distinguished from another by spelling out visual attributes. The proliferation of sculptured and painted celestial beings was enormous, the more the better to earn merit. We shall content ourselves by indicating the features of a Bodhisattva and emphasizing their differences from a Buddha (figs. 7.12, 7.13). The Buddha is in a full lotus position, seated on a throne, with the usual attributes—ushnisha, urna, and long ear lobes on the head, and right hand in the mudra (gesture) that means fear not, saying, in effect, there is a way out of suffering and he has found it. A Bodhisattva, whether Indian, Chinese, or Japanese, does not exhibit this cluster of features.

Usually the Bodhisattva figures are standing, display elaborate hairdos, even sport mustaches, wear crowns and sumptuous robes, and wear much jewelry, including rings,

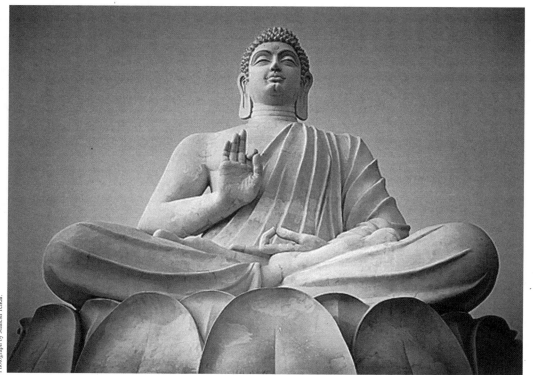

Fig. 7.12 Seated Buddha near the entrance of the Belum Caves, India.

necklaces, and bracelets on arms, wrists, and ankles. A female Bodhisattva has most of the same characteristics. When seated they normally have the right leg lifted with the right arm supported on the knee and the left leg dangling, a leg posture (asana) called royal ease. Sometimes the legs are crossed, but rarely in the lotus position. In India and Japan, some Bodhisattvas have multiple arms, which is never true of a Buddha image. It is worth repeating that the iconography of these figures was viewed as a means of focusing attention and aiding meditation. The mudras of a Buddha image capture elements of teaching in a gesture accessible to literate and nonliterate people alike.

Hinduism

Traditional Hindu ideas about nature, man, and society are a vast synthesis of beliefs and practices drawn from various sources, including primitive animism (belief that elements of nature are alive), Vedic literature, Buddhism, and Jainism. In time, at least by the Gupta era, Hinduism had become a comprehensive way of life that is not best described narrowly as "religion," although religion is obviously a large part of it. The emergence of Hinduism was a response to the challenge of Jainism and Bud-

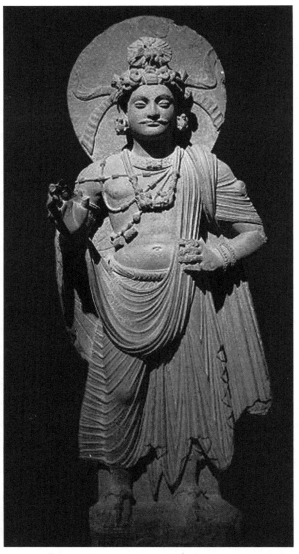

Fig. 7.13 Ghandara style Bodhisattva, first to second centuries C.E.

dhism, but also to the mystical individualism of the Upanishads, and the development of aspirations and disciplines outside the Vedic tradition. The problem, no doubt perceived early on by astute Brahman priests, was how to preserve the authority of Vedic literature and the Brahman priesthood while making room for visions of salvation from indigenous, non-Aryan sources that did not rely on sacred texts or priests.

Four Ends of Life

By Gupta times Hinduism as a way of life was in place. The framework within which that way of life is understood and lived comprises four ends (purushartha) that take into

account essential needs and purposes of life bearing on conduct, practicalities, pleasure, and salvation. The four ends are pursued by adjusting the tempo of individual life to four stages (ashramas)—student, householder, hermit, and homeless wanderer. The general idea behind this elaborate eight-fold scheme is that human life is series of graded roles played out against the background of karma and reincarnation, whose ultimate terminus is deliverance from all social masks, whether sacred or secular. Behind the conventional roles of society lies the ultimate reality in which distinctions vanish and rebirth ceases. For a time, it is good to live in a world of social duties, material goods, and sensual pleasures. If that is all one does, however, the consequence is incarnation in future lives that repeat the same patterns and events without end.

In the West, ideas about purpose and meaning in life are less focused and settled. There is no doubt that worldly success and pleasure, two of the Hindu ends, are widely sought as paramount goals. In modern America, money, entertainment, and individualism rank high in the scheme of values. There is a general sentiment that moral behavior and ethical standards matter, but there is no consensus about precisely what is to be done or what conduct best corresponds to the Hindu idea of dharma, nor is there a consensus about gender roles. As for religion, again there is no consensus in modern Western societies about the status, nature, or intentions of divinity, or what salvation is and how best to achieve it. India's advantage is that conduct, gain, pleasure, and deliverance work together in a more or less coherent system on which there has been a long record of agreement.

The first end is dharma, a word whose root meaning is "to sustain"; but the word, like so many Sanskrit words, has a number of meanings and is not precisely translatable. Perhaps the best rendering, other than duty or obligation, is "right behavior" in all phases of life. Every individual contracts a debt to gods, parents, ancestors, and communities as a result of coming into the world. In addition, there are obligations to fellow humans and nonhuman creatures who participate in the drama of life with us. Each social group, regardless of class or caste, has its particular dharma, which is to fulfill prescribed duties, meet preordained obligations, and exhibit standards of conduct set down in the sacred law books and scriptures.

Within the group, a person's dharma specifies what can be eaten and worn, who can be spoken to and how, who is suitable for marriage, and what property may be owned. In the *Law of Manu* we find rules for taking a bride, the deportment of women, the behavior of the four classes and specific castes, the relations of husband and wife, the duties of a king, the disposition of lawsuits, the proper conduct of rites, and even the etiquette of gambling. Not much is left to chance or choice.

Every detail of an individual's life, male or female, is spelled out by instructions of dharma, whose true significance is that rules monitor behavior so completely from birth to death that what Westerners call "personality" or "individualism" has little chance for free expression. For the Hindu there is no thrashing about to "find oneself," no sowing of wild oats before settling down, no experimentation to find the right "lifestyle," no living as one pleases according to desire or inclination. Surely there are still differences between individuals, but the point is not to accentuate or exaggerate those differences for the sake of ego. A defense against egoism is provided by a road of life that is fully mapped.

What seems to a secular man or woman in the West as intolerable restraint and confor-

mity is to a Hindu the perfect framework for achieving spiritual freedom. A life guided by dharma will be steady and undistracted. No energy or time will be squandered on fruitless actions, feelings, and ambitions. Wearing the social mask with sincerity, commitment, and tranquility is the condition for apprehending the spiritual reality that lies behind it.

Meanwhile, there is no doubt in the *Law of Manu* as to which class and gender dominate the social hierarchy: "Of created beings, those which are animate are the best; of the animate, those who subsist by means of intellect; of the intelligent, men are best; and of men, the brahmans are traditionally declared to be the best. . . . The very birth of a brahman is the eternal incarnation of dharma. For he is born for the sake of dharma and tends toward becoming one with the Brahman. . . ."[44]

The second end is artha, the material, political aspects of life, which embrace all those activities associated with the creation, acquisition, use, and disposition of things; possessions and wealth; and the means of getting, preserving, and exercising power to afford protection against injustice and tyranny. Human life cannot progress and flourish in its natural spheres with only the austerities of the yogi. Tangible things are needed to sustain families and fulfill the duties of religious life, so desiring, securing, and enjoying possessions are natural and expected aims up to a point. The many roles played out in family life require resources. Family life contributes to social discipline, which prepares an individual, through respect for dharma, to enter later stages on the road to spiritual release (moksha).

Society must be governed justly and protected from evil. People must be guarded so they are not victims of greed and cruelty. Of course each person, whether king, minister, husband, wife, priest, or mendicant, must go about their duties righteously and in conformity with the moral injunctions of dharma, but once that constraint is accepted, there is nothing wrong with being affluent or wielding power in public affairs. Since all government in ancient India was monarchical, kings needed advice and wisdom about how to govern well. The *Arthashastra* as well as other literature on the same subjects provide exhaustive counsel on means for achieving worldly advantage.

The third end is kama, a word that denotes all the possibilities of pleasure, enjoyment, delight, and gratification, which includes sexual desire and its fulfillment, and the meaning of pleasure in the arts—dance, music, and especially poetry and drama (there is a god called Kama, who presides over pleasure and is a deity worshiped by courtesans). A number of specialized treatises were composed to deal with these subjects. The best known is the *Kama Sutra* (Aphorisms of Love, or Treatise on Love), an exhaustive manual of sexual technique no doubt helpful to couples in traditionally arranged marriages in which the girl had usually just reached puberty, and designed to instruct people of every type in as many situations as possible. Detailed instructions are given for care of a man's body—bathing, sleeping, eating, accessorizing, socializing—and similar analysis is given to signs of a girl in love, proper use of nail indentations when passion is at its peak, and more. Human love is often connected with divine love, like the love of Krishna for his milkmaids (gopi), with whom he flirts and frolics, or the idealized love of Rama and Sita in the *Mahabharata*.

As mentioned before, pleasure is not confined to the flesh but is extended to the arts. In Hindu literature, there are theories about the nature of aesthetic pleasure and how art differs from nature. The essence of aesthetic pleasure in a play, for example, is in emo-

tions expressed rather than characterization and plot. The best emotions are lofty ones dealing with love and heroism; the minor ones are ephemeral, like anger or jealousy. Indian treatises provide lengthy classifications of emotions in both categories. While everyone can experience emotion, only a person with a receptive mind and heart, cultivated in the arts, will respond appropriately to a poem, dance, or musical composition. The uncultivated person is too distracted and confused by shifting, raw, and immediate feelings to react totally.

The function of art, and the secret of its power to give pleasure, is to distill and concentrate emotions from their transitory individual settings, defuse their painfulness, as with anxiety or loathing, and transform particular feelings into universal ones. The key to all of this is the concept of moods or flavors (rasas), discussed earlier in connection with Kalidasa's classic drama, Shakuntala. Aesthetic and sexual experiences alike overlap with the spiritual, have their connections with the gods, and provide opportunities to achieve self-transcendence.

The fourth end is moksha, which has two distinct possibilities in Hinduism, one theistic, the other monistic. In the theistic mode salvation comes by surrender to a titular deity, usually Shiva, Vishnu, or Devi, the Mother Goddess. The way to moksha is single-minded devotion (bhakti) and unfailing ritual acts of worship (puja). From the theistic point of view, the soul and the god are not the same. It is not always clear how rebirth is transcended on these premises, but gods are taken to be incarnations of the ultimate world spirit, so what is expected by theists is union, in some sense, with the god and thereby union with a higher reality.

From the monistic point of view, the words "release" or "deliverance" are preferable to salvation, which implies a dualism of worshiper and protecting deity. In the loftiest flight of Hindu thought, however, personality and the individual soul are illusions, masks that are dominant while a person cleaves to worldly ends of dharma, artha, and kama. When the masks have served their purpose and are discarded, the last round commences, which is withdrawal to end all attachments and achieve union with Brahman.

The *Bhagavad-Gita* says: "When one renounces all desires that have arisen in the mind . . . and when he himself is content with his own Self, then is he called a man of steadfast wisdom." Again: "He who feels no attachment toward anything; who, having encountered the various good and evil things, neither rejoices nor loathes—his wisdom is steadfast." And yet again: "When one's properly controlled mind becomes steadfast within the Self alone and when one becomes free from all desires, then he is said to have accomplished yoga."[45]

It bears repeating that moksha is not about the survival of personality or the immortality of an individual soul; the objective of the fourth end is just the opposite—the termination of individual existence and the cessation of rebirths through union with a more inclusive reality.

Four Stages of Life

The four stages (ashramas), which are intended to serve the normal interests of an individual's life while preparing that individual for disengagement from them, are intimately connected with the four ends. The first three stages are disciplines in the world as an

individual applies himself to being a student, a family man, and a hermit, roles staggered across the early and middle parts of his life. All three stages are governed by dharma. In the last stage, exclusive focus is on deliverance from rebirth, and dharma becomes irrelevant.

The student stage is especially crucial to spiritual preparation and development. Assigned to a guru, the student's first obligation is complete obedience and total submission to the teacher. He becomes a receptive vessel into which the guru pours his knowledge, skills, and personal examples of virtue. Nothing must interfere with the tone and continuity of the relationship—no nights out on the town, no reading of unauthorized literature, and, above all, no independent spirit of criticism. There can be no individualistic deviation. The guru is the student's deity, and his iron rule is blind acceptance and faith.

Justification for such uncomplaining faith comes as the role of student is played out; it comes from experience rather than through theory or argument. The student becomes twice born with the passing of a sacred thread over his shoulder and now must live up to the challenge of substituting wisdom for the normal pursuits of an energetic young man. The wisdom he seeks from a guru is hoarded jealously and dispensed only to a worthy subject, who must demonstrate worthiness in every action, intention, and word.

When the period of study with a guru ends, the next step comes immediately—the submissive student is thrust into marriage and becomes a householder. A wife is selected by his parents, and children appear as soon as possible. He enters the family business or takes up a profession. The pleasures, trials, and responsibilities of family life are mixed with issues of money and property, for he must maintain a standard of living suitable to his class, pay for obligatory sacramental rituals, and retain a domestic priest for the house, a paid Brahman guru, who performs services from spiritual advisor to physician to magician. Thus the ends of dharma, kama, and artha are played out for the next twenty or thirty years.

The role that follows householder also comes abruptly. With sons and daughters grown, civic and religious duties can be put aside for departure to the forest, to begin the stage of forest dweller, or hermit. The wife usually follows the man into this preliminary retreat from mundane, conventional involvements to pursue inwardness. This third stage is a training session for the final push toward deliverance when all social masks are dropped and there is no concern for future or present; attachments to place and relationships cease if the preparatory stage of forest dwelling has been successful.

The fourth stage of homeless wanderer is the culminating adventure of a man who has done all the expected things well and now cuts every tie to pursue complete detachment, the condition for release from the prospect of further rebirths. The *Bhagavad-Gita* describes the perfect man of wisdom ready for union with Brahman: "He who behaves alike to foe and friend; who likewise is even-poised in honor and dishonor, who is even-tempered in cold and heat, happiness and sorrow; who is free from attachment; who regards praise and censure with equanimity; who is silent, content with anything whatever; who has no fixed abode, who is steadfast in mind, who is full of devotion. . . ."[46]

The holy man as wanderer is still a common sight in modern India—a man, and sometimes a woman, with no home, possessions, social attachments, ambitions, or purposes other than a single-minded goal of absorption into the timeless ground of all being.

8

India's Religion and Mythology

Hindu literature and art teem with mythological themes and figures. No art in any of the world's great civilizations is so permeated with gods, goddesses, sacred animals, supernatural places, emblems of divine power, and pictorial stories about divinities. For example, in a granite cliff sculpture like *Descent of the Ganges* at Mamallapuram, nothing presented to the eye is merely decorative or extraneous (fig. 8.1). Every detail has meaning and features a multitude of mythological beings and their stories. Elephants, path breakers of the forest, symbolizing an open path to salvation, converge on one side to witness the spectacle of waters descending from the long hair of Shiva perched on Kailasa, his mountain retreat in the Himalayas. Carved into the granite face are numerous other beings—human, animal, divine—drawn to the cosmic drama in the central cleft, where the Ganges flows from its heavenly source into the world. In the cleft, snake gods with their sinuous tails, beings sacred to water and its power, are easily visible. They both symbolize and are identical with the torrent falling from Shiva's mountain retreat.

Left of the cleft down which the Ganges pours, Shiva, patron of yogis, himself the greatest yogi of all, gazes serenely on the austerity of a holy man standing on one leg to show his disdain for bodily comfort (fig. 8.2).

© Matt Mayer/mattmayer.com

Fig. 8.1 Descent of the Ganges, right side of sculpted cliff, 663–668 C.E. Mamallapuram.

Fig. 8.2 Detail of Shiva and yogi, Mamallapuram relief.

Keeping track of gods and their doings is a daunting task involving intricate stories, relationships between deities, and the iconography that sets them apart. Identities can be confusing because gods and goddesses morph into one another and appear in many forms. Fortunately, these matters can be simplified and compressed up to a point. Nonetheless, one must be careful not to gloss over a feature crucial to understanding the significance of an image. Mythologies of Hinduism can be approached by keeping in mind several broad principles.

First, a seemingly boundless profusion of gods and goddesses are assimilated to a few major deities, specifically Shiva, Vishnu, and Mahadevi, the Great Goddess. Over time, no deity was ever abandoned, whether prominent or obscure. All of them found devotees and advocates, although all were not honored with shrines and temples. One way or another, the obscure beings or creatures end up associated with a highly visible god or goddess in an orderly hierarchy, from the minor to the great, the local to the universal. The unifying idea is that all the gods are manifestations of Brahman, the ultimate, non-dual source of all existence.

Second, the principle of organization and assimilation is incarnation. Shiva has as many as twenty-five incarnations, Vishnu has ten, which include Krishna, who advises the reluctant warrior Arjuna to fight a battle in the *Bhagavad-Gita,* Rama, hero of the epic *Ramayana,* and Buddha, who rejected the Vedas but finds a place in the Hindu system.[47] When any of these incarnations are identified by distinctive emblems, the viewer is in the presence of Vishnu as well. A worshiper of Krishna is also worshiping Vishnu at a distance.

Third, male and female can be represented separately or as a unity. In some images the figure is a man on one side and a woman on the other. Male and female are frequently represented by symbols of sexual organs—the yoni for the woman, the linga for the man. In Figure 8.3 a protective cobra coils around a linga protruding from a yoni. In Figure 8.4, Shiva appears in four contrasting personifications on a linga, an image not uncommon in temples dedicated to the god. Women are viewed as having special generative energy and power (shakti), which can be creative or destructive. The energy of male gods comes from shakti, which is taken to be the driving force in nature and the source of all renewal—hence the intimate ritual association of linga and yoni. The goddess appears in many forms. Shiva's female side can be the beautiful, benign Parvati, the mountain goddess, or the grotesque Kali with a protruding tongue, standing on a victim amidst a shower of skulls, a fearsome goddess who relishes death (figs. 8.5, 8.6).

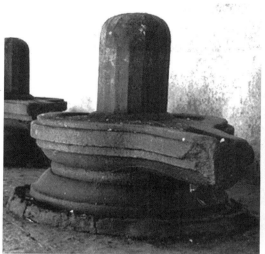

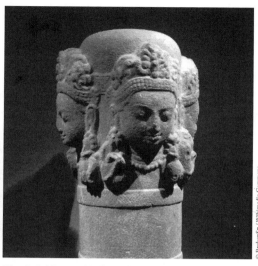

Fig. 8.3 A male symbol (linga) set in a female symbol (yoni).

Fig. 8.4 Linga with four personifications of Shiva (900–1000 B.C.E.)

Fourth, while assimilation and incarnation are the main principles of organization, male or female deities change not only into one another but also into a variety of animals. Sometimes animal and human are fused, as with Ganesh, the elephant-headed son of Shiva, or Kalki, a horse-headed incarnation of Vishnu. Composite images permit a devotee to behold and worship two gods at the same time. An example is Harihara, an image divided

Fig. 8.5 Parvati, consort of Shiva, as a queen, eleventh to twelfth century.

Fig. 8.6 Kali, consort of Shiva, by Richard B. Godfrey, 1770.

between Shiva and Vishnu. On the Shiva side is matted hair and two hands holding his emblems; on the Vishnu side is a tapering crown and the other two hands holding his emblems. As noted above, an image might also be half man and half woman.

Fifth, all gods and goddesses have attributes or emblems that identify them (e.g., the three-pronged trident [trishula] for Shiva, weapon of a hero, the lotus for Vishnu, emblem of a creator), and usually something to ride on (e.g., the bull, Nandi, for Shiva; the hawk, Garuda, for Vishnu; the crocodile monster, Makara, for Ganga, the river goddess; and so on). These attributes are more crucial than physical appearance (traditionally sculptors were guided by proportions and features amounting to a standard physique) for identifying a god or goddess, and all of them have special meanings. Often multiple arms and heads appear in representations of gods to indicate various functions and powers. It takes more than two hands to hold the attributes of Shiva or Vishnu. While it is rare, an image might have up to eighteen arms. Four heads look in the four cardinal directions, embracing the world, and express several possible roles of a god in the cosmic scheme.

On the island of Elephanta in Mumbai harbor (formerly Bombay) on the west coast, a cave temple from the seventh century C.E. is dedicated to Shiva. His image, a sculptural masterpiece, is against a wall with three visible faces, one expressing wrath on the left, a second expressing feminine beauty and compassion on the right, and a charismatic expression of yogic detachment in the middle (the fourth, facing the rock wall, is unseen). This symbolic expression of the god's identities is 23-feet high, 19.5-feet across, and carved in high relief (fig. 8.7).

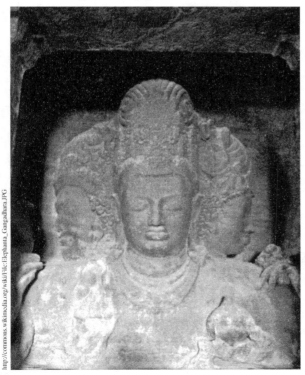

http://commons.wikimedia.org/wiki/File:Elephanta_Gangadhara.JPG

Fig. 8.7 Three headed Shiva and marriage of Shiva and Parvati, Elephanta.

An adjacent bas-relief depicts the marriage of Shiva to Parvati (fig. 8.8) The river goddess Ganga, his second wife and female personification of the Ganges River, lives in his matted hair from which the Ganges flows to slow its potentially destructive entrance into the world.

Sixth, the principle of incarnation keeps multitudes of divine beings in a semblance of order, but ultimately all are considered one in Brahman without distinctions, when mythology sheds it colorful garb and modulates into high philosophy. On one side, there is an unlimited supply of deities with different powers and manifestations to satisfy every shade of belief and practice, while, on the other side, there is an erasure of all distinctions, including those between good and bad, love and hate, truth and falsehood, divine and human.

Meaning in Hindu myth is a tangled

subject. The gods and their stories are numerous and involve hundreds of symbols and physical attributes. The towers on Hindu temples are literally taken to be sacred mountains, for gods are associated not only with caves but with high places. We have encountered two such lofty places in Hindu mythology. Mt. Meru is the world mountain rising in the middle of a flat, round universe, the reference point for surrounding continents, seas, and celestial bodies. Mt. Kailasa is the home of Shiva. The tower on a temple dedicated to him becomes the mountain when the god is "in residence."

The snake (naga) stands for water, which is emblematic of the deepest unconscious in which worldly distinctions vanish. Water also sustains the world. The Ganges River is the most sacred body of water. All Hindus want to bath in it and need a sip

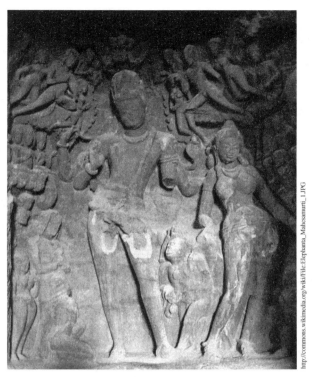

http://commons.wikimedia.org/wiki/File:Elephanta_Mahesamurti_1.JPG

Fig. 8.8 Three headed Shiva, cave temple of Elephanta, eighth century.

at the moment of death. The snake is also associated with creation in the form of Ananta ("the Endless"), the cosmic serpent. In a myth featuring Ananta, the home of the gods, Mt. Meru, rests on Ananta's coils while gods take one end, demons the other, and by pulling back and forth churn the ocean to produce a divine elixir called soma, a major sacrificial offering in Vedic rituals and also the name of a Vedic god.

The yogic positions assumed by many sculptural figures and the emotionless calm of their expressions indicate the state of consciousness achieved with fixed attention, controlled breathing, and mystical union with Brahman. Apparently, fanciful sculptural ensembles with strange creatures remind the viewer that existence is an illusion (maya). When elaborate mythology is added to cosmic cycles of creation and destruction that never end, and the world is seen as outer forms inhabited by gods, it is not difficult to understand why a strong scientific tradition never developed in India, despite some achievements in mathematics and astronomy.

Shiva's iconography is rich in spiritual meaning. His name means "Beneficent," "Gracious," and "Blessed One," even though he is also called the "Destroyer," for destruction and death are preludes to creation and life. Sometimes he is called Shiva Vishapararana (destroyer of poison), which refers to his compassionate act of swallowing poison that welled up when the cosmic ocean was churned. Among the gods, he is also the most unpredictable and capable of outrageous behavior. He is also called Nataraja, Lord of the Dance, creator of 108 dances that are the foundation of classical Indian dance.

In a bronze masterpiece from the eleventh century, he is depicted in his role as cosmic

dancer (fig. 8.9). The dance is associated with creation, destruction, and the promise of release from rebirth. The face expresses the calm of a yogi in meditation. Long tresses flow outward carrying the Ganges to earth. The right foot tramples a demon who looks up at the Lord meekly and who represents ignorance (avidya) of the reality that all opposites are an illusion. One of the two left hands points downward at the raised foot and simulates the trunk of an elephant, the path breaker and remover of obstacles. One of the two right hands expresses the mudra "fear not" with palm facing the viewer. The other right hand holds a drum whose vibrations create the phenomenal universe. The other left hand holds a bud of fire that destroys it. Surrounding the entire image is a ring of fire, symbolizing the impermanence of existence and Shiva in his role as destroyer. Few images display iconography so varied, powerful, and rich. It is virtually a summary in bronze of Hindu ideas about the nature of the universe and the true vocation of man.[48]

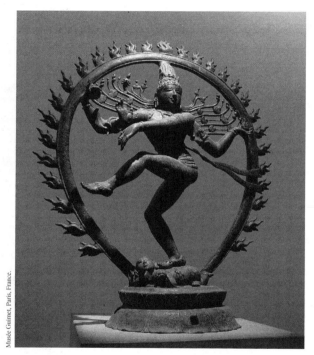

Musée Guimet, Paris, France.

Fig. 8.9 Shiva Nataraj ("King of Dancers"), twelfth to thirteenth centuries.

Devotees of Shiva are called Shaivites and wear three stripes of ash across the forehead to indicate membership in the cult. The ash comes from cremation grounds where Shaivite ascetics sit contemplating the unreality of the sensible world. Mendicant followers can often be seen carrying a trident, an important attribute of Shiva, his weapon of choice, which can be seen protruding from the ground in front of temples dedicated to the god. The weapon is used by Shiva to destroy forces of darkness and death. The three prongs signify his powers of will, action, and knowledge, also the meaning of the ash stripes on Shaivite foreheads.

Vishnu is the preserver who brings continuity and stability between cosmic acts of creation and destruction. While Shiva manages the beginning and end of things, Vishnu controls the time that lies between. He is the god of domestic life, love, and feeling. Domesticity is the focus of Vaishnavite cults. Some of his incarnations represent this emphasis on home life (Rama) and the performance of dharma (Krishna). For Vishnu, the disc or wheel (chakra) stands for eternal time, and is also his chosen weapon, while the conch shell stands for eternal space and can be heard sounding in his temples.

Attributes can become complicated as symbols, depending, for example, on which of the four hands holds an attribute. Different emanations of a deity can be indicated by placement of the emblems. Vishnu supposedly has twenty-four emanations, the number that comes out when two mudras (hand positions) and two emblems (say the disc and

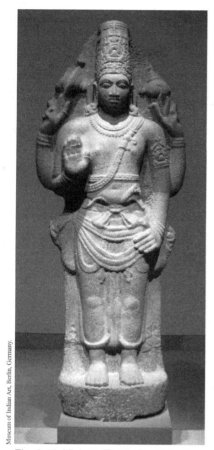

Fig. 8.10 Vishnu, Tamil, South India 1000 C.E.

conch shell) are rotated around four arms. Other attributes are the club and the lotus. A South Indian image shows him holding two attributes always associated with him—the discus, one of his preferred weapons, and the conch shell, in the hands on either side of him, slightly to the rear (fig. 8.10). His consort is Lakshmi, goddess of good fortune and prosperity, although, like Shiva, he has other consorts as well. Lakshmi can appear as a queen and also take the form of a lotus, one of Vishnu's attributes.

Vishnu as dreamer who brings the universe into being is his most powerful guise in Indian art. The panel in which he sleeps on the milky cosmic ocean is one of several placed on the walls of a ruined temple at Dogarh, one the earliest examples of a freestanding religious edifice (fig. 8.11). The Vishnu panel can be seen to the right. Vishnu rests on the coils of Ananta, king of snakes, with several hooded heads serving as a parasol, a symbol for the yogi, over Vishnu (fig. 8.12). Below him are the five Pandava brothers, heroes of the *Mahabharata,* one of whom is Arjuna, the principle character in the *Bhagavad-Gita.* Also pictured is their shared wife. She represents mind, while the brothers are the five senses. They are part of Vishnu's dream; Lakshmi, also known as Lady Lotus, rubs his leg and makes the dream unfold.

One of Vishnu's attributes, the lotus, floats above the sleeping god on which Brahma, the instrumental creator god, sits with his four heads reaching in the four directions. At his left is Shiva riding his bull with Parvati. To Brahma's right is Indra on his elephant, the god who

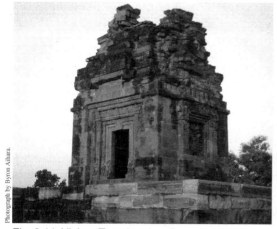

Fig. 8.11 Vishnu Temple ruins, Dogarh, 550 C.E.

Fig. 8.12 Vishnu on Ananta, panel in the ruined Temple of Dogarh, 550 C.E.

sustains the illusion of worldly existence. The image of the universe as a dream arising from the cosmic ocean and a sleeping god is a mythically powerful evocation of *maya*, the idea that the changing world of experience is unreal.

The major gods and goddesses have cults and shrines, frameworks for worship and expressions of devotion. Some minor deities are also worshiped, but most simply appear here and there unobtrusively in ensembles of the gods, such as the celestial family, the most popular presentation of divinity. From about the third century B.C.E. to the Gupta period, Brahmanical ritual and sacrifice gave way to various devotional cults whose focus was on straightforward worship free of theology and philosophy.

Devotional activities are for specific deities and take place in temples or public and domestic shrines. The essence of worship is *darshan*, which means something like "auspicious seeing." The worshiper looks upon the god and is seen in turn. An image is not regarded as an idol, or a mere symbol, but serves as a residence for the god or goddess. Most Hindus are either Shaivites or Vaishnavites, or worship one of the two god's many incarnations (avataras or descendents). As we have seen, the possibilities for attachment to a god or goddess are numerous. All of Vishnu's ten incarnations have distinctive legends, stories, attributes, and powers.

What is the purpose of membership in a cult and what is worship (puja) supposed to accomplish? What must one do, and what can be expected in return? Motives include the common human desire for personal well-being (wealth, healthy children, and longevity), the satisfaction and safety of having power over others, fear of what a god might do if displeased, and loving attachment to a god. In temples, sacred words, chants, and bells announce the arrival of priests requesting audience with the god.

Once in the sanctuary, the image is washed and anointed with fragrant substances so the god will take up residence in it. The high point of a ceremony is circumambulation, walking clockwise around the image to participate in the flow of energy that radiates from it in the four directions. In many temples, ambulatories are provided to circle the deity.

Usually the public is not admitted to the sanctuary but must be content to worship in an adjoining room just beyond the entrance. For a numerous public that cannot all fit in a temple, a god like Shiva becomes visible in elaborate public processions. An image or symbol of the god or goddess is carried in a "chariot," which is a portable temple. An image may or may not be the one from a temple, but it does not matter, because the god can be persuaded to occupy a substitute image with suitable offerings and prayers. India resounds daily, as it has for 2,000 years, with ecstatic festival processions to celebrate and honor its gods.

Domestic shrines, which were and are everywhere, feature in a conspicuous place attributes of the favored deity, perhaps the trident for Shiva or the discus for Vishnu. Hindu worship is colorful, whether in temples, processionals, or domestic shrines. Acts of worship take the form of audible and silent prayers and the presentation of gifts like fruit, incense, flowers, clarified (strained) butter, food, drink, or even money. The deity may be entertained with dance and music at different times of the day and night or with readings from sacred texts. When ceremonies end, the deity sleeps or goes elsewhere until the next round of devotional observances invite him to return.

These mythological beliefs can be viewed in three ways. First, myths in Indian religion and art may be taken as true and literal rather than as the symbolic dress of beliefs and

ideas. Mythic stories are allegedly not mythical at all. For the faithful believer, they account for gods and goddesses that actually exist, including their various manifestations. Their powers are real, and their deeds really happened. Ritual and prayer, it is believed, may be used to communicate with them and produce results. The world and human life are unintelligible without them. No doubt people by the millions, and not only in India, organize their lives around such unquestioned beliefs.

The problem, of course, is that such convictions are justified by faith rather than experience and reason. Their authority comes from unquestioned traditions. Disagreement is inevitable, for every god or goddess claimed to exist from one religion to the next, and the feats he or she performs, are not accepted universally. Judaism has its Torah and the parting of the Red Sea by Yahweh. Christianity has its New Testament and the raising of Lazarus from the dead by Jesus. Islam has its Koran and the ascent of Muhammad to heaven on a creature half-horse and half-woman. Hinduism has its vast pantheon of deities acting out their varied roles. Are these tales mythic symbols or facts of experience? If the latter, which one is true? How does one decide? The common response of one exclusive faith to another is to say, or imply, "my religion is true and yours is false." Jews do not accept the divinity of Jesus. Most Christians believe that Jesus was a unique incarnation of God and born of a virgin. For Muslims, Jesus was merely a prophet superseded by Muhammed, the last and authoritative prophet.

For a devotee of Islam, there is only one god, and Hinduism is condemned as a blasphemous, idolatrous creed. Since Allah, the one God, is the supreme image maker, humans cannot make images without offending him. Consequently, Muslims who invaded India demolished temples when faced with innumerable, often provocative images. Christians in the ancient world rejected the polytheism and anthropomorphism of Greek and Roman mythology, while Hindus are prepared to give every deity his, her, or its (animals can be gods too) proper due and absorb all of them into a comprehensive system. Equally legitimate are worshipers of Vishnu, Shiva, Devi, the Great Goddess, or a hundred other deities, all of which are considered realities rather than myths among other myths and objects of imaginative stories. There is no principle of exclusiveness.

A second approach to mythological beliefs is that myths are not literally true but point symbolically to deep underlying realities of human existence—birth, death, suffering, impermanence, and all the other trials that afflict humanity. Such common experiences of human beings converge in similar myths, based on a substratum of deep insights called archetypes, which is why analogous symbols for similar experiences are often found from culture to culture. Myths can be explained, therefore, as imaginative stage plays about generic realities of the human condition.[49] For example, the mythic pattern of withdrawal, enlightenment, and return, during which a religious hero is tempted, cleansed, and receives a revelation, can be applied to stories about Buddha, Jesus, and Muhammad. The idea of a nourishing mother occurs in most religions, as does belief in a world mountain, a high place where gods live or where humans contact them—Mt. Sinai where Moses received the Ten Commandments, the stepped ziggurat found in every Mesopotamian city, Aztec temples where human sacrifices were offered, Mt. Olympus where the Greek pantheon lived, and Mt. Meru, the world mountain of Hinduism.

The third approach is to view myth as a way of thinking, a mythopoetic connection with the world of experience, which is perhaps the best way to understand Hinduism.

A myth is poetry or storytelling, especially stories about gods, which enunciate what a believer takes to be a truth remembered or called up by ritual actions. Opposites are merged, and there is no longer a clear distinction between appearance and reality, objective and subjective, life and death, natural and supernatural. The one is the same as the other. The world of dreams is not considered different from concrete experiences in a waking state. Symbols do not merely stand for things outside themselves. The symbol and the thing it signifies may be intertwined or even identical. In the realm of transformation, a god can change into an animal and back again; the animal, for a time, is the god. In the material realm, physical objects like statues and buildings are not always distinguished from nonmaterial beings and forces.

In Hindu mythology, statues and temples are identified with deities in a provisional way. An image is a receptacle, or a "house," and a god is invited to take up residence by a show of aesthetic excellence and ritual. An image of Shiva, or his linga housed in a temple, may be just a statue or a vertical stone pillar, or it can be inhabited by the god himself. The tower on a temple is a symbol of Shiva's home on Mt. Kailasa when he is absent; it becomes more than a symbol when he is persuaded to take up residence by the majesty of its height, the beauty and profusion of its sculpture, and the ritual devotion of worshipers.

An example of Hindu mythopoetic thinking is the story of Ganesha, the elephant-headed protector of doorways and dispenser of prosperity, although Hindus do not believe he is a purely mythic being (fig. 8.13). Parvati wanted a child, but Shiva refused to contribute his semen because, as the patron of yogis, he is sworn to celibacy. He goes on a trip,

and during his absence Parvati washes dirt from her legs and makes a child. Shiva returns and sees his unknown son standing outside Parvati's bathroom. An argument ensues, neither recognizing the other, and Shiva angrily decapitates his son. Parvati explains who the boy is and Shiva repairs the damage by instructing a servant to go out and take the head of the first being he finds, which turns out to be an elephant. Shiva promptly mounts the head of the elephant on the body of his son, who is resurrected. In appreciation for the fact that he courageously defended his mother's doorway, the revived son is made protector of doorways and put in charge of the ganasi, mischievous dwarfs that attend Shiva (Ganesha means Lord of the Ganas).

Two of Ganesha's emblems are a mahout's goad used for guiding elephants,

Fig. 8.13 Ganesha, the elephant-headed god, panel from Khajuraho, eleventh century.

symbolic removers of obstacles, and an ax. In India, innumerable entrances have a figure of Ganesha planted on the lintel, and his cult is very popular, with thousands of images manufactured every year for worshipful festivals. Without the intervention of Ganesha, any undertaking—marriage, a business deal, an examination—is in jeopardy. He is the supreme remover of obstacles. The story is not myth for worshipers but a historical reality, and the images are not just painted plaster or carved wood, but vessels in which Ganesha is present.

The Ganesha tale is a mythopoetic fusion, or juxtaposition, of opposites accompanied by no rational discomfort or doubt.[50] So it is with all Hindu myths, which are not considered merely useful, symbolic fictions by those who believe them. A skeptic in the Charvaka tradition might have raised these questions: Did events recounted in the Ganesha story really happen? How did dirt from Parvati's leg become a child? Can thousands of Ganesha images in doorways and festival processions accommodate him at the same time? Is Ganesha, in some sense, real? If so, what and where is he when no longer occupying a discarded image?

To the faithful, these are not helpful questions calling for analysis and resolution. Responses are likely to be sincere proclamations of unshakable faith, appeals to scriptural authority and tradition, a preference for emotional satisfaction over matters of fact, or a combination of all three. This way of thinking is not compatible with Western rationalism.

9

India's Way of Thinking

Hindu literary tradition and its ideals rest on a distinct way of thinking about nature, human nature, society, knowledge, and truth. In what follows, the past tense is used, but it should be understood that the way of thinking described still persists in the modern world. Despite the plurality of deities and complex mythologies that envelop Hindu thought and life, the drift was toward the universal rather than the individual and particular, the unchanging rather than the changing. The realm of change is maya, a pervasive illusion of reality sustained through endless cycles of cosmic destruction and regeneration.

In the social sphere, mobility between groups was sacrificed to a strict hierarchy of dignity, privilege, and duty. The function of hierarchy, a precise scale of dignity and worthiness, was to preserve order and meaning as a framework for ultimate spiritual release from the illusion of existence and the consequence of perpetual transmigration. Inequalities between groups and individuals were explained and justified as inevitable results of karma at work from one life to the next. Consequently, there was little interest in reform through deliberate public efforts to improve life through political, social, economic, and technological initiatives.

As individuals are pushed by karma from life to life through endless universal cycles of time, punctuated by phases of creation and destruction, there was slight interest in studying the world of experience and searching for natural laws. Instead, poetic and mythological expression were preferred to systematic empirical and rational inquiry. Historical consciousness was poorly developed, neither encouraged nor promoted by the view that an "objective" world, including the past, is illusory, in marked contrast to the Chinese, for whom historical precedents meant everything and demanded the accumulation of written records.

A culture of toleration and conciliation was fostered by pluralism and eclecticism, which meant an abundance of religious sects, mythologies, cults, and philosophies flourished. All religious practices and philosophical outlooks were believed to find ultimate resolution in oneness with Brahman. The stress was on practice within dharma rather than on orthodox belief enforced by a central authority. The range of Hindu religious belief is striking, from unsophisticated animism at the lowest level to philosophical monism at the highest, all supported by innumerable cults.

Within this pluralistic setting, religion and philosophy are mostly indistinguishable. The philosopher usually had a religious goal, and an individual's state of being was always more important than what he thought. The idea of "God" in thought and religion was flexible. All major gods and lesser deities of Hinduism are manifestations of a higher reality that is without identifiable qualities. There was no reigning, exclusive God in the monotheistic sense, or a single God who dominated the rest.

Jainism and Buddhism had two sides: the quest for release as a one-pointed commitment, essentially a monastic ideal, and an ethical way of life for laymen who chose to live in the world. In the first instance, there are parallels with Hinduism, such as withdrawal from mundane affairs, meditation, reverence for life, and vegetarianism. The difference is that Hinduism contrived a way to accommodate ascetic ideals with book learning, commerce, pleasure, and family life.

The truly committed Jain or Buddhist was obliged to withdraw from ordinary relationships and obligations. Mahayana Buddhism offered an alternative of living in the world while seeking salvation or enlightenment with the help of a Bodhisattva, a potential Buddha on the brink of Nirvana, or one just over the line, who turned back to help others still ensnared by karma and reincarnation. A layman could hope for improved karma by adopting ethical teaching of a chosen sect. In the case of Jainism, the chief guideline was ahimsa, absorbed later as a Hindu ideal, but there were other high standards of conduct as well. The lay Buddhist could travel partially along the Eight-Fold Path by complying with stages of right speech, action, livelihood, and effort. In all these cases what mattered was practice rather than theory. The test was always what one is and does rather than what one thinks or believes. Knowledge and inquiry about the world and the past, driven by curiosity and a questioning mind, were not central to the Indian way of thinking, nor was the Western view that knowledge and character are independent of one another.

10
India's Ideals of Beauty

Very little painting has survived from the third century B.C.E. to the thirteenth century C.E., so we will concentrate on sculpture and architecture to illustrate Hindu ideals of visual fitness and beauty. Secular art in old India has all but vanished. There are no richly decorated palaces like Versailles in France and Schönbrunn in Vienna. Nearly all the works that survive are religious in expression and intent. Art was not for the sake of individual achievement and recognition. It had a predominantly public function that was mainly spiritual—to make the gods and the cosmos manifest to the senses. The purpose of sculpture, painting, and architecture was to provide gods with recognizable outer forms, which weak devotees needed to move themselves along spiritually, but the emphasis was always on what is meant rather than on what is seen.

There were no art galleries or shops where sculptors and painters might exhibit and sell their work. A sculptor, painter, or architect worked on commission from kings, courtiers, merchants, priests, and other influential people, but mainly from kings, the only people with the resources for major building projects. Architects and sculptors were not self-conscious artists in the modern sense. Rather, they were skilled craftsmen, some undoubtedly with abilities in the realm of genius, who plied a trade within a tradition. Their names have vanished from the historical record.

Craftsmen and builders had at their disposal rulebooks specifying how things were to be done. While there was room for individualized touches, especially in sculptural groups on temples, the degree of latitude was narrow, and certainly no one was free to do as he pleased. A historical analogy might be the European Middle Ages when cathedral building flourished and other arts, like painting and sculpture, were subordinated to architecture. With rare exceptions, the master builders, sculptors, and painters were anonymous, as was the case in India, and they created according to tradition and theological guidelines.

What did "beauty" mean? Indian sculpture and temples were produced according to strict rules and were always associated with religious aims and ritual purification so that physical outcomes would please the gods.[51] Beauty meant the conspicuous presence of ornamentation so deities would feel comfortable taking up "residence" in works of architecture and sculpture. Ornamentation is not merely decorative. A temple built without ornamentation would not invite divine habitation; nor was a sculpted figure worthy of a god or goddess without abundant, skillful decoration. Temple builders avoided empty spaces. Every surface and cranny had to be filled with figures or floral designs so gods would not feel offended by the existence of a void.

The tower of the Rajrani Temple at Bhuvaneshvara, like virtually all Hindu temples and shrines, is heavily ornamented with sculptured figures and motifs (fig. 10.1). Their prevalence conveys the accurate impression that Hindu architecture is overwhelmed by sculptural art and driven by a sculptural ideal applied to architecture to fulfill symbolic purposes.

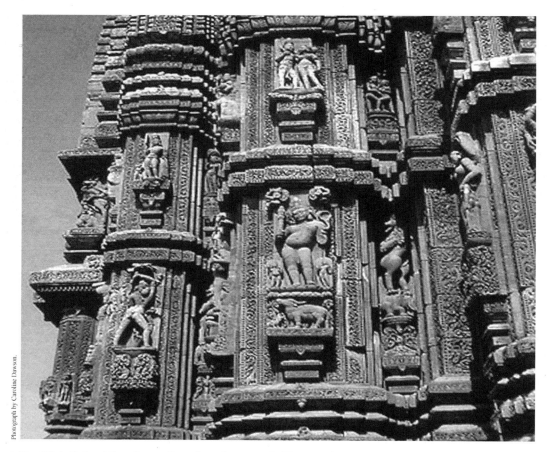

Photograph by Caroline Dawson.

Fig. 10.1 Rajrani Temple, portion of southwest wall, Bhuvaneshvara, 1100 C.E.

Sculpture

Style in sculpture was governed by tradition. Innovation was avoided and frowned upon. For images of men and women, whether gods or mortals, narrow conventions of physical type were followed after the Gupta period. Men have a wide chest and shoulders, a thin waist, smooth, round limbs, a little roll of stomach flesh over a belt or sash, but no anatomical definition of musculature of the sort one sees in Western Renaissance sculpture. Women usually have broad hips, large, firm, spherical breasts, alluding to sexual energy (shakti), a sinuous "three bend" posture, achieved with tilts at the neck, shoulders, and hips, with a slight protrusion in the lower abdomen, and lots of jewelry. Also evident is a pronounced contrapposto in the posture of standing figures—one leg bent, the other straight, indicating the distribution of weight and forces in a free-standing figure, as shown in the wall sculptures of a temple in Khajuraho in the modern-day state of Madhya Pradesh (fig. 10.2).

Since jewelry has magical implications, the more the better. Ganga, the river goddess who dwells in Shiva's hair as his second wife, is loaded with it (fig. 10.3). Gods and

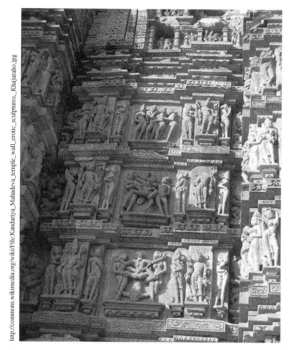

Fig. 10.2 Imagery of the "joining wall," Kandariya Mahadeva Temple, Khajuraho, 1000 C.E.

goddesses have the usual extra heads and multiple arms in various positions, though not always, and hands carry objects to identify them and represent their virtues and powers. Mortal men and women look normal. Goddesses usually wear intricate headdresses, and gods may wear head-pieces as well. Cult figures intended for a sanctuary or shrine tend to be static in appearance compared to more animated, often erotic forms carved on exterior temple walls.

Despite an aura of religious mean-ing and purpose that imbues sculpture, painting, and architecture, most of what one sees does not stress asceticism or withdrawal from the world of sensuous experience, which distinguishes Hindu art sharply from Christian art of the Middle Ages; half naked women in provocative poses are not to be seen on Gothic cathedrals. On Hindu temples, emotions and sentiments like sorrow, unhappiness, despair, and yearn-ing for purely spiritual existence are seldom displayed. The paradox is that India's tradi-tion of art is worldly, sumptuous, and cheerful while serving religious purposes. No doubt craftsmen had detailed instructions, worked from long standing iconographic rules, and endured priestly supervision, but they man-aged somehow to express delight in the world and the flesh rather than a single-minded desire for closure with the Absolute. In the midst of philosophizing about maya (illu-sion) and the tediousness of reincarnation, art expressed unmistakable joy in the pleasures and diversions of life.

One of the most exceptional sculptural figures from the Hindu tradition expresses a love of women and the grace they bring to

Fig. 10.3 Ganga, Goddess of the Ganges, Bengal, twelfth century.

Courtesy of the Archaeological Survey of India, New Delhi.

Fig. 10.4 Nokhas, stone fragment, ca. tenth century.

the world (fig. 10.4). The artist-craftsman is unknown, but he produced a notable work of genius that retains all its power even as a stone fragment. The head is mostly gone and the pose has traditional sources, but the body expresses an appealing softness in its elegant contours and leaves an impression of refined sensuality and irresistible femininity, as well as a reverence for woman as a vessel of fertility and cosmic energy.

Most sculpture was produced to adorn temples or shrines. Cult images were needed for temple sanctuaries. Sculptural forms were also placed at entrances to acknowledge a resident god or to afford protection from evil forces. Architecture never liberated itself from woodworking and sculpture. Façades of cave temples in particular show their indebtedness to forms carved from wood. The option of using stone without embellishment to build designed edifices was never realized. Architecture and sculpture merged as the same craft. There was no use of arch or dome for structural (load-bearing) purposes. The structural system commonly employed was post and lintel, with occasional elegant use of corbelled "arches," in which stones are piled up in an overlapping pattern so they project increasingly outward from the bottom to form the semblance of a vault.

Architecture

Some general features of Indian architectural forms are easily summarized from Ashoka's time to the thirteenth century C.E. Forms were limited to reliquary stupas, rock-cut temples (chaitya, or worship halls) both in cliff sides and in the open with monk's cells (viharas), and freestanding temples in two basic styles—northern and southern. At first temples were built from wood, which was replaced almost everywhere by stone from the end of the Gupta period (600 C.E.). Rock-cut sanctuaries, which betray their debt to wood construction, came mostly to an end and were displaced by freestanding structures.

While wood was respected as a building material for female deities, stone and brick were considered best for male gods, who were thought to prefer its durability and potential for majestic forms. The mature period of temple building from 900 to 1300 C.E. produced the most spectacular structures. Although the repertory of styles was limited, there was considerable regional variation among structures.

Before addressing freestanding forms, the rock-cut Kailasa Temple (eighth century C.E.) in Ellora (south-central India) invites special mention. The monument is a wonder of human industry and artistry, audacious in its conception, and remarkable in its execution, because everything depended on what was removed rather than added. There was no room for error or miscalculation. It illustrates a purely sculptural approach to places of worship, but in the open rather than in an excavated cave. The king who undertook its creation wanted to establish himself as a universal emperor (chakravartin) and believed that having the mountain residence of Shiva in the middle of his kingdom would bear witness to his exalted status. The temple would mark his kingdom as the center of the earth.

The whole ensemble was carved from an imposing cliff of basalt, a tough stone, and slants upward in profile from the entrance to its tower-mountain over the house of the enshrined god (fig. 10.5). However, the carving was done *downward* after trenches had been dug to expose the mass of rock to be shaped. There is a gatehouse leading to a shrine for Shiva's mount, the bull Nandi, flanked by ceremonial columns.

A stairway goes to the upper level and a large meeting area, behind which is the sanctuary that houses a linga. The sanctuary is on a terrace ringed on three sides with small shrines. Rising 95 feet above the floor over the sanctuary is the tower, Shiva's Mt. Kailasa.

The length from end to end is about 290 feet, the width some 170 feet. Around the sides of the temple are additional chapels, niches housing lesser gods, and carved mythological scenes. Elephants, as removers of obstacles, are included freestanding and in relief, and the temple is ornamented everywhere with animals, deities, and other motifs.

Fig. 10.5 Kailasanatha Temple, Ellora, 750–850 C.E.

Nothing in view was "built," yet the sculpting was done with great skill to simulate an edifice constructed from the ground up, with all the familiar architectural features one might expect to see—pilasters, cornices, moldings, and roof-like forms. Transforming such a mass of stone sculpturally into the illusion of a constructed freestanding temple was a stupendous feat of conception, planning, and execution. There is nothing like it in India or the world.

Every phase, task, design issue, and choice of materials in temple building had a religious meaning, traditional expectations, and a mythological background. Beauty was understood as fitness according to those standards. Construction required purification of an appropriate site, development of a floor plan or sacred diagram, called a mandala (usually in a checkerboard pattern with lines running at right angles to one another), and attention to relative proportions of temple parts.

Hindu temples are complex structures with much stylistic variation. Whatever the details of their appearance, however, their functions were similar throughout India. The two major styles, northern and southern, underwent development in size and ornamentation, with the most mature forms appearing between the ninth and thirteenth centuries. The technical vocabulary associated with construction, styles, and iconography is extensive, but it can be summarized.[52] Some acquaintance with this vocabulary is a step toward understanding and deeper appreciation.

The basic structural system was post and lintel. The arch was neglected perhaps because curves are too active and suggestive of movement. The tranquility and humility of flat, static slabs resting on beams was preferred. Quarried blocks of granite or sandstone, the two most common choices of material, were laid one on top of the other with no mortar. The choice of stone would affect problems and outcomes of sculptural work outside the temple. Obviously granite is more durable but tougher to work than sandstone, which invites chiseled refinements. Brick was also used. There was a division of leadership as well as labor in construction. An architect-craftsman would handle issues of design and conformity to tradition, and a supervisor would look after practical matters of assembling materials and guiding a multitude of workmen in their tasks.

A badly proportioned temple would offend the gods, so attention was paid to the mathematics of architectural form. The basic square, divided into smaller squares, was a pantheon of the gods and a frame within which the cosmic man might be fitted with arms and legs drawn up (fig. 10.6). The center of the mandala, the navel, is the sacred spot from which divine energy radiates outward. The temple is a cosmogram that includes a mountain (the tower), a cave (the sanctuary), and a pair of cosmic axes (vertical from tower top to sanctuary and east-to-west from entrance to sanctuary).

Preservation of surviving Indian temples after about 700 C.E. was undertaken by various royal dynasties, such as the Pallavas, Chalukyas, and Cholas in the south, which led to differences in stylistic detail. Whatever their dynastic connections may be, however, temples have shared features whether they are northern or southern in style. Normally they sit on platforms called plinths. There is an entrance set above a stairway; an assembly hall, or intermediate space (mandapa) for worshipers; a sanctuary (garbhagriha) where the god's image or symbol is kept; and a main tower (called a shikara) over the sanctuary, which was viewed as the axis of the universe. At the peak of the northern tower is a cushion, the amalaka, and topping that off, a small vertical finial, a vase of plenty.

Fig. 10.6 The Cosmic Man, mahapurusha, from an ancient architecture manual.

Sometimes other spaces are included along the main axis from entrance to sanctuary, as in the Lingaraja Temple at Bhuvaneshvar (see below).

In earlier centuries the forms were smaller, simpler, less decorated, and towers were not included, the sanctuary usually having a flat roof. From the eighth to the thirteenth centuries, the trend everywhere in temple building was stone rather than wood construction, great size, and profuse sculptural decoration that threatened and often did over-whelm the structure itself. In mature temple forms, the tower symbolizes a sacred mountain, either Kailasa, home of Shiva, or Meru, navel of the universe. In the north, towers are curved; in the south, they are pyramidal in shape. Freestanding temples seldom had a logical or organic relationship to the surrounding landscape; nor did their builders go out of their way to exploit a natural site. The buildings could have been dropped willy-nilly from outer space.

Three famous temples illustrate the northern style and suggest its variety—the Khan-dariya Mahadeva Temple at Khajuraho, the Lingaraja Temple at Bhuvaneshvar, and the Surya (sun god) Temple, also called the Black Pagoda, at Konarak (fig. 10.7). Aside from stylistic differences, the temples have basic, shared components. The Khandariya Mahadeva temple in north-central India, built about 1000 C.E., is perhaps the finest ex-ample of the medieval Hindu style out of some twenty-five surviving structures. It sits on a platform, has an entrance at the top of a steep staircase, and has one large meeting hall roofed by a succession of smaller towers leading the eye upward to the main tower over the sanctuary. The three main divisions of entrance, assembly hall (two smaller mandapas precede it), and sanctuary for the image with the vertical axis of the tower extending from the top down to the shrine can be seen in the temple profile (fig. 10.8). The sanctuary provides space for worshipers to circle the god's image.

The central tower curves along its entire length and is echoed by subsidiary half- and quarter-sized towers on its flanks, magnifying the upward thrust and conveying the impression of a mountain surrounded by smaller peaks. The temple face is elaborately ornamented, the standard of beauty derived from magical properties of jewelry, and the expectation that gods would refuse to inhabit temples with unadorned exterior spaces.

While surfaces are covered with sculpture and other motifs, the forms have no back-grounds or planes to separate one figure, or row of figures, from another to create spatial relationships, a convention visible on the shikara of the Khandariya temple, which includes figures in erotic poses or engaged in explicit sexual activity. The source of this eroticism on

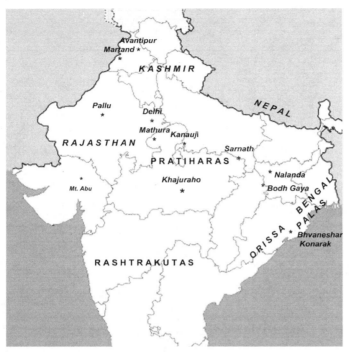

Fig. 10.7 Map of India.

a sacred building is the belief that the universe is pervaded by sexual energy (shakti) that gives it life and motion. This view was associated often with the Mother Goddess and a Buddhist Tantric sect for which sex was part of the ritual, but also with Shiva, who is commonly represented as a linga. Nothing amiss was seen in displaying this life force at work in gods and humans. The simplest explanation is that copulating men and women were a prevision of the rewards awaiting the faithful, a form of yoga providing "delight" is religion.

At Bhuvaneshvar, on the east coast of India (fig. 10.7), the Lingaraja Temple dedicated to Shiva is more elaborate but with all the usual symbolism. In addition to the temple proper, there are smaller shrines in the precinct that imitate the larger sanctuary. The main structure is a long sequence of four halls after the entrance—one for offerings, a second for celebratory dancing, a third for worshipers to assemble, and a fourth for the sanctuary, which contains a linga (figs. 10.9, 10.10). The impressive tower over the sanctuary starts curving sharply a third of the way up and terminates in a large, ribbed-stone disc like a mushroom cap at the top derived from a fruit believed to have healing powers, which is crowned with a "vessel of plenty" finial. The upward thrust of the tower is magnified by narrow but deep vertical openings that contrast with horizontal in-

dentations. Sculptural groups also have a place on the tower, but not as lavishly as on the Khandariya Mahadeva Temple (fig. 10.8).

The Temple of the Sun at Konarak, also on India's east coast near Bhuvaneshvar, was at one time among the largest in India before its physical decline, which included the collapse of its tower, originally some 200 feet high. It differs from other temples in the north by originally having two shrines and other build-

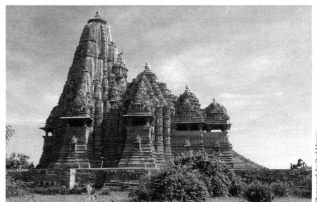

Fig. 10.8 Khandariya Mahadeva Temple, Khajuraho, ca. 1000 C.E.

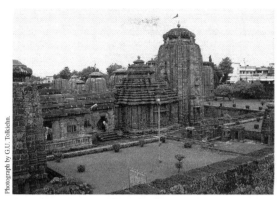

Fig. 10.9 Lingaraja Temple, Bhuvaneshvara, 1000 C.E. Temple.

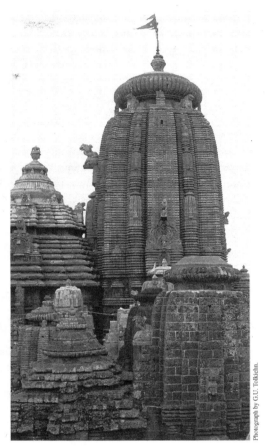

ings separated from the main assembly hall (mandapa) and its tower in a spacious walled precinct with three gateways. All that remains is the assembly hall, flanked by rubble from the collapsed tower (fig. 10.11). A number of dramatically executed protective sculptural groups are in the courtyard, including a mythical beast trampling an elephant. The assembly hall, and previously the tower, rests on a high platform that simulates a chariot with twelve ornamented wheels, a spectacular vehicle to carry Surya, the sun god, across the sky (fig. 10.12). The assembly hall exterior still displays erotic sculpture promising delights to occupants of the sun god's realm.

Fig. 10.10 Lingaraja Temple shikara.

For changes and development in style, the south offers a more continuous sequence of temples, because Muslim assaults on Hindu shrines after the ninth century did not affect the south as catastrophically as the north. A dramatic example of the southern style is the Rajarejesvara Temple at Tanjore, about 1000 C.E., named after a Chola king. It sits in a

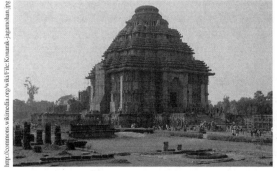

Fig. 10.11 Temple of the Sun, Konarak, thirteenth century.

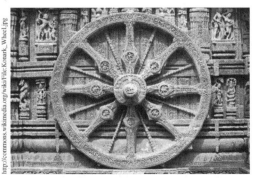

Fig. 10.12 Temple of the Sun Chariot Wheel.

large precinct with a number of minor shrines. The entrance is imposing, and the approach affords a fine view of the tower (fig. 10.13). The sanctuary walls are in two stories, divided by an eave, with the image of Shiva housed in the second story and the tower providing the usual symbolism of an axis mundi intersecting with the shrine. Many recesses and projections separated by pilasters to accommodate deepset sculptures are visible.

The tower, with its typical southern pyramidal shape, rises 216 feet, tapers gracefully, and is capped with an enormous, bulbous amalaka and water pot. Raising the huge amalaka to its position on the tower was a feat of engineering for the builders. In a profile of the temple, (also visiable from the frontal view) is a notable feature of the long, low-lying, flat assembly hall. Sculptural extravagance to please the god is visible throughout. Organized along the east-west axis are several structures in addition to

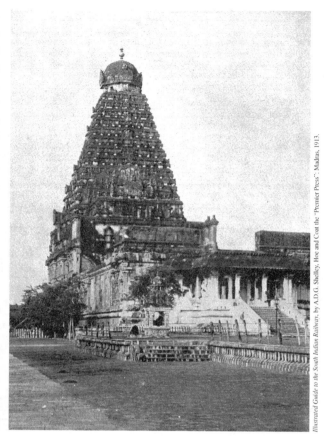

Illustrated Guide to the South Indian Railway, by A.D.G. Shelley, Hoe and Coat the "Premier Press", Madras, 1913.

Fig. 10.13 Rajarajesvara Temple from the front, Tanjore, early eleventh century.

the mandapa that include a hall with pillars and a Nandi (Shiva's bull mount) pavilion in addition to the assembly hall and sanctuary.

Temples in Indian Life

Temples everywhere were centers of community, cultural, and economic life. Priests had considerable influence. Donations and royal grants endowed prominent temples with substantial wealth. Apart from rituals, prayers, and other activities going on from morning until night (there were at least four major ceremonies daily) in and around the temple proper, the precinct might house a school and a hospital and host festivals. Music, dance, and recitations of popular literature like the epics would take place in the temple meeting hall. The arts were sustained and promoted by temple patronage of sculptors, painters, and architect-craftsmen.

People from different walks of life were employed, mostly part time, for wages and access to land—up to 600 or so according to a temple inscription from the early eleventh century. Among the service people listed were musicians, dancers, jewelers, carpenters, accountants, stonemasons, ceramicists, astrologers, lamplighters, and parasol carriers. For

centuries, temples throughout India provided or supplemented the livelihood of untold millions, in addition to seeing to their religious needs and thirst for beauty. In the modern world, that continues to be the case as India struggles to modernize.

Surviving temple architecture and sculpture in India continue as part of a living tradition alongside jet planes, computers, and nuclear weapons. With few exceptions, Hindus, many of whom use cell phones, watch television, travel by rail, and surf the Internet, still believe fervently in karma and reincarnation and observe ancient domestic or public rituals to honor an army of gods, goddesses, and other mythical or historical beings. Temples and shrines have no lack of worshipers. Physical marks of a remote past are visible everywhere and retain their grasp on minds and hearts, intertwined with a hierarchy of beliefs and practices that range from the simplest animism to the loftiest philosophical conceptions of ultimate reality and its meaning for human life.

Notes

1. Ainslie T. Embree, *Sources of Indian Tradition*, vol. 1, 2nd ed. (New York: Columbia University Press, 1988), 244.

2. Sarvepalli Radhakrishnan and Charles A. Moore (eds.), *A Source Book in Indian Philosophy* (Princeton University Press, 1957), 179.

3. Embree, *Sources of Indian Tradition*, 218.

4. For an account of Jain-Buddhist cosmology in its mature form, see Joseph Campbell, *The Masks of God*, vol. 2, *Oriental Mythology* (New York: Viking Press, 1962), 219–224. The account here is taken from Heinrich Zimmer, *Myths and Symbols in Indian Art and Civilization,* edited by Joseph Campbell (Princeton University Press, 1972), 13–19. For original Jaina notions of chronology, see Jack Finegan, *The Archeology of World Religions: The Background of Primitivism, Zoroastrianism, Hinduism, and Jainism* (Princeton University Press, 1952), pp. 203–205.

5. These passages are taken from *Kalidasa: Shakuntala and Other Writings*, trans. and introduction by Arthur W. Ryder (New York: E.P. Dutton, 1959), 44, 57, 71, 81. The emphasis is mine.

6. Radhakrishnan and Moore, *Source Book*, 189–190.

7. Ibid., 173.

8. Ibid., 199.

9. Ibid., 198.

10. Ibid., 135.

11. Ibid., 107–108.

12. Ibid., 108–109.

13. Embree, *Sources of Indian Tradition*, 323.

14. Ibid., 324.

15. For introductory material on the six systems, with ample selections in readable translations, see Radhakrishnan and Moore, *Source Book*, 49 passim.

16. Radhakrishnan and Moore, *Source Book*, 439.

17. Ibid., 459.

18. Guenon argues that dualistic interpretations of purusha and prakriti are misreads, although most writers on Indian thought take it that way. I defer to the majority view, but Guenon's dissent is worth noting as an example of how thorny the interpretation of Sanskrit texts can be. See Rene Guenon, *Man and His Becoming According to the Vedanta,* trans. Richard Nicholson (New York: Noonday Press, 1958), 48–52.

19. Radhakrishnan and Moore, *Source Book*, 393.

20. Ibid., 359.

21. Shankara, *Crest-Jewel of Discrimination*, trans. and introduction by Swami Prabhavananda and Christopher Isherwood (Hollywood, CA: Vedanta Press, 1947), 40.

22. Ibid., 41.

23. Ibid., 49.

24. Ibid., 113.

25. Ibid., 69.

26. Ibid., 47.

27. Ibid., 116.

28. Ibid., 129.

29. Ibid., 121–122.

30. Ibid., 235.

31. Embree, *Sources of Indian Tradition*, 9, 11, 12.

32. Ibid., 21.

33. The most important texts were translated from Sanskrit by Robert Ernest Hume, *The Thirteen Principal Upanishads*, 2nd ed. rev. (New York: Oxford University Press, 1931).

34. Embree, *Sources of Indian Tradition*, 31.

35. Quoted in Zimmer, *Philosophies of India*, 377.

36. Embree, *Sources of Indian Tradition*, 37.

37. For a deeper discussion of the Noble Truths and the Eightfold Path, see Donald W. Mitchell, *Buddhism: Introducing the Buddhist Experience* (Oxford University Press, 2002), 45–62.

38. Radhakrishnan and Moore, *Source Book*, 277–278.

39. Embree, *Sources of Indian Tradition*, 113.

40. Ibid., 112.

41. Scholars have been arguing about the earliest appearance of Buddha images for a long time without reaching a definitive conclusion. See Robert E. Fisher, *Buddhist Art and Architecture* (New York: Thames and Hudson, 1993), 42.

42. Meher McArthur, *Reading Buddhist Art: An Illustrated Guide to Buddhist Signs and Symbols* (London: Thames and Hudson, 2002), 95, 119.

43. Embree, *Sources of Indian Tradition*, 177. On Mahayana schools of thought and their subtleties, see Mitchell *Buddhism*, 130–145. Doctrinal disputes, always benign, are discussed in Edward Conze, *Buddhist Thought in India: Three Phases of Buddhist Philosophy* (Ann Arbor: University of Michigan Press, 1967), chapter 2.

44. Embree, *Sources of Indian Tradition*, 222.

45. Ibid., 294–295.

46. Ibid., 296.

47. The ten incarnations of Vishnu are discussed in detail by T. Richard Blurton in *Hindu Art* (Cambridge, MA: Harvard University Press, 1993), 118–147.

48. Zimmer, *Myths and Symbols in Indian Art and Civilization*, 152–155.

49. Joseph Campbell's writings are an example of explaining myths as archetypes. See *The Mythic Image* (Princeton University Press, 1974), passim.

50. Henri Frankfort, et al., *Before Philosophy: The Intellectual Adventure of Ancient Man* (New York: Pelican Books, 1949), 19 ff.

51. Heinrich Zimmer, *The Art of Indian Asia: Its Mythology and Transformations*, completed and edited by Joseph Campbell (Princeton University Press, 1955 I: 318. Coomaraswamy, historian and connoisseur, stresses the importance of aesthetic intuition and perception aroused in a "competent" audience by an artist's vision expressed in a work of art that points beyond itself to a transcendental reality. See "That Beauty Is a State," in Ananda K. Coomaraswamy, *The Dance of Shiva: On Indian Art and Culture* (New York: The Noonday Press, 1957), 44–53.

52. Stylistic types, regional variations, royal patronage, and temple vocabulary are addressed in George Michell, *Hindu Art and Architecture* (New York: Thames and Hudson, 2000), chapters 2, 3, 4, which cover the period from the second century B.C.E. to the thirteenth C.E. For additional detail, see Michell's *The Hindu Temple* (University of Chicago Press, 1977), which contains more than any nonexpert might want to know.

PART III
CHINA

11
China's Historical Foundation

Chinese civilization is an immense subject about which thousands of volumes have been written in many languages. All we will do here is indicate and comment on some major landmark features. By the time China was unified in 221 B.C.E., a number of these features were in place; others came later. Before offering more detail, here is an overview of the historical landscape:

- *Geographical factors* (intensive farming, physical isolation, self-sufficiency).
- *Dynastic structure* (dynastic cycle)
- *Economic theory and practice* (pro-agriculture, anti-commercial).
- *Self-image* ("All Under Heaven" and "Middle Kingdom").
- *Stability of key elements* (family, economy, language, and social structure).
- *Imperial political system* (bureaucracy selected by examination).
- *Role of the past* (change only within tradition and pride in culture).
- *Political theory* (Mandate of Heaven, Son of Heaven, rule morally justified).
- *Cosmology and religion* (Yin-Yang, Five Elements, divination, sacrifice, ancestor worship).
- *Confucian ideology* (moral government, nonhereditary bureaucracy selected on merit).
- *Theory of international relations* (tribute system)

Chinese civilization has a continuous record of some 3,500 years extending from the remote past into the present, which, along with the civilization of India, is one of the longest, relatively unbroken spans in world history. The task of the historian is to under-

stand and explain such extraordinary longevity. Compared to India, the history of China has a better-documented and unusual record of continuity reflected in institutions, ideas, and art. The reasons are not hard to find. What follows is an attempt to summarize them within the framework of the dynastic system, geographical circumstances, the village economy, the written language, the Confucian trained "scholar-gentry," and attitudes toward foreigners.

The Land

As the most advanced culture of East Asia, China was isolated from most of the rest of the world until the early nineteenth century. To the east is the Pacific Ocean, with Korea and Japan not far off. To the west is the Tibetan Plateau, with the highest mountains in the world, and Central Asia, home of various nomads who frequently invaded China proper. To the northwest are Mongolia and Manchuria with their deserts and mountains. To the south are the dense, inhospitable jungles of North Vietnam, which have swallowed whole armies in the past (see fig. 1.1). Curious and intrepid visitors found their way to China by land and sea, but with no effect on the civilization. The position of China in East Asia made it the dominant cultural force.

With few exceptions surrounding peoples acknowledged the superiority of Chinese civilization—Koreans, Japanese, Mongols, Manchus, Vietnamese—and even those who succeeded in conquering the great empire. Once a conquest was accomplished, the conquerors eventually adopted the Chinese language, institutions, ideas, material culture, and ways of life. This unquestioned cultural hegemony prompted the Chinese to call their land the Middle Kingdom (chung kuo / zhong guo) and All Under Heaven (t'ien hsia / tian xia). Isolation and cultural dominance meant that China was free to develop institutions and ideas with only sporadic outside interference for more than 2,000 years. The only serious influx of non-Chinese ideas was Buddhism in the second and third centuries C.E. For the most part, borders were secure against alien ways, and when they were breached, people who did so were likely to be absorbed and largely assimilated.

Climate and topography contributed to the great endurance of Chinese culture. Both were varied—dry in the north and wet in the south, a result of China being part of monsoon Asia; China is also endowed with mountains, forests, plains, lakes, deserts, and rivers, and many legendary places of great beauty that inspired poets and painters. Two major river systems thread across China, the Yellow River (Huang ho / Huang he) in the north and the Yangtze (Yangzi) in the south, both with headwaters in the Tibetan highlands. Food was abundant when the economy was well managed. Wheat, millet, and barley were grown in the north, rice in the south. There are good harbors along the southern coast for coastal trade. In the traditional period, there was an abundance of resources—plants, animals, soils, fish, minerals, and so on. As an agricultural civilization, China was self-sufficient and wanted little from the outside world.

Dynastic System

The period before 221 B.C.E. was predynastic, a long era noted for the gestation of cosmology and philosophy, while a number of independent states within China fought and

competed for survival and dominance. The period after 221 B.C.E. was when the brutal state of Ch'in (Qin), whence came the name "China," defeated rival states and unified the country and inaugurated the imperial phase of Chinese history. Except for a 400-year interruption after the Han dynasty collapsed, the imperial system continued until 1911, when the last of some twenty-six dynasties met its end. The long time line from about 1700 B.C.E. to 221 C.E. indicates that China already had a long, eventful history before unification. With one above-mentioned period of disunity, the dynastic era spanned two millennia, and from the T'ang (Tang) dynasty on, the ideas and institutions of Chinese civilization interlocked to achieve remarkable stability, interrupted only by periodic changes of dynasty, including three "barbarian" dynasties: the Jurchen Northern Sung (Song), the Mongol Yuan, and the Manchu Ch'ing (Qing).

China's unification was guided by a philosophy called Legalism (fa-chia / fajia), a form of psychological realism that argued for the intrinsic evil of human nature, which justified absolute authority of a ruler backed up with strict laws enforced by harsh punishments. A regime governed by laws and the ruler's point of view was expected to result in an effortless succession of emperors. Two vivid symbols of this first dynasty have survived. A terra cotta army of thousands was buried near the First Emperor's (Ch'in-shih huang-ti / Qinshi huangdi) tomb in Sian. The life-size soldiers, uniformed and armed with excellent bronze weapons, supported by chariots and their horses, have individual faces and hairstyles. The army that unified China was reproduced in clay (figs. 11.1, 11.2). The second symbol is the immense defensive wall in the north that the First Emperor created by splicing together walls built by the states he conquered (fig. 11.3). The influence of Legalism continued after the Ch'in dynasty collapsed owing to its harshness and excesses. Thereafter China was always a despotism softened by an overlay of Confucian ideas about virtue and service to the people. Since Legalism had no effect on art, we shall not give it equal space with Taoism, Confucianism, and Buddhism.[1]

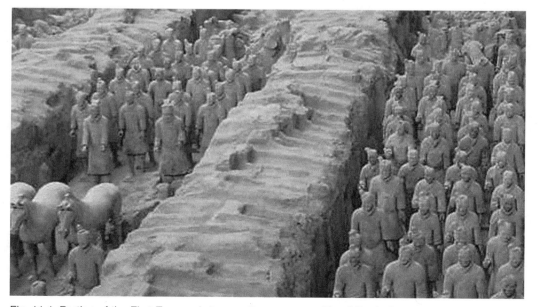

Fig. 11.1 Portion of the First Emperor's terra cotta army, near Sian (Xi'an), Ch'in dynasty.

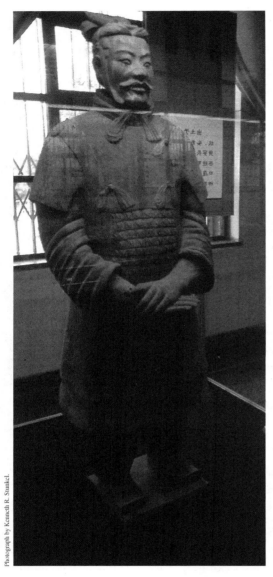

Fig. 11.2 Infantry officer from the terra cotta army.

The dynasty was the basic unit of China's traditional past. Altogether there were twenty-six of them. Their succession through time was explained and justified by moral ideas like the Mandate of Heaven. So entrenched was dynastic thinking in Chinese history that when a dynasty fell to be replaced with another, the succeeding dynasty would go to work compiling a history of its predecessor. Consequently, there are twenty-four dynastic histories running to hundreds of volumes, making the Chinese, along with the West, one the world's notably historical-minded civilizations.

After 221 B.C.E. China was an empire ruled by an emperor with great powers, but also with moral responsibilities defined by Confucianism and other ideas. In its mature form, the governing doctrine was that an emperor is the "Son of Heaven" (t'ien- tzu/ tianzi) who rules over "All under Heaven." Each ruler and dynasty was legitimized by a "Mandate of Heaven." The mandate bore the condition that the emperor would rule virtuously and provide benevolent government. To the extent that he met that responsibility, heaven, man, and earth—the cosmic triad—would be harmonized. Peace, justice, and prosperity would prevail.

The emperor was not alone in his duties. He was assisted by a bureaucracy whose officeholders were chosen by examinations based on the Confucian classics to be sure they possessed culture and moral excellence. Part of the emperor's job was to set an example for everyone. Part of a high-ranking bureaucrat's job was to remonstrate with an emperor whose behavior fell short of wisdom and benevolence, a necessary but potentially dangerous and even fatal initiative for the official. Although in principle absolute, emperors did not always fare well at court. In the second half of the nineteenth century, the young Kuang-hsu (Guangxu) emperor defied the authority of his mother, Tz'u-hsi (Cixi), who was regent and empress dowager. She imprisoned him on an island in the imperial gardens, where he had no choice but to pine away, stripped of power and mobility.

In Chinese tradition, it was believed that Heaven would deliver signs, or portents, if imperial rule became corrupted. The portents, or "warnings," might range from floods,

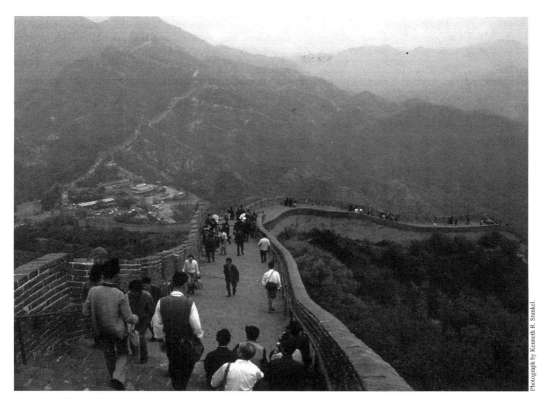

Fig. 11.3 Great Wall at Badaling.

droughts, and epidemics to rebellions and invasion. Celestial phenomena like comets and meteor showers were also taken as signs that all was not well in the capital. Some historians have argued there was a pattern of vigor, decline, and collapse—the so-called "dynastic cycle." At the beginning of a dynasty when it was fresh, the bureaucracy was lean and relatively honest. Land was redistributed to dispossessed peasants to increase the empire's tax base, but the tax burden placed on them was relatively low. Emperors were generally conscientious about their duties and provided decent leadership.

As a dynasty wore on, however, the bureaucracy became bloated and greedy. Taxes on peasants reached the breaking point as officials enriched themselves without restraint. Scheming, unprincipled eunuchs looking after the emperor's women usurped the authority of officials, sought to discredit or even assassinate the good ones, and made arbitrary state decisions. Emperors became insulated from the needs of the empire owing to pleasure seeking and court intrigues. Falling revenues, mismanagement at all levels, and indifferent, self-seeking power-holders resulted in confused leadership, military weakness, a breakdown of infrastructure (roads, canals, walls), uprisings of desperate peasants, and eventual vulnerability to warlike nomads north of the Great Wall eager to plunder China's riches. Challenged from within and without, in due time a dynasty staggered and fell, usually with violence and great loss of life. The mandate then passed to a new dynasty and the cycle started over again. Helping to stitch the dynastic system together, this body of ideas about historical change justified and explained imperial unity.

Village Economy

Unity and continuity in Chinese civilization was tied to the land, which influenced the emergence and development of ideas about man, nature, and society. The economic foundation of society throughout China's history was agricultural production and landownership. The basic unit of production and labor was the village. Most Chinese were illiterate and lived in the countryside on thousands of small farms, a few acres each at most, where they raised crops by intensive hand-cultivation more like gardening than farming. Their labors were the ultimate source of wealth, which was codified in the class system and in Confucian doctrine. Since commerce, industry, and associated financial institutions were tightly managed or actively discouraged in favor of agriculture, economic problems revolved around the distribution of wealth rather than its production.

While peasants ranked high on the social scale, second only to the scholar-gentry, their lot was in fact hard, insecure, and often intolerable. Taxation might be bearable at some stages of a dynasty in the hands of reasonable bureaucrats, but at other times the burden would escalate, with greedy collectors driving families to despair. Meantime, in the off-season, peasants were subject to forced labor on roads, canals, walls, and other building projects. It was rare for a peasant to escape the trials and burdens of his fate. For women, the situation was often worse because they had to endure successive childbirths without much in the way of amenities. It was the job of imperial magistrates and local scholar-gentry to keep the situation under control with occasional tax relief, food distribution from government storehouses, and fair administration of justice.

Language

well said
succinct

The written language was a major factor that held China together politically and preserved cultural stability through time. The concreteness of the language and the way it is written had a profound influence on thought and art. The main point is that spoken and written Chinese must be understood separately (until the late twentieth century, there was no Chinese alphabet that represented spoken sounds). A Chinese written document can be understood by people speaking two mutually unintelligible dialects. There are many dialects, the two main ones being Mandarin in the north and Cantonese in the south. Mandarin made its appearance as the official language of the empire with the advent of the Ch'ing (Qing) dynasty in 1644.

In simplified terms, spoken Chinese tends to be monosyllabic; that is, the number of sounds available to talk about things is more limited than in other languages.[2] This problem was overcome by using a tonal system to stretch the meanings of one sound. In the four monosyllabic examples shown in Figure 11.4 (*yī, reń, tŭ, and dà* in pinyin), a different tonal indicator results in a different spoken meaning, or in at least four possibilities of primary meaning for each of the syllables. In further illustration, the syllable *ma* means "mother" in the first position, "hemp" in the second, "horse" in the third, and "to scold or curse" in the fourth, and all four are written with a different character. Even characters with the same sound and tone could have different meanings.

The writing system consists of ideographs, which are drawn rather than "written" as one might write a word in an alphabetic language. Ideographs descend originally from

Fig. 11.4

high, rising, dipping, falling

The Chinese Language For Beginners by Lee Cooper, Tuttle Publishing, a member of the Periplus Publishing Group.

— high (example: *yī*)
／ rising (example: *reń*)
⌣ dipping (example: *tǔ*)
＼ falling (example: *dà*)

Fig. 11.5 Ancient pictographs that became ideographs.

oracle bone jiaguwen	greater seal dazhuan	lesser seal xiaozhuan	clerkly script lishu	standard script kaishu	running script xingshu	cursive script caoshu	modern simplified jiantizi
shān (*srān) mountain							
rì (*nit) sun							
yuè (*ŋot) moon							

Created by Lawrence Lo.

straightforward pictures, or pictographs, which originated in the early Shang period more than 3,000 years ago. Over time, the pictographs became more stylized and abstract, but the resulting ideographs often retained a rough similarity to earlier forms (fig. 11.5). Each ideograph, or character, will fit neatly within a square, and the text was read from top to bottom, right to left (fig. 11.6), although this changed to left to right, line by line from the top in the mid-twentieth century. The direction of reading was convenient because strokes making up a character are made from top to bottom. The elegant calligraphy is that of Ou-yang Hsun (Ouyang Xun), a T'ang dynasty scholar-official.

Strokes making up a character are drawn with a stylus or brush dipped in ink (now usually written with pen or pencil) on bamboo, silk, or paper, and sometimes engraved on stone or bronze. All the strokes, from one to twenty-seven, must be drawn in a definite order; otherwise, the character will not look right. Although phonetic values are assigned to characters, they are not in themselves phonetic symbols like the twenty-six letters of the English alphabet. Meaning is communicated visually and goes directly to the brain.

In written Chinese there was no capitalization, punctuation, or inflection (plural or singular, past, present, future, or conditional tenses, although it is now punctuated). Much grammatical detail has to be supplied by the context in which a character appears. In a simplistic example, the two characters in Figure 11.7 can mean "the man is big." A definite article and verb must be inserted. It can also mean, however, the man was big, the man will be big, or the man could be big. Notice all the words that must be added to make a good English sentence. Moreover, most characters have secondary or even tertiary meanings, which have to be assessed within context, which makes translation into another language always problematic. Clues for meaning are the context in which a character appears.

Fig. 11.6 Fig. 11.7

For a short poem by Li Ho (Li He), a leading T'ang dynasty poet, a literal translation obviously will not do (fig. 11.8). The translator must supply words and decide on an overall choice and their order in a way that conveys meaning and a poetic effect with the power to ignite a reader's imagination. A.C. Graham has accomplished this intricate task with skill and perception, summoning in words an impression of distance experienced by the poet while he stood on the Great Wall.[3]

Some 49,000 characters are listed in the eighteenth century *K'ang Hsi Dictionary.* Reading a newspaper takes knowledge of about 2,000 to 3,000 characters. A scholar might need up to 10,000 to 15,000. Success in the imperial examinations and reputation as a scholar clearly demanded a superior memory. But, knowing thousands of characters, along with their multiple meanings and the stroke order for each one, was not enough. The traditionally educated man, and occasional woman, also needed an extensive knowledge of literature. All traditional Chinese literature is extremely allusive; that is, works of history, poetry, philosophy, or correspondence make reference to poems, stories, events, and people in other works. The richness of an author's store of allusions gave a work of literature its claim to merit. Bare bones communication even in a letter was not advisable. Even when uttering an official greeting one might quote a poem from the second and first century B.C.E. *Book of Songs* (Shih-ching / Shi jing)*,* and expect an appropriate quotation in return. The allure of Chinese writing was such that even trivial communications relied

Fig. 11.8

HU	CHIAO	YIN	PEI	FENG
Tartar	horn	tug	North	wind,

CHI	MEN	PAI	YU	SHUI (rhyme)
Thistle	Gate	white(r)	than	water.

T'IEN	HAN	CH'ING-HAI	TAO	
Sky	hold-in-mouth	Kokonor	road,	

CH'ENG	T'OU	YUEH	CH'IEN	LI (rhyme)
Wall	top	moon	thousand	mile.

A Tartar horn tugs at the North wind,
Thistle Gate shines whiter than the stream.
The sky swallows the road to Kokonor:
On the Great Wall, a thousand miles of moonlight.

on literary knowledge. In a literate family, a son making a request of a father would write it down, and the father would respond in kind.

The writing system has shaped Chinese civilization in three ways. The first lies in how meanings are conveyed. People speaking mutually unintelligible dialects can look at the same written text and derive much the same meaning. The written language was therefore like mortar between bricks, holding together groups of people speaking various dialects across expanses of time and space. Wherever officials were serving in the vast empire, they read common meanings from official documents, messages, and literary texts. Whenever anyone learned to read and write, whatever their dialect, the characters were shared ground. The written language is a major explanation for China's long tenure as a civilization.

The second issue is that mastering the characters and the literature written in them was difficult and time consuming. The years of effort needed meant that people without resources were mostly out of luck. Writing became the key to political power and advancement through the imperial examination system that reached maturity in the Sung dynasty. The bureaucratic ruling class of China, the scholar-officials or mandarins, and the scholar-gentry or literati (shen-shih or shenshi) shared the same worldview because they read the same books and communicated in characters drawn with a brush. With a monopoly on the written language and its literature, they perpetuated themselves at the center of power for centuries. The mystique of Chinese writing and reverence for ancient texts consolidated ideas by which the structure and workings of the universe were understood and applied to human affairs.

A third significance of writing involved art. Writing Chinese characters is actually a form of drawing easily transferable to painting. Calligraphy, the forming of characters with an inked brush, was an art form parallel to painting, and many literati practiced both as amateurs. Skillful calligraphy was a necessary condition for making it through the imperial examinations. What one said in a document was often less important than

the quality of the brushwork, which could be appreciated on its own merits. Beyond the play of aesthetics, how characters were formed came to be seen as a clue to the mind and spirit of the man wielding the brush.

Scholar-Gentry/Literati (*shen-shih / shenshi*)

For some 1,500 years the ruling class of China consisted of men who had mastered the written language and Confucian literature sufficiently to qualify for the imperial examinations. This group must be understood because it was the main repository of ideas and the source of much pictorial art in imperial China. Its privileged members shared the distinction of being literati, men who had succeeded at one level or another in the imperial examinations; they were all scholars. The other side of privilege was significant ownership of land. If all were not gentry in that sense, they aspired to be so.

Wealth, in the form of land, was usually a necessary condition for the extended leisure needed to prepare for examinations, unless a talented young man without resources was fortunate enough to attract support from a wealthy patron. Gentry who took and passed the district test did not necessarily move on to the next two stages, and few ever became imperial officials. A minority in government employment had succeeded at the highest level of the examinations and usually served a few years before returning to their estates with greater wealth and prestige.

The imperial bureaucracy staffed by these men was the main instrument of power in traditional China, which was in every respect a bureaucratic state. Unlike many bureaucracies in history, however, the Chinese version was not a faceless, impersonal hierarchy of offices and regulations; nor was it an ideal or end in itself. Personal administration was more important than mere efficiency, and there was much looseness in the actual practice of management. The ideal was government by virtuous men motivated by ethical obligation, not detached officers following a manual of rules, which was characteristic of the "rational" type of bureaucracy developed in Western civilization.[4]

Although the state supported some education by Ming times, there were few public schools, so study was usually at home with tutors or at special schools supported by local gentry. The main institution of higher learning was the Hanlin Academy (Board of Academicians) in Peking (which was the capital during the Ming and Qing dynasties, for several years during the Republican period, and, starting in 1949, the capital of the People's Republic of China) staffed by leading scholars. The Academy protected, interpreted, transmitted, and enforced the Confucian tradition. The imperial examinations were held every three years from the Sung dynasty on at the district, prefectural, and metropolitan levels. Success at the district level resulted in the hsiu-ts'ai (xiucai), or flowering talent, degree, which admitted an individual to the scholar-gentry class and provided access to the prefectural examination. With success at the prefectural level, the degree awarded was chu-jen (zhujen), or recommended man, which opened the door to some minor offices and eligibility for the next level. At the metropolitan level, a successful candidate became chin-shih (jinshi), or presented scholar, which qualified him for major posts in the imperial bureaucracy. The top ten candidates in the metropolitan examination were ranked by the emperor with his vermilion brush, and earned highest preference for influential posts.

At each level, for three days, candidates wrote highly structured essays, the notorious Eight-Legged (eight-paragraphed) Essay, on questions and issues provided mostly on the canon of the thirteen Confucian classics. Judgment was based on knowledge of the Five Classics, Four Books, and Chu Hsi's (Zhu Xi) commentaries; diction or choice of words; use of rhyme; poetic expression; and calligraphy. Failure to measure up on all counts meant failure to achieve status as a shen-shih (shenshi) and denial of access to the higher examinations. The system was the preeminent road to power and reputation. Getting there was not easy.

An accomplished Ming dynasty poet, scholar, and artist, Wen Ching-ming (Wen Jing-ming), who died in 1559, took the second-level examination ten times without success. He was finally given an honorary but insignificant post at age fifty-two, and within three years was forced out by envious colleagues.[5] On the whole, outside the royal family, there was no other doorway to official preferment. Occasional degrees could be purchased or awarded as favors, but their inferior status was always indicated and known.

The contribution of this system to China's longevity was a highly institutionalized bureaucratic state rationalized by Confucian ideas. Those ideas defined the literati, or scholar-gentry. They read the same books, shared the same worldview, and regarded themselves as stewards of the cultural heritage. They had the same privileged social position, which meant distinctive dress as well as immunity from lawsuits, taxes, corporal punishment, and manual labor. They shared the same aesthetic outlook. The mark of a "true man," apart from the moral qualifications of the chun-tzu (zhunzi), the Confucian "superior man," was skill in calligraphy, poetry, and painting, the Three Absolutes, or Three Impossibles (san chueh / san jue). Mastery of the written language, literary education, and refined taste in calligraphy and painting set the literati apart from everyone else.

The Confucian idealist Mencius (Mengzi), several hundred years B.C.E., spelled out the fateful distinction before China was unified: "Some labor with their minds and some labor with their strength. Those who labor with their minds govern others; those who labor with their strength are governed by others. Those who are governed by others support them; those who govern them are supported by them. This is a universal principle . . ."[6] This dualism persisted until the last dynasty fell in 1911.

Foreigners and the Tribute System

China's relative geographical isolation and the conviction that of all cultures under Heaven China was superior, resulted in a suspicion of outsiders, an ethnocentrism that was institutionalized as a tribute system as part of foreign relations. Foreigners were welcomed in China—Muslims, Jews, and Nestorian Christians were allowed to settle—but only with restrictions and under surveillance. The general idea was that China admitted foreigners on sufferance and not out of necessity. Most outsiders came bearing tribute to acknowledge the emperor as Son of Heaven. They were granted an audience with the emperor, performed a ritual kowtow (nine kneelings and three prostrations), received gifts in return, frequently richer than the ones they brought, and made their way home.

There was no suggestion of equality between tribute bearers and the Chinese. Outsiders were considered "barbarians," a designation that indicated cultural inferiority. Cultural mixing occurred, but there was nothing in traditional China like the Western ideology

of "multiculturalism," which to the Chinese would have seemed debased and suicidal. The gap between a barbarian and a Chinese was closed to the extent that Chinese culture was adopted and absorbed. Otherwise, foreigners were under quarantine, whether living in China or just passing through. The effect was to discourage and dilute foreign influences, with the notable exception of Buddhist art forms and Buddhism in general, thus reinforcing China's stability and continuity as a civilization.

Tributary states, which included Burma, Siam, Korea, Vietnam, and Japan, acknowledged the preeminence of Chinese civilization under the Son of Heaven by sending tribute missions. The nomadic Manchus, who conquered China in 1644, had been classified as barbarians. Subsequently they became "Chinese" despite strenuous efforts to distinguish themselves from their subjects, for example, by requiring Chinese to wear pigtails. Chinese dress, manners, written language, institutions, and philosophical ideas were adopted.

The Manchu Ch'ien-lung (Qianlong) emperor, whose long reign from 1735 to 1799 was a high point of Chinese culture, was an enthusiastic patron of the arts. He assembled an immense collection of works from the past and his own time, much of which still survives. He had a private study, the "Room of Three Rarities," for painting, calligraphy, and poetry, and it was equipped with the paraphernalia of the Chinese scholar-artist, where he withdrew from "ten thousand cares" to compose mostly ordinary poetry as an accomplished member of the literati (fig. 11.9). He was the very model of a native Chinese Son of Heaven.

Palace Museum, Beijing

Fig. 11.9 Emperor Ch'ien-lung (Qian Long) in his study.

12

China's Social Net

The social basis of traditional China was the family and a hierarchy of social status that included emperor and family, scholar-gentry, peasants, artisans, and merchants. Family relationships were the social energy that kept the system stable and functioning. Five Relationships are praised as a world-harmonizing force in a Han dynasty Confucian text called *The Doctrine of the Mean* (*Chung-yung* / *Zhongyong*): "There are five universal ways (in human relations) . . . The five are those governing the relationship between ruler and minister, between father and son, between husband and wife, between elder and younger brothers, and those in the intercourse between friends. These five are universal paths in the world."[7] Three of the relationships belonged to the family, although in the case of ruler-subject, the emperor's relationship to the people was traditionally characterized as a benevolent father smiling on his children. Society was viewed as a patriarchal family at large. If each member bowed to the principle of status, which meant accepting one's own and respecting that of others, the result would be universal harmony, the ideal echoed in architecture and painting.

Status and hierarchy defined a person's role in the family. Women were subordinate to men, wives to husbands, children to fathers, the young to the old, the living to their ancestors. Here one sees the yin-yang distinction at work. Woman is yin, the female principle; man is yang, the male principle. Wife is yin, husband is yang, and so on. Both are necessary and complementary but also governed by a principle of subordination. The universal rule was to know and keep one's place. By doing so, harmony and order would result, which were ideals for cosmos and state as well as family.

Cardinal virtues were obedience to and reverence for parents, which included, when they died, an elaborate, sometimes bankrupting, funeral and a three-year mourning period as a public expression of filial piety. Rights and due process did not exist either as ideas or in practice. Each member of the family had defined duties and obligations. Marriages were arranged to strengthen and protect the family, not to promote the happiness of the individuals involved. Romantic love existed, but only among privileged people who could afford the luxury and get away with it.

The purpose of marriage was to ensure family continuity by producing children. For women, dalliance outside of marriage was sternly punished. The worst crime was to disgrace the family with publicly unacceptable behavior. No one in traditional China could go far without support from the family. All power and authority were centered in the patriarch. Disobedient, wayward children could be beaten or even killed. The nuclear family largely prevailed among peasants. Among well-to-do scholar-gentry with abundant land, three generations might live under one roof, and the patriarch might have multiple wives and concubines. In times of trouble, relief could be found only within a cohesive family group, whose members might be far away but were obligated to take in any relative who appeared at the door.

Although women were under the tutelage of men from birth to death, in affluent fami-

lies they were often literate and skilled in calligraphy, poetry, and painting. While there was no access for women to the imperial examinations, and hence no access to power, except for the occasional empress dowager (notably Empress Wu in the T'ang dynasty) or favorites of the emperor, some women clearly had access to aesthetic expression with the same tools and forms used by men. Nevertheless, throughout Chinese history, women, because of their theoretical yin status, were considered inferior to men. Some authority for this view can be found in the teachings of Confucius: "Women and servants are most difficult to deal with. If you are familiar with them, they cease to be humble. If you keep a distance from them, they resent it."[8]

The subordination of women was confirmed during the Sung dynasty and thereafter by the crippling, agonizing practice of binding the feet of young girls, so their instep was broken, to produce the erotically desirable "lily foot." The mutilation became, in due time, a status symbol sought by women beyond the upper classes, mostly in north China. In a time of trouble and disorder, women and children were exceptionally vulnerable.[9]

Continuity, harmony, and stability were served by a class system that allowed for some vertical mobility, but not enough to disturb a stable hierarchy of dignity and power. The hierarchy of classes was a formulation of inequalities and differences perceived to set people apart. At the top were the emperor and his family. Next came the scholar-gentry, who were maybe five percent of the population. They were important landowners socialized into Confucian ideals by the imperial examination system, and some held public office at one time or another. The scholar-gentry drew their power from a monopoly on the written language and its classical literature. Next in line were peasants, the most numerous group, with relatively high status in theory because they were major producers without whom the empire would not exist. In practice, however, the lot for most ranged from bearable to intolerable. Then came the artisans who made things—shoes, saddles, lacquerware, ceramics, and a thousand other items either needed or wanted. At the bottom of the social pyramid were the merchants, people who buy, sell, and handle money but produce nothing of value. Whereas in Europe merchants became increasingly influential and powerful by the time of the French Revolution in 1789, in China they were kept firmly in their place as men who cared only about profit and not about what is right. Confucian economic theory put land and agriculture ahead of money and commerce.

Conspicuously missing from this lineup of classes were military men and clergy, who were prominent in European social structure before the French Revolution. Soldiers and generals were needed but were denied official status because their specialized job, however necessary, was to fight and kill. As for religious leaders, other than scattered Taoist and Buddhist monasteries and temples, China lacked a central, institutionalized religion that would require them. Ancestor worship was the dominant religion, a diffused "faith" practiced at home and managed by the head of the family.

13

China's Cosmology

Despite a widespread belief in spirits and "gods," which were served by numerous cults and rituals, the loftiest Chinese conception of the universe was secular and rational. In Chinese literature, there is no creation myth that involves a divine architect of nature. No one made the world and its contents. A Han dynasty document tried to come up with something to put finishing touches on the Confucian cosmology of the time. While it is obviously a mythical account, there are no gods or supernatural agencies at work.

> Before Heaven and Earth had taken form all was vague and amorphous. Therefore it was called the Great Beginning. The Great Beginning produced emptiness, and emptiness produced the universe. The universe produced material force [ch'i / qi], which had limits. That which was clear and light drifted up to become Heaven, while that which was heavy and turbid solidified to become Earth . . . The combined essences of Heaven and Earth became the yin and the yang; the concentrated essences of the yin and the yang became the four seasons; and the scattered essences of the four seasons became the myriad creatures of the world. . . . If we examine the Great Beginning of antiquity we find that man was born out of nothing to assume form as something, Having form, he is governed by things.[10]

The universe that emerged from the Great Beginning is self-sustaining, self-operating, and obeys its own internal principles. No supernatural providence, interference, or tinkering are needed. The Chinese explained the universal reality of change with an elaborate system of correlations that describes nature as an organism whose movements obey oscillations of yin and yang and cycles of the Five Elements of metal, wood, water, fire, and earth.[11] The universe is like an organism because all its parts are interconnected and mutually influence one another, a change in one part necessitating a change in other parts. This reciprocal relation between all parts of nature means that things do not happen for causal reasons; there is no linear cause and effect, such as event *A* resulting in event *B*, like the blow of a stick on a cymbal causing a sound. Within this framework, time moves in one direction. There is no sign of the Indian taste for endlessly recurring cycles of time. Space was not viewed as something abstract that extends uniformly in all directions, but as discrete regions—south, north, east, west, center—correlated with the Five Elements.

Chinese thinking sought explanations of phenomena in their comprehensive relations with other phenomena rather than in isolated causal chains.[12] In this network of ideas, no inquisitive Galileo Galilei, probing the relation of time and distance in falling objects, could appear. Western natural science is based on the assumption of a universe governed by causal laws that can be discovered and explained with contrived experiments and mathematical descriptions. This mechanistic approach to knowledge of nature is just the opposite of the Chinese organic approach.

This Chinese way of thinking is profoundly relational rather than sequential. It follows from this reciprocal idea of change that no parts in the universe are unwelcome or out of place. All that exists is necessary to the harmonious operation of the world, which comprises nature and man. The mechanism of the yin and yang is oscillation back and forth into and out of one another. One side of an opposite gives way to the other side, is dominant for a time, and then yields to the other side. The two are not mutually exclusive or at war; they are complementary. Both are necessary to existence and cosmic order.

The classic symbol of yin and yang, as we have seen, is the diagram of an egg showing the interpenetration of one principle with the other—a dot of white in the black, a dot of black in the white, each intimating that reversal will take place without either being obliterated (fig. 2.2). Yang is the active principle signifying male, heaven, light, strength, dominance, and penetration, Yin the passive principle, signifying female, earth, darkness, quiescence, submission, and absorption, opposing qualities that are complementary rather than exclusive.

To the extent that traditional Chinese acknowledged the existence of absolutes, they are the nondualistic, interacting yin and yang. Dualisms like purity and sin or good and evil are rejected as unintelligible. If evil were absent from the world the idea of good would be meaningless, just as a right hand would have no meaning without a left hand. It is the alternation of opposites that produces movement, content, and meaning. Evil is as crucial to existence as darkness, old age, and death, whose opposites are light, youth, and life. Since everything in the world is connected to everything else simultaneously, the idea of harmony means acknowledging and acting on organic connectedness. Chaos is the absence, perversion, or neglect of such connections.

The second mechanism is the Five Elements (wu hsing / wu xing), natural forces understood in two ways: first, as a sequence of mutual production—wood produces fire, fire produces earth, earth produces metal, metal produces water, water produces wood—and, second, as a sequence of "mutual conquest"—wood conquers metal, metal reduces fire, fire douses water, water is blocked by earth, and earth is controlled by wooden tools. Thus metal overcomes wood, fire overcomes metal, water overcomes fire, and earth overcomes water, a scheme that probably originated from phenomena observed in the four quarters of the country, each assigned a direction, plus the middle, which was assigned to earth.

Each dynasty was said to be under the influence of one element, and adjustments in many things were made accordingly. Thus in the Ch'in (Qin) dynasty the dominant element was water, which is associated with the color black (officials had to wear black robes) and the number five (axles on carts had to be five-feet long). When the Han dynasty replaced the Ch'in, the former adopted earth as its sign because it blocks water, claiming the sign of earth was taken as an explanation of just dynastic succession.

The five elements or phases invited classifications based on the number five, an elaborate exercise in numerology—five directions, five tones, five colors, five relationships, and so on. One detailed example will suffice. Water is correlated with winter (season), north (direction), salt (taste), rotten (smell), six (number), moon (heavenly body), rain (weather), hearing (human function), quiet (style of government), works (government ministry), black (color), pig (domestic animal), millet (grains), liver (organs), and so on.

In the Han dynasty the yin and yang and Five Elements were put together into a wide-reaching system of correlations by the Confucian philosopher Tung Chung-shu (Dong

Zhongshu), who worked out reciprocal connections of the two fundamental principles with everything under the sun.[13] The idea of the world as an organism with interactive parts had a counterpart in Medieval-Renaissance Europe, but the system was one of hierarchical correspondence rather than reciprocal correlation. The world of man mirrored the cosmos—a microcosm-macrocosm relationship that was a chain of being stretching from an immobile earth at the center of the solar system through seven crystalline "planets" riding on spheres and three additional spheres circling the earth with God seated in Heaven (the Empyrean) just outside the tenth sphere. The natural orders on earth corresponded to the structure of the heavens. Everything and everybody had a fixed place created by God.[14]

With relational cosmology in place, the door was open to seek explanations and guidance in medicine, astronomy, historiography, moral philosophy, aesthetics, literary criticism, and other areas of practice and inquiry. A political application that survived for the next 2,000 years was to correlate imperial behavior and dynastic justice with portents, signs from Heaven, which would signal the presence of abuses with natural disasters and rumblings of the people. An oppressive tax policy from the court might, through resonance with nature, produce a drought or a meteor shower. In Han times the *Book of Changes* (*I ching / Yi jing*), one the five Confucian classics, assumed importance not just as a handbook of divination, but also as a summation of the cosmos (see Chapter 14). The sixty-four hexagrams formed by various superimposed combinations of the eight trigrams were taken to express all phenomena of nature and their mutual interactions.

These cosmological notions were pervasive in literature from early times and informed the thinking of uneducated as well-educated men and women for centuries.

14

China's Ideas in Literature

In China, an extensive and ancient literary tradition was the chief repository of ideas about man, nature, and society. Literature was divided into four categories: classics, history, poetry, and belles lettres (essays, letters, memoirs). Novels full of colorful characters, adventure, and eroticism and plays teaching moral lessons were written from the Mongol Yuan dynasty on but did not enjoy high status among literati despite their popularity.

The Classics

The Five Classics (Wu ching / Wu jing) ultimately numbered thirteen altogether. The most important comprise the five ancient books of *Odes* (or *Songs—Shih / Shi*), *History* (or *Documents—Shu*), *Changes* (*I / Yi*), *Spring and Autumn Annals* (records of the state

of Lu, modern Shantung / Shandong, Confucius's home state), and *Rites (Li)*. Later, in the Sung dynasty, the Four Books were sorted from the thirteen classics as the epitome of Confucian teaching—comprising the *Analects (Conversations)* of Confucius (*Lun-yu / Lunyu*), the *Mencius (Meng tzu / Mengzi)*, the *Great Learning (Ta hsüeh / Da xue)*, and the *Doctrine of the Mean (Chung-hsüeh / Zhongxue)*. The latter two short documents are in the *Book of Rites (Li ching / Li jing)*. These "books" are also commonly referred to as classics (Ching, or jing), as in the *Classic of History*.

This canon was long in the making, but once established by 1200 C.E., it dominated Chinese thought on ethics and political theory until the end of the dynastic system in 1911.[15] The significance of the classics, some of which are not easy reading, is that China's ruling class, the mandarins, studied them avidly and carried away a shared view of the world, the ideal state, and the virtuous life. Mastering the classics was a necessary condition for success in the imperial examinations, which had their beginning in the Han dynasty. Quoting the classics to justify policy and imperial edicts became the dominant form of argument in statecraft. Magistrates appealed to the classics when making judgments about wrongdoing or disputes at the local level. What distinguished the scholar-gentry and scholar-officials from everyone else in China was their intellectual and moral possession of the classics.

The *Book of Odes* is a collection of 300 short poems, allegedly culled by Confucius from a much larger body of verse for instructional purposes, but probably assembled earlier, around 600 B.C.E. In any event, Confucius evidently considered the poems useful for two purposes: first to temper and discipline the emotions, and second to impart a sense of style, aptness, and beauty in the use of language. The poems were originally accompanied by musical texts, subsequently lost, and were intended to be sung rather than read. Literate Chinese in later centuries were expected to have the poems at their disposal from memory so that they could recite them for the appropriate occasion.

Good taste and acute perception were often judged by how apt a quotation from the *Odes* might be at meeting or parting. Quoting from the poems in the Chou (Zhou) period was a means of expressing indirectly views and feelings about what might be going on.[16] This practice continued in later times. Although some of the poems may have authentic political overtones, complaints about injustice, and the like, most are straightforwardly about nature, love, hardship, bereavement, and similar nonpolitical matters. Later commentators, however, chose to find either explicit or hidden references to political decline in the Chou period, or to read most of the poems as didactic allegories of decay and failed virtue applicable to any historical period.

The *Book of History* is a collection of edits, conversations, speeches, and counsels from the time of the mythical sage kings to the early Chou period. The book contains two durable ideas—The Mandate of Heaven and the ceding of the throne. We have already encountered the Mandate of Heaven, a key idea of traditional Chinese political theory. On emulating virtue of the past, the *Book of History* says: "We should not fail to mirror ourselves in the lords of the Hsia; we likewise should not fail to mirror ourselves in the lords of the Yin. We do not presume to know and say that the lords of Hsia undertook Heaven's mandate so as to have it for so-and-so many years; we do not

presume to know and say that it could have been prolonged. . . . It was that they did not reverently attend to their virtues and so they prematurely threw away their mandate. Now the [Chou] king has succeeded to and received their mandate. . . . Being king, his position will be that of leader in virtue."[17] The corrupt Shang was overthrown by the virtuous Chou.

This powerful idea provides a rational justification for moral rule and insists that virtue comes before and not after Heaven delivers its mandate. The second idea (ceding of the throne) has to do with recognizing virtue as more important than hereditary succession. The legendary sage King Yao passed over his son and delivered the throne to Shun, a commoner. Shun was given three years to prove himself, and, having done so, Yao abdicated in his favor. Needless to say, this model was not faithfully respected in later Chinese history, but it retained a certain authority and influence when the *Book of History* became part of the Confucian canon.

The *Spring and Autumn Annals* is a chronicle of events in the feudal states between 722 and 481 B.C.E., originally compiled in Confucius's own state of Lu (modern Shantung / Shandong Province). The title indicates a chronicle that was pegged to the seasons. Events are enumerated with no background or commentary, resulting in a quasi-factual heap rather than a coherent narrative, and the literary style is undistinguished. Why, then, did the book end up in the Confucian canon?

First, because it was falsely attributed to Confucius, who supposedly put it together from records available in the state of Lu. The attribution was made by Mencius, who cites Confucius as saying that he will be known and condemned by the *Spring and Autumn Annals*. Second, later scholars were convinced that Confucius had tampered with words and sentences to transmit a secret message about proper government and standards for a ruler's moral fitness which would anger those in authority. The trick was to read between the lines and decipher the Confucian code. Eventually, several commentaries purporting to scan the concealed message were attached to the Confucian canon.

The greatest of these commentaries is the *Tso chuan* (*Zuo juan / Tso Commentary*), a narrative beginning in 722 B.C.E. and ending in the year 48 C.E. some thirteen years after the *Spring and Autumn Annals* appeared. The document is a product of the Confucian school, is a major source for Chou history, and is considered one of the finest prose works of ancient China because of its vivid style and realistic, often dramatic treatment of events. Despite the outward dress of "objective" historical narrative, which gives a hearing to evildoers and political cynics as well as virtuous men, the book's overarching purpose is to provide instruction about proper conduct. Confucian ideas of benevolence and righteousness appear often in the mouths of scholars and rulers, but the word most often evoked is *li* (ceremony, propriety, rites), which turns out to be the book's philosophical underpinning.

Confucian authors of the *Tso chuan* expand the word's meaning beyond merely appropriate ritual behavior: "Ritual (*li*) is the constant principle of Heaven, the righteousness of Earth, and the proper action of mankind. . . . Ritual determines the relations of high and low; it is the warp and woof of Heaven and Earth and that by which people live."[18] To live and behave with propriety, as though attending a great ceremony or a solemn ritual, is to harmonize both self and the world. The *Tso chuan* uses historical figures and

events to illustrate the consequences of behaving or not behaving according to universal rules of propriety.

The *Book of Changes* (also called the *Classic of Changes, I Ching, or I Jing*) is a manual of divination based, as we have already seen, on the cosmology of yin and yang. Traditionally, the book was attributed to the sage king who founded the Chou dynasty. Accompanying the original divinatory text is a set of commentaries showing both Taoist and Confucian influence, schools of thought that valued the book but put it to different uses. Broken and unbroken lines of the eight trigrams represent yin and yang, respectively (fig. 14.1).

Trigrams	Name (Chinese)	Name	Attribute	Image	Family relationship
☰	Qian	the Creative	strong	Heaven	father
☷	Kun	the Receptive	devoted	Earth	mother
☳	Zhen	the Arousing	movement	thunder, wood	eldest son
☵	Kan	the Abysmal	danger	water, clouds	middle son
☶	Gen	Keeping Still	standstill	mountain	youngest son
☴	Xun	the Gentle	penetration	wind, wood	eldest daughter
☲	Li	the Clinging	light-giving	lightning, fire	middle daughter
☱	Dui	the Joyous	pleasure	lake	youngest daughter

Fig. 14.1 Table of trigram correlations

For consultation, diviners cast lots, or stalks, which yielded either odd (yin) or even (yang) numbers. Two trigrams were combined into a hexagram of six lines, with the possibility of combination being sixty-four. The two at the top of Figure 14.1 are Ch'ien (Qian) for Heaven, six unbroken lines, and K'un (Kun) for Earth, six broken lines.[19] Both hexagrams are assigned to particular months; thus Ch'ien belongs to May and June, when light and warmth are at a peak; K'un to November and December, when darkness and cold are at a peak. There are dozens of additional correlations with things, substances, tastes, colors, directions, activities, and ideas.

Among other things, the trigram Ch'ien tells us in unmistakable Confucian terms: "The movement of heaven is full of power. Thus the superior man makes himself strong and untiring." K'un tells us, also in Confucian terms: "The earth's condition is receptive devotion. / Thus the superior man who has breadth of character / Carries the world." The general idea pursued by later commentaries on these cryptic sayings is that a wise man must take into account constant change going on around him and prepare to adapt by readiness to move in any direction at a given moment. Since the hexagrams are a summary of change in all its possibilities, finding the right hexagram at the exact time for a particular decision can make the difference between success and failure. Most of the classics, however, deal with ethical and political ideas.

Why would Confucians include a manual of divination in the canon, which seems remote from the moral and social interests of early Confucian teaching? Including it was probably a strategy to defuse the influence of Taoists, whose stock in trade was speculation about operations of nature, and because the book provided needed scope for cosmological speculation and a framework for pondering the universe as whole. Indeed, the Neo-Confucian synthesis of the Sung dynasty would be unthinkable without ideas contained in the I Ching and its commentaries. *has this been introduced ye[?]*

The *Book of Rites* is a complex ritual text that consists of documents assembled in the former Han dynasty. For the most part, they reflect early Confucianism and its preoccupation with propriety as the key to harmonizing the world. The portions on ceremony lay out procedures and standards for behavior at funerals and sacrificial rites, as well as for handling everything from setting up a dinner party to naming a child.

Standards for mourning the dead were reinterpreted by Han scholars to strip away ancient beliefs that one must try through ritual to summon spirits of the dead to reinhabit their bodies, or that a wealth of objects buried with the dead are really used by them. In line with Confucius's teaching, the spirit and sincerity of ritual observances are emphasized and humanized; that is, one *wishes* the dead person's spirit to return without expecting it to do so, but a clear distinction is made between the living and the dead.

The *Book of Filial Piety* (*Hsiao ching / Xiao jing*) was originally part of the *Li ching* but was pulled out later and given its own status among the thirteen classics. Although quite brief, it embodies the Confucian view that devotion to parents is the foundation of all moral knowledge and action, an idea remote from Western ways of thinking. Parents in traditional China are to be remembered and served in death (by sacrifices) as well as honored and obeyed in life. Love for parents and siblings is the condition for showing benevolence toward others outside the family.

In the twelfth century, the Neo-Confucian scholar Chu Hsi (Zhu Xi) added the "Four Books" to the traditional five classics, all of which became canonical and required reading for the examinations from 1313 on. Two of the Four Books were the *Analects* of Confucius and the *Book of Mencius*. The other two were the *Doctrine of the Mean* and the *Great Learning*, which were pulled out of the *Book of Rites* and given separate status.

The *Analects* consists of unsystematic, aphoristic sayings, responses to questions asked by disciples, and short conversations, all collected by pupils and followers of the master long after his death in 479 B.C.E. The book is the foundation of Confucian teaching. Virtues of the chun-tzu (superior man) are discussed, the moral life extolled, ethical self-cultivation defined, an ideal of public service proclaimed, and a humanistic point of view consistently maintained.

The episodic structure of the book can leave one puzzled about its immense influence, not only in China, but also in Korea and Japan. Perhaps the best explanation is that its attenuated messages fasten on the mind with time and repeated readings. Many of the sayings attributed to Confucius reverberate only with the concrete experience of life, which invests them with deep meaning. In any event, the *Analects* has been one of the world's most revered books.

The *Mencius,* a lengthy text of 35,000 Chinese characters, was probably assembled by students and followers, but may contain some material directly from the philosopher's hand. The book contains many exchanges between Mencius and the rulers he tried to

influence. While Confucius is not directly and forcefully critical of rulers, Mencius does not hesitate to fault them, either directly or by comparison with the behavior of past examples, both good and bad. On balance, he aims to persuade more by exhortation and rhetoric than by logic and is not watchful about inconsistency.

Apart from his central doctrine of man's natural goodness, the book contains many practical suggestions for improving the life of ordinary people, from education to land management. Probably the greatest influence of the book lay in Mencius's positive theory of human nature, a quasi-mystical notion that "all things are already complete in oneself," which appealed to later Neo-Confucian thinkers, and a feisty willingness to match his provocative views against those of powerful men who might have punished him.

The *Doctrine of the Mean* is one the most philosophical of early Confucian writings. It contains three big ideas important to later Neo-Confucian thought—the unity of man with nature, the power of sincerity to sustain harmony between both, and the nature of the sage. The idea of a "mean" in the English title suggests a life of moderation espoused by Confucius, but the Chinese title, *Chung yung* (*Zhong yong*), suggests something more— what is central (chung) and what is universal (yung). In both instances later Confucian thinkers saw in the words what is changeless: "What Heaven (*T'ien*, Nature) imparts to man is called human nature. To follow our nature is all the Way (*Tao*). Cultivating the way is called education. . . . Equilibrium is the great foundation of the world, and harmony its universal path. When equilibrium and harmony are realized to the highest degree, heaven and earth will attain their proper order and all things will flourish."[20]

The role of humanity in promoting universal harmony is to be sincere: "He who is sincere is one who hits upon what is right without effort and apprehends without think-ing. He is naturally and easily in harmony with the Way. Such a man is a sage. He who tries to be sincere is one who chooses good and holds to it."[21] The notion of effortlessness is reminiscent of the Taoist wu-wei (action without action), which is joined in this one statement with the Confucian injunction to seek righteousness. The text goes on to say: "Only those who are absolutely sincere can transform others. . . . Sincerity means the completion of the self, and the Way is self-directing. Sincerity is the beginning and end of things. Without sincerity there would be nothing. Sincerity is not only the completion of one's own self, it is that by which all things are completed."[22]

The flawlessly sincere man is a sage because his qualities harmonize Heaven, Earth, and Man. Only character at such a high level can exercise trusted leadership in the state: "Only the perfect sage in the world has quickness of apprehension, intelligence, insight, and wisdom, which enable him to rule all men; magnanimity, generosity, benignity, and tenderness, which enable him to embrace all men."[23] All of this is simply another way of talking about Confucius's ideal man—the chun-tzu (zhunzi)—combining cultivation with action in the world.

The *Great Learning* also comments on self-cultivation and sincerity, but the main idea is how to go about "rectifying" self, family and state, that is, bringing them into harmony, by cultivating self through "the investigation of things" to "extend knowledge." Another idea that made a profound impression on later Confucians is the unremitting watchful-ness of the sage. The path of rectification has several steps. Order to the state comes from regulation of the family, which comes from personal cultivation, which comes from

rectifying one's mind, which comes from making the will sincere, which comes from extending knowledge, which comes from "the investigation of things." The steps are then reversed so one goes from investigation to ordering the state: "From the Son of Heaven down to the common man, all must regard cultivation of the personal life as the root or foundation."[24] The "root" means what must be perfected through knowledge acquired by investigation into man's moral nature and its relationship to Heaven and Earth.

Chu Hsi, in his commentary on the *Great Learning*, says all things have "principles" that merit investigation, but what he had in mind is not an empirical search for natural laws (see Neo-Confucianism in Chapter 15). The last word in self-cultivation, the basis for rectifying family and state, is virtue sustained in isolation: "What is meant by 'making the will sincere' is allowing no self-deception. . . . Therefore the superior man will always be watchful over himself when alone. When the inferior man is alone and leisurely, there is no limit to which he does not go in his evil deeds."[25]

Ssu-ma Ch'ien (Sima Qian) and History

Reverence in traditional China for the past cannot be overstated. Whereas the West has been oriented toward the future since the nineteenth century, expecting miracles of progress from science and technology, China has looked backward for moral ideals and worthy models. As might be expected, absorption in the past gave rise to an extensive body of historical literature with specific intention and content. The major figure in this development was Ssu-ma Ch'ien (Sima Qian, ca. 145 or 135–86 B.C.E.), main author of China's first comprehensive history, from the ancient sage kings to about 110 B.C.E., known as *Records of the Historian (Shih chi / Shi ji)* in 130 chapters.

His organization, categories of subjects, moral point of view, and breadth of coverage far exceeded that of any previous historical work and became the template for succeeding dynastic histories, of which there are some twenty-four, including a draft history of the Ch'ing dynasty finished in the 1920s. The first was the *History of the Former Han Dynasty (Han shu)*, covering the period 209 B.C.E. to 25 C.E., which faithfully adhered to Ssu-ma Ch'ien's structure of Annals (rulers and previous regimes), Treatises (on rites, astronomy, economics, etc.), Chronological Tables (dates and events), Hereditary Houses (feudal states of the Chou and fiefs of the Han), and Biographies (philosophers, generals, ministers, etc.), as well as his view that history's main task is to transmit moral lessons, and to praise the good and censure the bad so unfortunate consequences of unwise human actions can be avoided in the present.

In later centuries, an entrenched focus on the past was reflected in art and literature. Landscape painters of the Ming and Ch'ing, for example, revered artists of the Sung as unrivaled masters to be emulated, and scholar-gentry from the Sung dynasty onward developed a connoisseurship in bronzes, jades, lacquerware, painting, and calligraphy—just about anything that was old and set a standard for craftsmanship and beauty. Whatever was past had to be better than what was present.

15

China's Traditions of Thought

Confucianism, Taoism (Daoism), and Buddhism are the leading thought systems that influenced symbolism and style in Chinese art. Confucianism stresses wisdom in tradition, social harmony, moral excellence achieved by self-cultivation and the study of classical literature, service to society, and reverence for ancestors and parents. Harmony in the world of nature and man is achieved by the superior man (chun-tzu), who knows what is morally right and applies it to human affairs.

Taoism seeks spontaneity, simplicity of living, identification with the processes of nature, and action in the world by doing as little as possible (wu wei). The path to cosmic and social harmony is withdrawal from worldly affairs by following the Way (Tao / Dao). Buddhism teaches the voidness of sensory reality, the vanity of ambition and worldliness, and reverence for near Buddhas (Bodhisattvas) as well as the historical Buddha. All three traditions became intertwined in ways that affected painting, sculpture, and architecture.

The emphasis in traditional Chinese thought is on concord and equilibrium. The history of China, like that of all past and present civilizations, has had more than its share of conflict and violence, but the spirit of ideas and art was on the side of harmony in nature and human relations. Struggle and competition were shunned as unworthy principles, and chaos was viewed as the worst of outcomes.

In traditional Chinese thinking, there is little tolerance for a romantic individualist wanting to burn life's candle at both ends, or for a Western-style Faustian personality consumed with unlimited, insatiable desire, although such people existed throughout Chinese history and appear conspicuously in novels from the Yuan to the Ch'ing dynasties. The ruthless First Emperor of China was not content with unifying China but wanted to live forever, and he probably died of mercury poisoning from "immortality" potions administered by Taoist alchemists.

The colorful T'ang dynasty poet Li Po (Li Bo—also goes by the name Li Pai / Li Bai) was notorious for his waywardness, drinking, and family irresponsibility. But these examples were not the ideal. Harmony was the goal of thought, society, and art. It follows from this preference for harmony over tension that Chinese social arrangements favored hierarchy and status rather than anything resembling democratic egalitarianism or a high priority for social arrangements that promoted individual happiness.

Two of the three traditions arose during the turbulent Warring States Period from the fifth to the third centuries B.C.E. before China's unification under the state of Ch'in in 221 B.C.E. The pervasive problem was warfare and conflict as some half-dozen states jockeyed and fought among themselves to control China. The solution was to bring harmony out of the chaos, but there was no agreement about how this might be done or what harmony meant. The result was a plethora of conflicting diagnoses and prescriptions, the "Hundred Schools," to cure political and social diseases. Advocates of one philosophy or another traveled from one royal court to the next to convert rulers, all promising triumph over rivals, unity, or some version of harmony.

Along with Taoism and Confucianism, Legalism was a contender for minds and hearts. Legalism, a pessimistic, anti-intellectual philosophy advocating centralized power, harsh laws backed by rewards and punishments, and merciless conquest, won the support of kings in the state of Ch'in. The argument was that a proper system of laws would make a virtuous personality at the top unnecessary. After the First Emperor's reforms and his passing, other emperors would succeed one another harmoniously.

Both Taoism and Confucianism agreed on the problems of their age—disunity, violence, confusion, and bad government. They disagreed profoundly about solutions and the type of man who could harmonize the world. Taoism was not a philosophy for ruling a state, and Confucianism, before its success in the Former Han dynasty, failed to carry the day as well. Eventually, however, both philosophies exerted lasting influence on Chinese thought and art, and interacted with one another like yin and yang.

Since Taoism and Buddhism had a notable effect on later Confucian thinking, we will depart from strict chronology and explore worldviews of these two philosophers before addressing the Confucian tradition.

Taoism (Daoism)

Traditional Chinese ideas and art are unintelligible without an understanding of Taoism and Confucianism. Like Confucianism, Taoism is more than one thing. For purposes of this book, we will distinguish the teachings of Lao-tzu (Laozi), Chuang tzu (Zhuangzi), and the Neo-Taoist movement that arose shortly after the collapse of the Han dynasty. While there are core ideas shared by all professed Taoists, differences among them must be noted.

Among the schools of thought that rivaled one another in the Warring States Period, Taoism offered rulers an alternative unlikely to work either for creating or managing an empire. The overriding need of the age was for decent, rational government that would benefit the peasant population as well as the ruler.[26] The blunt Taoist message was that men should obey nature rather than society to achieve peace and tranquility. Taoists were empiricists fascinated with the contents and operations of the natural world. They were respectful of facts and had no qualms about getting their hands dirty to pursue knowledge. Chinese knowledge of minerals, plants, obscure forms of life, and chemical processes came mostly from the work of Taoists. They were in many respects proto-scientists receptive to empiricism and naturalism, even though much of what they came up with was mixed with magic, shamanism, and mysticism.[27] No moral judgments were made about what happens in nature or the world of man. The Way is to see and accept things as they are as though the mind were a reflecting mirror.

This philosophy of nature entered the mainstream of Chinese thought and retained its vitality to the end of the imperial era. Without Taoism, Chinese civilization would have evolved in a different direction. Taoism was reflected in every facet of life from government to philosophy, art, and cooking. Even Confucianism was influenced by it, though Taoism ruled it out as a meddlesome doctrine responsible for much of the trouble in human life.

Confucianism as the way of the morally acute and socially responsible sage was complemented by Taoism as the way of an unattached, liberated sage in harmony with the multiplicity of nature—in short, yang in the first case and yin in the second. After a

tough day at the office, a conscientious official might well go home to comfortable robes, warm wine, incense, and spontaneous song and poetry composed on the spot with friends. A busy, perhaps harried Confucian, loaded with duties and obligations, would modulate for a while into a liberated Taoist riding the wind.

Taoists were not the only ones to use the word Tao or Way. All competing philosophers of the Warring States Period (403–221 B.C.E.) had a "Way" to sell to the various rulers. Confucius talks about the "Way" as cultivating principles of the chun-tzu and exemplifying them in public service, which is a moral, social, and political ideal. Mo-tzu (Mozi) defended the "Way" of abstract universal love for mankind. Han Fei-tzu (Han Feizi) defined the "Way" as absolute power invested in a ruler who regulates unruly humankind with laws, rewards, and punishments.

For Taoists, the Way is living in harmony with external nature so man's true internal nature can be fulfilled. The two greatest Taoist works are those of the legendary Lao-tzu (Laozi), the *Tao-te ching* (*Daode jing* [*The Way and Its Power*])*,* and Chuang-tzu's *The Chuang-tzu* (*Zhuangzi*). Both, with far reaching effects on ideas and art, continued to be read and cited by philosophers, officials, poets, and artists for centuries—and are influential to this very day.

Lao-tzu (Laozi)

More existing commentaries, about 300 complete ones and as many that are fragmentary, have been written on the 5,000-word *Tao-te ching* than any other Chinese work. It is a combination of poetry and prose, but mainly has the character of a highly elusive, suggestive philosophical poem that contains the basic ideas of Taoism.[28]

Tao refers to the spontaneous operations of nature in their totality. Since all of nature is included, it cannot be discussed without making narrow distinctions between this and that. In effect, Tao cannot be named or defined without falsifying it, because Tao, viewed as the whole, cannot be named as a part: "The Tao (the Way) that can be told of is not the eternal Tao, The name that can be named is not the eternal name."[29] Whatever happens in uncreated nature is spontaneous, unaffected, and self-sufficient. The effortlessness with which rain falls, birds fly, rivers flow, and clouds form is the power (te/ de) of Tao, which is nevertheless a void: "Tao is empty (like a bowl). It may be used but its capacity is never exhausted."[30]

The movement of Tao is the alternation of yin and yang: "Reversion is the action of Tao. . . . The Tao which is bright appears to be dark. The Tao which goes forward appears to fall backward. The Tao which is level appears uneven. Great virtue appears like a valley (hollow). . . . The ten thousand things carry the *yin* and embrace the *yang,* and through the blending of the material force (*ch'i* [*qi*]) they achieve harmony."[31] The ch'i referred to, a form of energy believed to pervade the universe, is the theoretical foundation of Taoist breathing exercises to achieve longevity.

The power of the Tao is harnessed by receptivity, by not resisting nature, which means to act without calculated ends. The seemingly paradoxical advice of Lao-tzu to act without acting (wu wei) does not mean doing nothing at all, a clear impossibility, but rather to let nature run its course and be itself without interference: "The softest things in the world overcome the hardest things in the world. Non-being penetrates that in which there

is no space. Through this I know the advantage of taking no action. Few in the world can understand teaching without words and the advantage of taking no action."[32] All self-conscious action produces reactions. Taking action instantly breaks with the spontaneous movement of nature and requires judgments and distinctions. Labeling views or behavior as good automatically implies that which is bad. For the Taoist, Confucians are misguided in their notion of an evaluating mind, which requires focused action, study, self-cultivation, and moral judgment.

Having identified what they think is good merely confirms for Taoists what has been lost: "When the great Tao declined, the doctrines of humanity (*jen* [*ren*]) and righteousness (*i* / *yi*) arose. . . . When knowledge and wisdom appeared, there emerged the great hypocrisy."[33] One should not try to change the ways of nature by pursuing conscious ends: "Tao invariably takes no action, and yet there is nothing left undone. If kings and barons can keep it, all things will transform spontaneously."[34] Harnessing the power of the Tao requires abandonment of ends and purposes so nature can be obeyed in complete harmony, which is the true meaning of freedom for the individual. The ruler does the same by leaving everyone alone, which is to rule without ruling. The more rules, laws, directives, edicts, and demands there are, the more resistance and dissatisfaction there will be. Inaction is action in accordance with nature.[35]

The condition of a person born into the world is that of an uncarved block (p'u or pu) without features. Then society—parents, teachers, magistrates, priests—begins to carve the block with rules, commands, moral injunctions, and social expectations. Recapturing the true self means returning to the uncarved block: "He [the sage] will be proficient in eternal virtue, and returns to the state of simplicity (uncarved wood)."[36] Complexity obscures the Tao; simplicity reveals it.

The ideal world has no place for laws, policies, administration, and formal education. Unlike the other great Taoist, Chuang-tzu, Lao-tzu has policy recommendations disconcerting for any society bent on material growth, mobility, military power, and technological control of nature. Here is his vision of the ideal society:

> Let there be a small country with few people.
> Let there be ten times and a hundred times as many utensils
> But let them not be used.
> Let the people value their lives highly and not migrate far.
> Even if there be ships and carriages, none will ride in them.
> Even if there are armor and weapons, none will display them.
> Let the people again knot cords, and use them (in place
> of writing) . . .
> Though neighboring communities overlook one another . . .
> Yet the people there may grow old and die without ever
> visiting one another.[37]

Rulers were not likely to be enthusiastic about a vision of society that leaves no room for political initiatives, development of knowledge, elaboration of culture, or expansion of empire. The call for simple living, however, remained for educated Chinese an inspiration amid the complexities, restrictions, and dangers of conventional social life. An irony is

that a committed Taoist in the purest sense would not be found painting landscapes even though his view of life was part of the background of Chinese pictorial art.

Chuang-tzu

The *Chuang-tzu*, a thirty-three-chapter book written by philosopher-poet Chuang-tzu (369–286 B.C.E.), is one of the finest, most startling works in Chinese literature. The writer was a provocative philosopher of change and relativism with the gifts of a poet. His imagery and parables still excite the mind.[38] While Lao-tzu stays close to the world of experience and makes distinctions between strength and weakness and good and bad, Chuang-tzu abandons all distinctions and seeks a radical transcendence that has a mystical flavor. In this transcendent state, there are no good and bad men as there are for Lao-tzu. Few writings in world literature pose such a challenge to Western rationalism.

Although Chuang-tzu's version of the liberated sage seeks oneness beyond all distinctions, he does it without abandoning nature: "The perfect man is a spiritual being. . . . Even if great oceans burned up, he would not feel hot. Even if the great rivers are frozen, he would not feel cold. And even if terrific thunder were to break up mountains and the wind were to upset the sea, he would not be afraid. Being such, he mounts the clouds and forces of heaven, rides on the sun and the moon, and roams beyond the four seas."[39]

A further difference between the two Taoists is unique in Chinese literature and philosophy. Lao-tzu is aphoristic, often mysterious; less interested in arguing a case than in provoking sudden flashes of insight, he specifically warns against disputation: "A good man does not argue; he who argues is not a good man."[40] Chuang-tzu uses reason to overturn and obliterate distinctions established by reason and experience: ". . . there are things which analysis cannot analyze, and there are things which argument cannot argue."[41] His prose brims with colorful imagery but is nevertheless logical in its appeal to the mind as well as to intuition. He resorts to four types of argument.

The first is that all distinctions are relative. What seems ugly or sour to you seems beautiful and sweet to me. Nothing is more relative than perceptions of space and time. The eagle knows distance as the dove never can. Some insects live a few hours, while other creatures live for many decades. Strength and weakness, bigness and smallness, knowledge and ignorance are all variable and therefore relative to what, where, and when one is. A child might think the village idiot is a genius because he knows where to draw water. Chuang-tzu expresses this relativism in paradoxes: "There is nothing in the world greater than the tip of a hair that grows in the autumn, while Mount T'ai is small. No one lives a longer life than a child who dies in infancy, but P'eng-tou (who lived many hundred years) died prematurely."[42] Chuang-tzu's relativism is a tendency in the Chinese language. Concepts such as height, width, and length are rendered as high–low-ness, wide–narrow-ness, and long–short-ness, indicating a desire to acknowledge both physical conditions at the same time.[43]

A second argument is that opposites cancel each other. Life implies death and vice versa. Since one cannot do without the other, they are really the same: "The 'this' is also the 'that.' The 'that' is also the 'this.' The 'this' has one standard of right and wrong, and the 'that' also has a standard of right and wrong. Is there really a distinction between 'that' and 'this'? Or is there really no distinction between 'that' and 'this'? When 'that' and 'this' have no opposites, there is the very axis of Tao."[44]

A third argument is that perspectives are variable and ambiguous. The most quoted of his examples is the dream paradox: "Once I, Chuang Chou [Chuang-tzu], dreamed that I was a butterfly. I was conscious that I was quite pleased with myself but did not know that I was Chou. Suddenly I awoke, and there I was, visibly Chou. I do not know whether it was Chou dreaming that he was a butterfly or the butterfly dreaming that it was Chou."[45]

A fourth argument is skepticism about all claims to truth. Chuang-tzu can make the head spin by playing on what logicians call an infinite regress. He pushes back indefinitely the possibility of establishing agreement or disagreement by finding and agreeing on a standard of judgment.

> Suppose you and I argue. If you beat me instead of me beating you, then are you really right and am I really wrong? If I beat you instead of your beating me, am I really right and are you really wrong? Or are we both partly right and partly wrong? Since between us neither you nor I know which is right, others are naturally in the dark. Whom shall ask to arbitrate? If we ask someone who agrees with you, since he has already agreed with you, how can he arbitrate? If we ask someone who agrees with me, since he has already agreed with me, how can he arbitrate? If we ask someone who disagrees with both you and me to arbitrate, since he has already disagreed with you and me, how can he arbitrate? If we ask someone who agrees with both you and me to arbitrate, since he has already agreed with you and me, how can he arbitrate? Thus among you, me, and others, none knows which is right. Shall we wait for still others?[46]

If we do wait for others to arbitrate, there will be still another person, and another, and still another standard of truth, to infinity. It follows from the unreality of distinctions that everything should be left alone. To interfere with nature is to lose touch with the Tao and become a focus of conflict and trouble. Do not meddle in the affairs of others or try to make nature do your bidding. The result can only be resentment, confusion, hostility, and other unpleasant consequences. The Taoist sage, unlike the Confucian, has no interest in understanding things or aligning himself with righteousness. Knowledge and virtue are not means of harmonizing the world, for they appeared only after the Tao went into decline. In effect, they are signs of corruption.

Many people fear death as a terrible unknown. Chuang-tzu faces the prospect of personal oblivion with detached serenity, viewing it as a benign event in the natural course of things: "The universe gives me my body so I may be carried, my life so I may toil, my old age so I may repose, and my death so I may rest . . . Therefore the sage roams freely in the realm in which nothing can escape but all endures."[47]

One of Chuang-tzu's characters is all "crumbled," near death, and is asked if he dislikes it: "No, why should I dislike it? Suppose my left arm is transformed into a cock. With it I should herald the dawn. Suppose my right arm is transformed into a sling. With it I should look for a dove to roast. Suppose my buttocks were transformed into wheels and my spirit into a horse. I should mount them. . . . When we come, it is because it was the occasion to be born. When we go, it is to follow the natural course of things. Those who are contented and at ease when the occasion comes and live in accord with the course of Nature cannot be affected by sorrow or joy."[48]

One arrives, lives a while, and departs; there is nothing more to it. But oblivion is not the end. What follows death in the cauldron of the universe is transformation into other forms. This attitude toward death repudiates a dualism of body and spirit. To die is to be changed into another form by processes of nature, a notable departure from conventional Chinese ideas about death and the Christian idea of immortality in another world, although it resonates with the Buddhist notion of reincarnation.

Neo-Taoism

Shortly before and after the bloody collapse of Later Han authority in the third century C.E., and before Buddhism made an impact in China, Taoism enjoyed a moment of ascendancy. Alienation and withdrawal overcame intellectuals disillusioned with a failed Confucian establishment. Tung Chung-shu's (Tong Zhongshu) theory of mutual influence between man and nature was no longer compelling. Renewed study of Lao-tzu and Chuang-tzu encouraged a lightness of spirit and a desire to flow through the universe as pure being. The philosophers among Neo-Taoists were former government officials attracted to Taoist teachings. Although Han Confucianism was repudiated, Confucius was not, and he remained the leading sage for Neo-Taoists. A number of passages in the *Analects* have a distinctly Taoist flavor. Two related movements emerged—one centered on a way of life called "light conversation" (ch'ing-t'an / qing tan), the other on philosophical speculation (hsuan-hsüeh / xuan xue).

The romantic conversation group is best characterized by the Seven Sages of the Bamboo Grove (third century), who drank abundantly, joked, defied convention, invited local swine to join their party, and amused themselves with poetic paradoxes that negated distinctions between right and wrong, wealth and poverty. Their program was to revere spontaneous nature and follow every impulse without inhibition as evidence of high integrity. Liu Ling was the champion drinker among the sages. A servant followed him carrying a jug in case he wanted a sip and a shovel to dig his grave should he drop dead. When visitors to his house were disconcerted to find him walking about without trousers, he responded: "The whole universe is my house and this room is my trousers. What are you doing here inside my trousers?"[49] A later member of this school had an impulse to visit a friend who lived far away. He took off at night despite heavy snow, arrived in the morning, raised his hand to knock on the door, and, at that moment, the impulse left him, so he returned home without seeing his friend.

Taoist sentiment pervades Chinese painting and calligraphy. A Sung dynasty work by Ts'ui P'o (Cui Po) embodies a moment of Taoist spontaneity (fig. 15.1). A magpie has startled a hare with its cries. Like all animals in Chinese art, the two creatures have symbolic meanings. While the magpie is a good omen, it was considered noisy and mischievous as well. The hare stands for longevity and occupies the fourth spot in the Twelve Heavenly Branches, a scheme in the larger system of cosmic correlations.

Ts'ui P'o's image captures a frozen instant in which the hare turns to look at the bird. The space between them is charged with the energy of this spontaneous confrontation. With shriveled leaves blowing in the wind, the season is probably late autumn. Tree, foliage, and animals are depicted in a state of unselfconscious harmony. The execution of *Hares and Jays* must have been swift, for landscape painting after the tenth century C.E. was

Fig. 15.1 Ts'ui P'o (Cui Po), *Hare and Jays*, dated 1061, hanging scroll (cropped at bottom), ink and colors on silk.

premised on spontaneous handling of the brush. An artist in touch with the Tao was expected to act as unselfconsciously as the subjects in his painting.

Buddhism

Buddhism entered China as a result of the Han dynasty's collapse and the ensuing period of disunity, invasion, and uncertainty. Several intrepid Chinese pilgrims made their way to India and returned with Buddhist texts and images. The domestication of Buddhism was a difficult and highly improbable task, but efforts succeeded, more or less, and soon north China had rock-cut shrines, and temples were being built everywhere.[50] The Buddha image took hold as a major category of Chinese art. Acceptance of Buddhism in China is a major historical case study of alien ideas taking root in a hostile cultural environment. The interpenetration of Buddhist ideas with those of Taoism and Confucianism was a major event in the history of Chinese thought.

Buddhism encountered many obstacles before it could take root. Chinese soil was notably inhospitable to a number of apparently irreconcilable contrasts and ideas:

- The Chinese language is uninflected and monosyllabic, while Sanskrit and Pali, languages of the Buddhist scriptures, are highly inflected and polysyllabic.
- Chinese thinking is down to earth and concrete, while Buddhist thinking is lofty and abstract. Buddhism is not mentioned in the Confucian classics, so there was no authority for it in the Chinese tradition.
- Chinese cosmology puts limits on time and space, while Buddhist cosmology entertains eternal cycles of time and space.
- Chinese attachment to their culture as being superior to all others was challenged by a totally alien and culturally impressive tradition.
- The family was the undisputed social system of traditional China, while the monastic ideal of Buddhism forbade marriage.
- Especially troubling was the practice of monks shaving their heads. Confucians taught that any harm to the body was an affront to one's parents.

- As a result of the adoption of Confucianism as the official state doctrine in the Han dynasty, the Confucian Classics ended up competing with the Buddhist Canon—Chinese scholars developed a *Tripitaka* (*Three Baskets*—early Buddhist scriptures dealing with Buddha's discourses, rules for monks, and higher teachings) that paralleled the Indian version.
- For the Chinese there were spirits of ancestors, but no transmigration of souls from one life to the next. That idea, which depended on the associated idea of karma, was especially difficult to comprehend and absorb.

With so many impediments to overcome, how did Buddhism succeed in becoming such a force in China between the second and the ninth centuries, ultimately becoming part of the Neo-Confucian synthesis in the Sung dynasty?

The ignominious collapse of the Han dynasty in the third century C.E. left a spiritual void and widespread disillusionment. Hardships were immense, and life was cheap. As one historian put it, north China became one vast cemetery. The Buddha's message of existence as universal suffering was perfectly illustrated in that world for all to see. The prospect of tranquility in a monastic life became attractive. The appeal of compassion and peace in Buddha's message was widespread, as was the prospect of salvation through the intervention of Bodhisattvas.

Also influential was the alleged superiority of Buddhist "magic," since many supernatural powers were attributed to the Buddha and his attendant bodhisattvas. Peasant conversion was extensive in the great monasteries that were founded, and much of north China was converted to the alien creed by roughly 380. Foreign succession states in the north found Buddhism politically and ideologically useful as a counterweight to neutralize the influence of Confucianism and to vindicate alien rule. The result was extravagant temple building and the patronage of Buddhist monks to win merit, characteristic of Mahayana Buddhism.

In prior decades, translators had gone to work on texts brought from India. Problems of translation were tackled by finding terms in Chinese that might be used to represent Sanskrit words, a technique called "matching concepts" (ko-i / geyi). The best source of such terms was Neo-Taoism, with such unlikely matches as chen jen (zhen ren—Taoist immortal) for Arhat, the Tao for dhamma or bodhi, and wu wei for Nirvana.

Obviously these "matches" do not convey an accurate understanding of Buddhist doctrine. For the Arhat, there is no immortality. The Tao does not mean either teaching or enlightenment. Action through nonaction is not Nirvana. The consequences for understanding Buddhist doctrine were considerable. It is fair to say that Buddhism in its earliest Theravada form, which meant self-reliance and individual enlightenment by treading the Eight-Fold Path to its end, was not understood widely in China or pursued by more than a few converts.

Meanwhile, a body of apologetic writing, much of it highly convoluted, attempted to bridge the gap between Chinese and Indian ways and explain why it was acceptable for a Chinese to become a Buddhist and still honor principles like filial piety. Chinese intellectuals, the literati, who included unemployed officials, discovered that Buddhism enabled them to pursue familiar avocations—scholarship, art, calligraphy—in a new and impressive arena of ideas. Buddhist thought and art had a powerful philosophical and aesthetic appeal quite apart from its spiritual satisfactions.

When Buddhism had been absorbed by the sixth century, about the time China was reunified under the Sui dynasty in 589, there were ten Buddhist sects, all of them with a favorite scripture and with doctrines often expressed in Taoist language. Most were Mahayana (the "large raft"), for Hinayana (the "small raft," the dismissive name for Theravada, the Doctrine of the Elders) never achieved a wide following because its beliefs and practices were too alien to the Chinese way of thinking. Inconsistencies and contradictions between texts had to be reconciled, since all scriptures were considered Buddha's teaching.

The solutions were eclecticism and toleration. Sects that did well in China adjusted Buddhist teaching to ideals of harmony and concreteness. Successful ones recognized and appreciated all scriptures but chose one main text as the centerpiece of their teaching. Monks traveled freely between monasteries to sample all the practices and study all the scriptures. There were no violent sectarian battles, mutual persecutions, or abrasive feelings as there were between Christian sects in Europe during the Reformation era in the sixteenth century.

Among the Chinese Buddhist sects, some ten altogether, a traditional preference for harmony and integration is illustrated by T'ien-t'ai / Tiantai ("Heavenly Terrace"), whose scripture of choice was the *Lotus Sutra*. The early patriarchs of T'ien-t'ai, which was founded in the sixth century, were determined to establish that while all Buddhist texts and teachings available in Chinese are a unity, the Lotus School possessed complete truth while the other schools had only partial truths. Where scriptures appeared to contradict one another, the correct interpretation was that of myriad perspectives, the "heavenly terrace," all leading to the realization of the Buddha-nature in each moment of thought, which does not lie outside the dharmas, or impermanence of phenomena.

Since the Buddha originally taught that detachment from clinging to impermanence is the condition for enlightenment, the idea that a middle path lies between the voidness of the dharmas and their provisional reality required a leap of both intellect and imagination. In a scripture of the Lotus School, we are told: "All one can say is that the mind is all *dharmas,* and that all *dharmas* are the mind . . . It is obscure but also subtle and extremely profound. Knowledge cannot understand it, and words cannot express it. Therefore, it is called 'the realm of the inconceivable.'"[51] T'ien-t'ai acceptance of phenomena as real appealed to the Chinese predisposition for concreteness of experience and thought. The Buddha nature could be found in colors and fragrances. Since all dharmas (objects, thoughts, and ways) interpenetrate, there can be no falsehood or error in doctrines and practices of various sects.

Existence and Buddhahood are not mutually exclusive. All existing things possess the Buddha-nature because of their "emptiness"—another term for impermanence. The essence of emptiness, also called "suchness" (tathata) in Mahayana philosophies, is Nirvana. One need only come to realize the oneness of the two by meditating on impermanent forms rather than rejecting them. This meditation can take several directions, depending on readiness of the individual. Buddha was flexible in doctrine and practice. His teachings were adjusted to different audiences and stages in life. When the teaching of sudden enlightenment failed to be understood, he moved on to gradual enlightenment and the intervention of Bodhisattvas, and then back again to sudden awakening. Meditation in silence to achieve a state of non-duality is only one path to awakening. One can

also practice "walking meditation," concentrating on bodily movements and breathing, meditate on the surrounding multitude of objects in one's daily life, or focus on destructive and negative states of mind. These various options proved effective and popular for converts in China.

Pure Land (Ching-t'u / Jingtu) was an important sect for art. The object of Pure Land worship is Amitabha (O-mi-to-Fo in China, Amida in Japan), the Buddha residing in the Western Paradise. Pure Land is a Mahayana sect that emphasizes practice and inspiration rather than theory and doctrine. In Pure Land worship and piety is found all the paraphernalia of a salvationist religion—heavens, hells, angels, demons, miracles, prayers, amulets, prostration before images, and personal immortality, although the faithful are expected to meditate on their impurities and correct them. Salvationism is based on a distinction between one's own strength, which is considered inadequate except for the very few, and the strength of another, or devotional faith in a particular Buddha or Bodhisattva.

In the case of Amitabha's realm, the direction "West" is invoked because Taoists thought it auspicious for health and prosperity, a good example of Taoism's role in the assimilation of Buddhism. Amitabha's chief attendant Bodhisattva was Avalokiteshvara (Kuanyin / Guanyin), one of the most popular subjects for sculptural representation, a goddess of love and mercy whose task is to guide the faithful after death to the Western Paradise. There is nothing spiritually rarified about the paradise of Amitabha, which is a frankly materialistic realm teeming with explicit riches and pleasures awaiting the faithful, all vividly illustrated in paintings that survive in the great Chinese cave temples.

The chosen scripture of the Pure Land sect is the *Sutra* ("thread") *of the Buddha of Limitless Life*, which promises the faithful rebirth in Amida Buddha's paradise. The portal to salvation is the sincere recitation of Amida's name (Namo O-mi-to-Fo), a practice that became commonplace in all Buddhist sects and not just among devotees of Pure Land. One advantage of the Western Paradise is the absence of temptations, notably women, who were considered a source of defilement.

One of the Five Recollection Gates, or five practices, at the heart of Ching-t'u ("Pure Land")—in addition to prostration before Amitabha, recitation of his name, wanting to be reborn in the Western Paradise, and readiness to share benefits with others—is visualization of the Pure Land, which requires the imagery of sculpture and painting as well as imagination. In north China in the fifth century, cave shrines were excavated at Yun-kang (Yungang), Lung-men (Longmen), and Tunhuang (Dunhuang). Each had adjacent monk's cells with spectacular sculptural representations of Amitabha and Vairocana ("shining out"—refers to the celestial Buddha comprising the entire universe) in two dimensions, although they can also be read iconographically as the historical Buddha (fig. 15.2).

These rock-cut shrines were contemporary with those carved at Ajanta in India, from where the practice came to China. Inside the shrines were elaborate paintings and more sculpture depicting Buddhas, Bodhisattvas, the Western Paradise, and Buddhist legends.

The third influential sect that also left its mark on art was Ch'an (Chan, Zen in Japanese), from the Sanskrit dhyana, which means meditation, but which in China came to mean direct enlightenment of the mind rather than contact with ultimate reality through

Photograph by Jim Gourley.

Fig. 15.2 Buddha Amitabha, cave 20 at Yungang, Shansi Province, 460–493 C.E.

Indian yogic practices or study of texts. The nature of mind was the chief interest rather than understanding the connection of phenomenal experience with Nirvana.

The source of Ch'an was the Buddha's last sermon on Vulture Peak during which he lifted a flower in silence. His senior disciple, Kasyapa, who appears frequently in cave sculpture, was the only one who got the message that the Buddha nature is immediately present everywhere—one already has the Buddha nature without knowing it. The discipline of Ch'an is to realize the presence of that nature in oneself apart from external authority or ritual practices. Philosophically, the Ch'an doctrine of silence, the idea that "the first principle" is inexpressible, was to find its way into Confucian thinking in the Sung dynasty. Sung Ch'an painters sought to hint at the inexpressible in black ink paintings, as in Mu Ch'i (Mu Qi)'s *Persimmons* (fig. 15.3). The fruit appears suspended in timeless space and yet has weight and texture. The forms appear even more palpable resting in the Buddhist void.

The legendary first patriarch of Ch'an in China, the twenty-eighth in India, was Bodhidharma (460–534). He demonstrated his prowess at meditation while facing a wall for nine years. The dominant Ch'an text is the *Diamond Sutra,* which stresses the nature of mind. Two schools emerged, the northern and the southern, under several major teachers vying for the patriarch's robe. They had conflicting ideas on how the mind works but were joined in the shared vision that enlightenment comes from direct experience without the authority of scriptures or the aid of images.[52] With respect to interpretations of the mind, northern theory and practice stressed a period of deliberate meditative cultivation

Daitoku Temple, Kyoto

Fig. 15.3 Mu Ch'i (Mu Qi), active ca. 1296, *Persimmons*, ink on paper.

and discipline to clear away impediments to enlightenment; in the south, preparatory meditation was rejected, and enlightenment, or knowledge that is not knowledge, was taken to be instantaneous.

The difference between the two was actually minimal, since enlightenment in both cases, when it came, was immediate and not gradual, and all schools of Ch'an resorted to meditation. The northern school vanished in the tenth century, but its method and view of the mind were represented by one of the two schools that flourished in the south, known as Soto Zen in Japan. The northern school used paradoxical questions and statements to break down the door to enlightenment, known as Rinzai Zen in Japan. Both schools were founded in the tenth century and moved to Japan in the twelfth century.

The paradox of enlightenment for both schools is that nothing is gained after enlightenment, no problems are solved, and Buddhist teaching becomes irrelevant (the metaphor of a distant shore beckoning and then vanishing as it is reached). After the ninth century, the southern school was the most prevalent in China. The northern school that survived in Japan as Soto Zen stresses zazen, or sitting in meditation, while the southern school came to Japan as Rinzai Zen, whose method is to challenge the acolyte with a hopeless puzzle (koan) that breaks down the barriers of reason and opens the door to Buddhahood—"the bottom of a tub falling out."

The nature of Mahayana Buddhism was to multiply deities, and they proliferated much more in China than in India. Therefore the Chinese had to figure out how new gods would be represented. Iconographic choices had little Indian guidance, since very few Buddha

images were available from India. Hints could be found in scriptures—for example, the appearance of various Buddhist heavens, hells, demons, and celestial musicians. As we have seen, Mahayana doctrine argued for more than one Buddha. Buddhas had preceded the historical figure of Shakyamuni, and Buddhas would follow him.

As a consequence, the historical Buddha was eventually abandoned for a transcendent conception that allowed for a number of Buddhas operating in different spheres, such as Amitabha (meaning "infinite light") in his Western Paradise, complemented by Buddhas and paradises in the other cardinal directions as well. A more general transcendent presence was Vairocana, the universal Buddha, situated in the middle position of celestial Buddhas in the four quarters. All of these Buddhas are associated with attendant Bodhisattvas, monks called Lohans (Chinese for Arhat), and ferocious looking guardians.

There was no single iconographic rule or rigidly fixed canon of attributes for a Buddha or a Bodhisattva as Buddhism spread across Asia. The result in China is some uncertainty in deciding who is represented in sculptural images. An apparently standard Buddha image sitting in meditation or preaching may be Amitabha rather than Shakyamuni. Usually, however, Buddhas are depicted with legs in a lotus position in meditation on a lotus throne, with most of the expected attributes. Seldom are they shown standing, but when they are, the base may also be a lotus. In Figure 15.4 the image is not Shakyamuni, the historic Buddha, but Maitreya, the Buddha of the future, the rather casual hand mudras signifying reassurance on the right and gift giving on the left. In the case of Bodhisattvas, the signs are more definite (fig. 15.5). They stand or sit, but not in meditation, and

are dressed and adorned lavishly, as they are in India. They may have long ear lobes but seldom an ushnisha on the forehead and never a cranial topknot.

In the eighth and ninth centuries, reestablishment of the dynastic system and thus the empire led to persecutions of Buddhism, as Confucianism was reasserted as the state ideology, although the animus behind persecution was not religious intolerance but distrust of the economic and political power the great monasteries had accumulated. Buddhism and its ideas about nature and the human condition remained part of Chinese culture on a reduced scale, but the effect on later Confucian thought was to be profound.

Confucianism

The key to understanding traditional China is Confucius and his influence. Confucius is the Latinized form of K'ung Fu-tzu (Kong Fuzi), or Master K'ung). His teachings must

Fig. 15.4 The Buddha Maitreya, Northern Wei Dynasty, 443 C.E.

Tokyo National Museum.

be distinguished from later developments called "Confucianism." He would have been mystified by the fate of his views in the hands of others over many centuries. The Confucian tradition passed through several stages.

First, there were the relatively uncomplicated moral teachings of Confucius in the later sixth and early fifth centuries B.C.E.

Second, two rival schools arose in the later Chou period, a century or so before unification—those of the activist-idealist Mencius (Meng-tzu or Mengzi) and the skeptic-realist Hsun-tzu (Xunzi).

Third, during the Han dynasty the moral and political doctrines of Confucius were overlaid with an elaborate cosmology based on yin and yang and the Five Elements, featuring a theory of portents (warnings from Heaven) associated with the Mandate of Heaven, a stage in which this quasi-scientific brand of Confucianism became the official doctrine of the Han state.

Fourth, during the Sung dynasty, the theories of Taoism and Buddhism were integrated with Confucian moral, political, and social ideas to form a new synthesis called Neo-Confucianism, which was to dominate Chinese thought and the imperial examination system from the early thirteenth century until the fall of the Ch'ing dynasty in

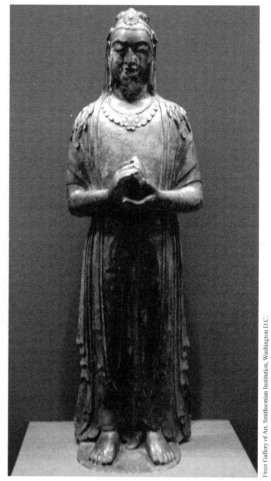

Fig. 15.5 Bodhisattva, Northern Ch'i (Qi) Dynasty, c. 570 C.E.

Freer Gallery of Art, Smithsonian Institution, Washington D.C.

1911. Commentaries of the Neo-Confucian scholar Chu Hsi (Zhu Xi), who died in 1200, and his organization of the Classics were the prevailing influence on many generations of educated Chinese.

Confucius

Confucius lived in the troubled times of 551 to 479 B.C.E., when competing warring states made life insecure, violent, and potentially short. As China's first professional teacher and founder of a tradition that lasted for the next 2,500 years, he shaped the minds and behavior of millions for more than two millennia and was at least as influential as Buddha and Jesus. While not much is known about him from contemporary sources, he bequeathed a short autobiography in the *Analects* (*Lun-yü / Lunyu,* or Conversations): "At fifteen my mind was set on learning. At thirty my character had been formed. At forty I had no more perplexities. At fifty I knew the Mandate of Heaven. At sixty I was at ease

with whatever I heard. At seventy I could follow my heart's desire without transgressing moral principles."[53] What could be more to the point!

He aspired to be a government official, but the military aristocracy was unimpressed with his radical views on how to achieve ethical government: "A ruler who governs his state by virtue is like the north polar star, which remains in its place while all the other stars revolve around it."[54] Grieved by the carnage, treachery, and warfare that haunted China, he made the rounds, like other itinerant philosophers of the time, in an effort to win the support of various rulers for moral ideas of statecraft and acceptance of his students as virtuous ministers.

Failing to do so, he established a school, became China's first professional teacher, and launched a unique experiment to change the world by creating a new type of man through education. Although groundbreaking in his redefinition of manhood at its best, he was a traditionalist who looked to the past for inspiration and firmly conservative in his reluctance to challenge the social and economic status quo. His innovation was to view government as a problem of ethics rather than one of power and politics.

The ideal he created was the chun-tzu (zhunzi), which normally meant "son of an aristocrat," a meaning he changed to "gentleman," "superior man," "noble person," or "man of humanity," a person made what he is by moral character rather than privileged birth. This man, no matter what his social or familial privilege, was superior solely as a result of ethical cultivation, moral judgment, and diligent study: "The superior man thinks of virtue; the inferior man thinks of possessions. The superior man thinks of sanctions; the inferior man thinks of personal favors."[55] In his teachings, Confucius consistently distinguished the chun-tzu from the hsiao-jen (xiao ren, inferior man), but he believed that all men at the beginning are capable of virtue. What makes a moral difference in men is practice: "By nature men are alike. Through practice they have become far apart."[56] His "school" never had many pupils, perhaps thirty or so, but there was nothing like it in imperial China. It set in motion a movement of thought and standards of behavior that shaped the future of China.

On the one hand, admission to his school was open and unprejudiced: "There has never been anyone who came with as little a present as dried meat (for tuition) that I have refused to teach him something."[57] On the other hand, standards were high: "I do not enlighten those who are not eager to learn, nor arouse those who are not serious to give an explanation themselves. If I have presented one corner of the square and they cannot come back to me with the other three, I should not go over the points again."[58] He applied lofty standards to himself as well: "To remember silently (what I have learned), to learn untiringly, and to teach others without being wearied—that is just natural for me."[59] His instruction avoided superstition, sensationalism, and religious enthusiasm: "Confucius never discussed strange phenomena, physical exploits, disorder, or spiritual beings."[60] His pupils report a man of high character: "Confucius was completely free from four things: He had no arbitrariness of opinions, no dogmatism, no obstinacy, and no egotism."[61]

Although Confucius often evoked "Heaven" as a moral force, the distance between him and the supernatural was clearly governed by humanistic ideals. When asked about serving spirits, he replied: "If we are not yet able to serve man, how can we serve spiritual beings. . . . If we do not yet know about life, how can we know about death?"[62] Among subjects omitted from the curriculum were science and abstract philosophy; his goals were

practical, social, and moral. The vocabulary of virtue developed by Confucius permeates Chinese literature, ideas, and traditional institutions. The chun-tzu was not identified by wealth, power, or pedigree but by traits of character, which included personal integrity, a sense of right and wrong, filial respect for parents, a feeling of benevolence toward others, regard for ceremonial forms, reciprocation of kindness, and good manners: "The way of the superior man is three-fold. . . . The man of wisdom has no perplexities; the man of humanity has no worries; the man of courage has no fear"[63] Acting and thinking in accordance with humanity puts death aside as a problem, for if the Way is known in the morning, one can die serenely in the evening.

A closer review of the chun-tzu's qualities reveals that they are not mutually exclusive. They imply, overlap and often include one another. Human heartedness (jen / ren) is the essence of altruistic morality; it means a positive feeling toward the well-being of others and acknowledging their humanity and wanting to bring it to fulfillment: "If you set your mind on humanity, you will be free from evil."[64] Confucius was a "man of jen," confirmed by the existence of his school and devotion to his students. The ideograph for jen combines two characters, one for man, a second for the number two, indicating the closeness of one man to another and implying fellow feeling.

For Confucius, human heartedness is not an abstract admonition to "love your fellow man" at a distance. It suggests direct action and lifelong commitment. When asked what he wanted most in life, he replied: "It is my ambition to comfort the old, to be faithful to friends, and to cherish the young."[65] Not only must one do well by others, but human suffering should be intolerable to the virtuous man. In the Confucian moral world, jen is the core virtue, the thread that runs through the master's teachings.

Wisdom, or inner integrity (chih / zhi) means standing up for what is right with an impartiality uncorrupted by personal desire: "Someone said, 'What do you think of repaying hatred with virtue?' Confucius said, 'In that case what are you going to repay virtue with? Rather, repay hatred with uprightness and repay virtue with virtue."[66] In this saying, Confucius is out of harmony with Christian teaching that you should love your enemy. Another way of putting the matter is to repay injustice with justice.

Reciprocity, also called altruism (shu / shi), is best explained as a version of the biblical golden rule: "When you go abroad, behave to everyone as though you were receiving a great guest. Employ the people as if you were assisting at a great sacrifice. Do not do to others what you do not want them to do to you."[67] For Confucius, shu is a light to dispel darkness for a lifetime, a completely reliable guide. The word shu means "one's heart," and suggests being guided by a feeling of fellowship with other men in the challenges and trials of life, extending oneself in good will to others. On the other hand, care must be taken in the choice of friends: "There are three kinds of friendship which are beneficial and three kinds which are harmful. Friendship with the upright, with the truthful, and with the well-informed is beneficial. Friendship with those who are meek and who compromise with principles, and with those who talk cleverly is harmful."[68]

A sense of right and wrong (i / yi) defined the Confucian "evaluating mind," which, at least in theory, set the chun-tzu apart from everyone else: "The superior man understands the higher things (moral principles); the inferior man understands the lower things (profit)"[69] Some actions must be avoided at all costs because they are bad, while others are mandatory because they are unconditionally good. What distinguishes actions according

to *i* from all others, such as putting on a teakettle or deciding what to wear for the day, is their moral rightness. Out of all the actions performed by human beings in a lifetime, this is the only one that makes them human and has a clear relationship to both jen and shu: "The superior man regards righteousness (i) as the substance of everything. He practices it according to the principles of propriety. He brings it forth in modesty. And he carries it to its conclusion with faithfulness. . . ."[70]

The idea of an evaluating mind is the heart of orthodox Confucian moral philosophy. The later, received standard for understanding human nature is that no one lacks an evaluating mind capable of distinguishing right from wrong. This view became official when *The Book of Mencius* was adopted in 1313 C.E. as one of the required classics that had to be mastered for the imperial examinations. Confucius, however, appears ambivalent in the *Analects* about the evaluating mind as a universal human trait: "To those who are above average, one may talk about higher things, but may not do so to those who are below average."[71]

Loyalty, or conscientiousness toward others (chung / zhong) means wanting others to do well and assisting them to do so: "A man of humanity, wishing to establish his own character, also establishes the character of others, and wishing to be prominent himself, also helps other to be prominent."[72] Again: "The superior man brings the good things of others to completion, and does not bring the bad things of others to completion. The inferior man does just the opposite."[73] The idea of conscientiousness also means making demands on oneself: "[A good man] does not worry about not being known by others but rather worries about not knowing them."[74] Loyalty to oneself as well as others means consciousness of personal faults, weaknesses, and failures, in short, what the classical Greeks called "self-knowledge." Indeed, conscientiousness toward others is not likely without honest knowledge of one's own internal moral terrain.

Filial piety (hsiao / xiao) for parents is for Confucius the foundation of being human. A sense of humanity is formed in the family and only then can be extended to others. Respect and benevolent regard for others begins at home: "Never disobey . . . When parents are alive, serve them according to the rules of propriety. When they die, bury them according to the rules of propriety and sacrifice to them according to the rules of propriety."[75] Criticism of parents has limits: "In serving his parents, a son may gently remonstrate with them. When he sees that they are not inclined to listen to him, he should resume an attitude of reverence and not abandon his effort to serve them."[76] Filial piety not only required years of official mourning when parents died, but imposed an obligation not to harm one's body during life so it could be returned at death as it was received from one's parents.

The Christian idea that one should love mankind in general (a doctrine proposed as a "Way" to harmonize the world by Mo-tzu), seemed to Confucius psychologically unrealistic and contrary to experience. In early life one can love only those who are close by—father, mother, brothers, and sisters. That primary love can be extended to others by wishing them well, acting benevolently, and assisting their moral development: What more can be asked of human beings usually uneasy with anything or anybody remote and strange? The chun-tzu is a vehicle of fraternal love, which begins in the family, expressed with cultivation as propriety and humanity: "If a superior man is reverential (or serious) without fail, and is respectful in dealing with others and follows the rules of propriety, then all within the four seas (the world) are brothers."[77]

Qualities indispensable to the character of a chun-tzu are supplemented by two "outer virtues" that round off his character. The outer virtues enable a man to behave properly in every possible setting with people from different walk of life. The superior man needs also a respect for decorum and ritual (li), and a demeanor without rough edges that invests him with culture (wen). Being cultured for Confucius meant an appreciation of music and poetry as evidence of a sensitive demeanor. One of the books he praised is the *Classic of Poetry*. The value of poetry, among other things, lies in its power to inspire self-reflection, improve skill with words, and relieve daily tensions.[78]

The idea of li is especially central to Confucian thought. Without ritual there are no external forms or rules to shape inner attitudes. The performance of rites was originally a fixture of the hereditary aristocracy. The later universality of ancestor worship gave ceremonial observances a hold on almost everyone. For Confucius, participation in ritual was less a set of precise observances than a means of regulating emotion, building character, and strengthening social ties. Propriety is to know the rules and code of behavior that maintain social harmony. Li implies more than simply conformity to whatever is customary; it means right behavior at all times and in all circumstances, behavior that flows from moral judgment.

Rites are meaningless if merely for show and performed insincerely, especially at funerals, where, in Confucius' time, hypocrisy and material exhibitionism apparently thrived: "In rituals or ceremonies, be thrifty rather than extravagant, and in funerals, be deeply sorrowful rather than shallow in sentiment."[79] Confucius transformed li from a once narrow meaning to a universal one embracing his ethical system. Propriety came to mean demonstrating all the virtues of a superior man consistently and at once. To act with li was to be a man of humanity in the fullest sense.

Without culture, a morally correct person may be abrupt, discourteous, and boorish: "When substance exceeds refinement (wen), one becomes rude. When refinement exceeds substance, one becomes urbane. It is only when one's substance and refinement are properly blended that he becomes a superior man."[80] The chun-tzu is expected to be a gentleman in the fullest sense. He is also expected to know a charlatan and a fool when he sees one.

A subtle Confucian idea is that words and perceptions can lie about reality. Men and events may be characterized in ways that are false. The chun-tzu must be alert and ready to rectify terms, to call things by their real names and expose what they really are: "When a cornered vessel no longer has any corner, should it be called a cornered vessel? Should it?"[81] Should a man dishonest, treacherous, conniving, and indifferent to right in private life be called a superior man? In public life, if a ruler is irresponsible, selfish, negligent, and egotistical, should he be called a king? Confucius declared this principle without openly tearing away the veil of "public relations" and image building that rulers of his time hid behind. As we shall see, Mencius went about exposing and questioning the great and powerful with relish.

The Confucian sage at his best means an individual who acts effortlessly on behalf of what is right. The evaluating mind responds to every situation with inner calm and tranquility. Conscious evaluation of deeds, words, and thoughts is needed in the early stages of developing a character governed by the primary virtues. In time, however, the superior man becomes a sage whose movements and choices are spontaneous, flowing

without impediment from a self in seamless harmony with the world of man. At that stage, when the sage acts rightly without calculating ends, there is convergence of the Confucian Way with the Taoist Way, a point to which we will return.

Means of cultivation in a Confucian education, which included the moral example of Confucius, was immersion in the Five Classics of poetry, history, ritual, annals, and changes, and supplemented later by the "Four Books," the *Analects,* the *Mencius,* the *Great Learning,* and the *Doctrine of the Mean.* This literature was about the past and dwelled largely on moral, social, and humanistic issues. There was no instruction in technical subjects, unless one views the *Book of Ritual* as a kind of technical treatise with moral implications, unlike a book on bridge building. The chun-tzu was not viewed as a technician confined by a narrow range of practical knowledge and craft: "The superior man is not an implement."[82] He is not like a tool needed to fix a roof or to cook a banquet. Rather he is a generalist whose distinction is maturely developed humanity and moral knowledge of what is right.

Technicians cannot be trusted to advise rulers and are incapable of harmonizing the world through virtuous acts. Their interest is confined to specialization. This anti-technical point of view, shared by men who in due time became the ruling class, explains in part why China's science and technology, although the best in the world around 1500 C.E. during the Ming dynasty, was strictly controlled and kept on the margins of society to restrain technocrats who might disturb the social order.

Mencius (Mengzi)

Founder of the idealist sect of Confucianism, Mencius lived from about 372 to 289 B.C.E. He revered the past and the legendary sage kings like Confucius and referred to his own age as "a drowning empire."[83] Unlike Confucius, he did not hesitate to confront rulers and remonstrate with them. When asked by a king if it was right for a minister to murder his king, he replied: "He who injures humanity is a bandit. He who injures righteousness is a destructive person. Such a person is a mere fellow. I have heard of killing a mere fellow Chou, but I have not heard of murdering (him as) the ruler."[84] This passage is also a good example of the Confucian "rectification of terms," saying outright what things really are. Like Confucius, Mencius says it is better to die than to betray righteousness and humanity: "I love life, but there is something I love more than life, and therefore I will not do anything improper to have it."[85]

He agreed with Confucius that love begins in the family and is then extended by degrees of fitness to others. Relationships are not on the same level and call for different magnitudes of feeling and types of commitment: ". . . between father and son there should be affection; between ruler and minister, there should be righteousness; between husband and wife, there should be attention to their separate functions; between old and young, there should be a proper order; and between friends, there should be faithfulness."[86]

He openly ranked scholars above hereditary aristocrats: "The compass and the square are the ultimate standards of the circle and the square. The sage is the ultimate standard of human relations."[87] To know what is right, one must think rather than kneel blindly to authority or live a mindlessly conventional life: "To act without understanding and do so

habitually without examination, following certain courses all their lives without knowing the principles behind them—this is the way of the multitude."[88] He was aggressive in argument and cared little about making mistakes or being inconsistent. What mattered was staying on course with principle.

He applied virtue to success, arguing that it could move one ahead of others, and came up with concrete legislative programs for rulers to consider, like his well-field system for working the land, a square divided into eight inner-squares, two along each side of the rim for peasants, the ninth in the middle to be worked communally to pay taxes. He also proposed the creation of government-supported schools for the people.

His greatest single idea, however, and the one that influenced future generations of Chinese, is the natural goodness of man, a claim Confucius did not make. When born, a person has what Mencius calls the four beginnings of compassion, shame, modesty, and knowledge of right and wrong, which in due time, with cultivation, will blossom into mature virtues: "The feeling of commiseration is the beginning of humanity; the feeling of shame and dislike is the beginning of righteousness; the feeling of deference and compliance is the beginning of propriety; and the feeling of right and wrong is the beginning of wisdom. Men have these Four Beginnings just as they have four limbs."[89]

Seedlings of a chun-tzu are present in the human breast waiting to be cultivated by education, example, and practice: "If a man can give full development to his feeling of not wanting to injure others, his humanity will be more than he can ever put into practice.'[90] If men become evil, it is because the four beginnings have been corrupted or blocked by bad example, evil circumstances, or ignorance of principle. His four beginnings led Mencius to a quasi-mystical belief that what matters is already complete within human nature. All that remains is for education to preserve and nourish it.

Hsun-tzu (Xunzi)

Hsun-tzu, the founder of Confucianism's realistic sect, was active around 298–238 B.C.E. If Mencius was optimistic in his doctrine of original human goodness, Hsun-tzu was pessimistic and claimed the opposite—that humans are intrinsically bad and self-seeking: "The nature of man is evil; his goodness is the result of his activity. . . . Crooked wood must be heated and bent before it becomes straight. . . . Without teachers and laws, man is unbalanced, off the track, and incorrect, Without propriety and righteousness, there will be rebellion, disorder, and chaos."[91] He is explicit enough about the meaning of good and evil. "By goodness at any time in any place is meant true principles and peaceful order, and by evil is meant imbalance, violence, and disorder."[92]

Rules of propriety were laid down by "the sage-kings of antiquity." They had an exceptional hunger for virtue and consequently acted with exceptional determination to acquire it.

The rules must be absorbed from the outside by education and laws. Hsun-tzu was critical of Mencius, who, he felt, went wrong because he failed to distinguish between human nature and human effort. Men can be schooled in goodness, but it is does not exist prior to instruction and guidance. Men hunger for propriety just as they hunger for food, good looks, or comforts, but all such things must come from the outside.

His naturalism went so far as to argue that Heaven should be controlled rather than

obeyed: "Instead of regarding Heaven as great and admiring it, why not foster it as a thing and regulate it? Instead of obeying Heaven and singing praise to it, why not control the Mandate of Heaven and use it?"[93] These ideas, which might have led to a scientific attitude and even a belief in progress by controlling natural phenomena, were rejected by Taoists and by most Confucians. Thereafter the emphasis was squarely on an organic harmony of man with the moral order of Heaven.

Both conflicting views of humanity were important to the unfolding of Chinese thought in dynastic China. Hsun-tzu was the teacher of Han Fei-tzu (Han Feizi), the legalist philosopher, and Li Ssu (Li Si), chief minister to the first Ch'in emperor, both of whom accepted the view that man is evil and needs restraint. Mencius was less well regarded than Hsun-tzu during the Han dynasty, whose rulers were attracted to his view that flawed human nature requires control as well as cultivation, which resulted in a fusion of Legalist and Confucian ideas. In later centuries, Hsun-tzu fell by the wayside, and Mencius was declared next in line after Confucius in doctrinal transmission.

Apart from the argument that human nature is evil, Hsun-tzu's reputation suffered because he was associated with a dynasty that persecuted Confucians and imposed a severe Legalist philosophy on all of China, an era later repudiated by all good Confucians. Also working against him was a thoroughgoing skepticism about the respected theory of portents and their connection with a Mandate of Heaven, which he condemned as unfounded superstitions. With Hsun-tzu squeezed out of the inner circle, Mencius's doctrine of man's natural goodness was embraced and became official in Neo-Confucianism, while, during the Sung dynasty, the *Book of Mencius* became one the Four Books added to the original Five Classics. Hsun-tzu's writings were excluded from the canon of classics.

Han Dynasty Confucianism

During the Han, Confucian moral, political, and social ideas underwent a transformation in the hands of one man, Tung Chung-shu (Dong Zhongshu), who was largely responsible for making his version of Confucianism the official state philosophy and laying the foundations of the examination system.[94] While the new dispensation was in many respects a mask for Legalist principles, it nevertheless imposed limitations on the emperor and gave officials some leverage in his regime. The realities of despotism were softened by an overlay of Confucianism expressed in a comprehensive vision of man in nature and society.

Tung Chung-shu was the first philosophical system-builder in the Chinese tradition. He proceeded methodically to discuss the world, human nature, the ethics of social relationships, personal virtue, and the responsibilities of imperial rule, stitching all of it together in a grand synthesis. He made explicit in most domains of Chinese thought the principle of correlation, in which everything is connected dynamically to everything else, and provided Confucian officials with a powerful tool to restrain the excesses of rulers—warnings from Heaven through portents in nature that the mandate to rule might be withdrawn.

With respect to the world, he identified ten constituent parts—Heaven, Earth, Man, yin and yang, and the Five Elements. All things come from Heaven, Man, and Earth. Heaven originates things, Earth sustains them, and Man brings them to perfection. Yin and

yang wax and wane, rising to a peak and then declining, doing so in relation to the four directions, the four seasons, and the Five Elements, and making a circuit as they rise and fall. Heaven favors yang over yin despite their mutual dependence. The Five Elements are related in patterns of mutual production and mutual dominance; for example, wood produces fire but overcomes soil, while fire produces soil but overcomes metal.

Man achieves moral perfection by means of culture, specifically ritual (li) and music (yueh / yue). In all of this, the correlative or relational way of thinking is the guiding principle. Tung Chung-shu's account of man illustrates this principle: "Therefore in the body of man, his head rises up and is round and resembles the shape of heaven. His hair resembles the stars and constellations. His ears and eyes . . . resemble the sun and the moon. The breathing of his nostrils and mouth resembles the wind."[95]

On the question of human goodness, Tung Chung-shu quibbled with Mencius about the natural goodness of man and held that human nature is not already good but rather potentially good. While man is not evil, his latent goodness must be cultivated through study, example, and practice. Relations in society are governed by yin and yang with numerous correlations. Three of the five relationships were singled out—sovereign and subject, husband and wife, and father and son—as correlates of yin and yang. Personal behavior was to be guided by the five Confucian virtues. Although Tung was not explicit about connections between the Five Elements and the cardinal directions, other Han scholars noted correlations—e.g., righteousness with metal in the east, propriety with fire in the south.

Tung Chung-shu then focused these ideas on imperial politics and the succession of dynasties, arguing for a correlation between government and Heaven. The ruler has four ways of governing (benevolence, rewards, punishments, executions) and Heaven has four seasons; each, in effect, has a counterpart. Such an intimate set of connections means that whatever happens in government must affect Heaven and generate a response. If a ruler is unjust and negligent, the outcome will be portents (warnings) and prodigies (threats) delivered by Heaven—earthquakes, famine, meteor showers, drought, floods, and uprisings.

Since rulers founded a dynasty based on the Mandate of Heaven, they must be vigilant about portents and prodigies and take them seriously as warnings that without reform dynastic collapse lies ahead. The theory of portents also encouraged officials as a matter of duty to remonstrate with the emperor if he fell short. The Han dynasty had succeeded the Ch'in after only fifteen years even though the First Emperor aspired for his regime to last forever, which was interpreted by Tung Chung-shu to mean that no dynasty could last forever even if it were virtuous. In due time Heaven would call for a change no matter how worthy the emperor.

Sung Dynasty Neo-Confucianism

The Han Confucian synthesis did not survive the bloody collapse of the dynasty, but its correlative philosophy and theory of portents lived on a thousand years later in a new synthesis called Neo-Confucianism, or the School of Nature and Principle (hsing-li hsueh / xingli xue). What was unique about Neo-Confucianism was a cosmology that took into account Buddhism and Neo-Taoism, which were spiritual and intellectual forces

in China during the period of disunity. When the short-lived Sui dynasty restored the empire in 589 C.E., Confucianism was called on once more to provide guiding principles and worthy men to serve in the state bureaucracy, but Buddhism continued to enjoy imperial patronage.

When the T'ang dynasty succeeded the Sui in 618, competition between Confucianism and Buddhism intensified. Both land and people had been harnessed by thousands of monasteries throughout the land, depriving the government of needed tax revenue to pay the bills, corvée labor to undertake building projects, and loyal supporters of the Confucian way. A prominent Confucian scholar, Han Yu / Han Yu (768–824), launched a ferocious attack on Buddhist ideas and practices that paralleled government persecution of Buddhist establishments, although official motives were political and economic rather than religious. In the ninth century, numerous monasteries were dissolved, their land confiscated, and untold thousands of monks returned to the tax registers. The way was cleared for a serious revival of Confucian thought, but not without the inclusion of Buddhist ideas, especially those of Ch'an Buddhism.

The times called for a wide-ranging philosophical system to rival and displace Buddhist thought, which set an example for detail, sophistication, and comprehensiveness of metaphysical speculation, the sect known as T'ien-t'ai (Heavenly Terrace) being a good example. The collective goal of Neo-Confucians was to weave a varied tradition of moral, political, and cosmological ideas into a coherent unity. Neo-Confucianism branched into two schools; one rationalistic, represented by Chu Hsi (Zhu Xi), whose commentaries on the classics became standard after his death in 1200, and one idealistic, represented by Wang Yang-ming in the sixteenth century.[96] Rationalistic Confucianism prevailed without debate until the idealistic school became successfully competitive, whereupon it enjoyed an excellent reputation for about 150 years. Then the rationalist interpretation reasserted itself, as idealism hovered in the background.

The basic difference between them was how ideas of "the Great Ultimate," principle (li), matter (ch'i), attentiveness, and "the investigation of things" were to be understood and applied to the nature of man, the meaning of humanity (jen), and political theory. The predominant idea in both schools was that particular things are united in a single reality (the Great Ultimate), and the single reality differentiates itself into particular things (li and ch'i), including material, moral, social, and political dimensions of reality. For the rationalists, there was a distinction between mind and the world. For the idealists, there was only mind. Both schools were heavily influenced by Buddhist and Neo-Taoist ideas. Neither would have been recognizable or even intelligible to earlier Confucianists.

Chinese rationalism in its Neo-Confucian guise was clearly articulated by Ch'eng I (Cheng Yi), one of its early theorists: "All things in the world can be understood in the light of reason. Each entity works according to its principle or the order of nature. In each, therefore, there is reason."[97] The scope of reason did not include systematic, empirical study of natural phenomena with the purpose of discovering verifiable laws. For these Chinese thinkers, empiricism had a different meaning: "Investigation of reason may be carried out in many ways: by reading books, by discussion, by evaluating the personalities in history and their actions, and by discerning the correct responses to what comes. All these kinds of procedure may be called investigation of reason." Now and then, however, something like an empirical understanding of nature surfaces in his

thought. On the question of ghosts, Ch'eng I says: "Did you see it with your own eyes? One should believe only in what one sees with one's own eyes. What is told in a story is not worthy of credence. Even what one sees with one's eyes may be caused by an ocular deficiency."[98]

Ch'eng I's skepticism is reminiscent of thinkers like Hsun-tzu and Wang Ch'ung Wang Chong), who became marginal in the Confucian tradition. The latter, for example, expressed his "hatred of falsehood and fictions," and affirmed that "in argument there is nothing more decisive than having evidence."[99] Neo-Confucian rationalism, however, was predominantly metaphysical, and its physical theories were elaborations of traditional notions of yin and yang, the Five Elements, and their numerous correlations with social, natural, mythical, and cosmological ideas.

The Chu Hsi school believed that all existing things are a combination of matter (ch'i) and a principle (li), which makes them what they are, be they shoes, ships, sealing wax, cabbages, or kings. But li exists prior to and independently of nature, which would be pure undifferentiated ch'i unless given shape and form by li. All individual manifestations of li that give shape and movement to the world are gathered up in one undivided reality, the Great Ultimate, which differentiates itself into the li needed to shape ch'i into particular things.

While this sounds like dualism, li and ch'i being separate from one another until brought together, that was not Chu Hsi's intention, even though his doctrine resembles Plato's theory of forms and his notion of the Form of the Good, which unites all the abstract forms that give shape to the world. Principle does not come from the outside, but is inherent in a particular thing, such as human nature, which is nothing more than li inherent in a human being. The principle of human nature is the Confucian virtues, especially human heartedness and a sense of right and wrong, both governed by propriety: "The Way (the Tao, Moral Law) is identical with the nature of man and things . . . The nature consists of concrete principles, complete with humanity, righteousness, propriety, and wisdom."[100]

Chu Hsi's interpretation of extending knowledge through investigation was comprehensive: ". . . everything should be investigated to the utmost, and none of it is unworthy of attention. Although we cannot investigate all, still we have to keep on devoting our attention to them in accordance with our intelligence and ability."[101] Obviously even the highest intelligence and ability must be selective if knowledge of various principles is to be extended, for the principles of morality cannot be exhausted. Not surprisingly, the priority for man is the principle of his own nature. The individual investigates "the nature of things" by looking into his own nature and cultivating its inherent li. Moral knowledge that comes from investigation must result in action. To know what is right and not pursue it is to be incomplete: Although knowledge comes first, action turns out to be more important. Good and evil result from different states of ch'i, which can be pure and clear or dark and muddy. Reflection joined with action is the means of purging away the muddiness and burnishing the pearl of li embedded in the ch'i of human nature.

The sage kings had pure ch'i wherein the principle of humanity was transparently evident, the source of their enlightenment and wisdom. Most humans have turbid ch'i, which must be cleansed in order for principle to emerge pristine from the grime. The means for cleansing ch'i is sincere attentiveness to li. A major influence on Chu Hsi was the teaching of Mencius that all is complete within us with the Four Beginnings (sympa-

thy, shame, deference, sense of right and wrong), which only require sincere cultivation to become mature virtues. Also influential were *The Doctrine of the Mean* and *The Great Learning*. From those works he elaborated the ideas of "attentiveness," "sincerity," and "investigating the nature of things."

Since government is a particular thing, it has a defining principle, which turns out to be no less than the governing philosophy of the ancient sage kings—a state harmonized by stability, prosperity, and benevolent rule. The ruler, as well as his advisors, ministers, and officials, must realize his own nature by investigating its principle, but there is the additional task of understanding and implementing the principle of good government, the key to harmonizing the relations of Heaven and Earth. The symbolic act of bringing kingly virtue into harmony with Heaven and Earth was the annual rite of sacrifice at the Altar of Heaven in Peking.

Everything in existence has a defining principle, while all principles are united as one in the Great Ultimate: "The Great Ultimate is nothing more than principle . . . Fundamentally there is only one Great Ultimate, yet each of the myriad things has been endowed with it and each in itself possesses the Great Ultimate in its entirety. This is similar to the fact that there is only one moon in the sky, but when its light is scattered upon rivers and lakes, it can be seen everywhere."[102] In this way, Taoist ideas about nature, Buddhist metaphysics, correlations of yin and yang and the Five Elements with "myriad things," and Confucian ideas of sageliness within, kingliness without, benevolent government, and life-long self-cultivation were fused into a comprehensive vision of reality.[103]

The great Sung landscapists, painting visions of man and the world while Neo-Confucianism took shape, sought in part to express the unity of nature, man, and society with brush and ink, which in turn could lead to self-cultivation and the investigation of things.

16

China's Religion and Mythology

There is no word for "religion" in Chinese as the idea is understood in the West. The most commonly used word, chiao (jiao), in traditional times meant something like "guiding doctrine" and was applied to many forms and objects of worship.[104] Cults, myths, and associated religious beliefs had considerable impact on Chinese decorative art. In some respects, like religious culture in ancient India, chiao was eclectic, drawing freely from various sources. It was polytheistic in its acceptance of multiple supernatural beings (e.g., spirits of the dead roaming the earth had to be placated), and practical rather than theoretical in its goals. Institutional religion included Buddhism, Taoism, and various sectarian societies, meaning that there were temples, shrines, and secret places for groups to assemble for ceremonies and rites.

There was no established religion, like Roman Catholicism in the European Middle

Ages, no priests who were authoritative for everyone, as in John Calvin's Protestant Geneva, no universal religious doctrine, like the Nicene Creed agreed on by Christian bishops in the fourth century Roman Empire. Chinese religion in traditional times had four dimensions: worship of Heaven, veneration of ancestors, divination, and sacrifice. In all of this, ritual and ceremony were fundamental and often elaborate.

The Confucian *Book of Rites* (*Li chi*) says that all things come from Heaven and that humans come from their ancestors. The cult of Heaven was reserved for the emperor and his court, an official religious practice designed for the few. Ritual sacrifices offered at the Temple of Heaven in Peking by the emperor and a huge retinue followed Confucian doctrine, and were intended to harmonize heaven, man, and earth to confirm the emperor's mandate to rule. This quasi-religious belief was based on the idea that a moral force (not a god) centered in Heaven governs the universe, and that every dynasty relies on a heavenly sanction, the Mandate of Heaven. Ordinary people did not participate in the ritual or even look on from the sidelines.

Ancestor worship was a diffused form of religion and nearly universal in its practice; rites could be performed only by the male head of a family. Acknowledging ancestors was considered essential for good fortune and continuity of the family. In the traditional Chinese view, there is a world of spirits that exists parallel to the human world. The belief was that humans have two souls—hun and po / bo. The first goes to some poorly defined and vaguely understood heaven. The second remains on earth as a guide to the ancestors but also as a potential agent of good or bad fortune. If the po spirits are restless and unhappy, they can make trouble. The purpose of periodic rituals was to make the spirits of ancestors comfortable and retain their good will, while affirming the gratitude of those whose existence the ancestors made possible.

A belief in divination, or foretelling the future by reading signs, was codified in the *I Ching's* system of trigrams and hexagrams, which were believed to encompass all phenomena and processes of nature. Evidence of systematic divination goes back to Shang times in the second millennium B.C.E., and the first Chinese writing arose in part to ask questions about the future and to record answers. The early characters are clearly visible on an "oracle bone"—turtle shells or animal bones subjected to heat at certain points to induce cracking. The fissures were then read by the diviner to supply answers to questions about the future (fig. 16.1). This example showing archaic Chinese characters asks about rain in the future.

The tradition of sacrificial rites to honor ancestors and spirits also stretches back to the Shang period in the second millennium B.C.E. Technically sophisticated and symbolically rich, bronze vessels were produced in great numbers as ritual offerings whose hieratic motifs continued to be used with variations by Chinese craftsmen for some 1,500 years. The word "hieratic" refers to the religious meaning of objects used in sacrificial rites associated with ancestor worship. The vivid mythical animal masks, or t'ao- t'ieh / taotie ("glutton"), probably were believed to embody powerful spirits (fig. 16.2).

The monster mask is bi-symmetrical, split down the middle, and can be viewed in two different ways. The two sides seen together are a *t'ao t'ieh,* a monster. However, each side, viewed in profile, is a highly stylized face called a dragon, or k'uei / kui, which, according to inscriptions on the vessels, was associated with royal ancestors. They stand nose to nose, identified by a horn, eye, and single claw. Other animal motifs are promi-

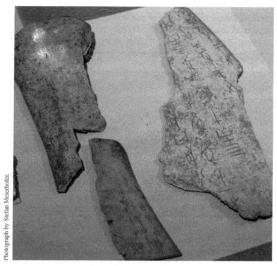

Fig. 16.1 Fragments of oracle bones with inscriptions, Shang Period.

nently displayed, dolphins at the top of the mask and cicadas below. In the interstices are spirals confined in small squares, the lei-wen, or "thunder pattern." The vessels were believed to have magical properties. About half of all recovered bronzes have some 15,000 inscriptions inside dedicated to ancestors.[105]

This assortment of brilliantly integrated hieratic motifs did not emerge all at once but underwent a long development, culminating about 1300 B.C.E. in the late Shang style. After the conquest of the Shang, bronzes continued to be made in the long Chou period, but over time the hieratic motifs lost their religious meaning and became secularized as surface decoration. The loss of imaginative and symbolic power is easily perceived by comparing a mature Shang vessel with one from about 400 B.C.E. in the Chou period, which merely has animal figures scratched into the surface (fig. 16.3).

Sacrifices accompanied all ritual acts. In the domestic ancestor cult, this meant gestures like bowing before a symbol of the ancestor—usually pictured on a tablet—burning incense and candles, offering food and drink to sustain the spirit, and chanting prayers. In addition to ancestral spirits, Chinese recognized an array of "gods" worthy of pious sacrifice. Among them were gods of the elements, such as wind, water, mountains, and fields; spirits of eminent men and ancient sages; brave martyrs; and even loyal officials. Thus the word

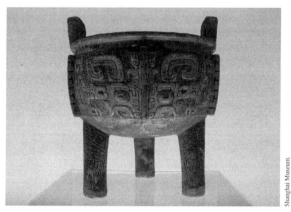

Fig. 16.2 Bronze vessel, Late Shang period.

"god" referred to a multitude of beings and had precedents going back to pre-imperial times. Meanwhile, popular Buddhism supplied its devotees with an ample assortment of heavens and hells inhabited by compassionate Bodhisattvas and malevolent demons, all of whom required some kind of representation in forms of art.

The most auspicious sacrifice of the year was made by the emperor to Heaven, his only superior in the universe. The time was at dawn on the winter solstice; the place from Ming times on was the Temple of Heaven complex in Peking, construction of which began in 1420—a sacred ceremonial center and a masterpiece of abstract symbolism from which the Chinese empire was adjusted to the cosmic order (fig. 16.4). The complex has three parts along a one-mile route—the three-tiered, circular Altar of Heaven situated in

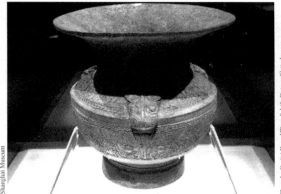

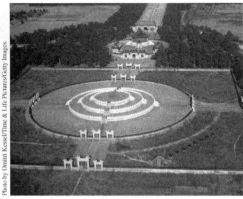

Fig. 16.3 Bronze vessel, type Tsun, middle-Shang period.

Fig. 16.4 The ceremonial complex called "The Temple of Heaven," Yuan dynasty, fifteenth century, Peking.

a square; the Temple of Heaven, the small peaked structure just between the two open gateways; and the Hall of Annual Prayers at the other end (not visible), the whole often referred to as the "Temple of Heaven." The complex in south Peking did not exist in the thirteenth century when the Mongols invaded, but it is reasonable to assume, given Chinese attachment to tradition, that ritual acts to honor Heaven remained much the same in the fifteenth century when the physical setting changed.

The ceremony took three days, and there were three stops on the emperor's mile-long ritual journey from the Hall of Annual Prayers to the Temple of Heaven and finally to the Altar of Heaven, attended by hundreds of officials, courtiers, and servants, all with prescribed roles.[106] Rites included fasting, meditation, and purification by the emperor. No doubt the emperor's Confucian advisors reminded him that without sincerity, ceremonies would be in vain, and they may have quoted *The Great Learning*: "What is meant by 'making one's' thoughts sincere" is this: "One allows no self-deception, just as when one hates a hateful smell or loves a lovely color. This is called being content within oneself, and this is why the noble person must be watchful over himself in solitude. The petty person, when living alone, is quite without restraint in doing what is not good."[107]

The living sacrifice of an unfortunate bullock was done in the Hall of Annual Prayers (fig. 16.5). The building rests on a marble platform with three levels, symbolizing the cosmic triad of Heaven, Man, and Earth (the symbolism of "three" is imprinted everywhere). From there the emperor was carried in a palanquin, over a marked path only for him, to the next stop just short of the altar, the Temple of Heaven, where he would engage in more prayers. At dawn on the winter solstice, he would mount the Altar of Heaven through triple gateways to three superimposed circular, marble platforms surrounded by a circular wall, symbolizing Heaven, which in turn is enclosed by a square wall, symbolizing Earth (fig. 16.6).

The altar is organized on the numerical principle of three and multiples of three, nine being the square of three and the highest single-digit yang number. The three tiers of the altar stand for Heaven, Man, and Earth, the circles are Heaven (the realm of nature), and the square is Earth (the realm of man). The three tiers have artfully carved marble

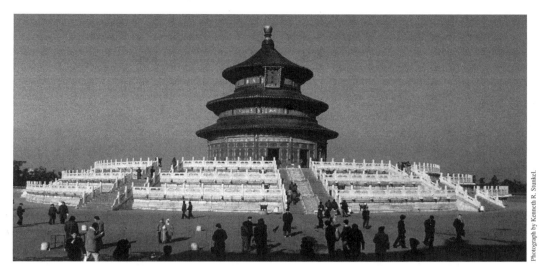

Fig. 16.5 Hall of Annual Prayers, Temple of Heaven complex.

balustrades topped with posts in multiples of nine. The first platform has 180 posts, the second 108, and the third 72, totaling 360, which comprises the full circuit of Heaven.[108] The emperor took his place as cosmic harmonizer, the Son of Heaven, at the center of the third tier. Nine circles or heavens radiate outward from him to culminate in an outer circle of eighty-one stones, the square of nine. In his central position, the emperor acknowledged obeisance only to Heaven. There is no roof, for the emperor is obliged to commune with Heaven directly.

All elements from the Hall of Annual Prayers to the Altar of Heaven are arranged along a horizontal axis, but the ideal arrangement would be a vertical axis beginning

Fig. 16.6 Entrance to the Altar of Heaven, Temple of Heaven complex.

with the Hall and culminating in the roofless Altar, with gateways to Heaven in between. The sacrifices included libations to Heaven, Earth, and his ancestors, a reading from jade tablets, and a sipping of ritual wine. The meaning of these acts lay in the ceremonies, not in religious feelings. Ritual was expected to harmonize the cosmic triad. The political order over which the emperor presided was paralleled by the cosmic order. The two were acknowledged to be in harmony through the power of ritual sincerely executed by the ruler holding the Mandate of Heaven.

17

China's Way of Thinking

Tendencies of traditional Chinese thought can be summarized as follows:

- A preference for the concrete over the abstract
- Veneration of the past
- Mostly indifference to logical argument
- Acceptance of hierarchy and patriarchal authority in social relations
- Reverence for nature as an organic unity
- Emphasis on harmony in all things
- Religion as a worldly means of harmonizing individual, family, and world
- Aloofness to foreigners.

In most respects, these tendencies of thought contrast sharply with those of traditional India.

Unlike the Indian outlook, the Chinese hew close to concrete experience, particular things, and the immediate world of formal social relations. There is little taste for lofty abstractions. This attitude was influenced by the written language. Individual characters communicate directly and vividly to the brain. Ideographs do not lend themselves to the discursiveness found in Sanskrit writings, although some Chinese philosophical writings are in extended prose. The writing of Taoists and Confucians, with qualified exceptions like Chuang-tzu (Zhuangzi), the Taoist mystic, Hsun-tzu (Xunzi), the Confucian realist, and Wang Ch'ung (Wang Chong), the skeptic, for the most part neglect logical argument and make no persuasive effort to supply observational evidence or reasoned proof for assertions about nature, society, and man.

Thus, one of the most ambiguous of Confucian sayings, that one must "investigate the nature of things," did not mean systematic, empirical scientific inquiry, whatever else it means. Chinese philosophy does not have an equivalent of Aristotle's *Posterior Analytics*, the first systematic treatise on logic. It is significant that Buddhist treatises on logic were not translated into Chinese. The followers of Mo-tzu, the champion of universal love,

identified three tests of an argument—the root of the assertion, the evidence for it, and the use of it, which is a bit like saying: (1) God exists on biblical authority, (2) because many people have experienced His presence, and (3) without His teachings, society would be worse off. For the Chinese, the first meant agreement with the ancient sage kings; the second, self-confirmation in personal experience; and the third, practical results for a moral life.[109] The first and third tests were adopted by Confucians.

In the main, however, argument for Chinese thinkers meant convincing another party by first sizing up his views, personality, and dispositions, and then bringing him around with irresistible eloquence. Isolation and analysis of similarities shared by objects and phenomena that could be formulated as regular laws of nature were always less important than finding correlations between opposites in a world of myriad organic relationships.

Two reasons for the neglect of logical argument can be suggested. First, adoption of Confucianism as the unchallenged philosophy of the empire meant that priority was given to moral and political issues requiring the judgment of an evaluating mind steeped in distinctions of right and wrong. To the generalized scholar-official, logic was a technical discipline unworthy of a "noble man." Social and moral issues were always more important than logical ones and were settled in a dispute by superior moral judgment rather than skillful argument. Second, after the Han dynasty, when the first important synthesis of Confucian moral philosophy with cosmological ideas took place, thought was emphatically relational, with no interest in understanding the world through an analysis of observable causal relations.

Consultation of elaborate charts of correlations between yin and yang, the Five Elements, and everything else in nature was enough to settle a dispute about what was happening or might happen. Logical demonstration was neither appropriate nor necessary. The Chinese were surely close to nature, which was simply accepted as a fact (the Chinese word for "nature" is tzu-jan / ziran, or "self-thus"), but it was a self-contained "nature," operated on internal principles, and organic in the sense that all its parts interacted mutually to maintain equilibrium and harmony.

The traditional Chinese way of thinking about self, society, and the world had remarkable consistency and uniformity, which were defined and reinforced by the power and longevity of the Confucian tradition. Deliberate, innovative change was resisted. Antiquity was the model, with its culture heroes, legendary or real examples of virtuous rule, and wise men on whom few had improved. Change was inevitable, but for the Chinese it was always change guided by tradition and exhaustive reference to the past. No major change could be made without support and vindication from events, wise men, and books that had gone before. As Confucius said, "A man who reviews the old so as to find out the new is qualified to teach others."[110]

All renowned Confucian reformers in Chinese history, from Wang An-shih (Wang Anshi) in the eleventh century to K'ang Yu-wei (Kang Youwei) in the nineteenth century, felt obliged to justify radical proposals to the throne with interpretations of the classics that revealed precedents and models for action in the present. Wang An-shih, a brilliant statesman-reformer, went before the emperor in 1068 to plead his case, first in language reminiscent of Legalism, then in unmistakable Confucian terms: "I am not going to argue that we should revive the ancient system of government in every detail. The most ignorant

can see that a great interval of time separates us from those days, and our country has passed through so many vicissitudes since then that present conditions differ greatly. So a complete revival is practically impossible. I suggest that we should just follow the main ideas and general principles of the ancient rulers."[111]

Chinese thinking about human relationships accepted status and hierarchy as social realities, with the family as the universal model. The justification for inequality was perceived differences between individuals and the need for clearly demarcated roles within a family. Not everyone is equal in experience, wisdom, and responsibility. Without the family, nothing could be done, and its stability depended on meeting obligations attuned to age and gender rather than proclaiming and demanding rights. This preference for hierarchy and inequality was extended as well to outsiders, who had a status lower in the scheme of things than their cultural superiors in the Middle Kingdom.

The traditional Chinese attitude toward foreigners as inferior outsiders and tribute-bearers was due in part to the experience of three centuries of disunity and occupation by foreign dynasties. A deeper explanation of this xenophobia from the southern Sung dynasty on is the self-confidence and satisfaction of a culture and society that became stable in all its parts. Institutions and ideas worked to the satisfaction of most Chinese for centuries after the expulsion of the Mongols in 1368 and the reaffirmation of "Chinese-ness" in the Ming dynasty. Ideas of a Middle Kingdom and a Son of Heaven presiding over All Under Heaven remained even when the Manchus took over in 1644.

For Chinese, there was no contradiction or spiritual discomfort in being Confucian, Taoist, and Buddhist all at the same time. Added to this eclectic mix were spirits of ancestors, local deities, and even ghosts. The emperor, his officials, and the scholar-gentry had Heaven as well ancestors to revere. The absence of a centralized church and religious doctrine left the individual free to find solace and inspiration from domestic and state cults. What mattered above all were rites to honor one's ancestors so that the strength and continuity of family ties might be confirmed. Annual sacrifices at the Temple of Heaven by the Son of Heaven were not intended to placate a god but to harmonize the triad of Heaven, Man, and Earth to ensure safety of the empire and continuity of the dynasty.

Religion and politics came together to confirm the universe as a self-sufficient organism and the emperor's role as the indispensable moral link with Heaven. If there was one theme that dominated traditional Chinese thought and institutions, it was the desire for harmony and the dread of chaos. Harmony in nature, harmony in the family, harmony in the state, harmony in individual character—these were the overriding priorities. The astonishing continuity and longevity of the social and political system under the Ming and Ch'ing dynasties demonstrate China's considerable success at controlling disorder with an intellectual ideal of harmony, at least, that is, until Europeans appeared in force to break the spell with opposing ideas.

18

China's Ideals of Beauty

Chinese arts and crafts have a continuous tradition of some 3,500 years. It is not possible to comment in this section on all forms that might qualify as art over the centuries, for the Chinese excelled at lacquer, bronzes, ceramics, textiles, and furniture-making as well as architecture, calligraphy, and painting. They carved marvelous works in ivory, wood, and jade.[112] For purposes of this discussion, a distinction is needed between "art" and "craft." Among the literati, forms worthy of discussion and theorizing as "art" were calligraphy and landscape painting, which of course were produced by that class. Everything else, including architecture and sculpture, was the work of humble craftsmen.

In the West, where ideas about art have been more expansive and inclusive in recent times, Chinese bronzes, ceramics, textiles, and jade have the status of minor arts. Bronzes and jades had an ambivalent status in China. Although produced by craftsmen of low social status, bronzes were collected and admired by connoisseurs among the literati, and jade was a subject of high theoretical speculation about its virtues and powers. Much sculpture was produced specifically to serve Buddhism, and in that domain the Chinese sculptural tradition was not outstanding, despite some pieces of exceptional beauty, vividness, delicacy, and workmanship produced late in the period of disunity and during the Sui, T'ang, and Sung dynasties (fig. 18.1).

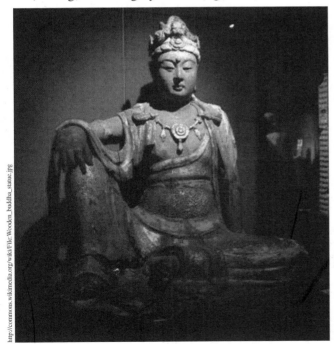

http://commons.wikimedia.org/wiki/File:Wooden_buddha_statue.jpg

Fig. 18.1 Seated Kuanyin, painted wood, late Sung (Song) Dynasty.

Images of Buddhas and Bodhisattvas generally were not executed in the round and were usually intended to be seen from the front. Other kinds of sculptural objects were produced—lions, tortoises, dragons, horses, and so on—to embellish palaces, temples, and tombs, and many of these are impressive. A good example is the sequence of guardian figures and animals lined up on both sides of the long ceremonial road that leads to the Ming tombs, culminating with a giant tortoise, the emblem of longevity (figs. 18.2 a–c).

Ceramic sculpture had moments of glory during the Ch'in and T'ang dynasties. The underground army of the First Emperor, a monument to ancient

Fig. 18.2 (a–c, clockwise) Ceremonial route to the Ming tombs, north of Peking, fifteenth century, lined with guardian figures and a stela with a giant tortoise opposite a bridge crossing a stream on the way to the tombs.

craftsmanship and industry, is there for contemporary humans to admire but of course was unknown to the Chinese or anyone else for more than 2,000 years (fig. 11.1). Numerous vivid ceramic sculptures of animals, people, and dwellings for tombs have survived from the T'ang dynasty. The Chinese were also incomparable at casting bronze, firing and glazing pottery, and carving jade.

While devoting some attention to these minor arts, this section explores beauty and visual suitability mostly in architecture, gardens closely associated with architecture, calligraphy, and landscape painting, with opening comments on the symbolism essential for understanding Chinese art. Architecture was not considered an art, but it dominated the visual landscape and bore a heavy load of symbolism and cosmic meanings, so we must include it. Beauty meant a fusion of order, balance, harmony, and tradition, all of which can be applied to architecture. The authority of past models and tradition in

measuring beauty in that sense are linked to Chinese cosmology. The universe as a self-operating system of dynamic, mutual relations meant there was no supernatural authority to lay down standards of judgment, and individual reason seemed inadequate to do so. Consequently, history became the source of authority for art as well as for ideas.

As with thought, social life, and government, harmony was an overriding goal in art. If beauty, or harmony, is yang, then ugliness, or disorder, is yin. Underlying ideas of harmony and balance, however, were principles of movement and asymmetry. Chinese harmony was based on the reciprocal movement of yin and yang, in which yin, although necessary, has less dignity than yang, and should not be confused with a static European notion of balance, in which two sides of building are matched or two sides of a painting have the same number of figures, as in Renaissance works like Raphael's large-scale painting *The School of Athens* (early sixteenth century) in the Vatican and Leon Alberti's geometrical façade in ratios of 2 : 1 for the church of Santa Maria Novella in Florence (fifteenth century). In Chinese ideas of balance, for example, two images of protective lions placed in front of public buildings to represent courage and justice included a male and a female for a harmony of interacting opposites not purely symmetrical.

Allusions to things outside a work itself were a criterion of beauty and fitness, which included symbolism in everything from bronzes to jade to architecture, yin-yang associations—as in the correct application of feng shui principles to discover sites fit for building—and the prevalence of colophons (commentaries by owners) on landscape paintings, giving the works continuity with the past.

Symbolism

Essential to a sense of beauty and rightness was the use of symbolism in virtually all the arts. For example, cosmological symbols flourished in architecture. A variety of symbols were drawn from history, mythology, folklore, and nature. Symbolism embodied in works of art was an aesthetic element contemplated and enjoyed along with the use and feel of rare materials, evidence of fine craftsmanship, and expression of philosophical or cosmic meanings. Eight types of symbolism have been identified: (1) the dragon mask symbolism on Shang bronzes; (2) cosmic symbols on bronze mirrors; (3) imperial symbols, of which there were twelve, the dragon being the most conspicuous among other mythical creatures; (4) Buddhist symbols like the Wheel of the Law; (5) Taoist symbols like the attributes of the Eight Immortals; (6) nature symbols like the three friends in winter—pine, plum, and bamboo—standing for constancy and endurance in hardship; (7) festival symbols like the gourd, emblem of the New Year and the coming of spring; and (8) pun symbols like the red bat (fu), a pun on the word for happiness.[113]

In the Han dynasty, bronze mirrors with cosmological motifs were a popular form of ritual and domestic art. Notable are the distinctive "TLV mirrors." The hidden side is a highly polished reflective, convex surface that could be used as a looking glass (fig. 18.3). The visible side is a cosmogram, a symbolic representation of the universe in its celestial and terrestrial aspects. While symbolism may vary somewhat from one example to another, the one before us can be read as follows: The square panel is Earth. Within the square there is a thin circle representing Heaven; the circular field outside the square can also be taken as Heaven. At the center is a large boss representing China, the Middle

Fig. 18.3 Bronze mirror from the back with cosmological symbols, Han dynasty.

Kingdom or center of the world. The T's on each side of the square are the four directions. The V's off the corners of the square, plus the central zone itself, are the Five Elements. L's at the rim on opposite sides of the squares are symbols of yin-yang as the Four Spirits—South (at the top) as pure yang, North (at the bottom) as pure yin, East (to the left) with more yang than yin, and West (to the right) with more yin than yang. The smaller bosses inside the square stand for the twelve heavenly branches. The eight bosses surrounding the square stand for the eight trigrams that form the sixty-four hexagrams in the *The Book of Changes*. Incidentally, the mirror was also a symbol of marital contentment. When a husband or wife died, their marriage was referred to as a "broken mirror."

A second example of symbolism in a minor work of art is an elegant jade ritual disc carved from white nephrite and embellished with tiny cloud patterns on the disc body and dragons on the rim (fig. 18.4). The clouds and the dragons bring rain. The circularity is a physical metaphor for Heaven. The hole in the middle is a negative space (yin) contrasting with the body of the piece, a positive space (yang). Producing such an apparently simple object was no easy task. Jade carving is a difficult craft that the Chinese raised to the level of art. Motivation came from the properties of the stone, which accumulated philosophical and religious meanings over time.

The beauty and wonder of the ceremonial disc lies in the craftsmanship needed to handle a jade block, one of

Fig. 18.4 Ritual pi (bi) disc, Chou period.

the hardest stones to carve. Jade ranks 6.5 on the Mohs scale of hardness (diamonds are a 10), which means something harder than jade must be used to work it—abrasives like quartz sand at a 7 or corborundum at a 9. The cutting and buffing takes weeks or months depending on the size and complexity of the object. Obviously, the work must proceed with care since a major mistake cannot be repaired easily or at all.

The type of jade favored by Chinese was nephrite (true jade), which usually has a pure white color. The other kind, familiar in the West, is jadeite (false jade), which commonly has an emerald green color. Chemical composition of the two jades is different.[114] True jade is white in its purest form (although other colors can creep in as impurities), quasi-transparent if thinly cut, takes on a brilliant polish, cold when touched, resistant to scratching with steel, and musical in tone when struck. The nephrite exploited by Chinese jade carvers did not come from China, but was imported a long distance from Chinese Turkestan, nearly 2,000 miles from the center of Chinese civilization, so much was it valued.

Nephrite jade was reputed to have magical qualities and was used in the Chou and Han periods for ritual purposes, particularly funerals. Jade burial suits encased the noble and wealthy dead, with a jade cicada placed in the mouth of the corpse as a symbol of eternal youth, since it lives longer than other insects. In later centuries the ritual function receded. Jade became an object of aesthetic worship, collected and admired by generations of connoisseurs, and was carved into a multitude of astonishing forms, such as a pure white nephrite scene of plant and bird life, executed with matchless delicacy (fig. 18.5), and a less pure nephrite cabbage with translucent stalks and a grasshopper nested in the spreading greenery of the top leaves (fig. 18.6).

Shanghai Museum. Photograph by Laura Brengelman.

Fig. 18.5 Nephrite jade desk weight, Ch'ing Dynasty.

In the Han dynasty, a scholar spelled out the stone's physical qualities, moral significance, and symbolic power: "Jade is the fairest of stones. It is endowed with five virtues. *Charity* is typified by its lustre, bright yet warm; *rectitude* by its translucency, revealing the color and markings within; *wisdom* by the purity and penetrating quality of its note when the stone is struck; *courage,* in that it may be broken, but cannot be bent; *equity,* in that it has sharp angles, which yet injure none."[115] In the realm of ideas, the persistence and patience needed to carve jade was associated with the self-discipline needed to achieve Confucian virtue through study and action. In no other civilization was jade so highly

http://en.wikipedia.org/wiki/File:IMG_35392.jpg

Fig. 18.6 Jade cabbage with grasshopper, Ch'ing Dynasty.

Fig. 18.7 Jade burial suit from a tomb, Western Han dynasty, 113 B.C.E.

valued or worked with such virtuosity as a reminder of moral excellence. The magical and protective properties of the stone inspired the creation of jade burial suits for nobility in the Han dynasty. The suit shown in fig. 18.7 consists of some 2,000 jade plaques stitched together with golden thread through small holes in the four corners of each plaque.

Much of the charm and depth in Chinese art and architecture lies in the naturalistic richness of its symbolism, an earthy humanistic feature in sharp contrast to the mythical, often trans-naturalistic repertory of Indian symbolism. The trees, mountains, animals, birds, flowers, insects, and occasional fantastic creatures in landscape painting have precise symbolic meanings. Where pine, plum blossom, and bamboo occur together, they are recognized as the "Three Friends of Winter," symbols of endurance and steadfastness because they stay green in the cold. The peony means spring; the lotus, summer; the chrysanthemum, autumn; and the plum, winter. The chrysanthemum also means being at ease in retirement from public office. Where plum, orchid, bamboo, and chrysanthemum occur together, they are the "Four Gentlemen." The willow signifies sorrow or loss. The peach suggests Taoist immortality. Bamboo is an emblem of the Confucian scholar's strength and uprightness.

In the Yuan period, when China was occupied and ruled by the Mongols, bamboo was a popular subject for literati painters silently declaring their integrity. While symbols from nature were commonplace in landscape painting and can be read as such, depicting certain objects as symbols was not always a self-conscious purpose of the artist, whose interest was more pictorial than intellectual. Images of bamboo, pine, and orchids can also be viewed as emblems of subjective feeling, temperament, and mood. All were favored subjects for painting, especially bamboo, which lent itself to controlled but inspired brushstrokes of a master, the work of Hsu Wei in the sixteenth century for example (fig. 18.8).

Among animals, the lion (see the figures guarding the Temple of Supreme Harmony in the Forbidden City) stands for justice and defends against evil forces. The tiger is the lord of land animals and embodies dignity and courage. The gibbon is a Taoist and Ch'an Buddhist symbol of gentleness, kindliness, and release from convention. Hearing its cry in the forest was a good omen. A herd boy riding a buffalo represents human beings controlling their turbulent natures in search of enlightenment or tran-

Fig. 18.8 Hsu Wei (1521–1593), Bamboo, section of a hand scroll, ink on paper.

quility. The deer is emblematic of immortality, a major theme in Chinese mythology and symbolism, although Chinese ideas of immortality were of this world rather than another. A fish stands for the regenerative powers of nature, the carp meaning success specifically in literary matters. Among birds, the crane stands for longevity, the mandarin duck for affection and marital harmony, and the wild goose for longing and sorrow. The quail represents impoverished scholars bearing up in hard times. In painting, birds usually appear in pairs, one looking up (yang) and the other looking down (yin). Among insects, the butterfly signals delight and the dragonfly unsteadiness. Among fanciful creatures are the four supernatural beings—dragon, phoenix, unicorn, and tortoise—although the first three were not considered fictional creatures.

The dragon is foremost, with composite features, depending on the species of dragon, from the camel (head), deer (horns), rabbit (eyes), cow (ears), snake (neck), frog (belly), carp (scales), hawk (claws), and tiger (palm). There are nine species of dragon recognized in Chinese mythology, the most important and most powerful of which lives in the sky, lord of clouds and water, beneficent and protective, and emblem of imperial power (with five claws). Nine is the square of three, which symbolizes the triad of Heaven, Earth, and Man. The numbers three and nine, as we have seen, appear

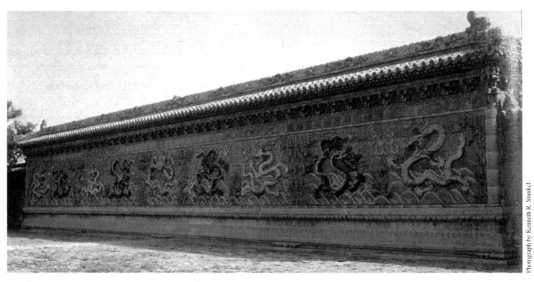

Photograph by Kenneth R. Stunkel.

Fig. 18.9 Nine Dragon Screen, Forbidden City, Peking.

often in Chinese art and thought. In the Forbidden City, there is a massive nine-dragon outdoor "screen" (fig. 18.9).

The phoenix is emblematic of peace and prosperity, as well as the empress. It too is a composite creature with a swallow's throat, a fowl's bill, a snake's neck, a fish's tail, a crane's forehead, and so on. Like the dragon, it is benevolent, has five colors corresponding to the five Confucian virtues, and remains hidden until reason and peace prevail in the land. The dragon and phoenix complement one another as yang and yin creatures. The unicorn, believed to have appeared just before the birth of Confucius, stands for felicity and wise administration. While the tortoise stands for longevity and is associated with ancient rites of divination (tortoise shells were among the Shang oracle bones used for divination), it achieved status as a supernatural being when grouped with the dragon, the phoenix, and the unicorn.

Architecture

Principles of Chinese architecture remained stable for centuries. When properly understood, traditional forms represent a great historic style with respect to structural technique, symbolism, and coherent meanings that transcend mundane functional purposes. The underlying aesthetic and philosophy can be summarized in five points.

Tradition

Architectural theory and practice were shaped and sustained by tradition. Once a satisfactory form was established, it became a model for builders, who could not or would not readily depart from it. There was change, but always under the watchful eye of tradition. With architecture, the past was prologue to the future. Chinese craftsmen

therefore, were not architects in the Western sense. They did not design buildings from scratch or come up with novel conceptions of how a temple, palace, or house should look. The architect was a master builder with severe limitations on what he could do. Eccentricity and originality were virtually unknown, because constructional methods and styles were standardized (there is an eleventh century manual that clearly outlines acceptable practices). Traditional designs, with only slight variations, were repeated century after century. Temples, audience halls, and palaces fabricated from wood, plaster, and tile might be demolished so they could be rebuilt on exactly the same plan with the same materials.

Symbolism

Everywhere in Chinese building there was attention to cosmic pattern and symbolism expressed as a feeling for the connection of cardinal directions, seasons of the year, topography (water and hills), winds, and celestial constellations. All such considerations were orchestrated by techniques of feng shui (wind and water), a discipline based on geomancy still practiced today. A geomancer did a preliminary survey of a building site. The purpose was to anticipate conflicts of terrestrial and celestial factors with yin-yang, the Five Elements, and the flow of cosmic energy, or ch'i (qi), a physical manifestation of Tao. Ch'i would be scattered if it were simply carried by the wind, so water is needed to regulate the flow. The ideal arrangement for a house, temple, or tomb is a cliff to the rear, hills to the side, and water in front with a southern exposure. The Ming tombs and their subsidiary buildings, for example, are backed by mountains with a stream running in front. A poorly situated building or architectural complex out of tune with cosmic patterns was believed to bring misfortune to its inhabitants. A feng shui expert and his helpers would scout the landscape for favorable and unfavorable signs with the help of a Lo-p'an (luopan) compass and direction finder whose makeup is based on yin-yang and Five Elements cosmology (figs. 18.10, 18.11).

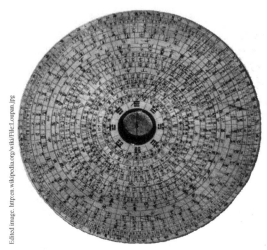

Edited image. http:en.wikipedia.org/wiki/File:Luopan.jpg

Fig. 18.10 Lo-p'an Compass.

Fig. 18.11 Pa-kua (bagua, eight-trigram) direction finder used in feng shui.

For 2,000 years, the basic plan for all architectural units was a square for the Earth and a circle for Heaven. The old city of Peking in Ch'ing dynasty times was a series of nested, walled-in squares, culminating in the Forbidden City (fig. 18.12). The north-south axis ran from gate to gate, from the outermost north wall to the outermost south wall. The Manchu City in the north was separated from the Chinese City in the south by twelve ritual spaces of the Forbidden City and its approaches. The northern quadrant consists of three walled squares—the Manchu City, the Imperial City, and the Forbidden City.

Fig. 18.12

The north-south axis intersects in the south quadrant with the Temple of Heaven complex (to the right) and the Temple of Agriculture (left). With its squared-off patterns, the city was designed to be one with the earth. A north-south axis was a universal feature of architectural design, no matter what the unit, north being the yin direction, and south the Yang direction. Thus town planning as well as the construction of temples, palaces, tombs, and homes obeyed a pattern in which the smaller world of man mirrored a larger universe and its forces.

Naturalism

The disposition of structures ideally was with rather than against nature. In other words, the initial step in a building project was not to demolish everything in sight (the bulldozer is often the first thing seen on Western construction projects). The surrounding landscape was retained or even enhanced as much as possible. Closeness to nature affected the choice of building materials. Building fabrics were impermanent, wood being the common choice (one of the Five Elements) rather than brick or stone. Joints were secured with wooden pegs rather than nails. Bamboo served ornamental purposes. Roofs were usually covered with ceramic tiles. Walls were plastered. Stone was used for gates, walls, bridges, and pagodas, seldom for buildings.

Structure

For load-bearing purposes, post and lintel was the structural system commonly used. Arches were confined to underground tombs like those of the Ming tombs north of Peking. Walls enclosed farms, homes, temples, and cities. Walls for temples, palaces, and many houses were the non–load-bearing screen or curtain type made of flimsy materials easily removable without structural danger. The distinctive Chinese roof, curving gracefully from a ridge beam downward to overhanging eaves, was achieved with a system of horizontal, vertical, and longitudinal beams of different sizes. The basic form was a post-and-lintel frame. Two queen posts, or spacing blocks, were placed a short distance inward on the main lintel to support a shorter beam.

The same procedure was repeated a number of times, moving shorter beams inward on queen posts, until a king post was reached under the ridge beam (fig. 18.13). The effect was a flexible stepped affair that could be adjusted and expanded. Longitudinal beams, or purlins, were laid on the edges of each step on top of the queen posts and the king post to support roofing material (fig. 18.14). The result was a curve in the roof that descended to protruding eaves supported by brackets. The origin of the curved roof is much disputed, but the likely explanation is that tiling was originally of bamboo, whose weight caused a sag in the roof that required a less than rigid system of support, resulting in a curve. When ceramic tiling was substituted for bamboo, the curve was retained and regulated,

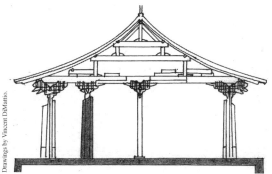

Fig. 18.13 Structural system with queen posts and king posts (cropped).

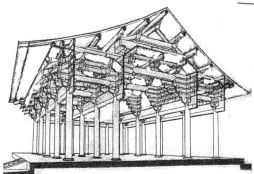

Fig. 18.14 Structural system with purlins (cropped).

Drawings by Vincent DiMattio.

probably for aesthetic and symbolic purposes—still another example of tradition holding its own in old China.[116]

Architectural units and forms were always on a human scale. Overwhelming structural gigantism was avoided. Tall structures like pagodas and watchtowers were placed outside city walls. Architectural planning was decentralized and stressed horizontal spaces. Chinese buildings hug the earth. Even comparatively large structures of the Forbidden City, like the Temple of Supreme Harmony (T'ai-ho t'ien / Taihe tian), have low-lying profiles so as not to disrupt the flow of ch'i. The temple and palace complex from which the Chinese empire was ruled is a place of splendor and wonder without being ostentatious in its vertical dimensions. A basic house consisted of bays (ch'ien / qian) and a central courtyard walled off from its neighbors.

A Chinese town was a modular affair—a succession of houses and courtyards could spread out in most directions, the whole separated from the countryside by a circuit wall. The larger pattern that emerged in Peking is suggested in Figure 18.12. Expansion for individual units simply meant adding another module of walled house and courtyard, the direction of expansion ideally being longitudinal and to the south. The walled-courtyard design was fixed by tradition and regulated by feng shui (fig. 18.15). For example, it could expand horizontally but not vertically. A well-off man might have two or three courtyards with additional buildings—in effect, a complex of modules. Looking down on a traditional Chinese town or city would show a maze of narrow lanes and low-lying walled courtyards.

Traditional Chinese cities spread out horizontally in more or less uniform modules that hug the earth. The human landscape has a sameness about it that makes distances and directions deceptive to a traveler passing through. Contemporary Peking (Beijing), and many other cities, wanting a modern look with an accumulation of high rises, have abandoned the horizontal orientation associated with the symbol Earth in traditional city planning.

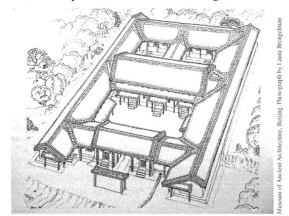

Fig. 18.15 A walled courtyard home.

Museum of Ancient Architecture, Beijing. Photograph by Laura Brengelman

Style

A result of all these characteristics was uniformity of style in buildings and the appearance of towns. There was no succession of distinctive styles as in the West—Classical, Gothic, Renaissance, Baroque, Neo-Classical, and so forth. Permanence was not important, as it was in ancient Egypt, because buildings could be redone in precisely the same style, which happened often because of losses from fire, as would be expected from the prevalence of wooden buildings and the rapid deterioration of impermanent building materials from use and weather.

This traditional style, however, was more or less permanent, representing philosophical and aesthetic aspirations of a society that aimed at cosmic harmony among Heaven,

Earth, and Man as reflected in material human works. From the Western point of view, traditional Chinese architecture seems repetitive and uninventive. From the Chinese point of view, its meaning and beauty arise from ideals of continuity, stability, and harmony. The same was true of architectural groupings, which obeyed the principle of enclosure shown in Figure 18.15, the motif of walled courtyards seen everywhere in traditional China, whether those of a farmer, a rich merchant, or the emperor.

The Forbidden City

The home of emperors from early Ming times qualifies as one of the world's great architectural ensembles. It was called the Purple Forbidden City after the "Purple Luminous Constellation," which has Polaris, the North Star, at its center, the celestial counterpart of the emperor.[117] It was "forbidden" because it was open only to the imperial entourage, or to those permitted inside under supervision. Completed in 1421 by the third Ming emperor, Yung-lo (Yongle), the layout is symbolic, the individual buildings masterpieces of craftsmanship, and the overall effect one of controlled magnificence. No structures around the Forbidden City were allowed to rival, in splendor or size, those within its walls. The architecture is classically Chinese and was mostly preserved in form and materials during any replacement construction in succeeding centuries.

Looking north along the central axis are the U-shaped Noonday Gate; the Golden Stream in the shape of a Tartar's bow (the ends of the bow are visible); the courtyard before entering the Gate of Supreme Harmony; the courtyard in front of the three-tiered platform holding the Three Great Halls of Supreme Harmony, Middle Harmony, and Preserving Harmony; and beyond, two palaces, the Imperial Garden, the Gate of Martial Valor, and Prospect Hill with its viewing pavilion. Off to the sides of the main axis are administrative and guard buildings toward the front and residences of the emperor's family and retainers toward the back (fig. 18.16).

The walls of the Forbidden City include a moat and imposing guard towers at the four corners. Like a nest of boxes, referred to earlier, the square of the Forbidden City was enclosed by walls of the Imperial City, and that, in turn, by walls of the Inner City. To the south was the Outer City, also walled in, where Manchu conquerors confined the Chinese population after 1644 (fig. 18.12).

Originally, there were twelve ritual spaces along the axis from the Ming Gate in the south to the Imperial Garden in the north, intended by

Fig. 18.16 Aerial view of the Forbidden City, Peking, along the south axis.

its designers as a journey to "Heaven" (fig. 18.17). Continuity of the Forbidden City along its main axis was destroyed by the communist regime with the construction of T'ien An-men Square and its huge neo-Egyptian buildings, which occupy the quarter-mile fourth space that fronts the Noonday Gate. The fifth space is the courtyard between the Golden Stream and the Gate of Supreme Harmony. The "city" is organized on a north-south axis that originally stretched nine miles (the square of three again) from the northern gate of Peking's walls to the southern gate. The exacting control of space is remarkable when the total ensemble is viewed from above.

Space was organized to emphasize rank and status, an architectural reflection of China's hierarchical society. The U-shaped Gate of the Noonday Sun (Meridian) Gate has three arched entrances with square doorframes and two inconspicuous doorways in the corners. The central doorway was reserved for the emperor, with a few exceptions (fig. 18.18). The empress passed through it on her wedding day, and, every three years, the three ranking scholars in the imperial examinations departed through it to honor their scholarship. The east door was for officials, the west door for members of the imperial family. The two corner doors were for civil officials and military officers when a Great Audience was held, and also for successful scholars entering the palace by rank for the last phase of the examinations. The three pavilions of the Noonday Gate have roofs with double-eaves, as do the Hall of Supreme Har-

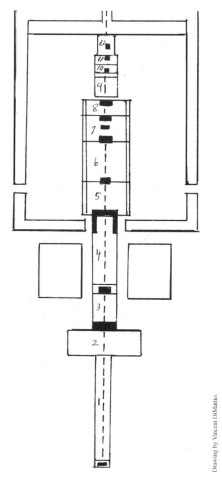

Fig. 18.17 Schematic (cropped) of the twelve ritual spaces along the axis of the Forbidden City and its approach from the south.

Drawing by Vincent DiMattio.

mony and the Hall of Preserving Harmony, an architectural symbol of high rank.

The entire architectural complex, from entering the U-shaped Gate of the Noonday Sun in the south to exiting through the Gate of Martial Valor in the north, is symbolic of cosmic centrality. As the residence of the Son of Heaven who ruled All Under Heaven, the Forbidden City was set in the center of Peking. The Hall of Supreme Harmony, the audience hall

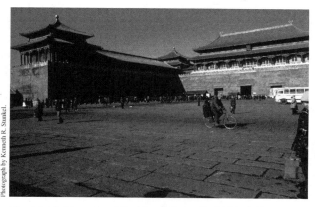

Photograph by Kenneth R. Stunkel.

Fig. 18.18 Noonday (Meridian) Gate, Forbidden City.

and main ritual center, was at the center of the complex. The emperor's golden throne was placed at the center of the hall as the focus of supreme power in the empire and the universe. The celestial model for empire and emperor was constellations circling the fixed pole star.

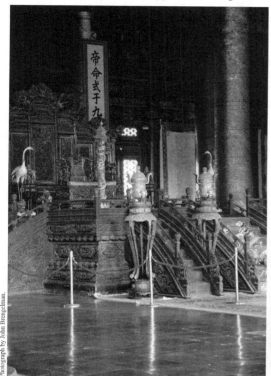

The emperor was occupied with numerous ceremonial duties largely confined to the outer courts, as distinguished from the private inner courts that lie behind the Three Great Halls. After a humbling trip along the ritual stations of the southern axis leading to the Noonday Gate, officials, envoys, and tribute-bearers entered the Hall of Supreme Harmony, no doubt with wonder and trepidation, to perform the kowtow (three kneelings and nine prostrations) before the Son of Heaven seated on his golden throne at the center of the universe (figs. 18.19, 18.20).[118]

Fig. 18.19 Throne room, Hall of Supreme Harmony, Forbidden City.

Fig. 18.20 Golden Throne, Hall of Supreme Harmony, Forbidden City.

The parts and their arrangement are expressive of cosmic meanings. Principles of feng shui, whose purpose is to regulate and harmonize the flow of cosmic energy, are at work everywhere. All major buildings face south, the yang direction. On the west side of the wall one can see the excavation sites of what were once artificial lakes (fig. 18.21). The water motif also appears with the Golden Stream as one enters from the Gate of the Noonday Sun. The Golden Stream flows in the shape of a tartar bow before the Gate of Supreme Harmony and its immense courtyard, spanned by five arched marble bridges, one of which is seen in the illustration, symbolic of Confucian virtues of righteousness, benevolence, ritual, loyalty, and wisdom (fig. 18.22). Earth dredged to create the lakes and the moat were used to erect Prospect Hill (also called Coal Hill) outside the north gate of the Forbidden City where the emperor could get outside and enjoy the view. The pavilion on top of the hill was the highest point in Peking (the second highest is the Noonday Gate at 125 feet). Thus, the imperial city conforms to feng shui principles: water at front and side, a "mountain" in the back, a modest scale, and auspicious directional orientation to harmonize the works of man with the forces of nature.

As one proceeds along the axis of the walled Forbidden City proper, from south to north, the pattern is a sequence of courtyards, with their entrances, halls, and palaces.

Courtesy of Google Maps.

Fig. 18.21 Northward aerial view of Forbidden City showing Tartar's Bow in the foreground, artificial lakes to the left, three Great Halls in the center, and Coal Hill in the rear.

Photograph by John Brengelman.

Fig. 18.22 One of five marble bridges crossing the Golden Stream to the courtyard of the Hall of Supreme Harmony.

Drawing by Vincent DiMattio.

Fig. 18.23 The Three Great Halls looking south.

The courtyards are negative yin spaces that alternate with positive yang buildings. Halls dominate the outer court (a yang place), palaces the inner court (a yin place). The courtyard in front of the Gate of Supreme Harmony is 7¼ acres in size, an expanse relieved and accented by the five bridges over the Golden Stream. Through the gate is the 10-acre courtyard that fronts the Hall of Supreme Harmony, capable of holding up to 20,000 people on special occasions.

At the center of the Forbidden City is the three-tiered stepped platform, twenty-six-feet

high with lace-like marble balustrades, on which The Three Great Halls sit, a major ritual center of the empire, second only to the Temple of Heaven complex. The three levels symbolize Heaven, Earth, and Man, the cosmic triad harmonized by the Son of Heaven (fig. 18.23).

The most imposing structure is the Hall of Supreme Harmony, the finest and largest example of palace architecture in China, where enthroned emperors greeted envoys bearing tribute (fig. 18.24). Its construction is pillar and beam, curtain walls, a high-ranking hipped, double-eave roof, with the familiar curve (there are five types of roofing in the Forbidden City), and rigorous symmetry, with glazed dragons and other mythical animals on the roof to indicate high status. Behind the main hall is the elegant Hall of Middle Harmony where agricultural tools were sanctified, and behind it is the double-eave Hall of Preserving Harmony, where the country's top scholars took the last of their examinations (fig. 18.25).

Along the remainder of the axis, as one proceeds to the rear gate, there are three palaces with their courtyards and the Imperial Garden, the last of the twelve ritual spaces. From the platform holding the Three Great Halls, the emperor was carried on a sedan chair down a marble fifty-four-foot ramp, the Imperial Way, with stairs on either side for servants. The ramp is decorated with nine lively dragons, again the square of three, floating in clouds, and is a masterpiece of architectural sculpture (fig. 18.26). The next stop is the Palace of Heavenly Purity (fig. 18.27). The throne room has a screen in the back bearing quotations from the Confucian classics (fig. 18.28).

Additional palaces in the rear have poetic designations suggesting private

Fig. 18.24 Hall of Supreme Harmony, the Forbidden City.

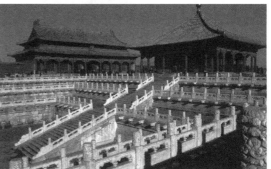

Fig. 18.25 Halls of Middle Harmony and Preserving Harmony, Forbidden City.

Fig. 18.26 Ramp descending from the rear of the Three Great Halls, the Forbidden City.

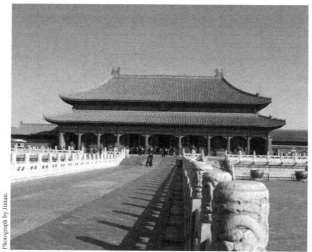

Fig. 18.27 Palace of Heavenly Purity, the Forbidden City.

Fig. 18.28 Throne, Palace of Heavenly Purity.

Fig. 18.29 Martial Gate, the Forbidden City, Peking.

worlds of reflection and pleasure—the Hall of Mutual Ease and the Hall of Earthly Repose. These palaces share the same platform and occupy the ninth, tenth, and eleventh ritual spaces on the north-south axis. They have a lower rank than the Hall of Supreme Harmony, but each is nevertheless a sumptuous dwelling with an individual throne room. In the rear of the Forbidden City is the imperial garden, the twelfth ritual space, restricted to the emperor, his family, and a handful of other persons. The exit from the garden is through the huge Martial Gate to Prospect Hill outside the walls (18.29).

Much expense, effort, and suffering was invested in this enclosed spectacle of halls and palaces. Construction of the Forbidden City was a formidable logistical, technical, financial, and human undertaking. Some 200,000 tons of rare wood were harvested from inhospitable forests and transported long distances at enormous cost in the lives of workers. The Imperial Way dragon ramp coming down from the rear of the platform holding the Three Great Halls, just one piece of major stonework, was a 300-ton block of marble dragged thirty-one miles from the quarry by 20,000 men and 2,000 horses at a cost of 145,000 ounces of silver. A million laborers and another million skilled craftsmen, out of a total population of about sixty million, took part in building the "city."[119] The emperor was pleased with the outcome. What laborers and artisans got out of it was probably very little, and on completion of the project they were forbidden access to their handiwork.

Gardens

In the second half of the eighteenth century the Ch'ien-lung emperor ordered an imperial garden in the Forbidden City. The entrance is a circular gate indicating a heaven on earth. On the other side is a world of visual whimsy that contrasts sharply with the formality of ceremonial buildings and palaces, a yin realm of meandering irregularity to balance the yang realm of regularity nested in precise squares (fig. 18.30). Inside are winding paths, ancient trees, fanciful pavilions, flowering plants, statues of mythical beasts, ponds for carp, and bizarrely eroded rock formations—in short, a Taoist rather than a Confucian environment, reflecting the alternation in Chinese thought of yang public responsibilities with a yin personal life (fig. 18.31). There is a Hall of Imperial Tranquility, nothing less than a Taoist temple with a dragon path leading to the entrance for the emperor. Ch'ien-lung explains his garden: *Need definition*

> Every emperor and ruler, when he has retired from audience, and has finished his public duties, must have a garden in which he may stroll, look around and relax his heart. If he has a suitable place for this it will refresh his mind and regulate his emotions, but if he has not, he will become engrossed in sensual pleasures and lose his will power.[120]

The Chinese garden is ideally an orchestration of old trees, pools of water, cunningly displayed plant life, curving paths, pavilions with extravagantly curved roofs, and fantastic rockeries, whose chaotic surfaces are riddled with openings—negative yin spaces that contrast with positive yang surfaces. Living in such an environment prepared the emperor for the public obligations that awaited the Son of Heaven in the audience halls. In the Hall of Supreme Harmony he was the ultimate Confucian, but in his garden, he became at least a nominal Taoist. What was true for an emperor was also true for the scholar-gentry class. Life for most alternated between disciplined public responsibility and the pleasures of private life. The perfect setting for the latter was a garden, which did not have to be big and expensive as long as it reflected the proper aesthetics of garden making.

Gardens in the later dynastic period were inspired by Taoism and Ch'an Buddhism. Emperors built them for "refreshment of the heart." They were places of informality, repose, and meditation, contrived to highlight and intensify a sense of oneness

Fig. 18.30 Imperial Garden, the Forbidden City.

Fig. 18.31 Imperial Garden, the Forbidden City.

with the elements and the beauties of nature. After the T'ang dynasty, landscape painting clearly influenced the conceptualization of gardens, and there is a sense in which many landscapes have the character of vast gardens enclosing the activities of man. Those that survive as traces or as still visible entities date from the reign of Kublai Khan in the late thirteenth century. In modern Beijing, there are several major garden spots, one of the largest of which is still open to the public on the extensive grounds of the Summer Palace, which offers spectacular buildings and expansive views. The main portion of the "garden" is dominated by a huge lake ringed with causeways, embellished with rows of willow trees and a seventeen-arch bridge connecting with an island (fig. 18.32). Tucked away here and there are more intimate gardens, one of which nests unobtrusively in the second with open pavilions behind walls.

Fig. 18.32 I-ho yuan (Summer Palace), view of K'un-ming Lake from Longevity Hill.

In the Chinese philosophy of building, the finest materials were reserved for temples and palaces. A garden was assembled ideally from cast-off waste material and reflected a world of the personal and unfinished, while temples and palaces represented changeless patterns of the cosmos and fixed ritual. Gardens were altered and embellished by successive owners who indulged themselves in self-expression. A parallel is the landscape scroll passed from one connoisseur to another. Finding and placing a rock or tree of memorable shape was like inscribing a colophon on a painting. With imperial gardens, however, it is doubtful that the Ch'ien-lung emperor,

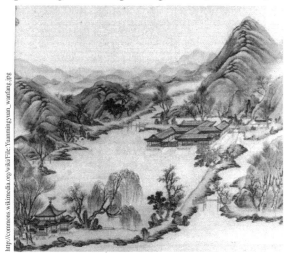

or the empress dowager Tz'u-hsi (Cixi) in the next century, settled for inferior materials. In the case of literati, gardens could vary in size between a few square feet and hundreds of acres with all sizes in between. The eighteenth-century palace garden near Peking had a circumference of seventy miles (fig. 18.33). The Wang-shih yuan (Wangshi yuan—Garden of the Master of the Fishing Nets) in Suchow (Suzhou), one of some twenty old gardens that have survived in this provincial town frequented in the past by poets and artists, is barely an acre in size (fig. 18.34). The attachment of literati to nature flourished after the Han dynasty collapsed and north China was plunged

Fig. 18.33 A Ch'ien Lung (Qianlong)-era painting, "Peace in All Directions," on silk, from "Forty Scenes of Yuan-ming yuan," by court artists.

Fig. 18.34 Wang-shi yuan, Suchow, site occupied by gardens since C.E. 1142.

into desolation, revolt, and barbarian invasions. Many scholars fled to wilder, more unfamiliar southern provinces with rude landscapes that were forbidding and initially uncomfortable. Thus sequestered, they retreated mentally into the teachings of Taoism and Buddhism, especially Neo-Taoism. In short, the times made relatively untamed nature a retreat from disillusionment, insecurity, and hardship. Moved by poetry, painting, and Taoist ideas, literati, if resources permitted, wanted a garden, especially during the Ming and Ch'ing periods.

A garden might include a pavilion, often visible in landscape paintings, for viewing choice scenery and hosting literary gatherings. Around the pavilion, plantings of pine, plum, bamboo, peony, and chrysanthemum, accented with weathered, fissured rocks of various sizes and perhaps a running stream for floating wine cups among the guests might be found. The ideal setting was one that mirrored the universe in microcosm. Taoism influenced literati gardens with the notion of wu-wei (action without action), which meant that garden configurations would best unfold in harmony with the spontaneous curves of nature. Within the "uncarved block" of his garden, a scholar could seek his own uncarved state of oneness with Tao.

Calligraphy

Skill at writing characters was essential to being a member of the literati class, which had a virtual monopoly on literacy. Writing with brush and ink defined the scholar and was a necessary component of painting. Poor calligraphy was not tolerated in the imperial examinations, and educated Chinese were convinced that a man's character, even his physical appearance, could be read from the form and rhythm of his ideographs. The same revelation of personality and state of mind was attributed to landscape painting.

In a sense, calligraphy and painting overlap as one art, for both draw on the same body of techniques, use the same materials, and rely on the same mental discipline. It is hard to talk about one without allusions to the other. Essential to both is the brushstroke, whose mystique cannot be underestimated as a pillar of Chinese tradition, entwined as it is with scholarship, social status, the examination system, writing, and art.

Calligraphy was more pervasive in Chinese culture than painting. It could be found everywhere—in homes and shops as well as palaces and temples. It turns up on every kind of material—silk, paper, stone, metal, wood, and ceramic. The ubiquity and power of calligraphy to elicit pleasure and a sense of mystery was shared by all traditional Chinese whether literate or not. It was one of the forces that held millions of Chinese together for centuries in a vast land. The materials of calligraphy and painting are known as the Four Treasures—brush, ink, inkstone, silk or paper. All four are part of the standard setup in Figure 18.35 that also includes a brush holder, water bowl, and a "chop," or name seal.[121]

Most of what is said here applies to Japanese calligraphy and painting as well. Brushes were made from different kinds of animal hair: deer, sheep, goat, wolf, rabbit, and fox, for example. The choice of hair depended on intended effects of the brushwork—deer for free flowing strokes, rabbit for more delicate work, baby hair or mouse whiskers for the finest strokes. Bristly rat's hair was recommended for strokes like the edge of a knife. Autumn

Photograph by Kenneth R. Stunkel.

Fig. 18.35 The calligrapher-painter's setup (brushes, water, inkstone, ink, paper).

fur of coddled rabbits, a major source of hair, was taken from the middle of the back or the flank. The hairs were washed to remove oil, sorted into sizes, bundled to allow for a fine point, and glued into the hollow end of a wooden holder, usually bamboo. Brushes could be of many sizes, some very large, again depending on the kind of brushstroke the calligrapher or painter sought.

Ink (mo) was made from several kinds of wood soot, but the soot of pine was preferred. Although the word "ink" is being used, it should not be confused with India ink, which has a different chemical composition and cannot produce the same effects as mo. To produce mo, pine soot collected from a plain surface was mixed with liquid gum made from ox hide in a ratio of two to one (ten parts soot to five parts gum), strained to remove impurities, and shaped into sticks of various sizes, which were allowed to dry and harden for at least a few years. Mature, quality sticks lasted many years, were highly valued, and were often passed down from one generation to the next. The caked black color was released from the stick by grinding it in water on the surface of an abrasive stone, which might be tile, brick, jade, or ceramic that could be fashioned into many decorative shapes, even qualifying as a minor work of art itself.

In the Later Han dynasty, paper was invented and, by the Sung dynasty, had mostly replaced silk as the common writing material because of its superior surface and relative cheapness. One of the great inventions of mankind, appearing 600 years before Muslims used it and 1,000 years before it reached Europe, paper was made from waste linen, tree bark, fishnets, and even water fungus. Calligraphers and painters

had a choice. Unripened paper, which was not further processed, was porous and good for bold work. Ripened paper, sized in a solution, was less porous and best for delicate work.

Calligraphy is made up of lines and dots. The dots are not circular, as understood in the West, but vary in thickness and have "tails" to indicate their direction of motion. A line can be thin or thick, light or dark, or, at some point, embody all of those characteristics. Beauty in a sample of calligraphy is judged by spontaneity of execution, whether the delivery of a stroke is rapid or slow, and the vigor of the resulting lines and dots. For lines, "bone structure," signifying strength and rhythm in the stroke, is the ideal. Also taken into account is the tone of the ink, which can vary in many shades of dark and light, depending on saturation of the brush and the pressure of the stroke. Ink soaks into silk or paper quickly, so a desired effect requires swift movement of arm and brush, and once the brush tip encounters an absorbent surface, corrections are not possible. An ideal brushstroke is irregular, a result of varying pressure, change of direction, and quantity of ink discharged. Subtle judgment and great skill with the brush are needed to regulate moisture, speed, pressure, and angles of position and motion. Misjudgment on any of these skills and can ruin the outcome.

Over time, many kinds of brushstroke were defined. Some types valued were willow-leaf, bamboo-leaf, silk-thread, bending-weeds, earthworm, water-wrinkle, iron-wire, ax-cuts, mouse-tail, orchid-leaves, lotus-veins, bullock-hair, and mi-dots (after a technique of the eleventh century Sung landscape painter Mi Fu). Important to the calligrapher are spatial relationships between the lines, dots, and individual characters, a sense of positive and negative spaces, which is achieved by adroit handling of light and shadow in the texture of the ideographs and their component strokes. Obviously many years of practice and single-minded commitment are needed to be worthy of such an exacting aesthetic. The quality of a calligrapher's brushstrokes is the standard for judging the worth of characters on a page rather than what they may say.

Taoist philosophy is integral to the aesthetics of calligraphy and painting. Every part of nature was believed to have a unique concentration of energy (ch'i), which does not vary with classes of things, like trees, birds, flowers, and rocks, but with each individual thing. No bird or flower has the same ch'i. The expressive power of the brushstroke aims to capture that uniqueness. The movement and concentration of ch'i found in natural objects and organisms belongs as well to ideographs and the dynamic act of forming them with the brush. Spontaneous, effortless formation of characters was viewed as oneness with Tao.

The calligrapher's ch'i expressed in a brushstroke was drawn from the ch'i that pervades the universe. The alternating opposites of yin and yang were manifest in calligraphy—the yang of the active brush, the yin of the passive ink, the yang of the active ink, the yin of the passive paper, the yang of the active calligrapher, the yin of the passive brush. By the end of the Han dynasty or shortly thereafter, several major styles of calligraphy were in use, from the archaic seal style, originating in Shang oracle bones, to a free and highly individualistic cursive style.[122] The significance of these styles for ideas and art is the extravagant investment of time, practice, and thought by calligraphers and painters to physical properties and accumulated meanings of the brushstroke. They were aware of great predecessors and revered accomplish-

ments of the past, and they practiced one or more of the traditional styles. An ardent calligrapher with time on his hands might devote a lifetime to mastering all of the styles. Without undue commentary, an attentive eye can see how the five styles differ in the flow and placement of brushstrokes.

The seal style (ch'uan-shu / quanshu) in its several forms has been found on bones and tortoise shells used in divination and inscribed on bronzes and stone (fig. 18.36). The first attempt to standardize this style was made in the Ch'in dynasty, when the characters were streamlined somewhat and made to occupy a square, which remained the practice with all calligraphy thereafter.

Fig. 18.36 An example of seal style.

Fig. 18.37 Clerical style.

The official style (li-shu), or "clerical" style, was also developed in the Ch'in dynasty and came to be standard during Han times for official documents and ceremonial inscriptions (fig. 18.37). It was in the heyday of li-shu that the art of calligraphy took off with the emergence of better materials, especially paper, which removed the limitations of writing on bamboo strips. Now the characters reveal more individuality and variation (thick, thin, light, heavy, and so on) in their strokes.

The regular style (k'ai-shu / kaishu, or "standing still"), a freer, more cursive version of *li-shu*, was embraced by later generations as a flexible medium for both mundane use and artistic expression (fig. 18.38).

A still more cursive style, hsing-shu (xingshu), or walking style (hsing means "to walk"), encouraged freedom of movement in forming characters so the result is more fluid in appearance (fig. 18.39). The chief ingredients are speed and compression, that is, separate lines and dots are

Fig. 18.38 *Sheng Jiao Xu* by Chu Suiliang: calligraphy of the regular style.

Fig. 18.39 *Mi fei*, running style, Sung dynasty.

often joined with one another in a continuous sweep without giving up continuity with the official and regular styles.

The running style (tsao-shu / zaoshu, or "grass") pushes speed and compression to a limit that results in a form of shorthand, which has been described as "characters dancing" on paper (fig. 18.40).

By general consent the most legendary and renowned of all calligraphers was Wang Hsi-chih / Wang Xizhi (307–365 C.E.), who mastered all styles. Fragments of his calligraphy have been revered, praised, and used as models for centuries. The sample in Figure 18.41 is from a rubbing. For innumerable Chinese calligraphers, Wang's characters demonstrate unsurpassed brushwork ingeniously designed without sacrificing rhythm, contrast, and balance. An admirer in old China said his calligraphy had the lightness of floating clouds and the vitality of a surprised dragon. A modern critic sees in his work the essence of movement, a power of "activity in stillness" balanced with "activity in action."[123]

Fig. 18.40 Detail of The Treatise on Calligraphy by Sun Kuoting / Sun Guoding (646–691), ink on paper.

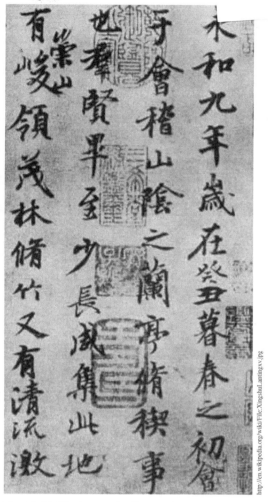

Fig. 18.41 "Preface to the Poems Composed at the Orchid Pavilion" by Wang Hsi-chih (Wang Xizhi).

Landscape Painting

For about one thousand years the dominant form of visual art in China was landscape painting (shan-shui, or mountains and water). After the tenth century, no subject for artists rivaled landscape, which at the same time had strong Confucian overtones of reverence for tradition and reflected Taoist ideas of cosmic energy and spontaneous activity believed to flow from a brushstroke. Here are two big questions. Why did artists turn from finite subjects like man, buildings, birds, and plants to the infinity of landscape where boundaries are tenuous and limits of the picture frame are purely arbitrary? What accounts for the appearance and longevity of landscape as a preeminent form?

An ideal landscape included hills, valleys, cliffs, lakes, ponds, rivers, waterfalls, and mountain ranges, as well as plant and animal life, with human inhabitants in the background, almost lost in the panorama. Until the late T'ang, Five Dynasties, and early Sung periods, the human world of figures and buildings held sway, as it did in premodern European painting, with primitive landscape motifs sometimes used as background or a subordinate setting. Figure painting was inspired by the hagiographical, moral purpose of

Fig. 18.42 Figures on a tomb tile, ink and colors on a clay surface, second or third century C.E.

depicting virtuous Confucians, filial sons, loyal ministers, and even idealized images of Confucius. Painting from the Han dynasty has largely perished, but surviving examples from tombs suggest that vitality conveyed by the rhythmic line was highly valued. A taste for line as the basis of movement in visual art continued with calligraphy and landscape painting. A fine example of such energy is a skillful image on a tomb brick of two elegant gentlemen engaged in lively conversation, which conveys a vivid sense of life and movement (fig. 18.42).

The fragmented period between the collapse of the Han and reestablishment of the empire under the Sui left few remains of painting that make use of landscape. Most examples are on walls in Buddhist caves at Tunhuang (Dunhuang). The works that survive reinforce the Chinese taste for flowing, vigorous lines. Perhaps the greatest contribution of those difficult times, during which one palace after another was destroyed along with its art collections, was the separation of painting from craftsmanship as a respectable

enterprise of the gentleman, and the articulation of aesthetic principles. The emergence of calligraphy as an art played a major role in these developments. So why landscape painting?

First, from the social perspective, the literati class was consolidated in the T'ang and Sung periods, which meant a shared view of the world acquired through the study of classical literature, a status usually conferred by the examination system, and skill in calligraphy as part of the scholar's training. At the same time, as noted earlier, calligraphy, in addition to its utilitarian function, was recognized as an art form. Over the centuries, the scholar-gentry dominated landscape painting. Perhaps as early as the T'ang dynasty, they were imbued with the ideal of painting as an amateur enterprise helpful for personal cultivation.

But within that class, the roster of distinguished painters varied in status and way of life. While some painters were virtual recluses, others were well-known scholar-officials. Even gifted women found a place in the tradition and sometimes won the patronage of emperors.[124] There were notable works by professionals, and some professionals were among the greatest figures in the tradition—Kuo Hsi (Guo Xi), for example, who rose to prominence through the ranks of court painters and became a legend in the Sung monumental landscape tradition with works like his hanging scroll *Early Spring*.

Second, long experience with Buddhism led scholars into previously shunned mountains and forests. As a result, temples were built in remote places, frequently on or near the summit of mountains. Taoists followed the Buddhist example and built similar refuges in untamed places. It was in nature that men of sensibility began to distance themselves from the distractions and trials of public life and the turmoil that enveloped everyone in times of trouble and upheaval. Temples and pavilions became places for meditation on the beauties of nature and provided settings for many of the common motifs in landscape— a path defined by a figure moving along it, a figure seated in sight of a striking view, a simple hut to shelter a recluse, a fisherman or woodcutter at work in a grand natural setting, flowing water, undisturbed plant and animal life. To the Taoist-Buddhist and the landscape painter, mountain landscapes were a spiritual home because humans and nature shared an affinity with Tao.

Third, Neo-Confucian philosophy inspired a new way of seeing nature, the idea that reality could be understood as the li (principle) of things grasped by "the investigation of things." Painting became an agent of such investigation. Each of the various components of Neo-Confucian thought—Taoism, Buddhism, Confucianism, yin-yang cosmology—had an influence. From philosophical Taoism came the unity and spontaneity of the world, the oneness of man with nature. Effects of this doctrine on the landscape painter included a deep affinity with the external world of mountains, streams, forests, and creatures. Plants and animals were to be depicted alive—no dead animals, cut flowers, or plucked fruit so familiar in Western still life. A provisional exception is Mu Ch'i's *Persimmons,* a line of fruit seemingly suspended in a void (fig. 15.3).

The spontaneous movement of creatures signified the guilelessness of nature and the natural rhythms of the cosmic order, as in Ts'ui P'o's magpie pestering a hare (fig. 15.1). From the Neo-Confucian perspective, the cosmos of landscape was a moral as well as a natural order. A further Confucian element was the passion of post-Yuan period artists for contemplating and emulating the tradition of great early masters like Li Ch'eng (Li

Cheng), whose *Buddhist Temple Amid Clearing Mountain Peaks* evoked the Great Ulti-
mate and the interplay of yin with yang, guiding ideas of Neo-Confucianism expressed
in landscape by contrasts of light and dark, high and low, solids and voids.

Landscape paintings were not hung in galleries, painted on walls and ceilings, left on
walls or other places as decoration, or contained in frames like Western art. They were
viewed in three major ways—hanging scrolls, hand scrolls, and album leaves. The first
two were rolled up, put away when not on view, and brought out by owners to contemplate
individually or on special occasions for personal pleasure, friends, and connoisseurs. The
hand scroll was unrolled from right to left and rerolled from left to right so the viewer
could see a continuous scene unfolding (fig. 18.43). The segment of a hand scroll by Huang
Kung-wang (Huang Gongwang) provides only a glimpse of his broad vision before and
after each segment as the scroll is unrolled. Such scrolls could be more than thirty-feet
long. The hanging scroll with the painting glued to it was displayed on a wall, unrolled
from the top, and usually secured by weights at the bottom (fig. 18.44). The album leaf,
8″ × 10″ or 8″ × 12″ in size, was displayed in collections bound like a book so the viewer
could see a succession of scenes by turning the folios. Even in such a small space and on
a cramped surface an accomplished artist could create the illusion of deep space, which
is evident from a comparison of a hanging scroll with an album leaf in figures 18.44 and
18.45. Landscape scenes were also painted on fans, screens, robes, and pottery, but those
kinds of media were not usually preferred by literati artists.

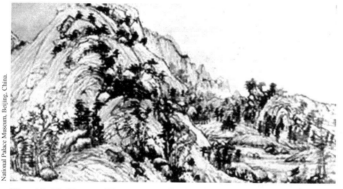

National Palace Museum, Beijing, China.

Fig. 18.43 Huang Kung-wang (Huang Gongwang), *Dwelling in
the Fu Ch'un Mountains*, section of a hand scroll, ink on paper,
dated 1350.

The dominance of one pic-
torial theme over such a long
period of time challenges fo-
cus and interpretation. In the
case of ancient Egyptian art,
a mostly uniform purpose,
method, and style prevailed
for thousands of years, which
included the technique of plan-
ning dimensions of sculptured
or painted figures on a standard
grid of squares. In the case of
Chinese painting, landscape
was the most popular subject
and the materials remained the same, but there was no stylistic uniformity in its treatment
across the centuries. Some painters worked only with black ink, while others chose to use
color washes. A variety of styles emerged from one period to the next, from one painter to
the next, even within the corpus of a single painter. Painters also had different motives.

In the Sung dynasty, the dominant theme was grand philosophical visions of nature
and an ideal of representation. In the Yuan dynasty, intimate personal expression emerged
as the highest priority. In the Ch'ing dynasty, there was much inspired reworking of the
entire tradition. Sung painters are noted for a "realistic" approach to landscape, the great
examples being Li Ch'eng, Kuo Hsi, Fan K'uan, and Mi Fei from the tenth and eleventh
centuries. The term "realism" can be misunderstood if it is taken to mean painting exactly
what one sees. What ended up on paper or silk, however, was determined by the nature of

Photograph by Kenneth R. Stunkel.

Fig. 18.44

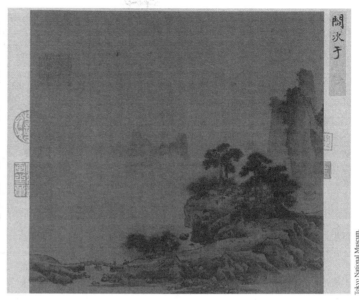

Tokyo National Museum.

Fig. 18.45 Untitled album leaf, Hsia Kuei (Xia Gui) 1195–1224.

the painter's materials—brush and ink. Usually an image was formed in the mind before a brush touched the surface and ink soaked into the paper or silk.

In Ming and Ch'ing times, however, some artists turned again to quasi-representations of nature and produced landscapes of recognizable places, marked by well-known temples, gates, roads, and pavilions, with minimal use of type forms. An early Ch'ing painter, Chang Hung (Zhang Hong), produced representational images with geological formations, buildings, paths, and other objective features known to people who lived in or visited the place depicted.[125]

The point is that diversity is a caution against oversimplification. Nevertheless, despite variety, exceptions, and contradictions, there are connecting threads that run through the tradition that make sense of diversity.

Thread 1. Whatever the stylistic fluctuations, the preferred subject was landscape, with bamboo a lively rival. Within a landscape, more limited pictorial forms—birds, flowers, trees, people, buildings—could be accommodated in a unified whole.

Thread 2. The same materials—ink, brush, inkstone, paper—were in common use, and techniques were derived chiefly from calligraphy. Since ideographs formed with brushstrokes are a kind of drawing, calligraphy and painting are clearly related. In general, the ideal in painting was a swift, spontaneous movement of the brush guided by an image in the mind. There were exceptions. Some painters made outlines to work from, and still others finished a work in stages rather than at one inspired sitting. In any event, the relationship of ink to paper made studied revisions unworkable Some artists painted on walls as well, like the Sung master Kuo Hsi, who exploited bumps and crannies on plastered surfaces to give an image texture.

Thread 3. Devices used to display images—hanging scroll, hand scroll, album leaf, and fan—remained constant for centuries, along with a taste for colophons, appreciative inscriptions by subsequent owners, and often owners' seals, a number of which are visible in Figure 18.45. Most of these additions to the image did not come into vogue until the Yuan dynasty. While enhancing the value of a work by connecting present admirers with those of the past, these practices could be overdone to the detriment of a painting. The Ch'ien-lung emperor was notorious for littering paintings in his collection with colophons and seals.

Thread 4. Landscape was commonly three complementary arts—calligraphy, poetry, and painting, known as the Three Perfections. As a hand scroll was unrolled, the viewer might enjoy not only an unfolding landscape, but also the poetry and calligraphy of the artist as well as colophons by previous owners. Many landscapes were, in effect, three works of art in one, no less than all the Perfections on display.

Thread 5. The aesthetic ideal that great painting and calligraphy must have "spirit resonance," or ch'i, a dynamic sense of life conveyed by the strength of the brushstroke, survived a thousand years in the Chinese imagination. From the Yuan dynasty on, however, such resonance could be achieved by contemplation of past works as well as from the direct contemplation of nature.

Fig. 18.46 Liang K'ai, *Li Po Chanting a Poem*, hanging scroll (cropped), ink on paper, mid-thirteenth century.

http://commons.wikimedia.org/wiki/File:LiBai.jpg

Ten categories of painting were recognized in the Sung period: Taoist and Buddhist subjects, human affairs, palaces and other buildings, foreign tribes, dragons and fishes, landscapes, animals, flowers and birds, ink bamboos, and vegetables and fruits.[126] Portraits of officials, emperors, Buddhist monks, empresses, and concubines were done by court painters, often with great skill. Sketches by amateur masters were more symbolic than rigorously faithful to the appearance of an individual. The idea was "to transmit the spirit," as in a Ch'an Buddhist's swiftly executed, energy-charged image of the freewheeling T'ang dynasty poet Li Po (Li Bo, also Li Pai / Li Bai) chanting one of his poems (fig. 18.46).

Portraits were used to shape moral character and convey the spirit of Buddhist, Taoist, and Confucian virtues. As the Han dynasty poet Ts'ao Chih / Cao Zhi (192–232) noted: "When one sees pictures of the Three Kings and Five Emperors, one cannot but look at them with respect and veneration. . . . When one sees pictures of rebels and unfilial sons, one cannot but grind the teeth. . . . By this we may realize that paintings serve as moral examples or as mirrors of conduct."[127]

A striking contrast with Western art after the Renaissance is the absence of nudes in Chinese painting, which emanated from Confucian moral considerations rather than prudery (nakedness was not unknown among Taoists). Like painting in the West, however, landscape was used as a background for figures until the T'ang dynasty before the two subjects were separated into distinct categories. An example of figures in a landscape is the Sung copy of a work called the *The Fairy of the Lo River* by Ku K'ai-chih / Gu Kai-

Fig. 18.47 Attributed to Ku K'ai-chih (Gu Kaizhi), *Fairy of the Lo River*, copy from the twelfth or thirteenth centuries, section of a hand scroll.

zhi (344–406), the tale of a water spirit who tries unsuccessfully to lure a scholar away from the shore (fig. 18.47). Another is the *The Emperor Ming Huang's Journey to Shu,* a later copy of an eighth century painting about the flight of an emperor from a rebellion, in which the prominence of landscape has obviously taken on more substance than the event it portrays (fig. 18.48). Nevertheless, in both works, landscape is clearly used as a

Fig. 18.48 Anonymous, *Emperor Ming Huang's Journey to Shu,* hanging scroll, ink and colors on silk, eleventh century copy of an eighth century original.

background for figures in a story to accent the space between them. By the tenth century, landscape had taken over as the dominant theme.

Most of the ten categories were executed by professional court painters, who were viewed, in later times, with aloofness by the scholar-gentry, for whom landscape and bamboo were usually the preferred subjects. Again one must qualify this statement and admit that birds and flowers, a standby of professionals for decorative purposes, were also painted by the scholar-gentry, and we should remember also that they were not always free to escape being paid professionals. On balance, however, from the Sung dynasty on the scholar-gentry embraced an amateur ideal, the wen-jen-hua (wenren hua), or literary scholar-painter, a man of broad culture, implying mastery of scholarship as well the Three Perfections. The amateur ideal expected much of an accomplished landscapist, nothing less than a transformation of nature and self in the loftiest sense. As the Sung dynasty painter-scholar Tung Yu (Dong You) put it, using brush and ink are equivalent to creation in nature. The most admired characteristic of the amateur was blandness, which meant harmony of character, a certain awkwardness belying superficial cleverness, and reliance on inner strength rather than the outer world, although inner balance was the key to illuminating the world of nature. The work of the Yuan dynasty master Ni Tsan (Ni Zan) was valued by connoisseurs because his images were perceived as "bland" in this sense.

would have been nice to see a Ni Zan here

The Brushstroke

As already noted, painting crossed over from calligraphy. Without experience with the brush achieved by forming characters over the years, painting with the brush was not a realistic option. Like calligraphy, landscape was preeminently an art of the brushstroke. Full appreciation of Chinese painting requires attention to the manifold variety of brushstrokes as they pull, push, flick, dot, sweep, lift, and fall upon the paper or silk. Beauty in a painting was judged by the quality and aptness of an artist's mastery of the brush, and then by insight and discretion shown in treatment of the subject. Nowhere is the cult of brushwork more evident than in renderings of bamboo (fig. 18.49). There is always an exception, like the Ch'ing dynasty painter Kao Ch'i-p'ei (Gao Qipei), who used his fingernails and even split a long fingernail so he could use it as a quill to make lines, the method by which he executed an astringent, otherworldly album leaf called *Landscape With Tall Peaks,* a work that dramatizes the variety of landscape painting (fig. 18.50).

Scholarship and the "Perfections"

The men who painted were educated in Confucian and Taoist texts and went through rigorous preparations for the imperial examinations. They shared a common philosophy of nature, man, and society. Painting was an activity related not to calligraphy so much as to literary studies. The literati considered it a possession of the Confucians, just as the other two "perfections," poetry and calligraphy, were identified with the common interests of the literati class.[128] The Confucian influence appears in the reverence for tradition, honoring past masters by trying to capture their spirit, and claiming the best work as having been done by predecessors, while the power of tradition kept landscape the preferred

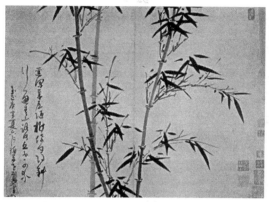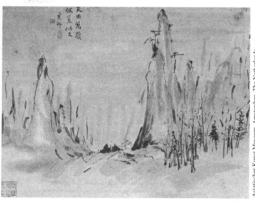

Fig. 18.49 *Summer Bamboo*, Wu Chen / Wu Zhen (1280–1354), album leaf ink on paper, dated 1350.

Fig. 18.50 Kao Ch'i-p'ei (Gao Qipei), *Landscape with Tall Peaks*, album leaf and light colors on paper, eighteenth century.

genre for centuries. No matter what the ups and downs of individual styles within that tradition, all relied on landscape as the subject. The accomplishments of scholar-gentry included the closely linked, virtually inseparable Perfections—calligraphy, poetry, and painting—which served together to establish the moral, intellectual, and artistic credentials of the individual.

Neo-Confucian Cosmology

Confucianism understands nature as the interplay of yin and yang with the Five Elements and holds that all phenomena are mutually and dynamically connected. This organic conception of the world, with its interactive oneness of nature, man, and society, was a fusion of ideas drawn from Taoism and Buddhism as well as Confucianism. All three were united, as explained earlier, in a philosophical synthesis known as Neo-Confucianism, a doctrine bent on universal harmony. With many painters, especially those of the Sung dynasty (when Chu Hsi consolidated Neo-Confucianism thought), landscape was a means of harmonizing the chief elements of nature—mountains, water, rocks, clouds, sky, animals, birds, plants, and man—while demonstrating the empathy and sincerity of the painter. Everywhere in a painting the complementary opposites of yin and yang were perceived to be at work. Dark areas on rocks (yin) contrasted with light areas (yang), the main trunk of a tree (yang) contrasted with its branches (yin), and so on. Light and dark brushstrokes were viewed as the interplay of yin and yang.

The Private Realm

While the cosmic aspect of landscape as a harmonization of myriad things in the world was commonplace in landscapes, so were the more subjective personal thoughts, feelings, and tastes of the painter, especially in works from the Yuan dynasty, when personal expression became an obsession with many artists. Whatever the expressive style, however, painting was a release from the cares and demands of social and official life, a Taoist window through which the individual could fly to the grandeur and beauties of nature. Where the personal element surfaced conspicuously, it was a clue to the artist's

sincerity (ch'eng / cheng). Since harmonization of self with the world was a traditional aim of painting, Chinese images are free of violence, social criticism, sexuality, and even allusions to romance between men and women. Natural objects and scenes are the chief subjects; the presence of humans was soft pedaled and guided by modesty, the way of man subordinated to the way of nature.

Tradition

Landscape painting was a path to self-discipline through immersion in tradition. In the *Mustard Seed Garden Manual of Painting*, the novice is given strict advice that applies to any discipline: "You must learn first to observe the rules faithfully; afterwards, modify them according to your intelligence and capacity. The end of all method is to seem to have no method. . . . First, however, you must work hard. Bury the brush again and again in the ink and grind the inkstone to dust. Take ten days to paint a stream and five days to paint a rock. . . . If you aim to dispense with method, learn method."

The manual goes on to enumerate "principles, standards, and rules"—The Six Canons (see below); The Six Essentials, the second of which is that design should accord with tradition, and the sixth that one must learn from the masters and avoid their faults; The Three Faults in handling a brush; The Twelve Things to Avoid in composition and the execution of a painting; and The Three Classes, which distinguishes levels of achievement—"divine," when "movement of life" is produced"; "marvelous," when brushwork, color, and expression are excellent, appropriate, and harmonious; and "accomplished," when form is right and "rules have been applied." Notable masters after the T'ang dynasty are mentioned who are worthy of study. Obviously there was more to painting landscape than mere desire and playing around with brush and ink as a form of recreation. The manual defines a standard of self-cultivation and mature experience necessary for making progress: "Study ten thousand volumes and walk ten thousand miles."[129]

Aesthetic Theory

Although little painting survives from earlier times, apparently enough had been done to justify the formulation of a self-conscious aesthetic. The painter-critic Hsieh Ho (Xie He), 479–501, wrote a treatise, *Classified Record of Ancient Painters*, which set forth six "laws" based on the work of twenty-six painters who worked before him. His formulation of this canon shaped Chinese aesthetics for the next 1,400 years. Later Chinese artists understood and accepted the propriety of obeying rules before intervening with individual taste and inclination.[130]

1. Spirit consonance, or resonance, and life movement.
2. The "bone method" (structural strength) in use of the brush.
3. Fidelity to the subject in accordance with its inner nature.
4. Color applied according to the nature of the object.
5. Proper placing and disposition of forms to achieve the harmony of Tao.
6. Copying of ancient masters to transmit their essence and spirit.

The first law is paramount and refers to the spirit that activates the artist's mind.[131] Inspiration comes from spontaneous movement of Tao and interplay of Heaven and Earth. Thus Taoism and Confucianism are a common ground as yin and yang from whence a spark leaps to ignite the painter's imagination. Through the writings of later commentators, the idea of "spirit resonance," a sense of vibrant life in a painting, acquired a philosophical meaning and came to be identified with the Universal Mind, or in the terminology of Neo-Confucianism, the Great Ultimate, the repository of all the principles (li) that give Heaven, Earth, and Man their meaning. From that perspective, the great landscape painter, who also was expected to be a scholar and visionary, was believed to harmonize the universe through the tip of his brush, activating cosmic forms and directing their energy.

The second law addresses the ideal quality and energy of brushwork. The "bone method" refers to strokes of the brush that do not falter, have inner power, and take on rhythmic life. The first step in evaluating a painting is to scrutinize the brushstrokes to determine if they are dead or vital. The Sung dynasty master Kuo Hsi said calligraphy and painting are the same thing. The only difference is that a landscape is more complex than a written character. Another painter explained that being a capable painter means grasping "the mystery" of brush and ink.

The third law means faithfulness to appearance, but in time it came to mean also not copying from life. Images in Chinese painting were in the minds of the artists, who wandered or sat in natural surroundings for a time, collected impressions, and then went home to paint. It is a mistake, however, to think the painter invented images by imagining them. There was always some correspondence between what was in the mind and in nature, though not one that was exact. An artist might carry ink and paper on a ramble to sketch an unusually shaped tree or rock, but the act of painting relied on what was in the mind rather than on a sketch.

Tung Yu (Dong You) explained "images of the mind": "Out of the forms of nature the images are produced. . . . They are first seen in the mind like flowers and leaves detaching themselves and beginning to sprout. Then they are given their outward shapes and colours by the work of the hand. . . . The vision or conception of the mind is the primary thing. . . . The work of the hand must be guided by the vision of the mind, not by exterior models."[132] Images were stored away, which then flowed spontaneously from the mind through the brush to paper at a favorable moment. In the words of a Ch'ing dynasty painter: "The idea must be conceived before the brush is grasped—such is the principle point of painting. When the painter takes up the brush he must be absolutely quiet, serene, peaceful and collected and shut out all vulgar emotions."[133]

With these principles in mind, a hierarchy of greatness was recognized. At the bottom is the clever man skilled with outward application of rules to assemble fragments of beauty. Next is the cultivated man good with brush and ink, but so immersed in the vagaries of personal taste that his results are incoherent and distorted. The third level is the divine or wonderful painter who comprehends everything in nature with effortless inspiration. Some Chinese critics were content to stop here with this third level as the summit of art. Others pushed along to a fourth, unnamable level where the painter is totally free and spontaneous in a state of oneness with Tao, creating images that are a perfect vision of organic reality.

The fourth law calls for fidelity to the object with respect to color. Although black ink

was the mainstay of Chinese painting, color had its place when modestly applied. Many painters held that a sense of color could be achieved by gradations of ink alone, from black to gray, a method that was preferred. When color was used, it was applied with special brushes in successive layers of gentle, flat washes over the ink forms. Varying tones could also be produced with ink washes alone. Color was not used to define forms or to manipulate the fall of light. Originally, the use of color was symbolic rather than aesthetic. Thus white was the color of mourning, autumn, and west; black the color of wickedness, winter, and north; and yellow the color of life, summer, and south.

The fifth law has to do with the relationship of objects to one another in distance and depth. A sense of distance was achieved in three ways—a low horizon looking up toward peaks (fig. 18.51); a middle horizon looking straight on, seeing peaks one behind the

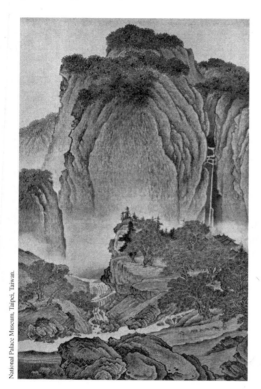

other (fig. 18.52); or high horizon, or "bird's eye" view, that takes in the whole scene at once (fig. 18.53). The use of a linear perspective was not unknown by later painters, but it was rejected in large part because it results in a view from a single perspective, whereas the Chinese painter sought to achieve multiple points of view. Space was not viewed as a geometric field subject to measurement and manipulation like the mathematical space of Renaissance painters in Europe.

Space was understood as limitless. In Sung dynasty works by Ch'an Buddhist painters, space may be an encompassing void, as in Figure 18.54, which consists of indistinct forms about to melt into a surrounding space, or perhaps emerging from it. The image borders on blankness. The forms, laid on swiftly with black ink, barely surface from the surrounding emptiness. Forms can be minimized no further without obliterating them altogether. Whatever reality the forms have is supplied by the void. Referring to space in landscape painting as "atmospheric" is therefore misleading, because a sense of space was commonly achieved by leaving the paper blank rather than using washes applied by a brush.

Fig. 18.51 Fan K'uan (Fan Guan), *Traveling Among Streams and Mountains*, hanging scroll, light color on silk, eleventh century.

National Palace Museum, Taipei, Taiwan.

Blank space in a painting affirmed that everything visible to the eye cannot be represented in practice, so the artist should not try to do so by merely filling space with forms, although some painters did just that, as in a fourteenth century work by Wang Meng in which there is no empty space, only teeming, luxuriant material forms crowding in on one another as if to spill out of the picture plane altogether; although viewed from the opposite perspective, the forms can be seen as flooding into the picture plane from the outside (fig. 18.55).

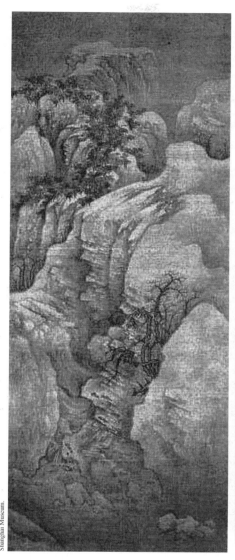

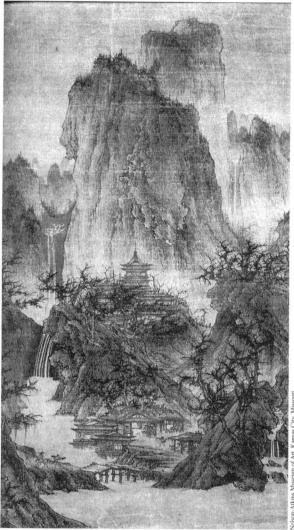

Fig. 18.52 Kuo His (Guo Xi), *Deep Valley*, hanging scroll, eleventh century.

Fig. 18.53 Li Ch'eng (Li Cheng), *Buddhist Temple in the Mountains After Rain*, hanging scroll, ink and slight color on silk, tenth century.

A second guiding rule connected with this law is the host-guest relationship, another pair of yin-yang opposites. The "host" in a painting by Kuo Hsi or Fan K'uan is the mountain, the main subject; the "guests" are secondary elements—waterfalls, lakes, temples, people, and so on. The painter must decide at the outset what the host-guest relationship is to be. Distance was generally regarded as essential to a superior work. As Kuo Hsi explained: "Landscapes are large things; he who contemplates them should be at some distance; only so is it possible for him to behold in one view all shapes and atmospheric effects of mountains and streams."[134] While birds, flowers, and bamboo had their devotees, the panoramic landscape with all its variety, forms, and cosmic implications occupied the throne of art as subject matter.

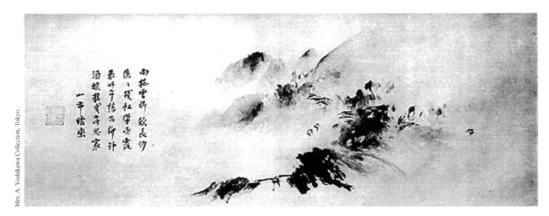

Mrs. A. Yoshikawa Collection, Tokyo.

Fig. 18.54 Ying Yu-chien (Ying Youjian), *Village in Clearing Mist*, early thirteenth century.

The sixth law enshrines tradition and the study of past masters as a preparation for independent work. Chinese painters started out by "copying" great landscapes of the past. A literal copying, like an art student reproducing a Rembrandt in a museum, was an acceptable option but was not the main purpose. The main idea was to capture the "spirit" of the master rather than duplicate exactly his forms and brushstrokes. Hundreds of landscapes are described by their creators as in the spirit or style of a particular artist in the past. Study of a painting, however, always counted for more than mere copying.

Originality was not quashed by respect for tradition, but it was not glorified and made into cult either as in modern European art, lest the painter relinquish the virtues of modesty and "blandness." The interplay of tradition with originality was a yin-yang relationship. There were other complementary opposites as well that restrained and guided the painter, such as principle (li) and matter (ch'i),

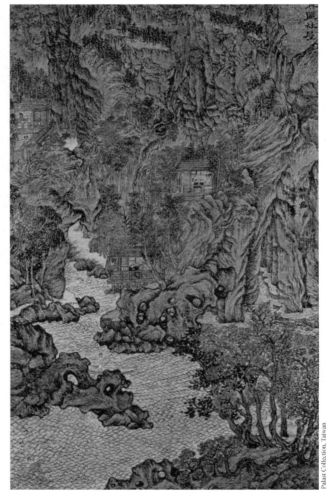

Palast Collection, Taiwan

Fig. 18.55 Wang Meng, *Dwellings at Chu-ch'u* (Zhu chu), hanging scroll, ink and colors on paper, fourteenth century.

heaven and earth, personal and impersonal, and humanity and nature. In all such relation-
ships the ideal was balance and harmony between the painter and the rest of existence.

The moral, aesthetic, and philosophic functions of painting explain in part its hold on
the Confucian ruling class. A ninth-century writer concluded: "Painting promotes culture
and strengthens the principles of right conduct. It penetrates completely all aspects of the
universal spirit. It fathoms the subtle and abstruse, serving thus the same purpose as the
Six Classics. . . ."[135] Just as scholarship and public service in the Confucian spirit were
means of self-cultivation and the achievement of manhood at its best, so were calligraphy
and painting, which came to reflect Taoist and some Buddhist values as well, a synthesis
in art that mirrored the Neo-Confucian synthesis in philosophy. Enjoyment of landscape
was also an escape from dust and turmoil of the world, as Kuo Hsi, or his son, affirmed:
"Contemplation of such pictures evokes in men corresponding ideas; it is as if one were
among the mountains, and the scenery existed outside the imagination. . . . When one sees
the cliffs, the streams and the stones, one feels like rambling among them. The contem-
plation of such pictures arouses corresponding reactions in the heart. It is as if one really
came to these places."[136]

Style in Landscape Painting

Stylistic variation was a major feature of the great landscape tradition as it unfolded from
the tenth to the eighteenth centuries. Identification and classification of styles is a major
occupation of art historians trying to make sense of innumerable landscapes produced over
a thousand years. The shared meanings of landscape embodied in subject matter, remained
relatively stable from Sung times and afterward: transcendence of time and place (though
not always); a sublime world of nature dwarfing human stature and activities; a means of
personal expression; a repertory of symbols drawn mostly from nature; Confucian respect
for tradition and Taoist yearning for the eternal; an organic fusing of pictorial art with
calligraphy, poetry, and colophons—all preoccupations of the scholar-gentleman.

Style has to do with the forms chosen by the artist—profiles of mountains, textures
of rock and water, shapes of trees and structures—and the execution of those forms with
brush and ink on absorbent paper or silk. Central to stylistic differences was the brush-
stroke, even when strokes had a standard function, like the short, pale texture stroke (ts'un
/ cun) to give rocks a persuasive appearance. In the development and transmutation of
styles, there were inevitable tensions between originality and tradition, content and form,
complexity and simplicity—in short, the familiar interplay of yin and yang.

Style in landscape painting went through five major transformations. Here we will
devote more space to the first, which already shows considerable variety, and somewhat
less to its successors.

Sung Realism

The first great category of style was the realistic, objective, comprehensive, philosophical
approach to landscape, usually termed "monumental," in the Sung dynasty. Great names
in the north—Li Ch'eng, Fan K'uan, Kuo Hsi—were complemented by the more intimate
realism of Ma Yuan and Hsia Kuei (Xia Gui) in the south. The best work of these men

evokes a sense of wonder in the presence of nature, as if eyes were opened for the first time to behold the splendors of mountain, forest, and water. Something of that awe is conveyed in the title of Kuo Hsi's treatise on painting, *The Great Message of Forests and Streams*. The freshness of experience and image were seldom repeated by later generations of artists but established a lofty standard for them in the next eight centuries. Even when painters were doing something radically different with natural forms, they might claim to be painting in the "spirit" of Li Ch'eng.

The Sung masters were acknowledged by later generations of literati painters to be in full accord with the six "laws" of Hsieh Ho. The legendary figure was Li Ch'eng, whose reputation was that of a superhuman culture hero (fig. 18.53). Fan K'uan explains that he got started by following the example of Li Ch'eng, which tells us that working from established models was already a practice in the Sung period, but then he changed his mind: "My predecessor's method consisted of a direct apprehension of things in nature; here I am, learning from a man, which is not the equal of learning from the things themselves. But better than either of these methods is the way of learning from my own heart."[137] Fan K'uan's one surviving masterpiece, *Traveling Among Streams and Mountains* confirms a direct experience of nature untainted by any kind of willful manipulation (see fig. 18.51).

Recently his signature was found amid leaves in the lower right corner of the painting. The landscape creates its own grand world and seems autonomous. The main subject is a huge bluff that occupies three quarters of the painting. A waterfall framed by a precipitous cleft accents the massive face and throws up clouds of mist at the bottom. In the foreground, a path winds between meticulously formed rocks and foliage, seemingly completely spontaneous. Along the path, dwarfed by the surrounding majesty of nature, a donkey train can be seen inching along.

What made the Sung northern school realistic was attention to detail, which included careful depictions of branches, leaves, buildings, boats, and other objects both natural and human. These artists were great observers but did not paint directly from life. Attentiveness to natural detail did not alter the fact that an image in the mind preceded a brushstroke. The Sung master Mi Fei, noted for graded washes of ink suggesting distance in levels and dramatic brushstrokes called "mi-dots" (named after the painter) said: "In Fan K'uan's landscapes you can even hear the water."[138]

Despite such attention to detail without painting directly from objects, a painter of landscape aimed to capture the essence or spirit of a mountain, stream, or clump of vegetation by recalling the image of an individual rock or tree. An alternative was to use formulaic "type forms" of rocks and trees of the sort catalogued in *The Mustard Seed Garden Manual of Painting,* the method of many later painters, from which a beginner could learn from scratch how to produce trees, rocks, and streams roughly like those of past masters.

Kuo Hsi's *Early Spring* is the only surviving work that is authenticated. The painter's signature is halfway down the left side (fig. 18.56). The inscription in the upper right is from a later time. That such a fragile work managed to survive for a thousand years confirms the power of Chinese tradition. When one confronts it, the centuries melt away, and one is drawn into the immediacy of Kuo Hsi's cosmic vision. The treatment of large-scale rock and cliff forms suggests an eroded natural order in violent motion. Harmony

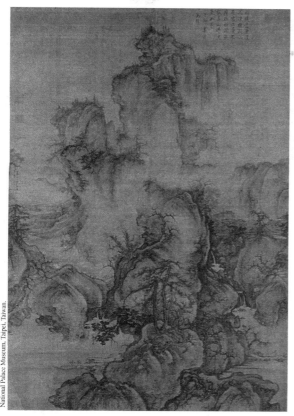

National Palace Museum, Taipei, Taiwan.

Fig. 18.56 Kuo Hsi (Guo Xi), *Early Spring*, hanging scroll, ink and color on silk, dated 1072.

is not detectable in those forms alone, which have a fantastic, disarming quality. The central mountain could almost be a writhing dragon.

Details in the painting are by contrast precise and realistic—the fisherman at the bottom left, the temple and pavilion at the upper right. The palpable sense of receding space is achieved with ever-lighter washes of ink applied at successive levels rising from the bottom to the top, with a forlornly worn valley to the left fading into a void. His genius manages to unify these conflicting elements into a deftly balanced composition. Although harmony was an ideal of landscape imbibed through Neo-Confucian philosophy, it did not always square with temperament or performance, as was the case with Kuo Hsi. *Early Spring* has elements of instability. The eroded masses of rock trailing off into space and a pavilion that can be seen hanging ominously on an overhanging cliff suggest a restive frame of mind unhappy with stability.

But the realistic approach of painters of the northern school before the Jurchen-Chin conquest of the northern Sung in 1127 was not the only stylistic option. In the south, after 1127, when the capital was moved to Hangchou, in a region with beautiful but less rugged terrain than in the north, a style known as the Ma-Hsia school emerged in which nature was tamed and domesticated. The name refers to the works of Ma Yuan and Hsia Kuei. They provide a contrast of forms and brushwork with the monumental works of Li Ch'eng, Fan K'uan, and Kuo Hsi.

Ma Yuan expresses a personal closeness with nature as a scholar under a willow tree watches birds in flight, a far cry in mood and scale from the monumental landscapes of the northern school. In a stylistic quirk, he usually swept his forms into one corner and left space in the opposite corner, earning him the nickname "one corner Ma." (fig. 18.57). The inscription is by an imperial consort who was an accomplished poet, calligrapher, and painter. She wrote: "Brushed by his sleeves, wild flowers dance in the wind; / Fleeing from him, the hidden birds cut short their song."[139] Hsia Kuei has a similar softness and intimacy of scale and execution that is comfortably and pleasantly accessible rather than awesome. The work on view was admired for the skill and nuance of the artist's brushwork and control of the ink. The washes range from intense black to near transparency (fig. 18.58).

Fig. 18.57 Ma Yuan. *Walking on a Mountain Path in Spring*, album leaf, ink and light colors on silk, early-thirteenth century.

Fig. 18.58 Hsia Kuei (Xia Gui), *A Pure and Remote View of Rivers and Mountains*, section of a hand scroll, ink on paper.

Yuan Subjectivity

The second generic style emerged in the Yuan dynasty as the literati retreated into self-expression and cultivation of the inner man at the expense of realism, as exemplified by Wu Chen (Wu Zhen), Huang Kung-wang (Huang Gongwang), Ni Tsan (Ni Zan), and Wang Meng (the Four Yuan Masters). No doubt a stimulus for this change was the despised rule of the Mongol conquerors, but there was also the incomparable achievement of Sung painters that discouraged further movement along their path of cosmic representation. Painters abandoned realism. What does one do in the wake of Fan K'uan and Kuo Hsi? The response was personal expression and a retreat from the vast scale and detail found in *Travelers Amid Streams and Mountains* or *Early Spring*.

Departure from objective standards of a monumental style into the subjectivity of personal feelings became a dominant trend. Ni Tsan was a pillar of this style with his meager, dry, detached, almost noncommittal *Trees in a River Valley at Yu Shan*, which is devoid of human life (fig. 18.59). His work was much admired for its "blandness," a sign of inner purity and removal from the dust of the world referred to earlier.

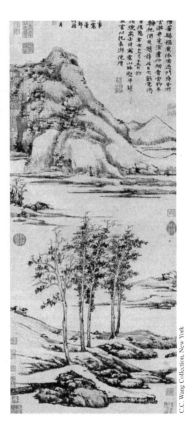

Fig. 18.59 Ni Tsan (Ni Zan), T*rees in a River Valley at Yu Shan*, hanging scroll, ink on paper, dated 1371.

Ming Traditionalism

The third style was a preoccupation in the Ming dynasty with theory and the contemplation of paintings in the tradition, rather than with nature itself. By this time, in the late

Ming period, the variety of styles available for "copying" from the past was enormous. If a painter had access to a collection of older works, he could focus on them for inspiration rather than the realm of nature that originally inspired their authors. In short, the possibilities for stylistic inclination were unlimited. The problem with such abundance was a lack of focus among amateur painters at a time when they needed more cohesion in a profoundly corrupt and oppressive Ming administration. The political setting was a literati class much abused by the imperial court and its scheming eunuchs.

The discipline of choice came from Tung Ch'i-ch'ang / Dong Qi-chang (1555–1636), who selected artists of the past as models and defended his decisions with prodigious scholarship and knowledge of his subjects. Tung was a high official who headed the

Ministry of Rites, the institution which oversaw the imperial examinations, and was also an accomplished scholar, calligrapher, and painter. His rather arbitrary, idiosyncratic writings on northern and southern styles became authoritative in the next dynasty. He took all the painters from the T'ang dynasty down to his own time and placed them in either a northern or a southern school. The two categories were not distinguished by style but rather by philosophical ideas. He linked the two schools of painters to the northern and southern schools of Ch'an Buddhism. What distinguished the latter was its emphasis on intuition and spontaneous enlightenment.

Tung associated the southern school of Ch'an with the amateur wen-jen-hua ideal of the literati, and the northern school of Ch'an, with its stress on deliberate, systematic discipline to achieve gradual enlightenment, with the academic, professional painters. The implication for painting was to work out of an inner rather than an outer landscape, which accounts in large part for Tung's dissonant violation of elementary principles of spatial arrangement. In the work on view, forms rather than concepts guide his hand as they pile somewhat haphazardly on top of one another (fig. 18.60). Thus his advice is the opposite of his practice: "Whenever one paints landscapes, one must pay attention to proper dividing and combining. The spacing (distribution of parts) is the main principle."[140] By narrowing the stock of models, however, Tung provided steady guidance for his colleagues to apply brushwork to the creation of pure form.

Fig. 18.60 Tung Ch'i-ch'ang (Dong Qi-chang), *Autumn Landscape*, hanging scroll, ink and light color on silk, early seventeenth century.

The Ch'ing Endgame

The last flowering of landscape painting which occurred in the first eighty years of the Ch'ing dynasty, was represented by the four orthodox Wangs (Wang Shih-min [Wang Shimin], Wang Hui, Wang Chien [Wang Jian], and Wang Yuan-ch'i [Wang Yuanqi]); individualists, notably Chu Ta (Zhu Da); and the Eight Eccentrics of Yangchou (Yangzhou), the last great school of Chinese painting, whose best representatives were Hua Yen (Hua Yan) and K'ao Ch'i-p'ei (Gao Qipei), with Lo P'ing (Lo Ping) rounding out the great tradition. The Four Wangs represented a vigorous orthodoxy that largely followed the dictums of Tung Ch'i-ch'ang, but their art still has real variety of style. The most original of the four was Wang Yuan-ch'i, a high official influential in the court academy. His work is sufficiently idiosyncratic to defy the label "orthodox." His claim to be inspired by the Sung master Li Ch'eng, although the title tells us it was Ni Tsan, is belied by the fragmented, nearly atomistic piles of rock that constitute a range of mountains. No one had seen anything quite like it before—for example, the contradictory horizons on each side and the pavilion down front that looks almost plastered to the ground (fig. 18.61).

J.P. Dubosc Collection, Lugano, Switzerland

Fig. 18.61 Wang Yuan-ch'i (Wang Yuanqi), *River Landscape in the Manner of Ni Tsan*, hanging scroll, ink and light color on paper dated 1704.

Early Ch'ing painting still had some thick juice flowing in its veins.

The spirit set forth by the writings and example of Tao-chi (Daoji) was to express without undue reliance on past models, to know one's own mind, and to allow the magic of the brush to do its work without being activated solely by tradition. He was a monk whose freewheeling aesthetic came chiefly from Taoist sources and the Book of Changes. In an obvious paraphrase of the Taoist principle of action by non-action, he said: "The method which consists in following no method is the perfect method."[141] For him, the brushstroke lay at the root of all existence and its varied phenomena, a mystical interpretation of calligraphy and painting. Despite the title, *The Waterfall on Mt. Lu*, the work does not refer to a particular landscape (fig. 18.62). Elements of the image are synthesized from Tao-chi's mind, a distillation of close observations during his customary hikes in mountainous terrain. Mists swirling between rock forms seem to play a counterpoint of noncorporeal spirit and solid matter. The figure on the ledge looking down into the cauldron of mist might be reflecting on that relationship. Although the work is highly individualist in subject matter and brushwork, it

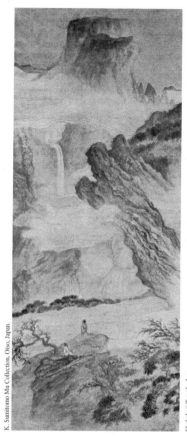

Fig. 18.62 Tao-chi (Tao-ji), *The Waterfall on Mount Lu*, hanging scroll, ink and light colors on paper.

Fig. 18.63 Chu Ta (Zhu Da), *Landscape*, hanging scroll, ink on paper.

Fig. 18.64 Hua Yen (Hua Yan), *An Autumn Scene* album leaf, ink and light color on paper, dated 1729.

has a grandeur echoing the great age of Kuo Hsi, whom the painter explicitly admired.

Perhaps oddest of the individualists was Chu Ta (Zhu Da), a heavy drinker, antisocial eccentric, and Buddhist monk whose somewhat wild brush style was as unconventional as his life. His method of painting was intensely improvisational, as one would expect from a man who usually worked while intoxicated. A landscape of his that resides in a Japanese Buddhist monastery is executed in a narrow space that climbs a long hill, beginning with sparse looking trees at the bottom, pushing on to a barely indicated rock sheltering some houses, and ending at the top with splotches of ink (fig. 18.63). Comparing Chu Ta with Tao-chi and Wang Yuan-chi confirms that immense stylistic differences were still possible from individualist painters in the same dynasty within the genre of landscape executed with brush and ink.

The Eight Eccentrics of Yangchou was the last of China's outstanding landscape schools. After them, landscape fell into a conventional, imitative groove. Perhaps greatest of the eight was Hua Yen (Hua Yan), whose work often resembles European surrealism. In *An Autumn Scene,* he manages to express distance, remoteness, and mystery all at the same time as a solitary traveler stands, framed between a monolithic rock and two bizarre plant forms, gazing across an empty plain (or lake?) at a distant peak (fig. 18.64).

The Tradition Ossifies

The fifth stage witnesses a decline in quality and inspiration as the great tradition began to feed excessively and

fatally off itself. Exhaustion at the end of a long thousand-year arc of achievement comes suggestively with the work of Lo P'ing (Lo Ping), one of the Eight Eccentrics, an artist well thought of in his time, whose death in 1799 can be viewed as a convenient terminal point of inventive landscape painting. His *Portrait of the Artist's Friend I-an,* part of a hanging scroll dated 1798, depicts a friend inhaling the fragrance of plum blossoms (fig. 18.65).

The face suggests a man who has gazed back to the days of Li Ch'eng and Fan K'uan, swept his eye over intervening centuries of art and thought, and yearns for solitude and rest. Elements of the "landscape" are reduced to a few tufts of grass and a massive, eroded rock, the sort usually found in literati gardens, pocked with holes and fissures, invested with a studied artificiality that overtook much late dynastic Chinese culture.

Landscape Painting, Man, and Nature

Landscape from the perspective of modern industrial society, which has little regard for the organic relations of soil, water, atmosphere, and nonhuman life, expresses values associated with the integrity, beauty, and healing qualities of nature, the unity of a natural world filled with diverse forms of life, and the role of man as a harmonizer rather than a disrupter of the natural order. In the modern world, these values would be identified as an ecological point of view, which comes from biology, a science of life, rather than physics, a science of matter.

Fig. 18.65 Lo P'ing (Lo Ping), *Portrait of the Artist's Friend I-an,* hanging scroll, ink and light colors on paper, dated 1798.

The remoteness of traditional Chinese sensibility from contemporary Western sensibility is evident from the titles of paintings across the centuries, such as "A Hill Path under Whispering Pines," "In Silent Idleness under Dark Trees," "In the Shade of Bamboos Winding up the Summer," "Penetrating the Mysteries of a Pine Covered Ravine," and "Light on the Stream and Shadow from the Clouds."[142] The titles suggest a sense of affectionate communion and even union with bamboo, pines, streams, and ravines.

A work painted by Shih-ch'i (Shiqi) in 1666, twenty years after the Manchus toppled the Ming dynasty and established the Ch'ing, illustrates the gulf between Western and Chinese ideas of what nature is about and the relation of human beings to it. Shih-ch'i's line belonged to the Ming imperial house, which made him suspect to the conquerors.

He chose the path of Buddhism and became a monk, finally settling down as an abbot near Nanking (Nanjing). He lived simply and alone in a cottage, procured his food from surrounding vegetation, and cultivated the life of an eccentric, which was one way to keep the imperial censors at bay. He also painted with great skill and style.

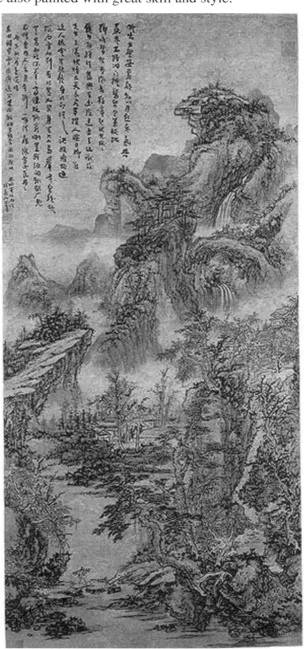

The hanging scroll titled *Climbing Wooded Mountains at Dusk* is distinguished for its grandeur, reminiscent of Sung monumentalism, and refined brushwork (fig. 18.66). The long colophon recounts his ascent of the mountain chosen as subject of the painting. His attitude toward the climb might be compared with the Renaissance humanist Petrarch's famous trek to the summit of Mt. Ventoux in the fourteenth century. Once on top, having done something no one else considered worth attempting, and confronted with a panoramic view, he took out a volume of St. Augustine and meditated on sin and the vanity of all things. Shih-ch'i went on his climb as an adventure of the spirit. In the colophon, he balances solemnity with wit as he recalls the summit "where the road comes to an end": "Since it serves to feast my eyes, it is also fit to rest my blisters."[143]

For this Chinese gentleman, climbing a mountain was a journey that required no further justification than being for a moment at one with Tao. A civilization that could nourish that sensibility and invest it with striking forms on silk and paper over many centuries has a lesson for the industrialized world—a moderating vision of man and nature in harmony that counters the destructive effects of unrestrained production and consumption. The example of old China's relatively benign ecological civilization is

Fig. 18.66 Shi-ch'i (Shi-qi), *Climbing Wooded Mountains at Dusk*, hanging scroll ink and color on paper, dated 1666.

Fig 18.67 Three Gorges Dam project, Feng jie #5, Yangtze River China, 2002.

painfully evident as 1.25 billion Chinese press ruthlessly ahead on land and water while degrading and poisoning both with industrial development and its wastes. One need only compare Shih-ch'i's seventeenth century vision of unviolated nature with Fig. 18.67, an apocalyptic image of the Three Gorges Dam project on the Yangtze River in 2002, to see how far China has fallen from the classical ideal embodied in landscape painting.

Notes

1. For Legalist philosophy, see Burton Watson (trans.), *Han Fei Tzu: Basic Writings* (New York: Columbia University Press, 1964). Han Fei-tzu (Han Feizi) was an advisor to the First Emperor until his death was engineered by the jealous first minister, Li Ssu.

2. See Richard Newman, *About Chinese* (New York: Penguin Books, 1971), 19–33, and Derk Bodde, *China's Cultural Tradition: What and Whither?* (New York: Holt, Rinehart, and Winston), 1957, 10–13.

3. On the origin and formation of Chinese characters, see Chiang Yee, *Chinese Calligraphy: An Introduction to Its Aesthetic and Technique*, 3rd rev. ed. (Cambridge, MA: Harvard University Press, 1973), chapter II. On problems of translating Chinese, see Achilles Fang, "Some Reflections on the Difficulty of Translation," in Arthur F. Wright (ed.), *Studies in Chinese Thought* (University of Chicago Press, 1953), 163 ff. Fang characterizes Chinese as "a language reputedly invented by the devil to prevent the spread of the Gospel of the Middle Kingdom."

4. Etienne Balazs, *Chinese Civilization and Bureaucracy*, trans. by H.M. Wright, edited with an introduction by Arthur F. Wright (New Haven: Yale University Press, 1964),140 ff, and Charles O. Hucker, *The Traditional Chinese State in Ming Times, 1368–1644* (Tucson: University of Arizona Press, 1961), 77.

5. Michael Sullivan, *Symbols of Eternity: The Art of Landscape Painting in China* (Stanford University Press, 1979), 121.

6. Wing-Tsit Chan, *A Source Book in Chinese Philosophy* (Princeton University Press, 1963), 69.

7. Ibid., 105.

8. Ibid., 47.

9. The book to read is Jonathan Spence, *The Death of Woman Wang* (New York: Viking, 1978), for a sad and harrowing evocation of injustice and death inflicted on an obscure woman in the seventeenth century, suggesting that the moral ideal of Confucianism failed a great many people.

10. Chan, *Source Book*, 346–347.

11. On Chinese correlative thought, see John B. Henderson, *The Development and Decline of Chinese Cosmology* (New York: Columbia University Press, 1984), chapter 1.

12. Colin A. Ronan, *The Shorter Science and Civilization in China: An Abridgement of Joseph Needham's Original Text* (Cambridge University Press, 1978), I: 167–168.

13. The example only suggests the extent of correlations. The Ten Celestial Stems, which consist of various substances and natural phenomena, are correlated with the Five Elements and also with the Twelve Heavenly Branches, which are a dozen interconnected symbolic animals, zodiacal signs, hours of the day, and compass directions.

14. This way of thinking can be sampled in Shakespeare's *Hamlet* and *Troilus and Cressida*. See Theodore Spencer, *Shakespeare and the Nature of Man,* 2nd ed. (New York: Collier, 1966), chapter IV.

15. The grand total of "classics" a thousand years after the Chou period (1122–221 B.C.E.) was thirteen: Songs, History, Annals (counts as three with its commentaries), Ritual (including two similar works), Changes, Conversations of Confucius, Book of Mencius, Classic of Filial Piety, and a body of glosses on literary texts.

16. Burton Watson, *Early Chinese Literature* (New York: Columbia University Press, 1962), 211.

17. Quoted in ibid., 30.

18. Quoted in ibid., 45.

19. *The I Ching or Book of Changes* (New York: Pantheon, 1950), I: 1, 9. This edition is the Richard Wilhelm translation, rendered into English by Cary F. Baynes. 2 vols.

20. Chan, *Source Book*, 98.

21. Ibid., 107.

22. Ibid., 108.

23. Ibid., 112.

24. Ibid., 86–87.

25. Ibid., 89.

26. There was no school of Taoism until the Han dynasty, when its two original components—hermits retreating from social chaos and magicians trying to master the operations of nature—came together. The two prominent, early Taoist writers, Lao-tzu and Chuang-tzu, do not always agree. See Yu-lan Fung, *A History of Chinese Philosophy*, trans. Derk Bodde, 2 vols. (Princeton University Press, 1952–1953), I: 172 ff.

27. Ronan, *Shorter Science and Civilization in China*, 98–103.

28. Quotations from the *Tao-te ching* do not follow Chan's versified translation, which is edited slightly for my exposition.

29. Chan, *Source Book*, 139.

30. Ibid., 141.

31. Ibid., 160.

32. Ibid., 161.

33. Ibid., 148.

34. Ibid., 158.

35. Holmes Welch, *The Parting of the Way: Lao Tzu and the Taoist Movement* (Boston: Beacon Press, 1957), 20–23.

36. Chan, *Source Book*, 154.

37. Ibid., 175.

38. For a translation rich in striking metaphors, see Burton Watson's *Chuang Tzu: Basic Writings* (New York: Columbia University Press, 1964).

39. Chan, *Source Book*, 188.

40. Ibid., 176.

41. Ibid., 186.

42. Ibid.

43. James J.Y. Liu, *The Art of Chinese Poetry* (University of Chicago Press, 1962), 48.

44. Chan, *Source Book*, 183.

45. Ibid., 190.

46. Ibid., 189–190.

47. Ibid., 194.

48. Ibid., 197.

49. Welch, *Parting of the Way*, 125.

50. On this encounter between two radically different civilizations, see Arthur F. Wright, *Buddhism in Chinese History* (Stanford University Press, 1959), to which my account is indebted.

51. Quoted in Mitchell, *Buddhism: Introducing the Buddhist Experience* (New York: Oxford University Press, 2002), 192.

52. Ibid., 200–206.

53. Chan, *Source Book*, 22.

54. Ibid., 46.

55. Ibid., 27.

56. Ibid., 45.

57. Ibid., 31.

58. Ibid., 31–32.

59. Ibid., 31.

60. Ibid., 32.

61. Ibid., 35.

62. Ibid., 36.

63. Ibid., 42.

64. Ibid., 25.

65. Ibid., 29.

66. Ibid., 42.

67. Ibid., 39.

68. Ibid., 45.

69. Ibid., 42.

70. Ibid., 43.

71. Ibid., 30. On the evaluating mind, see Donald J. Munroe, *The Concept of Man in Early China* (Stanford University Press, 1969), 49 ff.

72. Ibid., 31.

73. Ibid., 39.

74. Ibid., 22.

75. Ibid., 23.

76. Ibid., 28.

77. Ibid., 39.

78. On this point, with an apt quotation from the *Analects*, see Ch'u Chai and Winberg Chai, *Confucianism* (Woodbury, NY: Barron's, 1973), 1–2.

79. Chan, *Source Book*, 25.

80. Ibid., 29.

81. Ibid., 30.

82. Ibid., 24.

83. Ibid., 75.

84. Ibid., 62.

85. Ibid., 57.

86. Ibid., 69–70.

87. Ibid., 73.

88. Ibid., 79.

89. Ibid., 65.

90. Ibid., 82.

91. Ibid., 128.

92. Ibid., 130–131.

93. Ibid., 122.

94. The name of his book is *Luxuriant Gems [or Dew] of the Spring and Autumn Annals* (Ch'un-ch'iu fan-lu, or Chunqiu fanlu). Tung viewed the Confucian classic the *Annals* as a code with messages to be deciphered between the lines.

95. Chan, *Source Book*, 281.

96. A sequence of five major thinkers supplied the building blocks of Neo-Confucianism, later synthesized by Chu Hsi before 1200. The contributing ideas included the Great Ultimate, principle (*li*), and matter (*ch'i*). Fung, *Short History of Chinese Philosophy*, chapters 23 and 24. Wang Yang-ming developed more fully the idea of his twelfth-century precursor, Lu Chu-yuan (Lu Zhuyuan), that a distinction between nature and mind is a mistake. There is only mind. See Fung, chapter 26. The assertion of mind and denial of matter provided philosophical justification for turning inward among Ming dynasty landscape painters.

97. Quoted in Carsun Chang, *The Development of Neo-Confucian Thought* (New York: Bookman Associates, 1957), 211.

98. Quoted in ibid., 212.

99. Quoted in Fung, *Short History of Chinese Philosophy*, 210.

100. Chan, *Source Book*, 614.

101. Ibid., 610.

102. Ibid., 638.

103. Fung Yu-lan remarks: "Most Chinese philosophic schools have taught the way of what is called 'Inner Sage and Outer King.' The Inner Sage is the person who has established inner virtue in himself; the Outer King is the one who has accomplished great deeds in the world." *A History of Chinese Philosophy*, I: 2.

104. Alternative meanings of *chiao* are discussed in C.K. Yang, *Religion in Chinese Society: A Study of Contemporary Social Function of Religion and Some of Their Historical Factors* (Berkeley and Los Angeles: University of California Press, 1967), 2.

105. Mario Bussagli, *Chinese Bronzes*, trans. Pamela Swinglehurst (New York: Paul Hamlyn, 1966), 58–59.

106. A good description of these ceremonial activities is in Jacques Gernet, *Daily Life in China on the Eve of the Mongol Invasion, 1250–1276*, trans. H.M. Wright (Stanford University Press, 1962), 200–203.

107. Chan, *Source Book*, 331.

108. Liu, *Chinese Architecture*, 38, and C.A.S. Williams, *Outlines of Chinese Symbolism and Art Motives* (New York: Dover, 1976), 296–297.

109. A.C. Graham, *Disputers of the Tao: Philosophical Argument in Ancient China* (La Salle, IL: Open Court, 1989), 36–37.

110. Chan, *Source Book*, 23.

111. Quoted in Wm. Theodore de Bary, "A Reappraisal of Neo-Confucianism," in Arthur F. Wright (ed.), *Studies in Chinese Thought*, (University of Chicago Press, 1953), 101.

112. All of these "minor" forms in pre-dynastic and dynastic periods are discussed in Sullivan, *The Arts of China*, rev. ed. (Berkeley: University of California Press, 1977), passim.

113. Schuyler Cammann, "Types of Symbols in Chinese Art," in Arthur Wright (ed.), *Studies in Chinese Thought* (Chicago: University of Chicago Press, 1953), 195–231.

114. On the material properties of jade and techniques for shaping it, see, William Willetts, *Chinese Art*, 2 vols. (New York: George Braziller, 1958), 1: 56–60.

115. Quoted in Sullivan, *The Arts of China*, 40.

116. On the origin of the curved roof, see Willetts, *Chinese Art*, 2: 716 ff. The western roof truss is usually a rigid triangle that cannot be adjusted. The Chinese roof can be modified by simply changing the position of queen posts and the length of horizontal beams. The structure and nomenclature of the curved roof are best illustrated in Liang Ssu-ch'eng, *A Pictorial History of Chinese Architecture: A Study of the Historical Development Its Structural System and the Evolution of Its Types*, edited by Wilma Fairbank (Cambridge, MA: the MIT Press, 1984), 13. Nine types of roofs are illustrated, ibid., 11.

117. For diagrams and detailed commentary, see Wan-goWeng and Yang Boda, *The Palace Museum, Peking: Treasures of the Forbidden City* (New York: Harry M. Abrams, 1982), 32–44. The site of the

Forbidden City in Northern Peking was first developed by Kubla Khan in C.E. 1297 when he founded his capital there. Willetts, *Chinese Art*, 2: 67.

118. The kowtow, misunderstood by early Western envoys who refused to perform it, was an act of respect and acknowledgement rather than one of abject obeisance. The emperor was not exempt. He performed the ceremony before tablets of his ancestors and at the birth place of Confucius at Ch'u fu (Qufu) in the province of Shantung (Shandong).

119. Weng and Boda, *The Palace Museum*, 78.

120. Quoted in Maggie Keswick, *The Chinese Garden: History, Art, and Architecture* (London: St. Martin's Press, 1978), 60.

121. For a full discussion of brushes, ink, paper, and silk used in calligraphy and painting, see Willetts, *Chinese Art*, 2: 535–545.

122. The origin and characteristics of calligraphic styles, with many illustrations, are discussed in Chang Yee, *Chinese Calligraphy: An Introduction to Its Aesthetic and Technique*, 3rd ed. (Cambridge, MA: Harvard University Press, 1973), chapter 3, and Kwo-Da-Wei, *Chinese Brushwork: Its History, Aesthetics, and Techniques* (Montclair, NJ: Alanheld and Schram, 1981), chapters 2, 3, and 4.

123. Yee, *Chinese Calligraphy*, 125.

124. For example, Kuan Tao-cheng (Guan Daozheng) was born in the late Southern Sung and died in the early Yuan. Her bamboo painting was much admired. Especially influential were her innovative bamboo panoramas, extended landscapes dotted with bamboo groves. See Marsha S. Weidner (ed.), *Views from the Jade Terrace: Chinese Women Artists, 1300–1912* (Indianapolis, IN: Indianapolis Museum of Arts, 1988), 66–69.

125. James Cahill. *The Compelling Image: Nature and Style in Seventeenth Century Chinese Painting* (Cambridge, MA: Harvard University Press, 1982), 6–10.

126. The preface to the catalogue of the Sung emperor Hui tsung's collection of art, dated 1120, introduces the classification of ten categories. Apparently the list was a didactic scale of values and moral preferences. There is a separation between the human and natural worlds. Ink bamboo was prestigious because of its aesthetic resemblance to calligraphy, but was not judged as landscape.

127. Quoted in Osvald Sirén, *The Chinese on the Art of Painting: Translations and Comments* (New York: Schocken, 1963), 8–9.

128. Michael Sullivan, *The Three Perfections: Chinese Painting, Poetry, and Calligraphy*, 2nd rev. ed. (New York: George Braziller, 1999), 17–20.

129. Sze Mai Mai (trans. and ed.), *The Mustard Seed Garden Manual of Painting, Chieh Tzu Hua Chuan, 1679–1701* (Princeton, NJ: Princeton University Press, 1956), 17–22.

130. By the Yuan Dynasty, twelve things not to do had been codified: overcrowding, near and far not separated, mountains without arteries, water without a source, mountains on the same level, paths without beginning or end, indifferent atmospheric effects (mist, rain, clouds), rocks with one face, badly drawn figures, jumbled placement of buildings, and bad color. Sirén, *Chinese on the Art of Painting*, 115–118.

131. Soame Jenyns, *A Background to Chinese Painting* (New York: Schocken, 1966), 136–140.

132. Quoted in Sirén, *The Chinese on the Art of Painting*, 65. Internal visualization and pictorial representation by painters is discussed in Wen C. Fong, et al., in Images of the Mind (Princeton, N.J.: The Art Museum, Princeton University, in association with Princeton University Press, 1984), chapter 1.

133. Quoted in Sirén, *The Chinese on the Art of Painting*, 203.

134. Quoted in ibid., 43.

135. Quoted in ibid., 7.

136. Quoted in ibid., 48.

137. Quoted in Cahill, *Chinese Painting*, 32.

138. Quoted in Max Loehr, *The Great Painters of China* (New York: Harper and Row, 1980), 100.

139. Quoted in Sullivan, *The Three Perfections*, 30.

140. Quoted in Sirén, *The Chinese on the Art of Painting*, 142.

141. Quoted in ibid., 183.

142. Quoted in Jenyns, *Background to Chinese Painting*, 159.

143. Quoted in Sullivan, *Symbols of Eternity*, 150.

PART IV
JAPAN

19

Japan's Historical Foundation

Japan has been called a "moonlight civilization" because of extensive borrowing from the Chinese "sun" of art, ideas, and institutions between the sixth and the ninth centuries. The characterization is misleading, because China's gifts underwent substantial modification by the eighth century and became uniquely Japanese by the eleventh. It is useful to view this historical development as occurring in several stages:

- A late-Neolithic phase of decentralized clans headed by chieftains up to the sixth century C.E. in the region around modern Kyoto and the northern end of the Inland Sea
- A centralized civic monarchy on the Chinese model from the seventh to the tenth centuries C.E., heavily influenced by Buddhism, that unified much of the southern part of the country and provided a foundation of ideas about the nature of the material world and man's fate within it
- A decline of civic monarchy from the ninth to the twelfth centuries as numerous power centers emerged in rural areas when Heian functions of central government atrophied and aristocrats lost control of their estates to local warrior-chieftains
- The first stage of feudalism, from the late twelfth to the early fourteenth centuries, when the country was ruled by a Kamakura-based military shogun whose retainers swore allegiance to him personally rather than to the emperor. When the shogunate was established without allegiance to the throne, the emperor and his court were retained, supported by a stipend, and confined to ceremonial status in Kyoto
- The second stage of feudalism, from the late fourteenth to the late sixteenth centuries when the shogun's control of the country faltered, and civil strife prevailed as local lords, called daimyo, competed for power, with retainers swearing loyalty to them instead of the emperor or the shogun

- The third and last phase of feudalism, between 1603 and 1868, when the country was unified by violence and central control was restored under one shogun, to whom all daimyo and their retainers owed loyalty.

Within this rough temporal framework, a cluster of forces shaped Japanese thought, taste, and behavior, a number of which bear obvious resemblance to prevailing conditions in China:

- A land of beauty and hardships
- Self-image as a unique people, children of the gods
- A vigorous but complex written language
- Interplay of clan, civil monarchy, and feudalism
- Rule by aristocrats, daimyo, and samurai
- Co-existence of Shintoism, Buddhism, and Confucianism
- Preservation of ideas and institutions in the midst of radical change
- Minimal direct entanglement with the outside world

Land of the Gods

Japan's compact island landscape had a deep effect on its inhabitants' views of nature and themselves, and it affected philosophical ideas and art. The islands originated mythically as creations of the celestial gods Izanagi and Izanami, reminiscent of yang and yin, who dipped their spears in the ocean and let fall the droplets that congealed into Japan. Ideas and art were shaped strongly by the resulting geographical features. Moving from north to south, Hokkaido, Honshu, Shikoku, and Kyushu are the four big islands out of some 4,000 islands (fig. 19.1). Korea, from where Buddhism first entered Japan, is not far away to the west. The fragmented landscape is surrounded by seas on one side and an ocean on the other that wash onto 13,000 miles of rugged coastline, which contributes substantially to the visual beauty of a country in which nature worship was deeply rooted from early times. Much of the country is mountainous and was once heavily forested. The mountainous landscape promoted social and political division, explaining, in part, Japan's long experience with feudal decentralization. The Chinese referred to Japan as "the source of the sun" (Jih-pen / Riben), which was translated by the Japanese as Nippon or Dai Nippon (Great Japan). The use of "great" expressed Japanese regard for themselves as a people distinctive, unique, and superior despite the foreign origin of their name.

Physical fragmentation prevailed throughout the country, except in the region just north of the Inland Sea, sandwiched between Honshu and Shikoku. Populations tended to cluster in the south along the Pacific rim of the country from Kyoto to Edo (now modern Tokyo), which is still the case. The mountainous terrain allowed only a fifth of the land to be cultivated, most of it located in the Kanto region of Honshu near modern Tokyo. The soil was not exceptionally fertile, despite a volcanic environment (too much acid in the ash), and there are no great rivers or flood plains that could support big irrigation projects. Wresting a living from the soil was a challenge for Japanese families, whose lot was usually hardship and poverty, always a spur to frugality and simplicity.

Fortunately, the sea was usually nearby to put fish on the table. Mineral resources were scarce, which highlights the extravagant devotion of casting huge Buddha images of

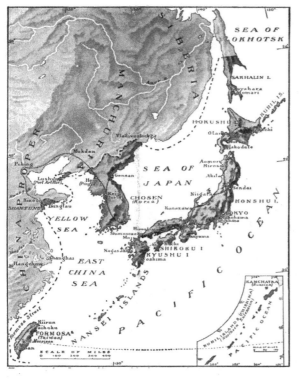

Fig. 19-1

bronze in the eighth through thirteenth centuries. Food production rested on a narrow base, and transportation was difficult, except by boat along the coast; life in Japan was further burdened with volcanic eruptions, violent earthquakes, and typhoons blowing in from the Pacific, all taken in stride as legitimate outbursts of nature. By way of compensation, however, the oceanic climate was temperate, mild, and moist.

When Buddhism arrived in the sixth century the total population was about two million. By 1000, it had increased to some five million. That 500-year period of adaptation to cultural influences from China by a growing population ate up a once lush forest cover. Environmental pressures were enormous. Virtually all building was in wood. There were few stone quarries. Stands of timber were stripped away to build thousands of temples and shrines. At the same time, domestic building consumed huge amounts of wood, which was also needed in charcoal braziers to cook and supply heat in the winter.

There was frequent rebuilding because of fires and deterioration from weather and normal use. Some shrines, like those at Izumo and Ise, were rebuilt every twenty years whatever their condition. When the Japanese began to produce ceramics after Chinese models in the eighth century, kilns were established that required tons of wood. Competition for forest resources aggravated relations between estate owners and monasteries, all of whom tried to protect their forests from one another and from common people in search of fuel and building materials. A critical shortage of wood owing to overuse and deforestation accounts in part for certain features that evolved in the traditional Japanese house, notably its small size and openness to nature, shielded only by fragile sliding doors.

With these reservations noted, Japan's landscape was also an inspiration and a physical key to ideas and art. The relative isolation of the islands meant minimal interference from neighbors. Two attempts at invasion by the Mongols failed in the thirteenth century. The Japanese were free to borrow or reject foreign ways and products as they saw fit. As a result, cultural development was autonomous despite heavy borrowing from the Chinese. Isolation also promoted the idea of uniqueness. Japan's population was markedly homogeneous. The indigenous Ainu in the north had been defeated and pacified by the ninth century but were kept in Hokkaido with little racial intermixture, and there was no large-scale movement of alien peoples into Japan. A mythopoetic account of Japa-

Fig. 19.2 Matsushima Bay.

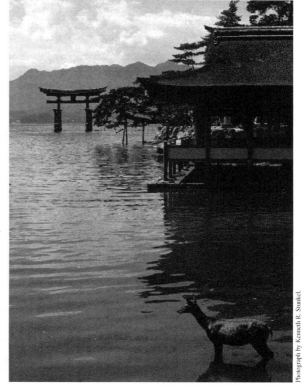

nese origins from the action of divine beings combined with geographical security and remoteness encouraged the notion of being a special people favored by the gods.

The conditions that often made life difficult—rocky shores and mountainous terrain—were sources of beauty as well. A wondrous joy in nature is the essence of Shinto, the indigenous religion before the coming of Buddhism. Celebrated beauty spots like Matsushima Bay in the north, with its profusion of pine clad islands, and Miyajima Island on the Inland Sea, with its large Shinto shrine surrounded by mountains, forest, and water, were places of pilgrimage for both religious and aesthetic motives (figs. 19.2, 19.3). The Japanese eye was always on the lookout for splendid old trees, oddly

Fig. 19.3 Shinto shrine of Utsukushima, Miyajima Island, the Inland Sea.

shaped rocks, and serene ponds. As art found a sure footing and established a solid tradition during the early period of Buddhist influence, it cohered with nature in every medium, most notably architecture, sculpture, painting, ceramics, and garden landscaping.

The Japanese garden that embellished even humble dwellings was viewed as a microcosm of nature at large, as necessary to a home as a ceiling or a floor. Nature was a persistent theme of poetic works—its awesome presence, moods, and associations with human emotion and actions. Shibui, an influential, sophisticated aesthetic idea, which underlies the Zen inspired cult of tea (chanoyu), is premised on a cultivation of simplicity and respect for natural settings and materials.

Clans, Civil Monarchy, and Feudalism

Japan's early political organization was dominated by hereditary clans, which were extended families governed by warrior chiefs descended in line from a common ancestor. In the sixth century the Yamato (which means "mountain footprint") clan, whose chief claimed descent from the Sun Goddess in the Shinto pantheon, had asserted itself over many rival clans without unifying the inhabited portion of the country or creating the idea of a sovereign state.

A revolution in Japanese political ideas and organization occurred when the T'ang dynasty model of ruler and state was absorbed and applied in the seventh and eighth centuries. The idea of a single kingdom ruled over by an emperor (tenno) emerged from the reforms of Prince Shotoku. The idea of a virtuous monarch ruling benevolently over a unified state paralleled the Chinese notion of All Under Heaven ruled by a Son of Heaven. Two additional ideas of consequence were the mutual influence of nature and society and the Buddhist teaching that rulers of virtue had the blessing of Buddha and earned merit by ruling justly and compassionately.

Law codes based on Chinese models were formulated and enforced by the civil monarchy. Written law rather than custom extended monarchial power over long distances and became a legacy of explicit order for the next generation. A bureaucracy was created, also on the Chinese model, to administer laws, collect taxes, and tend to affairs of state, although the Japanese never adopted a truly meritorious system based on performance in examinations. High offices remained in the hands of the aristocracy.

The civil monarchy broke down during the Heian period (1794–1192) as those with political responsibility isolated themselves at court and neglected their duties. The proliferating rural estates, the shoen system, were seldom visited by their Kyoto owners, who surrendered authority over the countryside to chieftain-managers and their private militias. By the eleventh century, Kyoto had ceased to be the power center of the country. Now there were many power centers with complex relations among estate managers, armed retainers, and peasants.

A major social and political development was the emergence of a warrior class, the samurai (retainers), who emerged from the flow of discontented, unemployed minor aristocrats into the countryside and from wars to conquer northern Japan. The effect on ideas and art was decisive. The rise of the samurai was connected with the development of private armies to guard estates of the Kyoto aristocracy, whose managers were the early daimyo.

Conflict between these power centers ended in brutal, destructive warfare between two great families—the Minamoto and the Taira—which forever altered the rarified, delicate culture and mood of the Heian court. Victory for the Minamoto resulted in the creation of a military government, the bakufu (tent government), led by a shogun (commander-in-chief), with a new capital at the village of Kamakura near modern Tokyo, far removed from the intrigues and effete manners of the imperial court at Kyoto. Samurai swore personal allegiance to the shogun and his clan and thereby initiated the first stage of Japanese feudalism.

Language

When borrowing from China was undertaken seriously in the seventh century, a fateful consequence was the adoption of Chinese characters to write Japanese. On first impression the written forms of both languages look enough alike to invite a hasty but false presumption of a relationship, but the two arose in different linguistic families. Chinese belongs to the Sinitic group, Japanese the Altaic group, which is related to Turkish. Chinese is in the main monosyllabic, while Japanese is polysyllabic. Chinese stretches a limited number of sounds by using tonal systems, four tones for Mandarin, nine tones for Cantonese (see fig. 11.4). Japanese has no tonal system and is pronounced in a more or less straightforward way by syllable. Since Chinese characters do not, for the most part, function phonetically but convey meaning directly to the brain by their stroke patterns, the use of them to write polysyllabic Japanese was cumbersome and artificial. In time it was necessary to create a system of writing that represented the sounds of Japanese more naturally and efficiently. This was done by Heian times with phonetic symbols in two systems called katakana and hiragana, or just kana.

Neither was an alphabet but, rather, syllabaries of forty-eight symbols each that represented Japanese syllables. Katakana borrowed parts of Chinese characters to indicate phonetic values. Hiragana abbreviated Chinese characters, making them more cursive, and was used by men and women to write letters, diaries, and romances. Lady Murasaki wrote *The Tale of Genji* in hiragana, and therefore in vernacular Japanese, while men were still composing poetry in Chinese. Women were discouraged from reading or writing Chinese. Both men and women produced beautiful calligraphy in hiragana. These systems worked for tenth century Japanese but became inadequate as sounds in the language continued to develop.

In the eighth and ninth centuries, Chinese writings were read in Japanese word order, with native words whose meaning matched Chinese characters. By the tenth century, compositions in Chinese had become a mixed language called Kambun ("Han writing")—part phonetic Japanese, part ideographic Chinese, which would have made no sense to a Chinese reader. As the Japanese language changed, the Chinese characters were retained, so there were no less than three writing systems—Chinese characters, or kanji, commonly with Japanese meanings superimposed; *kana* for poetry and some other literary forms; and a mixture of the two, with kana used to indicate grammatical connections between Chinese ideographs. The outcome of fusing these systems was a written language that is highly inefficient and very difficult to learn.

Bearing mention are two problems of transmission to Japan through the medium of

written Chinese. From the eighth to the ninth centuries some eight monks traveled to China to study Buddhist teachings of various sects. None of them spoke Chinese well enough to dispense with interpreters. It is also clear that none fully understood the Chinese texts they carried home. Misunderstandings of Chinese texts had consequences for thought in Japan. Scholars in the Nara sects and later sects wrote and read serviceable Chinese and therefore adhered closely to Chinese ideas. Other students who were burdened with mis-understandings found it easier and more tempting to introduce personal interpretations—most notably popular Buddhist preachers who reached out to the masses.[1]

The writing system adopted in the seventh century was unsuitable for spoken Japanese, while the result for art and ideas was uneven access to Chinese literature, at least in the early days before large-scale imposition of Japanese meanings on the Chinese characters and the need to write with brush and ink. As in China, calligraphy and ink painting be-came leading vehicles of high art. The link to Chinese characters continues to the present day, even though a text can be written entirely in phonetic symbols. The survival of a dauntingly complex mixed system of writing into the modern world confirms the power of tradition in Japan.

Aristocrats, Daimyo, and Samurai

There has been an emperor of Japan for 1,400 years, but emperors ceased to rule even in principle after the twelfth century, and it was not always clear who was in charge even during the Heian period, from the eighth to the thirteenth centuries, when resourceful monarchs in retirement might exert some authority and the court was dominated by the powerful Fujiwara clan. It is extraordinary that no political regime in the history of Japan attempted to end the monarchy. The reason is that emperors were credentialed as descendants of the Sun Goddess in an unbroken line; yet from Kamakura times onward (late twelfth to the fourteenth century), they had no kingdom, only a palace and court in Kyoto at the sufferance of shoguns or their regents.

During the Ashikaga period (1336–1573) there were an emperor, a shogun, and a regent ruling at the same time. Yoritomo in the twelfth century and Hideyoshi in the sixteenth came close to unifying the country, but both still recognized the emperor and his divine status. When Ieyasu Tokugawa vanquished all his rivals and succeeded in unifying the entire country, the system was still feudal, with more than 200 *daimyo* governing do-mains called han, each with its own separate band of samurai retainers, all beholden to the shogun as their mutual lord.

The emperor's formal position as Japan's "son of heaven," but also as the focus of primitive Shinto (the emperor was o-kami, the "one above"), was always recognized by those in power, and usually he was asked to back the authority of a shogunal ruler by decree. Occasionally during the shogunate an emperor would try to assert royal authority, but such efforts always failed without harm coming to the royal person or the institution of the monarchy. During the period of intensive borrowing from China, an aristocracy ruled Japan.

The Chinese ideal of holding public office after merit was demonstrated in formal examinations never took hold in Japan. Although the bureaucracy in Nara and Heian times was an imitation of the Chinese system, the offices were locked up by men with

connections and hereditary privileges. There was little or no mobility from the bottom rungs of society to the top. In the Heian period, it was the aristocrats who made and patronized literature and art. In the early feudal period, it was the daimyo and samurai who shaped the arts. The common people had to wait until the late-seventeenth century for the creation of an aesthetic unique to their tastes and interests.

In due time, the samurai shifted their loyalty from emperor and court to stewards of the estates, ensuring the breakdown of centralized government in Kyoto. Numerous small power centers began to fight one another for ascendancy as the Kyoto government floundered in the eleventh and twelfth centuries. Warfare between these armed groups ended with the triumph of Minamoto Yoritomo over his rivals, the most formidable enemy being the Taira clan.

He took the title of shogun and established the bakufu with the capital at Kamakura, a fishing village near modern Tokyo, for the purpose of escaping the decadence, corruption, and intrigue of the Kyoto court. Loyalty of samurai scattered around the country was given specifically to Yoritomo as shogun, but without distribution of land to his retainers. After Yoritomo's death, the center of power was formally vested in the shogun, but there were many shadow figures, ranging from emperors and their regents to shoguns and their regents. Ambiguities about who was in charge continued until unification of the country after 1600. In the succeeding three centuries samurai warriors emerged from almost continual civil war as the dominant class in the country.

The samurai code, later explicitly called Bushido, the Way of the Warrior, stressed courage in battle, personal frugality, indifference to pain or death, loyalty to one's lord, and mystical attachment to the beauty and killing power of the world's finest steel swords, also considered works of art. Bushido combines two words, bukyo, the "warrior's creed," and shido, "the way of the samurai. The detailed code was formulated in the seventeenth century, although the values embodied in it were at least 500 years old.

Nothing was more fundamental to samurai values than indifference when facing death. In a seventeenth century treatise on Bushido, how one confronts death is the key to honor and identity: "The idea most vital and essential to the samurai is that of death, which he ought to have before his mind day and night, night and day, from the dawn of the first day of the year till the last minute of the last day of it. . . . Think what a frail thing life is, especially that of a samurai. This being so, you will come to consider every day of your life as your last and dedicate it to the fulfillment of your obligations. Never let the thought of a long life seize upon you. . . ." Death is virtually the essence of life: "When your determination to die at any moment is thoroughly established, you attain perfect mastery of Bushido, your life will be faultless, and your duties will be fully discharged."[2]

Faced with imminence of death because of their profession, the samurai attraction to Zen Buddhist directness, its goal of enlightenment as voidness, and arts inspired by those ideas are more easily understood.

The masterstroke for Tokugawa control of the daimyo was the decree establishing the sankin kotai system ("attendance in turn"), which required all lords to be in Edo (Ieyasu Tokagawa's new capital—now Tokyo) for half the year, and their families to be there, essentially as hostages, for the other half. The decree obliged daimyo to be in motion every year between their domains and Edo, and to maintain two households, an expensive proposition that discouraged sedition and intrigue and siphoned off their fixed income. The result was swift urbanization of Edo and many places en route along the Pacific coast;

commercialization of the economy, including the rise of a money economy; the emergence of a new class, the townsmen (chonin); and the gradual impoverishment of many samurai and daimyo, who were obliged to convert their rice stipends into ready cash for goods and services. The commercialized, urban world that reached maturity by 1700 gave birth to a secular culture dominated by chonin, who called that culture ukiyo, the "floating world."

The political and social stability established and enforced by Tokugawa rule lasted 250 years, but it was eventually undone by population growth on a narrow agricultural base, economic instability caused by commercialization driven by money, and the intrusion of Western ambitions and superior power.

20

Japan's Social Net

The stress placed on human relationships in Japan meant that status was all-important. Rank and social position were always paramount, which explains the use of honorifics in the language, standards of consumption, and details of attire. The choice of pronoun in addressing anyone indicated inferior or superior status, male or female, old or young, friend or stranger. Failure to come up with the right honorific could result in temporary embarrassment or even prolonged disgrace.[3] Status was everything, but rules varied from one social group to the next.

Before the influence of China flooded Japan, Japanese social structure was organized around tribal clans, whose guiding principle was kinship based on a common ancestor. One result of the Chinese example was the adoption of a four-level class system—scholar-bureaucrats, peasants, artisans, and merchants—with mutual obligations setting the ground rules for behavior. The ruling bureaucrats, nearly all of whom were aristocrats, were selected, in principle, on merit, but the reality of status was heredity and genealogy. For nearly 400 years in Heian times, kinship relations were paramount in determining rank in the social pecking order.

The great division was clearly between Kyoto aristocrats and everyone else. Within that division, there was a second division between men and women. Women in the heyday of Sei Shonagon (ca. 966–1017, author of *The Pillow Book of Sei Shonagon*) and Murasaki Shikibu (ca. 973–ca. 1014, author of *The Tale of Genji*), had considerably more liberty and opportunities for self-development than women in later feudal periods, but their autonomy and range of choices were severely limited. While women created significant literature and art, for the most part they were confined indoors with servants and one another, occupied by refined distractions. What men and women at all levels had in common was the inability to do as they pleased. Behavior among the privileged was regulated in exhaustive detail by rules of protocol, birth, and taste. Behavior of the lower classes (peasants, artisans, merchants, warriors) was regulated by custom, hierarchy, and the unforgiving rigors of life.

In the feudal era from the late thirteenth to the early nineteenth centuries, warriors rose to the pinnacle of social and political status. Thereafter society took shape at the expense of the individual and has been described as a shame culture, in contrast to the traditional West, characterized as a guilt culture. The distinction means that bad behavior for Japanese was not accountable, as in the West, to divine authority or supernatural commandments, but to a hierarchical social order. Good and evil were defined within a complex network of social relationships governed by precise rules, and morality was determined by the group, not the individual. Everyone in the hierarchy knew what was owed to those above and what was expected from those below. Violating the rules and neglecting carefully defined familial obligations did not merely affect the individual but reflected adversely and primarily on the entire family.

The reaction elicited for unacceptable behavior was shame at disgracing others or letting them down, not uncommonly atoned for by ritual suicide. Group identity and responsibility regulated self-esteem of the individual. Men and women alike were bound by giri (duty) and on (obligation). Measuring up to those demands defined their lives. The idea of individual happiness and worth apart from group affiliation and obligations did not exist. There were no "rights," only "duties." The individual found meaning within the confines and expectations of clan, village, family, guild, or devotion to one's lord. For a samurai retainer, his daimyo was lord. For a woman, the lord before marriage was her father, then her husband, and on his death, her closest male relatives.

From Kamakura times until the unification of Japan in 1603 under the Tokugawa shogunate, samurai ruled the roost, but status for some commoners was a bit looser because of the unsettled times of frequent civil wars, when they served as archers and pikemen (Toyotomi Hideyoshi came from peasant stock). The status of upper-class women declined, the fate of village women changed little: hard domestic labor, unremitting work in the fields, and child bearing. The lot of most peasants, male or female, was a grueling existence largely devoid of cultural embellishment other than observances of marriage, birth, death, and the occasional Shinto festival. The situation deteriorated for commoners after Hideyoshi froze the four-class system and forbade anyone to cross social lines, a social pattern that persisted until 1868. Swords and other weapon were confiscated from all but samurai, who wore short and long swords as symbols of status. Above the four classes were the emperor and his family, the pinnacle of the social pyramid, at least in theory.

While a four-class system remained in place during most of the traditional period, there were two differences from theory and practice in China. Instead of scholar-bureaucrats at the top of the hierarchy, in Japan, warriors had the power from the Kamakura period on. The Chinese had decided that the civilian point of view would prevail, and they had no place for soldiers in the official class system. In Japan, samurai assumed the highest status outside the imperial court.

A second difference was the role of family. In China, kinship and loyalty to family came first. No principle was more revered than filial piety. In Japan, the mandate was reversed. Loyalty to lord or emperor was more important than kinship or family. Both kinds of loyalty were honored in principle, especially after the revival of Confucianism in Tokugawa times, but the contradiction between filial piety and loyalty to one's lord was often a source of painful ambivalence. When the chips were down, however, and a choice was unavoidable, family was likely to be sacrificed.

Subordination of the individual to group rules and expectations in a spirit of collective responsibility had its origin in Japan's village economy. The ruling samurai were only a small fraction of the population. Most Japanese were peasants confined to small farming communities in the countryside. Unlike the West, where cities like Athens, Alexandria, Rome, and Byzantium were the focus of civilization, the village was paramount in Japan. There were cities and towns, to be sure, and in time they grew larger and more numerous, but they were not the origin of the fundamentals of the social system.

Rural villages differed from towns and cities to the degree that conformity and consensus were expected to ensure timely planting and successful harvests. Rice cultivation is strenuous work done by hand that requires dependable irrigation. The entire village was involved in making decisions about canals and regulating the flow of water. Since cooperation was so important for survival, discordant individualism was not tolerated. Few people ever left their villages. Most were naïve, ignorant of the outside world, and illiterate. There were no secrets among, say, 150 men and women intermingling daily. There was no way to avoid fellow villagers, so getting along was essential for communal peace and mutual survival, which explains in part the Japanese habit of exaggerated politeness.

Duties and obligations defined roles. Authority was determined by seniority, land-holdings, and longevity in the village. There was no egalitarianism. The young deferred to the old, women to men, servants to masters. The precarious life of a village relied on experience and knowledge, which generally came with age. When crucial decisions were made, however, all families were consulted through their male leaders, a matter of collective survival not to be confused with democratic intentions. After all had their say, a decision was reached by consensus; there was no majority vote. The reason is that discontented minorities voted down by a simple majority could be dangerous to village stability. Better to have them out in the open and included as much as possible in con-sensual understanding.

These norms of traditional Japanese village life—hierarchy, primacy of the group, patriarchy, seniority, respect for age, duty, obligation, outward courtesy, defined roles, and consensus decision making—pervaded the whole society. The structure and assump-tions of social order formed the lens through which men and women saw and evaluated the world, others, and themselves.

21

Japan's Cosmology

Traditional Japanese ideas about the role of nature came from native mythology and from China. They are mixed and tangled with one another. There is little or no interest in separating phenomena of nature from human relations.[4] In the end, the guiding principle is that nature and man are one, a total, largely undifferentiated world teeming with kami,

meaning "superior," but commonly translated as "gods." The kami, humans, and nature account for everything that exists. Since mythology and cosmology are so mingled the reader might want to consult Chapter 24 to understand the information given here in a larger cultural context.

The first kami were self-created. From them came a number of pairs, Izanagi and Izanami being the most important, from whom the contents of nature—streams, forests, rocks, mountains, animals, and their associated kami—sprang. From Izanagi's right eye came Amaterasu the Sun Goddess, the source of light. The chain of mythological generations is luxuriantly complex and has nothing like Chinese clarity about the contents and operations of the universe.

In the historical experience of the Japanese nothing was directly known outside their island archipelago, which is clear enough from the mytho-historical works *Kojiki* and *Nihongi*, inspired by the Chinese dynastic histories and composed in the early eighth century to explain the origins of Japan. The long archipelago of some 4,000 islands was regarded as the ultimate cosmic reality.

Within that essentially unitary world three dimensions were recognized—high heaven, manifest world, and nether world, which are reminiscent of the European Medieval-Renaissance three-tiered universe of heaven, earth, and hell. In the Japanese scheme good and bad kami are distributed across the three dimensions, the best in high heaven, the worst in the nether world, but each sphere is permeable, which means kami can and do migrate freely from one to the other. This ease of passage from high to low and low to high sustains the idea of a single world.

The introduction of Buddhism also exposed the Japanese to Chinese cosmology, which was readily borrowed and then adapted to native beliefs. Chief among the ideas and practices absorbed were yin and yang, the Five Elements, and the principles of correlation, divination, and geomancy. Over time, Shintoism and Buddhism found all these ideas and practices useful. Unlike the Chinese objective recognition of a past as separate from the present, although connected with it through tradition, in Japan the past and the present were fused with one another, as though past events were in fact discernable in the present, and there was no fundamental difference between the two.

The elaborate cosmology shared by Jainism, Hinduism, and Buddhism in India, with its endless cycles of years rolling on in the billions, apparently made little impression in Japan. The major Buddhist sects that took root in the Nara and Heian periods were preoccupied in their different ways with understanding and realizing the Buddha nature by means of scripture study, ritual, and meditation.

All these sects were eclectic and shared overlapping goals and methods. In the wider world of belief and practice, their esoteric philosophies were for the few and not the many. When an image of the Buddha first came to a Japanese emperor from a Korean king in the sixth century, it was accompanied by a letter that said Buddhism is the superior doctrine but hard to understand and explain.[5]

In the end, Pure Land Buddhism (in Japan: Jodo) and its reliance on the accessible compassion of Amida Buddha in his Western Paradise, appealed to the masses. Zen Buddhism, with its stress on direct transformation of consciousness without doctrine and rejection of the impermanent world of the senses, appealed to a smaller, more disciplined audience. However, karma and reincarnation remained in the vocabulary and minds of all believers

(there are many references to both in *The Tale of Genji*), whatever their sectarian differences. They plowed along without the Indian cosmological framework, which was too abstract for the concreteness of Japanese thought and too hard to understand and explain.

22

Japanese Ideas in Literature

A few generalizations can be made about the entire body of traditional Japanese literature before a few works are selected for the ideas they contain.

Long works are rare, Murasaki Shikibu's *The Tale of Genji* being the obvious exception. The preference in poetry was for short verses like *tanka* (31 syllables) and *haiku* (17 syllables) expressive of compressed observation and emotional reactions. Obviously the taste for an abbreviated idiom leaves no room for discursive thought.

Literary works, whether poetic or otherwise, are not distinguished for a richness of ideas like the *Bhagavad-Gita* in the Hindu *Mahabharata*. Speculative thought is virtually absent.

Love, nature, and the brevity of life are dominant themes of poetry, which can be sampled in the *Man'yoshu* (Collection for a Myriad Ages), with some 4,000 verses, and the *Kokinshu* (Collection of Ancient and Modern Poems), with some 1,000 poems. Both landmark collections were put together in the eighth century. In the Heian period verses on love nature, and the shortness of life thrived among the aristocracy: "Soon I shall be dead. / As a final remembrance / To take from this world, / Come to me now once again— / That is what I long for most."[5] Prose works avoided taking on big issues over extended periods of time, such as China's *Dream of the Red Chamber* (*Hung-lo meng / Honglo meng*), a novel that explores family life over several generations.

Historical works are strong on mythology and bear little resemblance to the Chinese dynastic histories that inspired them, which, unlike Japanese accounts of the past, are replete with useful information on many subjects.

Prose, poetry, and drama before 1600 were predominantly aristocratic or upper class in authorship and audience. Although printing was known from China, it was used only sporadically for religious prayers and sutra texts (the first nonreligious text was not printed until 1591). As a result, classics of poetry and prose were not widely circulated. After 1600, printing made literary works more widely available, and popular forms of literature authored by people of lower status achieved wide popularity.

The Tale of Genji (Genji Monogatari)

Murasaki Shikibu was a Heian court lady who wrote a novel in Japanese (not Chinese) that runs over a thousand pages (fifty-four chapters) in Edward Seidensticker's translation. The work is acknowledged to be the finest prose achievement of traditional Japan and

ranks as a great work of world literature. The Chinese wrote novels, but nothing quite as monumental and neatly constructed about the life of a single person, and Indian literature has nothing comparable. Lady Murasaki's novel is technically sophisticated at a level not exceeded or equaled by subsequent writers in the traditional period.[6]

It is known that Murasaki married in about 999, had a daughter, was widowed in 1001, wrote the novel between 1010 and 1020, and died at about age fifty. Apparently part of the work was composed near Uji at Byodo-in, an aristocrat's elegant villa before it became a temple of light dedicated to Amida Buddha (fig. 22.1). The novel reveals that Murasaki was intimately knowledgeable and wise about court life, personalities, and intrigues of her time. One learns a great deal about the pecking order in Heian society, the intricacies of kinship, and the demanding minutiae of court protocol.

Insulated from the countryside, she had little regard for anything going on outside of Kyoto, but within those limitations, her psychological astuteness and aesthetic sensitivity are impressive. Her world was small and confined, but she captures its structure and movement with verve, eloquence, and intelligence. She was well educated in Japanese and Chinese literature, both poetry and history. Japanese taste for allusiveness and suggestion is expressed in *Genji* by hundreds of short poems, some original, others from previous famous collections of poetry, notably *Man'yoshu* in Japanese and *Kokinshu* in Chinese.

The novel spans three-quarters of a century. Its chief subject and hero is the "shining prince," Genji, whose amorous adventures and relationships are detailed in forty-one chapters. The last ten chapters, written in the village of Uji (the word means "forlorn"), deal with his ostensible son, and the final chapter, "The Floating Bridge of Dreams," suggests that Murasaki intended to continue the novel along different lines and with a different theme. In other words, there is no conclusion.

When Genji says to a character in the novel that in old romances read by women "there is scarcely a shred of truth," the response is that good and bad things happen in this world, "things that happen in this life which one never tires of seeing and hearing,

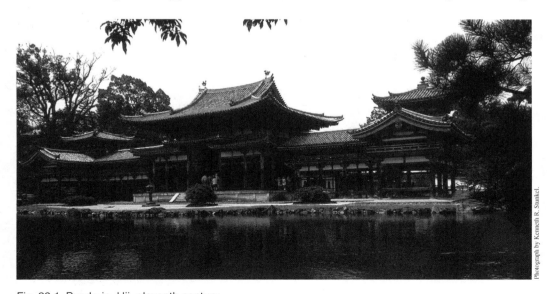

Fig. 22.1 Byodo-in, Uji, eleventh century.

things which one cannot bear not to tell of and must pass on for all generations."[7] Murasaki gave frank expression to her place as a woman despite possessing literary genius: "It is a very uncertain world, and it always has been, particularly for women. They are like bits of driftwood."[8]

The entire work is suffused with nostalgia and melancholy, as though to say all good things in life have already happened, and that the essence of reality is sadness. The metaphor "bridge of dreams" refers to our brief lives as they pass from one state to another. Genji notes the tension between the brevity of life and its burdens: ". . . a life as brief as the time of the morning dew continues to make its demands on us."[9] The novel is replete with a symbolism of sounds that indicates impermanence and sorrow—distant temple bells tolling, the cries of geese passing overhead, wind passing through a copse of trees, and so on: "A mist of tears blots out this mountain village, / And at its rustic fence the call of the deer." And again: "As I gaze at an autumn sky closed off by mists, / Why must these birds proclaim that the world is fleeting."[10]

Emerging from Murasaki's aristocratic milieu, in many respects claustrophobic and artificial, was an identifiable aesthetic, part of which survived into later centuries and offers something of value to the rest of the world. Universal in its possibilities is the idea of aware, a word that suffuses the language and incidents of Murasaki's epic novel, appearing over a thousand times. It implies a sense of wonder and surprise at sights or sounds unusually beautiful or striking, and it is often rendered as a response to the "ahness of things." The word also evokes a sense of impermanence and pathos (mono no aware) with regard to the world and its contents passing away after a moment of health and beauty. The word is loaded with associated meanings, including pitiful, sad, mournful, pleasing, melancholy, and intriguing.[11]

In one episode, Genji visits a cloistered emperor in the evening. The men sit and reminisce about the past, recalling friends, acquaintances, and lovers now dead. In the moonlight, a courtier plays a tune on the flute while insect songs emanate from surrounding pine trees. The overall effect is one of mono no aware, not unlike the inward melancholy that overtakes a person lingering over a drink for a quiet moment in a quiet spot, contemplating lost loves, deceased relatives, and vanished hopes in a rapidly changing world that ultimately swallows everyone. For modern men and women, a lesson and reminder might be that affluence, consumption, pleasures, and good health will not save them from the inevitability and depredations of transience.

The Pillow Book (Makura no Soshi)

Sei Shonagon is the second famous female court author, a contemporary of Murasaki Shikibu. They shared restrictions of upper-class women of the time as well as opportunities that wealth, leisure, and education gave them. Like Murasaki, she had an impressive knowledge of poetry and other literature, as well as an acute sensitivity to nature. Sei Shonagon displayed a sauciness and brutal frankness that was rare and always dangerous for a woman in later feudal Japan. Her book details the etiquette of love affairs and is often a litany of likes and dislikes: "I am the sort of person who approves of what others abhor, and detests the things they like." Her writing brims with acute observation. The elegant and charming include: "A white coat worn over a violet waistcoat." "A rosary

of rock crystal." "Plum blossoms covered with snow." "Floating lotus leaves are very pretty when they are spread out, large and small, drifting along the calm, limpid water of a pond. If one picks up a leaf and presses it against some object, it is the most delightful thing in the world."

Here are some dislikes: "It really is awful when someone rattles off a poem without any proper feeling." "I cannot bear men to eat when they come to visit ladies-in-waiting in the Palace." "Nothing annoys me so much as someone who arrives at a ceremony in a shabby, poorly decorated carriage." "A man who has nothing in particular to recommend him discusses all sorts of subjects at random as though he knew everything." And some likes: "At dawn, when one is lying in bed, with the lattices and paneled doors wide open, the wind suddenly blows into the room and stings one's face—most delightful." "During the hot months it is a great delight to sit on the veranda, enjoying the cool of the evening and observing how the outlines of objects gradually become blurred." "When crossing a river in bright moonlight, I love to see the water scatter in showers of crystal under the oxen's feet." "In the winter, when it is very cold and one lies buried under the bedclothes listening to one's lover's endearments, it is delightful to hear the booming of a temple gong, which seems to come from the bottom of a deep well."[12]

She devotes much attention to parochial aspects of the Heian aesthetic, which included a love of refined courtliness and elegance (miyabi). Shonagon was much put off by people who failed to use proper honorifics in their speech to indicate degrees of rank and status. Also prominent in her culture of refinement was a standard of ritualized discretion for a lover coming to or taking leave of a lady, also described many times in *The Tale of Genji*. In Shonagon's world, reputations were made and broken by indiscreet choices of color in obligatory layers of clothing. Also specific to Heian culture was the pleasure (en) of receiving a letter with just the right scent and spray of flowers, the delight (okashi) of an apt poetic quotation at the right moment that brings a brief smile to one's face, and for Shonagon, the feel of heavy silk or the sound of rustling maple leaves.

This love of delicacy and the habit of taking pleasure in small, beautiful things survived as a permanent aspect of Japanese sensibility, although it was absorbed into a later aesthetic called shibui, inspired by Zen Buddhism. In the rush and cacophony of modern life, there seems to be little inclination or opportunity for such studied refinement as part of the cultural landscape. Rather, experiences tend to be stimulated by overstatement and even deliberate coarseness. The Japanese way a thousand years ago, with its narrowness acknowledged, had a low-key attentiveness that seems eminently civilized and selectively worth emulating.

Shinkokinshu (New Collection of Ancient and Modern Poetry)

By imperial order, this major collection of poetry was completed in 1205. Its reputation is exceeded only by the *Man'yoshu*. In the original Japanese, the poems are noted for their elegant craftsmanship in the service of sober themes delivered with intense feeling, much of which is lost or obscured in translation. A tone of mono no aware hangs over many of the poems. Poets find in nature all the moods they require to express sad partings, lost

loves, meditative loneliness, and inconsolable disappointments. In continuity with Heian sensibility and aesthetics, the theme of impermanence is everywhere apparent. Here are examples of twelfth century voices—a Fujiwara aristocrat, a princess, a priest, and the poet Saigyo—in these four verses.

Nothing whatsoever
Remains of you in this grass
We once used to tread;
How long ago it was we came—
The garden now is a wilderness.

The blossoms have fallen,
I stare blankly at a world
Bereft of color:
In the wide vacant sky
The spring rains are falling.

Loneliness does not
Originate in any one
Particular thing:
Evening in autumn over
The black pines of the mountain.

Living all alone
In this space between the rocks
Far from the city,
Here, where no one can see me,
I shall give myself to grief.[13]

Hojoki (An Account of My Hut)

The twelfth century was a time of troubles when rival clans, notably the Taira and the Minamoto, struggled for dominance as Heian authority disintegrated. Towns and villages were destroyed. Death and destitution were commonplace. The capital itself was fair game for looting and destruction. The highly refined, cloistered sense of passing and impermanence expressed in Heian literature became brutally and grimly real. Kamo no Chomei wrote an account of his experiences before and during the turmoil with a Buddhist sense of the instability that pervades existence. He witnessed a third of the capital city burned to the ground and thousands killed: ". . . great houses have crumbled into hovels and those who dwell in them have fallen no less." People he knew had vanished: "They die in the morning, they are born in the evening, like foam on the water."

The depredations of man were compounded by the frequent natural disasters that historically shaped Japanese temperament. In 1180 a "whirlwind" ravaged the capital: "Every house, great or small, was destroyed within the area engulfed by the wind." Drought and famine followed. A count of the dead was attempted, "and found within the boundaries

of the capital over 42,300 corpses in the streets." In 1185 an earthquake and its after shocks further reduced the capital to rubble and magnified already unendurable misery: "All is as I have described it—the things in the world which make life difficult to endure . . . And if to these were added griefs that come from place or particular circumstances, their sum would be unreckonable." After losing his spacious ancestral home, and seeing his life "about to evaporate like the dew," he became a Buddhist priest and built himself a rustic cottage, a "hut ten feet square," in a setting adorned with beautiful plant life, haunting sounds, and benign creatures of nature, where peace and simplicity rule: "My body is like a drifting cloud—I ask for nothing, I want nothing. . . . I feel pity for those still attached to the world of dust . . . Now the moon of my life sinks in the sky and is close to the edge of the mountain."[14]

Kamo no Chomei's reports and musings on life and the harsh conditions of his time, permeated with Buddhist resignation to assaults of time and circumstance, would offer comfort and an example to people after him who were forced into a hopeless corner by uncontrollable changes in the world. His strength of character, understanding of how precarious wealth and power can be, and adaptiveness to shifts of fortune still resonate today.

The Book of Five Rings (Go Rin No Sho)

Zen Buddhism was a major force in Japanese thought, activity, and art, whish is illustrated in the life and ideas of an impoverished seventeenth-century warrior. A few weeks before his death in 1645, Miyamoto Musashi, the "sword saint" of feudal Japan, completed a treatise on swordsmanship, a study of strategy with the long and short sword. The sword treatise is suffused with Zen Buddhist ideas of discipline and mind culture. Its usefulness has been extended in the modern world to business and the management of private and public life. The author was an accomplished swordsman who dispatched his first adversary at the age of thirteen. For the remainder of his life he sought enlightenment through the way of the sword (kendo). He traveled extensively, studied crafts, and mastered painting, poetry, calligraphy, and music. His minimalist ink painting of a shrike on a branch is considered one of the leading masterpieces of Zen-inspired brushwork (fig. 22.2).

He fought sixty swordsmen, who challenged him in order to prove themselves, and vanquished all of them by the time he was twenty-nine. Confident of his skill, he gave up steel weapons and

Fig. 22.2 Miyamoto Musashi, *Shrike on a Branch*, ink on paper, mid-seventeenth century.

substituted bamboo ones. Even then no one could lay a blade on him. During the last two years of his life he lived in a cave and wrote *The Book of Five Rings*. He became a living legend of incomparable swordsmanship, versatile accomplishments, honesty, directness, and indifference to wealth, power, and sensual comforts. His book is organized around the Buddhist idea of five elements: Earth, Water, Fire, Wind, and Emptiness, which are the "five rings." Although the main purpose is to address mastery of the sword as a way to personal discipline and enlightenment, his principles and ideas can be applied to the mastery of life in general.

The Earth Ring stresses the value of wide study and observation. A narrow person is vulnerable to the unexpected and lacks inner resources as well as the knowledge to cope with subtle dangers. Breadth is needed to seize opportunities, so the advice given is "by knowing the large, you know the small, and from the shallow, you reach the deep."[15] The successful warrior plumbs the heights and the depths. Some trifling experience, observation, or shred of knowledge may intervene between life and death. Breadth also improves timing, without which there can be no hope of consistent success. Too much specialization can be fatal by reducing the field of vision and range of perception. One should try all the arts, explore the ways of many occupations, and pay attention to comparative advantages or disadvantages in all things.

In the Water Ring, the theme is adaptability, with overtones of both Taoism and Zen. The image of water is that "it follows the form of either an angular or round container" and "becomes either a drop or a great sea." Water finds its level in the most hostile environments and flows into every channel of opportunity, wearing away the hardest surfaces through its persistent, flowing action. The flexible swordsman flows effortlessly from one cut to the next as he "makes the mind like water."[16] In life, every new situation calls for further adjustment. The rigid person set in his ways will not be able to respond when a dangerous stroke is about to land, and so it is in life when the unexpected overtakes the unwary.

The Fire Ring dwells on aggressiveness, which means being alert to every advantage and moving with lightening intent. With a calm spirit, one presses one's adversary into "difficult places" and "difficult footing." When fighting outside, note the enemy's weakness, keep the sun to your back, appear vulnerable, and then leap like a coiled serpent. This is called crossing the ford with courage and will, knowing your strength and when to use it.[17] In life, one must know the right moment to strike when an opportunity presents itself.

The Wind Ring cautions that knowing only your own way is weakness, which was Musashi's reason for travel before retiring to a cave. Perfecting skills and expanding awareness is not possible without knowing other schools of swordsmanship and "becoming used to fighting with different opponents, by learning the proportions of a man's mind . . ."[18] In life, there is not much hope of transcending narrow ways and knowledge without venturing into the world in search of fresh experience. Without the breadth such experience provides, an individual will be at the mercy of unfamiliar challenges.

The Emptiness Ring drives home a lesson that technical skill with a sword is not enough. A virtuoso technique may not suffice if the mind is distracted or calculating. The idea of "emptiness," or void, refers to the Buddhist state of mind in which all conditioning has ceased. Without intention, motive, desire, or bias, the individual becomes wholly receptive, open, and spontaneous. If there is any worry about injury,

death, or being placed at a disadvantage, the timing and incisiveness of a response will suffer: "The heart of Emptiness is the absence of anything with forms. . . ."[19] Miyamoto Musashi won his fights by reason of practiced skill controlled by detachment from the outcome. Life or death were resolutely accepted, a frame of mind he acquired through Zen meditation in monastic retreats. Not wedded to a particular result, whether winning or losing, he was ready to seize with impartiality any small advantage that might arise.[20] Dualistic thoughts ceased, and he became psychologically "one" with the sword.

By implication, this psychological power, self-control, and attentive openness are transferable from combat to other spheres of life. Students, for example, might do better on examinations without anxiety about grades or an obsession with success. Such detachment might even work to the advantage of a stockbroker or a Wal-Mart floor manager. Detachment from the expected or desired fruits of action (compare Zen with Indian karma yoga) leaves the mind free to engage problems, questions, and tasks without interfering distractions.

Haiku

In contemporary Japan, millions of people compose haiku, a short poem divided into three segments of five-seven-five syllables, seventeen altogether. Out of millions of haiku composed perhaps a few rise above triviality, mediocrity, or banality. A poem of such brevity might seem easy to compose. The opposite is true. Success requires not only great skill but also a profound sense of nature and self. In Japanese literature, the contrast between Murasaki Shikibu's *Tale of Genji* and a haiku by Matsuo Basho (1644–1694) is instructive. *The Tale of Genji* was unique and did not contribute to the landscape of Japanese sensibility except in its appeal to an aesthetic of mono no aware, the melancholy of things passing away. Basho's succinctness and richness of compressed meaning appealed directly to an enduring Japanese taste for all that is brief, concrete, and symbolically dense, spilling over in suggestive associations.

The form originated as a comic segment of the renga, a form of linked verse in which a person would respond with lines of his own to lines written by another person, an additive process that could go on indefinitely. In due time, probably in the thirteenth century, the *haiku* became an independent form, discarded its humorous function, and reached a peak of excellence in the work of Basho. The form has continued in popularity, if rarely in greatness, to the present day.

Basho lived only fifty years. He had a family, about which one hears little, and became a Zen Buddhist later in life. Amid bereavements and disappointments, the death of relatives and friends, failure to achieve samurai status, and the loss of his beloved riverside house to fire, he turned away from the world to find solace in travel, meditation, and poetry, especially the latter: "What is important is to keep our mind high in the world of true understanding, and returning to the world of our daily experience to seek therein the truth of beauty. No matter what we may be doing at a given moment, we must not forget that it has a bearing upon our everlasting self which is poetry."[21] Beginning in 1684, he undertook a series of unique, arduous journeys on the main island of Honshu from the northern end of the Inland Sea to points far north of Edo.[22] The trips continued even when

his health deteriorated during the last five years of his life. Observations and experiences were recorded in travel sketches studded with poetry.

The frailness of life, so embedded in Japanese aesthetic sensibility from the Heian period on, is addressed in one of his haiku, for which we provide the following, a rendering in English, the transliterated Japanese, and a literal translation. Japanese custom was to compose a "death poem" if one was in a position to do so. Warriors normally would anticipate death and leave a farewell verse in their helmets. This poem was Basho's last, presented to friends and pupils on his deathbed. "On a journey, ill, / and over fields all withered dreams / go wandering still." "Tabi ni yande / yume wa kareno wo / kake-meguru" (three sections in seventeen syllables in Japanese), or "Journey on taken-ill/ dreams as-for dried-up-fields on/ run-about," in the literal translation.[23]

The idea in a haiku like this is to compress as much meaning and as many associations as possible into a few words, or more precisely, seventeen syllables in three sections. In a memorable haiku, the paradox is that adding more words would diminish both power and meaning. In the example above, space and time are suggested by a journey, the human condition by illness, an echo of human destiny in the image of withered fields, and a specific person's lament that his dreams have not yet found a place to rest.

The dynamics of a poem are rooted in a sharp contrast, which might be confined to phenomena or objects of nature, but is best realized when specifics of nature are contrasted with human feeling, as in the example above. Nature is simply there, and what it is can intensify or mirror human emotion. The best contrast is between something momentary and something less so. Every great haiku has overtones, reverberations that fan out beyond visible words and images. Thus "journey" points to Basho's lifetime of travels about Japan, not just to one trip. The word "ill" has overtones of the Buddhist teaching that all conditioned things are impermanent, including Basho's mortal body. "Withered" fields conveys the same Buddhist insight. Overtones abound in his "dreams still wandering." Life itself was often characterized in Japanese literature and thought as a "dream," but what Basho may be saying is that his dreams will continue to haunt withered fields after he is gone, perhaps in another life. A last overtone is that the poem occurred to him in a dream while in his last earthly sleep.

Clearly haiku poetry is a vivid expression of the Zen aesthetic called shibui (see below), whose core values are simplicity and suggestiveness. A close parallel in art is Sessue Toyo's *Broken Ink Landscape* of 1495 (fig. 26.3). Haiku is also a literary outcome of the Japanese preference for concrete experience of individual things—birds, trees, flowers, waterfalls—and intuitive feeling rather than logical thought. In a haiku, there is no room for abstract formulations, extended narrative, or elaborate distinctions, all of which go against Japanese taste. Successful poems heighten or stimulate awareness of small things—drops of rain in a pool, the sound of a cicada, a butterfly napping on a temple bell, a leaping trout, a sliver of moonlight, a fallen leaf, a yawning cat, the smell of bush-clover. Two more *haiku* by Basho will illustrate what can be done with brevity, contrast, and association and show how a few syllables can evoke the aesthetic of shibui.

"Old pond— / and a frog-jump-in / water-sound."[24] The contrast lies in the image of an ancient pond undisturbed, perhaps with a glassy surface, before a frog leaps in and produces a splash heard by someone and disturbs an all encompassing quietude. The smooth silence of the pond and the splash of a frog are two things in nature that simply

are what they are, and if perceived as such by an onlooker at the right moment of mental preparation, the result can be an intimation of enlightenment, a partial or aesthetic glimpse of satori.[25]

Here is the poem recognized as Basho's first masterpiece. "On a withered branch / a crow has settled— / autumn nightfall."[26] The Japanese, three sections in seventeen syllables, reads: "Kare-eda / ni / karasu-no tomari-keri / aki-no-kure." In this example Basho finds beauty and interest in natural phenomena that most people find gloomy. The three images reinforce one another—a withered branch, a black bird, and the onset of night in autumn when leaves are turning and days are growing shorter. Taking pleasure in things aged, worn, lonely, abandoned, or desolate became part of the Japanese sensibility after the Kamakura period. In a few words, Basho captures that feeling with amazing intensity, but he also conjures a believable world in dark images. The lighting of the crow on a dead branch is a matter of direct observation. The rest has a quality of timelessness about it.

What is the value of having such experiences and reading short poems about them? All intensity in life is a matter of contrasts. Rainy days enhance sunny ones. Autumn leaves accentuate spring flowers. Sadness and delight confirm one another. At the same time, details of common experience are frequently overlooked and have their best moments in haiku—the appearance of water as night falls, the angle of a bird's head when it cries out, the texture of a rock when touched, the odor of tall grass after a rainfall. Underlying all such contrasts is the Japanese Buddhist idea that phenomena of nature are the ultimate reality, that whatever happens and exists has the Buddha nature and is a potential source of enlightenment. Also at work is a straightforward love of things and creatures in flux, flourishing one moment, faded or gone the next.

Noh Theater

Perhaps the most difficult Japanese art form for Westerners to understand and appreciate is Noh, one the four types of drama in Japanese literature, which means something like "talent" or "performance."[27] Noh theater is a popular diversion, with about 300 plays written before 1600 and with about 800 extant today. The plays are performed outdoors by an all male cast on a small stage open on three sides. The Noh stage in a courtyard at Nishi Honganji (Western Temple of the Original Vow), a headquarters of the Jodo Buddhist sect in Kyoto, is one of two within the temple (fig. 22.3). Some of the actors wear masks, considered works of art, representing categories of people—for example, woman, young girl, old man, samurai, child. A fearsome mask represents a demon or a jealous woman (fig. 22.4).

An astringent, haunting, sporadic musical accompaniment is provided by flute, two hand-drums (sometimes a stick drum), and voices from a seated chorus that could heighten tension in the play. As developed by Seami (1363–1443), who wrote ninety plays and left some 300 pages of criticism, the Noh play became in feudal times an imaginative encounter with timelessness behind the violent flux of existence as civil war consumed the country.

A Noh play involves highly stylized dancing, recitation, and chanting to relate stories of well-known characters often appearing as ghosts. The actions and words are deeply sym-

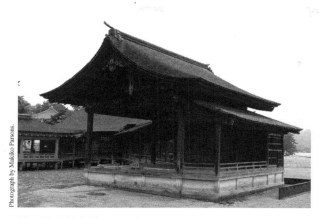

Fig. 22.3 Noh Stage at Itsukushima shrine on Miyajima.

bolic and always indicate something mysterious that lies behind them. Movement is slow and measured, with actors clothed in luxurious costumes.

Since beauty and elegance are required, Noh conserves a Heian aesthetic ideal of miyabi (elegance) adapted to new purposes. In the greatest Noh dramas, silences between words and motion communicate the deepest feelings, presenting actors with the ultimate challenge. Usually six plays on different themes were performed (and still are) over a six-hour period, sometimes in the morning, sometimes in the evening.[28] Needless to say, the dramatic form and conventions of performance require an audience with more than average powers of attention, patience, and concentration. The polar opposites of Noh in the modern world are rock concerts, MTV, realistic drama, and movies awash in sex and violence.

The significance of Noh drama lie in the aesthetic that rules its spirit and performance—yugen, which means "what lies beneath the surface," a thing suggested rather than shown outright, something mysterious rather than openly visible. The critical works of Seami make lavish use of the word. For him the essence and deepest meaning of Noh is the experience of yugen. An actor unable to convey yugen has failed utterly. The term applies most directly to Noh theater but has affinities with other aesthetic ideas—notably aware, sabi, and shibui. It is elusive and can only be suggested: "Yugen may be comprehended

Figs. 22.4 Hannya, a demon's mask, and Ko-omate, a young girl's mask.

by the mind, but it cannot be expressed in words. Its quality may be suggested by the sight of a thin cloud veiling the moon or by autumn mist swathing the scarlet leaves on a mountainside. If one is asked where in these sights lies the yugan, one cannot say, and it is not surprising that a man who does not understand this truth is likely to prefer the sight of a perfectly cloudless sky."[29] The point of yugen is penetration of a domain lying behind forms. There is no yugen in the modern paintings of Matisse, the Renaissance plays of Shakespeare, or the baroque music of Handel. Obviously, yugen has its roots in Zen Buddhism and the Buddhist idea that forms get their meaning from a void.

The function of an actor in one of Seami's Noh plays is to help an audience enter the realm of yugan. He does this by mastering "nine stages" of Noh, divided into groups of three stages. The "higher" three, "the flower of the miraculous," embrace the art of stillness and calm in which "all praise fails, admiration transcends the comprehensive mind, and all attempts at grading are made impossible." The "middle" three, "the flower of truth," involves revealing to viewers the essence of natural phenomena, the mystery behind their appearances, an "art of versatility and exactness," an "art of untutored beauty." The "lower" three, "the art of strength and delicacy," prepare an audience for deeper experiences through sturdy movement infused with delicacy (miyabi). The successful actor starts with the middle, goes on to the higher, and ends with the lower, whose mastery by itself is a dead end: "The lower three stages are the turbulent waters of No. They are easily understood. . . ." The other two stages bring an actor and his audience to a place where "being and nonbeing meet."[30]

The beauty and power of Noh lie in its respect for human imagination in the presence of spareness, ambiguity, and suggestion, the realm of yugan. In a tumultuous world of urban modernity the level of distraction is high. Attention to any one of myriad things pressing on one's consciousness at the same time is difficult. The brain swells and throbs under a load of incompatible images, sounds, and data. Noh is an invitation to focus the senses on a few artful hints that lead to quiet alertness. The mind is refreshed, the imagination stretched, the scope of vision widened, and inner tranquility cultivated. The effects of Noh are similar to those of the tea ceremony but Noh uses different means.

In Tokugawa times, with the reassertion of Confucianism as the dominant school of thought and a policy to downplay Buddhism, Noh performances were discontinued by the official court in 1711, but continued to be cultivated in private circles as part of the upper class "dual way" of daimyo and samurai. The "high" culture of Noh and its austere ideas of beauty were in distinct contrast to the "low" culture of Kabuki drama, which has nothing in it of Zen philosophy.

Saikaku, Kiseki, and the "Floating World"

With the end of civil war and the expansion of urban life under Tokugawa rule, a new kind of brash, earthy, satirical literature emerged in the hands of commoners for a popular audience. Intellectual content was thin but still detectable. While the major writers respected the Japanese tradition of aesthetics, there was no overt Confucian moralizing, no allusions to Buddhist texts, and no preoccupation with imported Chinese literature.

Prevailing themes fall under the general heading of hedonism—the idea that pleasure is the highest good, which meant for "floating world" authors sensual pleasures and the

satisfaction of having money to fulfill desires. The underlying principles of the floating world were materialism and gratifications addressed with single-mindedness and passion. A modern parallel in America is the urge to maximize wealth and lionize celebrities amid the glittering ephemera of popular culture. We shall return again to this theme in the section on ideas of beauty, but this is the place to comment on the kind of literature, and the secular worldview it expressed, that arose in the cities of the Tokugawa era.

The idea of impermanence, at the heart of Buddhist thought, and the attachment of Japanese to the intrinsic value of fleeting things and experiences since Heian times, takes on a curious twist. While falling cherry blossoms epitomize frailty of the world, as they did in innumerable poems and metaphors in the past, in the floating world (ukiyo) of townsmen, pleasures of the flesh are sought without limit, which gives them a kind of immortality. Variety, change, and the excitements of novelty became ultimate realities.

Greatest of the floating world writers was Ihara Saikaku (1642–1693). He reached a peak of fame around 1688 and fashioned a style of writing and thinking that extended into the eighteenth century. His creation was a new kind of literature focused on teeming life in brothels, bathhouses, theaters, teahouses, and the homes of commoners, disastrous entanglements between men and women, and the path and consequences of sexual dissipation and obsession with money. Worldly failures, prostitutes, fallen women, irresponsible young men squandering their lives, and hopeless love affairs that end badly are viewed with detached compassion for the first time in Japanese literary history, but Saikaku is also a sardonic, often satirical observer of the human comedy.

Greed and wantonness abound in his world. Since the most exquisite pleasures are not cheap, money is just about everything, precisely the opposite of standard samurai values. The new reality is the emergence of a money economy. Saikaku tells of a man who kept an abacus under his pillow to keep track of the money he made in his dreams. In his stories there is frequent reference to mon, a copper piece, fun, a unit of silver, and ryo, a unit of gold worth several thousand coppers.

These monetary units are the new reality of economic life, not the rice stipends of the samurai and daimyo. It seems that everything and everybody had a price without which little could happen, and that the price was set in coinage. Saikaku's *The Japanese Family Storehouse* lays out advice for getting ahead. Intelligent people might die in poverty, while ordinary people could become rich with ability, thrift, diligent labor, and the help of fate. Wealth was for present gratification, not just for storing away and passing on to relatives: "People will tell me when we die, and vanish in a moment's wisp of smoke, all our gold is less than dross and buys us nothing in the world beyond . . . And while we live (to take a shorter view) how many of life's desirable things is it not within the power of gold to give us?"[31]

In the uncertain tumult of urban life, love, or lust, is the target of novels like *Five Women Who Loved Love* and *The Man Who Spent His Life in Love*. As Saikaku's heroine says in his popular novel *The Woman Who Spent Her Life in Love*, anything might happen in the floating world. In the midst of fortunes made and lost, reputations lifted and dashed, and life unsure and painfully short, a woman who is low can live better than a man who is high. As Saikaku's sex-crazed woman notes: "To think a girl without the slightest virtue can enjoy luxuries beyond the reach of the aristocracy!"[32]

In *The Woman Who Spent Her Life in Love,* or *The Life of an Amorous Woman*

(an alternative translation), Saikaku follows her journey down the hierarchy of prostitution from wealth and renown to loneliness and debasement. The woman who gives her life to love begins at age thirteen and by the time she brings a long career of harlotry to an end at sixty five, passing through four ranks from highest to lowest, she has taken on 10,000 men. She says about her first love affair: "I, too, was steeped in love, as the yellow rose is steeped in its colour, when I had only begun to bloom. Plunging into the Rapids of the Roses, I let myself be swept away to ruin."[33] The ninety or so children she aborted appear to her reproachfully in a vision: "Thus I lived, drifting down the muddy stream of the floating world."[34] The heroine of this novel probably fails to outdo the hero of *The Man Who Spent His Life in Love,* who in an early chapter has already gone through 3,742 women, and at the end complains that love has left him wasted just as he decides to sail, at age sixty, in search of the Island of Women.

Saikaku was the model for "tales of the floating world." Ejima Kiseki (1667–1736) acknowledged his primacy by saying *The Life of an Amorous Man* had become a "sacred text."[35] Unlike Saikaku, Kiseki reveals little of himself or his views on life, and produced much thinner works. In *Courtesans Forbidden to Lose Their Tempers,* he explores in a stylish way the types and tricks of courtesans. In *Characters of Worldly Young Men,* he serves up in short sketches a gallery of human follies. These include spoiled children who think it is "fun to be disowned," a man intoxicated with conspicuous consumption, a swaggering young blade described as "a fool who was match for a thousand," a shopkeeper who degrades the tea ceremony's spirit of austerity with expensive accessories, Confucianists who are pompous and self-righteous, and a rake who "made his home in the gay quarters, while at his own house foxes settled down with their families, and owls came to do their washing," altogether an unfolding gallery of ne'er-do-wells, con men, loose women, drifters, and opportunists.[36]

With such a feast of human types laid out in stories and satires, there is little wonder that illustrators picked up the threads and turned verbal diversions into visual art, bringing into play a fresh, conventionally despised idea of what constitutes beauty.

23

Japan's Traditions of Thought

In the premodern Japanese intellectual experience, the two prominent sources of formal thought about man, nature, society, and meaning were Buddhism and Confucianism. Shintoism became more a body of thought when it was used to justify the centralized authority of the modernized Japanese state after 1868, but was not a serious intellectual rival of Buddhism and Confucianism in earlier times. Both are cited in the landmark seventeen-article Constitution announced by Prince Shotoku in the seventh century to pacify the country. The prominence of Confucianism, however, came much later in Tokugawa times after the country was unified politically and Buddhism went into relative decline. Both continue to resonate in minds and hearts to this day.

Buddhism

The place of Buddhism in Japanese thought is secure. Its appearance was a cultural tsunami that washed over the country with effects that endured for more than ten centuries. Buddhism was already 1,000 years old when it reached Japan, with constituencies spread across Asia from India to China and Korea. Its profound teachings about the human condition were expressed in the "Three Treasures" (Buddha, Teaching, Monastic Order), a monastic system organized around strict disciplines, with some dozen sects specializing in one body of ideas or another, a brilliant tradition of art in caves and temples, a huge literature, both formal (the *Tripitaka,* [the *Three Baskets* of doctrine], commentaries, and rules for the order) and informal (jatakas, or tales of Buddha's previous lives), an elaborate pantheon of deities, and an army of priests who not only taught high moral principles, but had knowledge of medicine, architecture, sculpture, painting, administration, engineering, and magic. The new religion, with its vast paraphernalia of ideas and art, took hold easily in Japan because there was no competition. In India there were other powerful religious movements—Brahmanism, Upanishadic mysticism, and Jainism—to challenge Buddhism, and in China the formidable rivals were Taoism and Confucianism.

Japanese Buddhism bears little resemblance to its Indian counterpart, or even to its original Chinese sources. The incoming sects were more or less Japanized from Chinese counterparts. No doubt the initial attraction was a belief in magical or supernatural powers that could ward off disease and other calamities. When the Emperor Shomu built the Todai-ji (Great Eastern Temple) in the eight century, the country was reeling from plague and smallpox. The temple was an offering to defeat misfortune. A feature shared in common by Buddhist sects was an eclecticism that drew from a variety of sources, and syncretism, a blending and joining of otherwise disparate sutras, doctrines, and practices. The philosophical result was often a doctrinal blur with little logical coherence. A major distinction between sects was esoteric teaching for the initiated and exoteric teaching for the public.

Ideas of karma, impermanence, and Nirvana were given a distinctly Japanese twist. Usually the desire was to be reborn into this world; impermanence was identified with the Buddha nature; and in the most popular sects Nirvana meant a place offering personal survival and worldly delights (these "faith-based" sects will be addressed in the chapter on religion). While philosophical speculation and close textual exegesis were not lacking, they do not appear to have been a high priority.

Although Mahayana notions of heaven and hell were vivid and much represented in art, the Japanese clung simultaneously to the concreteness of sensual existence, and apparently few believed anyone would really end up in a hell for violating strict Buddhist disciplines. Because texts had to be translated from Chinese into Japanese, it is not clear that intricate doctrines were adequately understood by converts, which may account for the intuitive, emotional profile of Japanese Buddhism, with a strong emphasis on practices like chanting and ritual. Japanese Buddhism was also influenced by Shinto, at the expense of rigorous thought.

While religion was the foundation of ethics in India, the family was the foundation in China, and the state played that role in Japan. Therefore, unlike Buddhism in India and China, where state patronage was commonplace but temples and monks were not usually

involved with politics, in Japan a direct relationship between religion and state power emerged almost from the beginning. There is reason to believe that Buddhism succeeded in Japan so well because all its sects were associated self-consciously, sometimes blatantly, with protection of the state and service to its rulers.

The Nara Sects

In the Nara period, the Kegon sect and its doctrine of a universal Buddha were housed in a great temple specifically as guardian of the state. In the Heian period, Saicho's Tendai sect built temples on the slopes of Mt. Hiei, northeast of Kyoto, to protect the emperor and the state from evil influences. A sect founded by Nichiren (1222–1282) was distinctly and aggressively nationalistic, chauvinistic, and exclusive in doctrine. Other sects and all sutras except the *Lotus Sutra* were rejected. Nichiren makes clear the dependence of Buddhism on native gods: "This Nation is a Divine Nation. Deities do not respond to those lacking respect. Seven generations of Heavenly Deities, five generations of Earthly Deities, and a multitude of Good Deities support the Buddha's All-embracing Teachings." If home deities are needed in a land "divine" among other lands, then Buddhism ceases to be "all-embracing," but Nichiren does not seem bothered by the inconsistency. Even Zen Buddhism, which rejected authority on principle, had its chauvinistic moments: "Though our land is situated out of the Way, everlasting is its Imperial Rule, noble are its people. This outland surpasses all others by far. . . ."[37]

In the late eighth century during the Nara period, a monk of the Hosso sect, already serving the throne as chief minister, almost became emperor with the support of the Empress Shotoku. Much later, Zen Buddhist monks also provided advice to rulers. In subsequent centuries, the mountain sects of Tendai and Shingon near Kyoto had armies of warrior monks who often demonstrated noisily in public for their demands and even resorted to violence, tendencies that led to the destruction of their strongholds by Oda Nobunaga in the sixteenth century.

The domestication of Buddhism in Japan was swift and even spectacular. Korea had only recently accepted and implemented Buddhist teachings from China before knowledge of the religion passed to Japan in the sixth century. Little came of it at first because of clan rivalries and resistance from Shinto priests, but by the seventh and eighth centuries, great temples had been constructed, and no less than six sects were functioning at Nara.

The ideas of the six Nara sects, which constituted a collective state religion, embraced four strategies: (1) Kusha and Jojisu explored the five grasping groups (skhandas) from somewhat different perspectives to achieve detachment by exposing the emptiness of their dependent origin; (2) Sanron, which stressed emptiness, and Hosso, which held that both ignorance and enlightenment are functions of the mind, analyzed content and levels of consciousness; (3) Ritsu stressed principles, rules of monastic discipline, and the ordination of priests, which became the standard for all later Buddhist practice in a monastic setting; (4) Kegon advanced the doctrine of Buddhist universalism, meaning that the Buddha nature pervades the cosmos and already exists in all living beings, symbolized by the image of Vairocana Buddha at the temple complex of Todai-ji.

The Heian Sects

In the Heian period, the two dominant sects were Tendai (Heavenly Terrace), founded by Saicho, and Shingon (True Words), founded by Kukai, both replete with jealously guarded symbols, secret texts, and elaborate rituals. Tendai is an esoteric, highly syncretic faith reliant on truths available only to initiates. Its chosen scripture above all others is the *Lotus Sutra*. The sect makes heavy use of mandalas (cosmic diagrams or diagrammatic representations of Buddhas and Bodhisattvas in their realms), mantras (chants to concentrate the mind), and mudras (gestures to accompany chanting and certain forms of meditation)—all adding up to disciplines for mind, speech, and body.

The use of mandalas, mantras, and secret scriptures came from Tantric practices from Indian and Tibetan Buddhism. Tantra, which means "to weave," accepted a unity between impermanence (samsara) and detachment from impermanence (Nirvana). Ignorance prevents people from seeing Nirvana in the world about them and from realizing they are already Buddhas. The purpose of Tantric practice, taken over by the founder of Tendai, was to visualize Buddha realms by means of sight, sound, and movement, all woven together, to remove defilements that block enlightenment, and to achieve Buddhahood in a single lifetime.

Meditation practices in Tendai are intricately systematized. Basic categories are tranquility meditation (stilling the mind and body) and insight meditation (breaking through consciousness to enlightenment), supported by silent-sitting before a Buddha image; walking clockwise around a Buddha image; half-walking, half-sitting (chanting mantras prior to sitting in meditation); and non-walking, non-sitting (concentration and insight in daily life while chanting and recalling an image of Kannon, the Bodhisattva of compassion).

The sect was elaborately organized to accommodate thousands of acolytes ready to become monks over a twelve-year period. The best of them became "national treasures." A second group served the numerous monasteries on Mt. Hiei, and a third group, with the least spiritual accomplishments, went forth to serve the nation in a variety of capacities. Tendai was the Heian state religion, whose function was protection of Great Japan. By the tenth century, Tendai split into two rival sects that came to blows. The result was armed monks who fought not only each other but also raided Kyoto if government policies failed to please them.

Shingon shares with Tendai its esoteric secretiveness, Tantric practices, and reverence for the *Lotus Sutra*. Shingon teaches three "mysteries" of body, speech, and mind, esoteric truths communicated from master to disciple independently of written texts. The three mysteries are in everyone and understanding them brings enlightenment. Mysteries of body include gestures (mudras) appropriate to Buddha or a Bodhisattva, meditation postures, and handling of ritual implements like the lotus flower. Mysteries of speech include secret formulas and the "true" words. Mysteries of mind include methods for grasping truth with the help of "five wisdoms."

The sect's monastic center was on Mt. Koya, which is much farther removed from Kyoto, to the southeast, than Mt. Hiei. Nevertheless, it too was considered a protector of the realm, though a lesser one than Tendai. The founder, Kukai (d. 835), a brilliant and prolific writer, was noted for his treatise *Ten Stages of Religious Consciousness*, which

had much influence, to the annoyance of the Tendai sect whose practice was not placed at the highest level.

The stages he laid out are: (1) consciousness trapped by animal desires; (2) consciousness governed by moral principles, or Confucianism; (3) childlike consciousness without fear, or Taoism; (4) consciousness knowing that only impermanence exists, or Theravada Buddhism; (5) consciousness freed from spiritual blindness, karma and the chain of causation, or the solitary Buddha who achieves enlightenment and does not preach to others; (6) consciousness that seeks the salvation of others and recognizes that only consciousness exists, or the Hosso school; (7) consciousness that negates all causality and confronts emptiness that brings inner peace, or the Sanron school; (8) consciousness on a cosmic scale in which all phenomena become one and are seen as pure, or the Tendai school; (9) consciousness that all beings and things possess the Buddha nature through Vairocana, the universal Buddha, whose radiance interpenetrates and unifies the universe, or the Kegon school; (10) consciousness cleared of all stains and obstructions through esoteric teachings so that the True Word (mantras) opens the spiritual treasure that reveals all virtues of the Buddha, or the Shingon school. The purpose of Shingon theory and practice is to guide development of a student through the ten stages to final and full enlightenment.

In Shingon teaching, matter and mind are not separate; they are one. This doctrine favored the arts as a window on Buddhist truth. Kukai was himself accomplished in several arts—painting, sculpture, and especially calligraphy—and wrote explicitly about their importance in reaching insight. For him the natural world, Buddhism, and art were united. The Buddha's teaching and its ultimate truth are without speech, form, or color. Art corrects the deficiency: "In truth, the esoteric doctrines are so profound as to defy enunciation in writing. With the help of painting, however, their obscurities may be understood. . . . Thus the secrets of the sutras and commentaries can be depicted in art. . . . Neither teachers nor students can dispense with it. Art is what reveals to us the state of perfection."[38]

Zen Buddhism

The two leading sects of Zen Buddhism, Rinzai and Soto, arrived directly from China in the thirteenth century, where they were known together as Ch'an (Chan) Buddhism (from the Sanskrit word dhyana, or meditation). Zen was to have a profound and far-reaching impact on Japanese ideas and art. Although the individualism of Zen seems radically different from sects like Tendai, with its secret doctrines, and Shingon, with its convoluted rituals, it is nevertheless a sect of Mahayana rather than Hinayana Buddhism. The common denominator is the claim that everyone and everything already has Buddhahood waiting to be discovered. Both teaching and practice resonated favorably with the native Shinto tradition, chiefly with respect to love of nature and warrior discipline. The samurai found Zen highly congenial to their taste and helpful to their profession. The emphasis in Zen was on the direct relationship of disciple to master. The goal of that relationship was to bring the student across a threshold of rational thought to Awakening (satori). In due time Zen created a cult of tea that fused the arts and became a fixture with samurai and daimyo, part of their "dual way" of peaceful and martial pursuits.

Both schools had their Chinese counterparts, but there were important departures from

the sources. Chinese schools of Zen (Ch'an) accepted and made use of various disciplines familiar to Tendai and Shingon, including recitation of Amida Buddha's name (a practice called Nembutsu), and had nothing to say about politics or the imperial state. Japanese Zen preferred two disciplines, koan and zazen, and went out of its way to achieve social acceptance by claiming that Zen would protect the country and the emperor as well or better than other Buddhist sects. Eisai (1141–1215), founder of Rinzai, noted misunderstandings that Zen had to overcome: "There are . . . some persons who malign this teaching, calling it 'the Zen of dark enlightenment.' There are those who question it on the ground that it is 'utter Nihilism.' Still others consider it ill-suited to these degenerate times, or say that it is not what our country needs." He goes on to declare that Zen is needed for the "benefit of posterity."[39]

Rinzai and Soto can be distinguished from one another by their views on how the mind works, the way into Enlightenment, the discipline paramount to Awakening, and the place of traditional disciplines like scripture study in a monk's training. For Rinzai, enlightenment is instantaneous and achieved by forcing a student into a psychological crisis, accompanied perhaps by shouting and blows, with impossible questions and dilemmas, or koans ("public cases"): for example, What is the sound of one hand clapping? What sound does a bell with no clapper make? Other examples of questions with some responses: What is the Buddha? The Master raises his fist. What is Zen? The Master replies, "Brick and stone." What is the meaning of the First Patriarch (Bodhidharma) coming from the West? The Master replies, "Ask that post over there." What is the final truth of Buddhism? The Master replies, "You won't know until you see it."[40] Here is a typical and hopeless puzzle: a man is suspended over a chasm by his teeth with hands tied behind his back. What does he answer when asked, what is Buddhism?

The purpose of koan discipline is to subject the rational mind to unbearable pressure with insoluble paradoxes until indirect, abstract thought drops away and the world in direct experience is seen to be the source of Buddhahood, including oneself.[41] It is not possible to think one's way into satori; when it comes, the experience is immediate and transforming due to active engagement when the student suspends rational judgment. Thus the transmission of Buddhist truth is not dependent on scriptures, mantras, mudras, and other devices prominent in sects like Tendai and Shingon; nor is Zen a matter of faith and dependence on a bodhisattva like Amida.

While under the guidance of a master, the acolyte is expected to be respectful, attentive, and obedient. Personal discipline is necessary, but the final objective of the relationship is to free the student from all authority by removing discriminatory thought that blocks the realization that one is already a Buddha. Temporary dependence on a master is the path to self-reliance and self-knowledge. Rinzai stories suggest that seeing the Buddha on a walk is an invitation to kill him, the point of which is that a distinction between oneself and Buddha inhibits Awakening. While images might be found in a monastery, they could also be smashed under the right circumstances as a rejection of dualistic thinking, and sutras might be tossed aside because they load the mind with ideas and symbols that distract and fragment the mind.

For the Soto sect, enlightenment comes gradually through disciplined meditation called zazen (sitting in meditation). Dogen (1200–1253) actually disliked the name Zen and preferred to identify himself with Buddha and Buddhism. He went along with Eisai

on the value of Zen for national well-being but departed from him on the value of koan practice and the place of scripture reading. Koan practice in his view is too much like trying to get something, a form of grasping which Buddhist discipline should eliminate. The virtue of merely sitting in meditation was to avoid specific thoughts and problems and realize the Buddha nature that is already there. In the course of habitual meditation, it unfolds gradually over time.

Meditation as a means should not be practiced with an end in view. The end will appear of itself: "Just to pass the time in sitting straight, without any thought of acquisition, without any sense of achieving enlightenment—this is the way of the Founder. It is true that our predecessors recommended both the koan and sitting, but it was the sitting they particularly insisted on. There have been some who have attained enlightenment through the test of the koan, but the true cause of their enlightenment was the merit and effectiveness of sitting."[42]

His advice about scripture reading was to sit on the sutra rather than letting it sit on you. His defense clearly addressed the problem of affirming the unity of Buddhist teaching in all the sects and staving off the criticisms of Tendai and Shingon. The idea that Buddhist truth can be transmitted only from person to person, from patriarch to disciple, is a mistake: "In the genuine tradition of the patriarchs there is nothing secret or special, not even a single word or phrase, at variance with the Buddha's sutras. Both the sutras and the transmission of the patriarchs represent the genuine tradition deriving from Shakyamuni Buddha."[43]

While wishing to placate other sects and win state support, it is clear enough that Soto Zen rejected the principle of esotericism, secret disciplines, and the claim of Shingon that Buddhist truth cannot be expressed in words.

The Confucian Revival

Obviously, Zen Buddhism had little to offer a ruler whose task was to consolidate government and manage the affairs of a united feudal country with a rigid class system. The attraction of Confucian teaching was its emphasis on social harmony, obedience to legitimate authority, loyalty to one's ruler (and family), personal moral cultivation, a clearly demarcated class system, and disciplined study of classical Chinese literature. The latter vocation was especially attractive as an outlet for samurai warriors languishing in idleness after civil wars had ended. While Confucianism was fine from a social, political, and moral point of view, it had little impact on the arts, certainly nothing to rival Zen Buddhism and nothing like the fusion of Neo-Confucian thought with landscape painting in China. Consequently, we shall not spend much time with the Japanese revival, whose chief purpose was to reinforce the stability of the state.

The type of Confucianism sponsored by the shogunate was the Neo-Confucianism of Chu Hsi (Zhu Xi). Once more, the reputation and authority of Chinese thought in Japan is on display. Neo-Confucianism had been official doctrine in China since 1200, and it spread outward from the Middle Kingdom as the model of rational thought and practical wisdom. The man most responsible for establishing it in Japan was Fujiwara Seika (1561–1619). He set off on a journey to China to study at the source, but was stopped at sea by bad weather. While delayed he came across the Four Books and commentaries of

Chu Hsi and decided a trip was no longer necessary. Everything he needed was at hand. There is a touch of Confucian universalism in some of his writing: "Between heaven above and earth beneath all peoples are brothers and things are the common property of all, everyone being equal in the light of Humanity."[44] That kind of moral and economic egalitarianism is rare in Japanese thought and was not the wave of the future. Of more interest to Tokugawa rulers was the power of Confucianism to regulate individual behavior to the advantage of government. To that end, Fujiwara Seika had this advice: "Raging waters and angry waves . . . are not so dangerous as human passions. Those who go around together . . . should act as a team for restraining and correcting the other."[45]

Seika's most influential pupil was Hayashi Razan (1583–1657), who became teacher of the shogun in 1608. The appeal of Confucianism lay in its rationalism, the "investigation of things" rather than a Buddhist turning inward, and in its humanistic emphasis on Five Relationships and their association with harmony, status, balance, and duties: "The Way of the Sages . . . consists in nothing else than the moral obligations between sovereign and subject, father and child, husband and wife, elder and younger brother, and friend and friend."[46] Confucian objectivity and morality were the mortar binding a feudal society together despite local allegiances and religious beliefs. The anticommercialism of Confucian thought also supported the status quo in a predominantly agricultural society. For the Tokugawa regime, as for dynastic China, change was suspect.

Razan defused Buddhism and its influence on the shogun's court by bringing Shintoism and Confucianism together for moral reinforcement in light of Japan's mythical past, to which Buddhism had nothing to contribute. Another important strand of thought was his identification of samurai with the Confucian chun-tzu (zhunzi), or superior man, as being endowed with virtues of humanity, righteousness, decorum, and wisdom, with all the implied responsibilities of moral self-cultivation and loyal public service. Since the samurai were warriors and not scholars by training and profession, Razan defined a "dual way" that combined the arts of war with the arts of peace: ". . . those who are adept at the handling of troops regard the arts of peace and the arts of war as their left and right hands."[47] The arts of war pursued were sword (kendo) and bow (kyudo) training. The arts of peace were scholarship, calligraphy, painting, Noh theater, and tea ceremony. While a radically different secular culture was to emerge in the towns and cities, in the countryside samurai and daimyo defined themselves according to Confucian ideas while subsidizing and practicing aristocratic, formal arts of peace.

24

Japan's Religion and Mythology

Japan's traditional culture was dominated by two religions—Shinto and Buddhism, both of which have survived into modern times. Confucianism was also influential in its Han dynasty guise of a pseudo-cosmological system of correspondences based on yin and yang, the Five Elements, and divination from portents indicating good or bad relations between rulers and the universe. The doctrine of filial piety especially suited the Japanese

as a support for family solidarity, as did the Chinese distinction of five social relations with different moral implications. Taoism was a fourth thread in the skein of Japanese thought, chiefly through its yin-yang doctrines, but its influence was limited because the teachings of Lao-tzu and Chuang-tzu stressed liberation of the individual from all social forms and rules, just the opposite of Japan's emphasis on tight, restrictive social relations.

Of the religions, Shinto is the simplest to approach and understand; Buddhism is more complex, with many sects and sub-sects embracing often intricate doctrines and practices, a number of which we have already explored in the section above on "Traditions of Thought." In the sixteenth and early seventeenth centuries, Christianity won converts among the Japanese, perhaps as many as half a million by 1615, but that flirtation with a Western faith came to an end when the movement was crushed by the Tokugawa shogun in 1638, which resulted in the slaughter of thousands of Christians who were trapped by samurai armies in a fortress on the Shimabara peninsula in Kyushu. The reason for persecution was that allegiance to a single deity was believed to undermine loyalty to emperor, shogun, and family. In any event, most Japanese were not inclined to give up a rich heritage of deities, Shinto and Buddhist, for one monolithic being. Some Japanese converts survived the last burst of persecutions and went underground, but thereafter Christianity ceased to be an open or culturally significant presence.

As we have seen, Confucianism was revived in Tokugawa times to serve ethical and political objectives of the government, becoming, in effect, the state religion, although humanistic, ethical ideas are better thought of as secular rather than religious. Running parallel to Japan's religious experience with Shinto and Buddhism is an elaborate mythology that arose in pre-Buddhist times to explain the country's origin, assert its antiquity, attribute a divine origin to the monarchy, and people the world with innumerable spirits, demons, gods, and forces.

A striking common feature of these religions, philosophies, and mythologies is that none were ever completely given up. Down through the centuries, when something new was embraced in Japan, older beliefs, institutions, and practices may have fallen into the shadows, but nothing was completely abandoned or forgotten. The Japanese could be contentedly eclectic in matters of religious belief in the same way that traditional Indians and Chinese could be. Being Shintoist, Buddhist, and Confucian simultaneously, while believing literally in mythological tales, brought no intellectual or emotional discomfort.

The Chinese belief that all Buddhist scriptures and practices reflect Buddha's teaching and offer alternative paths to enlightenment was adopted in principle by the Japanese in early years of borrowing, but in time it took a radically different course. The tendency was toward easy doctrines, personal salvation, and simple practices. From the Kamakura period onward sects became aggressively competitive over land, politics, and occasionally doctrine, going so far as to burn one another's temples and persecute rivals. Japan is the only country in the Buddhist experience that witnessed large-scale sectarian ill feeling and violence.

Shinto ("The Way of the Gods")

Settlers in Japan brought Shinto with them, so it is not quite accurate to call it an "indigenous" religion; nevertheless, we shall do so because there is no knowledge of what may

have preceded it. Shinto comes from two words: shin (gods) and to or do (the way). The Japanese islands are home to thousands of Shinto shrines. Some are elaborate precincts like Ise and Kasuga, whose entrances are prefaced by a post and lintel torii, while others are no more than striking rocks or trees encircled by a rope of rice straw (shimenawa) to mark a boundary between sacred and secular, and to indicate natural objects or sites worthy of reverence.

Shinto was originally animistic and polytheistic and always remained so, but there is otherwise no firm knowledge of the earliest beliefs before influences from Buddhism, Taoism, and Confucianism were absorbed. The central belief was in spirits (kami, which means "superior") that inhabit, or are identical to, impressive, awe-inspiring aspects of nature—waterfalls, trees, clouds, mountains, and living beings. Powerful human figures like the emperor and his ancestors were considered kami, as were individual places of exceptional beauty like Matsushima Bay and its multitude of pine-clad islands. Natural objects are not merely external symbols of kami lying behind or contained within them; they are kami. The same identification applied to the emperor as a Great Kami. In a poem in the *Man'yoshu*, an anthology of verse from the earliest times to 760, the sacred mountain Fuji says: "It baffles the tongue, it cannot be named, / It is a god mysterious"[48]

The purpose of worship was to summon, acknowledge, and propitiate the kami. Rites might involve one person or hundreds, but were always expressions of wonder and gratitude for spontaneous processes of nature. The proper heart (kokoro) of a supplicant at a shrine was expected to be pure (kiyoki), bright (akaki), correct (tadashiki), and straight (naoki). While these qualities appear to have an ethical ring, their true meaning is an attitude of ritual attention and obeisance before the kami. Ceremonies were heavy on processions, music, dance, chanting, and ritual gestures of thankfulness to kami for their beneficence.[49]

A demand for purity (tsumi-imi) means cleanliness rather than moral rectitude or guilt about wrongdoing. Examples of pollution needing ritual purification are death, disease, and a woman's menstruation. The value of cleanliness in Shinto worship accounts for the Japanese passion for bathing and applying water to hands and mouth before entering a sacred precinct. For the individual, worship at a shrine consists of summoning kami by clapping and bowing deferentially to acknowledge them. After such obeisance, there are prayers and offerings of drink, first fruits from harvest or fishing, and even the heads of enemies. Most shrines were headed by a medium believed able to establish communication between kami and rulers.

In Shinto, the totality of nature, including sex, was considered good. In nature there is no evil, which explains in part why the Japanese take earthquakes, volcanic eruptions, and typhoons in stride, a religiously inspired acceptance of violence in nature. Shinto is a an important source of the attitude that nothing in the life of man is inherently wrong—in other words, there is no such thing as sin. The Japanese never came to grips theologically or philosophically with the problems of good and evil.

An emphasis in early Shinto on ritual and acts of purification left no room for theology, ethics, or a morally-specified code of behavior. Those dimensions were beefed up in later centuries from largely Buddhist sources. By the late fifteenth century, Shinto nature spirits had taken on a highly philosophical character. Buddha and all the Bodhisattvas were held by a prominent Shingon commentator to be merely secondary traces of the

Gods: "'Kami' or Deity, is spirit without form, unknowable, transcending both cosmic principles, the yin and the yang . . . changeless, eternal, existing from the very beginning of Heaven and Earth up to the present."[50] A Shinto religion without doctrine in its early form was later clothed in the philosophical robes of Buddhism.

Initially the relatively simple ceremonies of Shinto did not compete with the brilliant, sophisticated rites of Buddhism adopted by the imperial court. While the native religion went into retreat at court, local cults continued to function in the countryside. But even among the aristocrats, the gods of Shinto cast a shadow when nature erupted with earthquakes and other natural disasters. By the late eighth century, Shinto and Buddhism had become associated. A Buddhist temple was built next to the shrine at Ise, the first of many "shrine temples." Buddhist priests participated in major Shinto festivals. An empress announced that her duties were "first to serve the Three Treasures, then to worship the Gods, and next to cherish the people."[51] The three duties refer to Buddhism, Shinto, and Confucianism, illustrating Japanese readiness to embrace and harmonize disparate belief systems without discomfort, which was also true of India and China. By the seventeenth century, some thinkers had conflated Shinto with Buddhism and Confucianism, making them one, all three ultimately derived from the gods.

Kukai, founder of Shingon (True Word) Buddhism, even warned that his school could not be understood without knowledge of Shinto. By the tenth century, Shinto gods were being identified as incarnations of various Buddhas and Bodhisattvas. For example, in the eighth century, Hachiman, the Shinto god of war, was given the title "Great Bodhisattva," and the "divine wind" that drove off the invading Mongols in the thirteenth century was interpreted as the work of Hachiman and the Sun Goddess. Buddhist priests presided over many Shinto shrines, and ceremonies of the two religions had become fused. The disintegration of imperial authority in Kyoto and the breakdown of Heian court life, which had been favorable to Buddhism, and the emergence of warrior rulers in the countryside, who smiled on Shinto, gave the native religion further impetus.

The cult of Shinto eventually operated on four levels—the home, the community, the craft guild, and the nation—and still does. The enormous pantheon of deities addressed many human interests while also being associated with beauties and wonders of nature. The home and its possessions, the village and its fields, the workshop and its materials, the entire country and its people recognized and appeased spirits with ceremonies of purification and ritual offerings. The most important connection between the human world and the realm of the gods was the emperor, who in due time was proclaimed a descendent of the Sun Goddess, Amaterasu. By the fourteenth century, the basis for an emperor's authority was his divinity rather than the limited status of the Chinese emperor as a mere Son of Heaven.

Devotional Buddhism

Buddhist sects discussed previously have enough intellectual content to qualify as traditions of thought. Some Buddhist sects, however, were almost wholly devotional in their teaching and had little to do with self-conscious reflection on matters of doctrine or efforts to clarify the nature of experienced reality. Inevitably they were embraced in the main by uneducated, spiritually hungry people in ordinary life. Buddhism as a matter

of faith was a radical departure from the original teachings of Shakyamuni, the historic Buddha, whose message was one of self-reliance and personal discipline, to "seek your own salvation with diligence." The principle was tariki, salvation by one's own strength. A faith cult like Jodo appealed to jiriki, salvation by the strength of another. In each case, "salvation" does not mean the same thing as Awakening or Enlightenment.

In the Kamakura period, Pure Land Buddhism, or worship of Amida, the Buddha of Boundless Light, presiding over a Western Paradise, attracted a wide following through the teachings and travels of charismatic evangelists. Amida had vowed eternities before that no one would be denied salvation who called on him by name. This Original Vow promised that nothing more was needed than to recite the nembutsu (Namu Amida Butsu, or Hail to Amida Buddha). At first, meditation on his name was sufficient, then thousands of vocal repetitions were needed, and finally calling on him once in a lifetime was enough.

The last concession to the strength of others was a simplified form of Tendai teaching that all things and beings interpenetrate as one, which allowed for a "circulating nembutsu," the promise that one person's saving call on Amida could benefit others as well. Amida worship was open to everyone without class or rank distinctions, including women, and borders on a form of monotheism. Pure Land had a profound effect on art, because painting and sculpture were accepted as a means of giving the Western Paradise visibility to all, as well as giving visibility to the hell that awaited those without Amida on their lips. The formal iconography of Shingon, which also acknowledged the power of art to nourish spirituality, was replaced by vivid hells, colorful scenes of paradise, and a resplendent Amida Buddha with attendants ushering the saved into the Pure Land.

An emotional approach to faith was also strongly represented by Nichiren, the proto-nationalist who scorned other sects and glorified Japan above other countries. For him all Buddhist truth was compressed in the title of the *Lotus Sutra*, which embraced the mysteries of mind, speech, and body. The lotus was for him what the cross is for Christianity, an invitation to faith and salvation. He condemned esoteric Buddhism as misguided because it favored the universal Buddha, Vairocana (mind); Pure Land fell short for worshiping Amida (speech); and Zen erred for emphasizing the historical Buddha (body). All of these specializations violated the unity of Buddhist truth. Nichiren's approach to salvation dispensed with deities and scriptures and promised that reciting the title of the *Lotus Sutra*, "Sutra of the Lotus of the Good Law," five words in Japanese, *Nam Myoho renge kyo*, would be sufficient.

Nichiren was persuaded that Japan would revive the true teaching of Buddha from its decline in the last and most corrupt stage (kali yuga, in Indian terms), of the cosmic cycle. The name he took for himself, Nichiren, means the Sun (nichi) and the Lotus (ren), or Lotus of the Sun. He saw his mission as spreading throughout the world the light of truth and purity in the *Lotus Sutra* as a gift from the Land of the Rising Sun.

Mythical Themes

Sources of Japan's myths are the *Kojiki* (Records of Ancient Matters) of 712 and the *Nihongi* (Chronicles of Japan) of 720. The first is predominantly mythic in content, the second partially so. Traditionally the Japanese have a highly developed taste for

mythopoetic belief, expression, and symbolism. There are two creation myths. One says Japan emerged from turbid waters when a giant carp woke up and thrashed about. The more important myth says two divinities, Izanagi (male-who-invites) and Izanami (female-who-invites), themselves descended from a vague chain of previous deities to the oily waters via a rainbow, dipped spear tips into the water, whose falling drops formed islands. The rest of the islands appeared, along with mountains and waterfalls, as an act of propagation between the god and goddess, concluding with creation of the wind. The two gods subsequently gave birth to the Sun Goddess, the Moon God, and the Storm God.[52]

The Shinto cult is associated strongly with a myth of Japanese origins in divine activity—kingship symbolized by the three regalia (magatama)—sword (courage), jewel (benevolence), and mirror (purity)—and the idea that emperors are divine, born of the sun Goddess, Amaterasu. The three regalia establish standards for governing the Land of the Rising Sun and stand as commands from a divine source. Other meanings of the regalia are resolution and wisdom for the sword, compassion and meekness for the jewel, and a selfless reflection of things as they are for the mirror. The mirror is associated with the sun, the jewel with the moon, and the sword with the stars—which affirms their cosmic importance.

Japan's origins myth includes the ruling house of the emperor. Down to modern times it was considered divine, continuous, and the chief symbol of the country's uniqueness. Such claims were affirmed in the fourteenth century: "Japan is a divine country. It was the heavenly ancestor who first laid its foundations, and the Sun Goddess left her descendants to reign over it forever and ever. This is true only of our country and nothing similar may be found in foreign lands. That is why it is called the divine country. . . . Only in our country has the succession [of the emperor] remained inviolate, from the beginning of heaven and earth to the present."[53]

25

Japan's Way of Thinking

The chief quality of Japanese thought was a narrow, one-dimensional, often chauvinistic outlook that had no influence on the world outside of Japan. The fate of ideas was unlike that of art, which caught the imagination of Europe in the late nineteenth century when block prints became known for the first time. One source of weakness in Japanese thought was a claim to dogmatic exclusiveness. Recall a boastful Shinto sentiment, which bears repetition: "Our great Japan is the country of the gods . . . Such things have happened to this country of ours that nothing is comparable to them in other countries. That is why this country is called the country of the gods."[54]

A second weakness was poorly developed and applied critical reason. Ideas were seldom pursued beyond a superficial level, and rigorous logical criticism was virtually

when

nonexistent until the Meiji era. This was the case despite the role of Chu Hsi's rationalistic Neo-Confucianism as the state "religion" of the shogunate from the seventeenth century onward. The only isolated exception was the school of Dutch learning (rangaku) that arose in Kyushu after the Tokugawa edict of seclusion and exclusion, which sought access to Western technology and science. Japanese students of the Dutch language and European culture were few and of little importance until the mid-nineteenth century.

While the Japanese were tolerantly open to learning from others with manifestly superior accomplishments, they also regarded themselves through mythic lenses as unique beings, and their inclination toward self-congratulatory particularism was widely reflected in literature and philosophy. Such an attitude is mostly absent from Indian and Chinese thought, which embraced ideals with more of a universal reach. Buddhism and Confucianism had cosmopolitan implications and were exported without difficulty to other countries. In the Chinese case, this was true even within the ethnocentric doctrines of the Middle Kingdom and All Under Heaven.

In India, violent strife between religious sects was unknown until Islam appeared. In China, Taoism, Buddhism, and Confucianism could be embraced by one person at the same time. Imperial persecution of Buddhism in the T'ang dynasty had predominantly economic and political motives. In Japan, intolerance appeared early among the six Nara sects as they competed for imperial favor. Intolerance among some Buddhists sects apparently conflicted with Japanese readiness to borrow from other traditions. Intolerance also worked against the peaceful coexistence of Shinto, Buddhist, and Confucian belief systems across the centuries.

An explanation of this apparent contradiction is suggested by three attitudes and developments. First, borrowing from abroad was always in Japan's interest and underwent modifications accordingly. Second, there was a notable lack of rational discrimination in the Japanese process of assimilating different ideas, which easily led to conflation of contradictory views. Thus, Shinto, Buddhism, and Confucianism were identified and conflated in a way that made them almost indistinguishable before 1600. Only after unification was Confucianism separated out from its rivals and packaged as the state ideology. Third, "toleration" of vague doctrines that became in many ways interchangeable supported primacy of the state, whether the state was ruled by emperors, shoguns, or regents. A body of belief that rejected Dai Nippon (Great Japan) would not have survived.

All major ideas were preserved, including mythological ones, because they glorified Japan and its "divinity," a way of thinking that was to surface with destructive consequences in modern times. Japanese tolerance rested on a narrow base of weak reason and restricted outlook. Tolerance in India came from the view that all beliefs, however primitive or sophisticated, were on a convergent path to moksha. In China, tolerance was encouraged by the belief that harmony and balance are essential to cosmic stability.

The Japanese mind in traditional times was shaped by distinct tendencies. As with Indians and Chinese, there were always exceptions, but on the whole, life in Japan adhered to a consistent pattern of attitudes, tastes, and beliefs that affected rulers and commoners alike in its control of the social nexus at the expense of independent, rational thought. As in China, ideas in Japan stayed close to the concrete realities of the physical world—with one striking difference. Veneration for changing phenomena of nature pervaded Japanese thought in apparent contradiction to the core Buddhist principle of impermanence. Both

Indian and Chinese thought accepted the notion that impermanence can and should be transcended, although the Chinese were more ambivalent about this notion.

A remarkable feature of Japanese Buddhism is a deliberate clinging to all aspects of impermanence as a manifestation of the Buddha nature, the precise opposite of early Buddhist teaching. Reality was conceived to be in things themselves, as Dogen, a founder of Japanese Zen Buddhism, makes clear: "Impermanence is the Buddhahood . . . The impermanence of grass, trees, and forests is verily the Buddhahood. The impermanence of the person's body and mind is verily the Buddhahood. The impermanence of the (land) country and scenery is verily the Buddhahood."[55] Japanese spirituality is not dualistic—this world and some other world, eternal or otherwise. Rather, the variety and change manifested in nature is the ultimate reality.

Taking pleasure in impermanence is not what Indian and much of Chinese Buddhism is about. For Japanese thought and sensibility, however, that which passes away is a source of both ultimate truth and sublime beauty. The Buddhist idea of impermanence simply reinforced a bias in favor of nature in all its changeableness—floating clouds, melting snow, falling cherry blossoms, and short, uncertain human lives. In Japanese poetry, the dominant theme of love is rivaled by an awareness of transience in natural phenomena—the passage of the seasons, the brief glory of flowers, and ephemeral sounds like temple bells and the warbling of birds.

Since man is part of nature, change and disappearance are unavoidable: "Today, taking my last sight of the mallards / Crying on the pond of Iware, Must I vanish into the clouds!" And again: "Beauty was hers that glowed like autumn mountains / And grace as the swaying bamboo stem. / How was it that she died—she who should have lived a life long as the coil of *taku* rope, / Though the dew falls at morn / to perish at dusk, / Though the mists that rise at eve / Vanish with the daybreak . . ."[56] Imagery that fuses human impermanence with fleeting scenes of nature is second nature to Japanese poets of all periods. The twist is that a native sensibility for the poignancy of change is seen as a source of Buddhist enlightenment rather than an obstacle. Therefore, in what seems to be a lament or a pessimistic commentary on things passing away, is an underlying sentiment that change is reality and conforms to Buddhist truth.

Despite this affinity with the changing face of nature, the Japanese did not develop a strong sense of the world as an objective realm inviting rational analysis. Their connection with nature was poetic, religious, and aesthetic. While their intuitive and emotional faculties were keenly attuned, their logical consciousness was poorly developed. A consequence was little interest in science and philosophical speculation. There is nothing in Japanese thought that resembles any of the Indian classical systems of philosophy, and there was no Japanese counterpart of neo-Confucian philosopher Chu Hsi.

A zeal for the beauties of nature was shared with educated Chinese, but there was a striking difference of emphasis. Unlike the Chinese, who loved broad vistas of nature in landscape painting, poetry, and gardens, the Japanese taste was for individual elements—a bird, an insect, a flower, a dewdrop, the toll of a single bell, a ray of moonlight—that cohered with a preference for delicacy and refinement rather than expansiveness. This inclination suggests the enduring influence of Heian aesthetics.

Many arts of traditional Japan are premised on small-scale visions and even miniaturization—for example, residential gardens, bonsai (miniature trees), Zen inspired

haiku poetry with its succinct seventeen syllables, and exquisite inro (a container) to hold small objects suspended by a netsuke (a sculptured toggle attached to a silken cord) from a kimono sash. Preference for the small over the large was often expressed in poetry: "In my garden fall the plum blossoms— / Are they indeed snowflakes / Whirling from the sky? The nightingale sings / Playing at the lower branches / Lamenting the fall of the plum blossoms."[57] In no other culture were elements of nature awarded lavish honorifics in the language, for example, attaching the honorific "o" to water (o-mizu) and tea (o-cha).

Japanese thrived on factionalism, which was encouraged by long experience with clan affiliation based on heredity, numerous and sometimes violently competitive Buddhist sects, decentralized feudal government, a social order of loyalties divided between family and ruler, and organization of the country into over 200 daimyo realms by the seventeenth century. The most intense and destructive phase of this factional inclination was from the twelfth to the early seventeenth centuries. It can be seen at work on a lesser scale, however, in the late Heian period and even during the long era of peace and unification under the Tokugawa. In 1868, factionalism became aggressive enough to end the shogunate.

Despite the fragmentation, there was throughout Japan a remarkable degree of cultural unity. Everyone was in some respect a beneficiary of Shinto and Buddhism. Among those with an education, Confucianism was respected, although it was like Buddhism adapted to specific Japanese needs. Sectarianism and factionalism did not result in art embracing newer styles at the expense of previous ones; nor did thought ever take off in radical directions that challenged Shinto and Buddhism.

Temple and palace architecture settled into basic forms everywhere during and after the Heian period and usually followed established traditions, despite stylistic flourishes like the Toshogu Shrine in Nikko. All literate people were calligraphers, more or less. Literary forms, once established, did not vanish in the face of innovation like the sensational novels of Saikaku. After the sixteenth century, shogun, daimyo, and samurai alike embraced chanoyu, the tea ceremony established by Rikyu in the sixteenth century as part of the "dual way" of martial and peaceful arts.

Given a weak interest in abstract thought and a commitment to aesthetics heavily weighted toward intuition, emotion, and concrete things, it comes as no surprise that the Japanese excelled at ritual rather than theology in religious matters. Religious values and frameworks of behavior, especially ethics, were generally weak and poorly developed, while the ceremonial and physical aspects of religion were elaborate and visually sumptuous. Fortunes were spent on the accoutrements of Buddhist temples, but disciplines of the faith—for example, the prohibition of drinking and sexual activity—were widely ignored.

Japanese worldliness and acceptance of human appetites and passions were often in tension with the core Buddhist teaching that the world of change must be transcended. This tendency to shun complex ideas and accept the natural inclinations of men was accompanied by a preference for symbolic expression that did not tax logical faculties. Buddhism swept through Japan in a short period of time and ultimately became a major cultural force, but the Japanese response was to make it their own by domesticating its doctrines and practices to an earthy acceptance of the sensual world.

26
Japan's Ideals of Beauty

Traditional Japanese aesthetic taste and preferences in art and architecture are a fusion of indigenous inclinations with influences from Korea and China. While there was such a thing as secular art and architecture, the continuous, subtle impact of Buddhism cannot be underestimated. With rare exceptions, some early, some late, Japanese art is usually characterized by a quality of sophisticated intimacy and naturalness that coheres with the environment in which it was created.

Recurrent Principles of Art (Five Aesthetic Preferences)

Japanese ideas of what art should deal with and how it should be made overlap in a number of ways, but in all of them there are recurrent and generally pervasive themes, although there are always exceptions.[58]

Naturalness

Most obvious is *closeness to nature* and a preference for naturalness in art. Love of nature was stimulated by the physical beauty of the land itself—imposing mountains, thick forests, swift running streams, magnificent coastlines, and seasonable variations. Shinto ritualized awareness of nature's grandeur, mystery, and charm with the notion of kami, the idea that spirits inhabit land and water. Major Buddhist sects like Shingon and Zen invested changing nature in all its variety with Buddhahood, from a waving blade of grass to the seasonal snow of Mt. Fuji.

Natural Material

A predictable consequence of these sentiments was *esteem for natural materials.* Natural materials were everywhere and therefore the necessary choice, but this was made manifest by a conscious attitude of respect in handling them. Sculpture made use of wood, bronze, clay, and dry lacquer. Painting relied on ground black ink and paper made from waste wood and other natural materials. Painting relied on black ink made from wood soot and animal glue, but also used colors derived from ground minerals and vegetable material. Almost all religious and domestic buildings, including palaces, were built of wood, thatch, and bamboo. While wooden or lacquered sculpture might be painted, Japanese taste preferred the natural colors of wood in architecture. The element of *respect* applies in all of these instances because of devoted, quality craftsmanship, or the skill and artistry used in exploiting the inherent possibilities of wood or clay.

 In ceramics, where this principle is most dramatic, imperfections in clay that has been fired, like scorching or irregular glazing, are left intact and enjoyed for their own sake.

Fig. 26.1 Shigaraki Tsubo, stoneware with natural ash glaze, fifteenth century.

Photograph by Reiji Yamashina. The Museum of Oriental Ceramics, Osaka, Japan.

The fifteenth-century example of ash-glaze stoneware in Figure 26.1 is riddled with imperfectons—flecks of unfused feldspar scattered over the surface, an unevenly shaped mouth, a natural green glaze running irregularly down the side. The orange color comes from trace metals in the fired clay. In all of these effects, the anonymous potter knew precisely what he was doing. The objective was a complete sense of naturalness.

Asymmetry

In Japanese art, starting in prehistoric times, there has been a recurrent preference for asymmetry. The preference can be seen in pottery, temple building, and painting. At the seventh-century Horyu-ji, for example, a temple in the T'ang dynasty style, the Chinese practice of placing two pagodas at the entrance to the complex was abandoned for one pagoda and one treasure house. A taste for suggestion rather than explicitness is associated with asymmetrical forms. If both sides of a painting or a piece of ceramic look the same, there is no room for play of the imagination. Symmetry is usually rejected because it seems to the Japanese mind repetitive and uninteresting.

A notable exception is the symmetrical temple-villa at Byodo-in with a plan like a bird—twin corridors running off on each side and a third extended in the rear. This is understandable, for without symmetry, the bird imagery would be lost. About the same time, however, the Muro-ji Kondo (Golden Hall) of the ninth century shows clear evidence of an emerging Japanese architectrural style, whose features are intimate scale, an asymmetrical, irregular ground plan, shingle instead of tile roofing, a wooden platform, and harmony with the surrounding natural landscape (fig. 26.2).

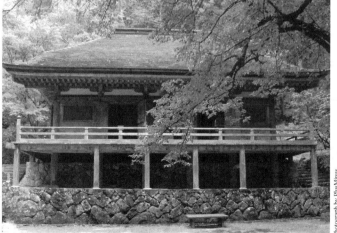

Photograph by PlusMinus.

Fig. 26.2 Muro-ji Temple Kondo (main hall), tenth to eleventh centuries, Nara Prefecture.

Untrammeled Space

A fourth preference is for empty space, which is related to the preference for asymmetry. Filling space with objects denies activity to imagination. Empty space also relates to the Buddhist idea of voidness. Cluttered space is an obstacle to enlightenment, for Zen satori comes at a moment of "no-mind," or voidness in which distinctions between this and that are no longer made. In painting, forms get their power and even their substance from the presence of such voids, as in the Sesshue Toyo's broken ink landscape (fig. 26.3).

The Buddhist void was expressed also in architecture, especially in the austere interior of a tearoom, with nothing visible but walls and ceiling, four or five tatami mats, a hole in the floor for a kettle, and a niche, or tokonoma, for displaying calligraphy, painting, and flower arrangements. The absence of clutter in a quiet space calms the mind and eases tension (fig. 26.4). Voidness also found its way into poetry, notably the spare haiku of Basho,

Fig. 26.3 Sesshu Toyo, *Broken Ink Landscape*, ink on paper, 1495.

http://commons.wikimedia.org/wiki/File:LandschaftSesshuToyo1481.jpg

which can tremble on the edge of nothingness: "This road; / with no man traveling on it, / autumn darkness falls."[59] A sense of voidness in the Buddhist sense has seldom been achieved with so few words and images.

Photograph by Makiko Parsons.

Fig. 26.4 Sekka-tei tea house at the Golden Pavilion, Kyoto.

Comfort with Extremes

Traditional Japanese taste alternated between austerity and extravagance, seriousness and playfulness. The first polarity is illustrated in architecture of a rustic teahouse and the Yomeimon (Sunlight Gate) through which one passes to the tombs of the early Tokugawa shoguns in Nikko. The teahouse is plain and unobtrusive, reflecting the inward calm and simplicity of Zen consciousness (fig. 26.5). The gate is florid with color and decoration, proclaiming wealth and power of the Tokugawa shogunate (fig. 26.6). Polarities of gravity and playfulness can be sampled in Sesshue's depiction of Hui K'o offering his arm to Bodhidharma (Daruma in Japanese) as proof that he has what it takes to be the patriarch's disciple, and Yoshitoshi's image of the fox woman leaving her child. In the

Photograph by Laura Thomas.

Fig. 26.5 Tea House at Tenryu-ji Temple (Temple of the Heavenly Dragon) in Kyoto.

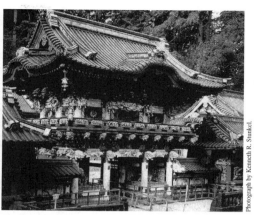

Photograph by Kenneth R. Stunkel.

Fig. 26.6 Yomeimon Gate, Toshogu Shrine, seventeenth century, Nikko.

first instance, Bodhidharma has come to China, cannot find a tolerable follower, and retires in disgust to a cave, where he sits for years in meditation before a wall. Hui K'o, an aspiring disciple, tries in vain to attract his attention with acts of humilty and finally cuts off his left arm as a token of devotion and commitment. Bodhidharma is impressed, Hui K'o enters his service, and thereafter he succeeds his master as patriarch in China (fig. 26.7). In the second instance, a legend has a nobleman concealing and saving a tired fox running from hunters. The fox is transformed into a maiden whom he meets and marries. She gives him a son. After three years, the woman realizes her time as a human is up and she must resume life as a fox. The woodblock print depicts her departure and partial transformation as the child clings to her garment (fig. 26.8). The two works also present a contrast between religious and secular art, which is mostly absent from traditional Hindu India.

The Chinese Connection

Japan's reputation as a "moonlight civilization" derives from a long history of borrowing Chinese ideas, institutions, written language, literary forms, art, and architecture, most of which remained integral to Japanese culture until modernization in the nineteenth century. The door to China remained open from the time of Prince Shotoku in the seventh century to the Tokugawa regime a thousand years later. The wave of borrowing had receded by the ninth century, but the prestige of China, if somewhat diminished, always loomed in the background. Buddhism, in one form or another, continued for centuries to influence thought and art, culminating with the culture of Zen just before the unification of Japan in 1603.

The "moonlight" metaphor, however, is not quite fair. Borrowed ideas and forms,

Fig. 26.7 Sesshu Toyo, *Bodhidharma (Daruma) and Hui K'o.*

Fig. 26.8 Tsukioka Yoshitoshi, *The Fox Woman Kuzu-no-ha Leaving Her Child*, woodblock print, nineteenth century.

as we have seen, were creatively modified to make them uniquely Japanese. In the case of ideas, a fusion of Shinto and Buddhism would not have been recognizable or intelligible to the Chinese, nor would later adaptations of Chu Hsi's version of Neo-Confucianism to Japanese circumstances when it became the state "religion" of the Tokugawa Shogunate in the seventeenth century. Ch'an Buddhism in China never had the far reaching influence that Zen, its Japanese counterpart, had in Japan. Stylistic changes in painting, sculpture, and architecture can be detected and described by art historians, but through all such changes, ideas and practices taken from China remained as common threads.

When the Japanese adapted Chinese characters to write their language, their commitment to calligraphy and its materials was inevitable, as was the transfer of that skill to painting. Calligraphy and painting were executed, as in China, on paper or silk with brush and a black color called sumi, made as it was in China from the soot of certain plants, mixed with glue from deer horn, and molded into solid cakes or sticks. Sumi is a versatile substance whose shades can be varied to suggest ranges of color through the manipulation of light and dark. While one occasionally sees Japanese sumi paintings (called sumi-e) described as works executed with black "ink," that is not the case, although ink continues to be the term used. Eight different ways of using "true" color have been described, but, in Japan as in China, color was used sparingly and the ideal was to achieve all desired effects with sumi alone.

As in China, brushes were made from the hair of deer, rabbit, sheep, fox, horse, squirrel,

and even hair from the kingfisher's beak. Mastery of the brushstroke in calligraphy was the discipline that led naturally to painting. The best stones, with fine, durable grains for grinding sumi in water, came from Kyushu, although some were imported from China.[60]

Architecture moved from Chinese styles of the T'ang dynasty to distinctly Japanese forms, both religious and secular, and sometimes a mixture of the two. The first great phase before the Heian period was almost wholly under the spell of Chinese ideas, iconography, and models. The major structures were temples, shrines, palaces, and residential dwellings. Not much is known about the latter two until Heian times. Fortunately temples and shirines are well represented since the inception of Buddhism.

With the initial guidance of Prince Shotoku, more than forty temples were built, which quickly became centers of learning and healing. Improbably still in existence is Horyu-ji, built in 607 for the Sanron sect but completely redone in 670 after a fire (fig. 26.9). It is a T'ang style Buddhist temple consisting of three historic buildings (pagoda, treasure pavilion, and teaching hall) surrounded by a narrow cloister with a fine gate at the south end (fig. 26.10). The treasure pavilion and teaching hall housed landmark Buddhist sculptures and paintings (now in the Tokyo museum), including the Tamamushi Shrine (the Beetle-wing Shrine, after glimmering wings of beetles that decorated the metal edging), which provides a hint of architectural style about 650 C.E. (fig. 26.11). On it are a number of paintings in oil on cypress wood, the earliest to survive. One of them depicts, in narrative form, Buddha in a previous life (from a well known jataka tale), hurling himself from a cliff to feed a starving tigress and her cubs (fig. 26.12).

Photograph by Michael Hitoshi/The Image Bank/Getty Images.

Fig. 26.9 Aerial view of the main Horyu-ji compound (the West Minster; there is a later East Minster), seventh century.

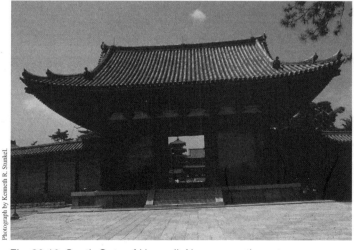

Photograph by Kenneth R. Stunkel.

Fig. 26.10 South Gate of Horyu-ji, Nara, seventh century.

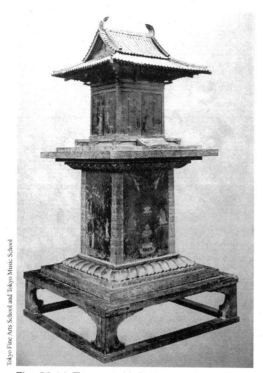

Tokyo Fine Arts School and Tokyo Music School

Fig. 26.11 Tamamushi Shrine, Horyu-ji, Nara. Roof of camphor and cypress wood; paintings, oil on lacquered cypress, seventh century.

Horyu-ji, Nara

Fig. 26.12 Jataka tale, Tamamushi Shrine painting.

With Chinese temples, the buildings normally had a linear arrangement, starting with a pagoda dedicated to Buddha, moving along to the treasure house, and ending with the teaching hall. The Japanese decided to break that lineup and put the pagoda and treasure house opposite one another so a visitor one could view all three buildings after coming through the gate. One result of this reshuffling was to demote the pagoda in importance. A second outcome was to achieve an asymmetry of building types, for symmetry would require two pagodas—one on each side. Of special interest at Horyu-ji, on the eastern side of the complex, is a graceful, octagonal meditation hall, the Yumedono, or "Hall of Dreams," built in 739 to honor Prince Shotoku, the seminal patron of Buddhism and Confucianism. The source is Chinese but the intimacy is Japanese (fig. 26.13).

Among sculptural treasures of the time, a transcendentally elegant seventh century camphor wood sculpture of Kannon was made for Shotoku just before his death and housed in the Yumedono. Kannon is the goddess of mercy, the Japanese version of India's Avalokiteshvara (fig. 26.14). Nothing like it has survived in China or Korea, and nothing quite like it was executed again in Japan. Exquisitely designed, she brims with Buddhist

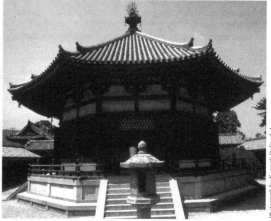

Photograph by Kenneth R. Stunkel

Fig. 26.13 Yumedono chapel, Horyu-ji, Nara, eighth century.

symbolism and ideas. Six-feet tall and austerely slender, she stands on a lotus, symbol of purity, with a detached smile. She holds in her hand the "wish-granting" jewel of Buddhism. The jewel symbolizes spiritual rather than material wealth and represents more broadly the treasures of Buddhism in the teaching. Her robes cascade downward from the shoulders and flow at successive levels outward, accentuating the figure's presence, but without the extravagant dress and ornamentation found in many Bodhisattva images. An oval halo of fire, symbol of both impermanence and spiritual power, surrounds a perforated copper crown that carries the image's lines upward to the halo's peak.

The materials of architecture and painting remained much the same with the emergence of new forms. With sculpture, however, wood and bronze images were supplemented as early as the Nara period by extensive use of clay and dry lacquer, favored materials for Buddhist portrait sculpture that continued through the Kamakura period, a superb example being the painted dry-lacquer image of the blind priest Ganjin from the mid-eighth century (fig. 26.15). Ganjin was imported from China by the emperor to ordain a fresh crop of Japanese monks and nuns. The expressive realism of his image is

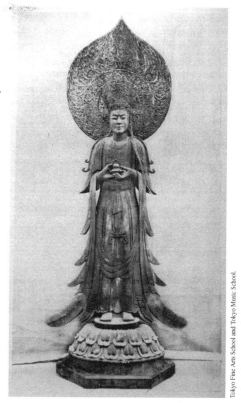

Fig. 26.14 Guze Kannon, gilded camphor wood with gold leaf, seventh century.

Fig. 26.15 Ganjin, dry-lacquer, Toshodai-ji, Nara, 761.

one of Japan's unique and enduring contributions to art. The sculptural technique is multiple layers of lacquer on cloth placed over a wooden armature. When the lacquer has been shaped and the image completed, the armature is removed and the result is a "sculpture" of leaf-like lightness that can be carried in processions.

The eighth century was the golden age of Buddhist influence and heroic temple building on Chinese models. A mighty temple and image were commissioned by Emperor Shomu in the eighth century. He described himself as a "slave" of Buddha and inaugurated a building program to prove it. The result was Todai-ji, the Great

Fig. 26.16 Todai-ji (Great Eastern Temple), Nara, eighth century.

Eastern Temple, which, although reduced in size from the original, is still the world's largest, oldest wooden building, headquarters of the Kegon, or Flower Wreath, sect (fig. 26.16). Behind it is a wooden storehouse, the Shosoin, containing no fewer than 756 ceremonial objects and personal belongings of the emperor—furniture, screens, textiles, weapons, pictures, musical instruments, ornaments—all in mint condtion with supporting documents, a unique snapshot of late-eighth century splendor, wealth, and refinement, a time capsule of Buddhist Japan under central rule. The collection includes gifts from other countries to honor Buddha. The Shosoin is constructed of logs that expand when air is humid, keeping it out, and contract when it is dry, providing ventilation. Imagine a similar collection existing intact for the Roman emperor Hadrian or the Holy Roman emperor Charlemagne. Even more remarkable is that over twelve centuries of political turmoil and warfare, the building and its varied contents have remained undisturbed—no destruction, no looting, surely a triumph for Japanese tradition and cultural continuity.

The massive image of Vairocana, the universal Buddha (53-feet high, the world's largest bronze image), was installed in 752 as guardian and unifier of the Japanese state (fig. 26.17). So much bronze was needed to cast the image that sculptors at a later time were hard pressed to secure the metal and, therefore, with the exception of the Great Buddha at Kamakura, such colossal images were abandoned. Emperor Shomu also decreed the construction of temples and pagodas in all the provinces. Temples placed strategically at Nara were in support of the six Nara schools of Buddhism, all derived from Chinese counterparts, which in turn had Indian counterparts. Despite a brief period of influence before the capital was moved from Nara to Kyoto, each school ultimately contributed something durable in teaching or practice to their successors.

The great Buddhist sculptural and architectural monuments of Japan from the seventh to the nineth centuries, as well as ideas of various Buddhist sects, seem oddly aloof from one

another, filtered as they were from China through Korea. They do not hang together as a wholly consistent legacy that is distinctively Japanese. What the Chinese connection did was open wide a door to unfamiliar, sophisticated ideas about nature, man, and society, while providing a range of models for art and architecture radically different from what had been available in pre-Buddhist Japan. Without rejecting ideas and preferences of a less civilized past, the Japanese raised themselves on a borrowed platform to new levels of thought and sensibility while preserving much of the past.

Once distanced from overpowering Chinese influence after the ninth century, taste and sensibility before modern times was consolidated in three distinct aesthetic vocabularies from the Heian through the Tokugawa period. The first reflected interests and ideas of an ultra-refined Heian court from the ninth to the twelfth centuries. The second was widely influenced by Zen Buddhism from the thirteenth to the sixteenth centuries and embraced by ruling daimyo and samurai as well as Buddhist

Fig. 26.17 Daibutsuden (Vairocana Buddha), Todai-ji, bronze, seated on a bronze pedestal, Nara, eighth century and later.

http://commons.wikimedia.org/wiki/File:TodaijiDaibutsu0224.jpg

sects. The third developed in urban centers around the life of townsmen in the Tokugawa shogunate and reached a peak of creativity toward the close of the seventeenth century.

Underlying the three aesthetic vocabularies are the five aesthetic preferences (see above) that endured from Neolithic times to the nineteenth century, perhaps the longest continuous reign of a coherent outlook on ideals of beauty in world history.

The Heian Aesthetic

An inclination toward activity and aesthetics rather than thought distinguishes the Japanese from other high cultures. Intuition and emotion usually trumped rational inquiry. Highly structured aestheticism unfolded in the Heian period, where court life was absorbed in a cult of beauty that involved innumerable rarified actions, ruled by precisely defined conventions. Heian aristocrats were consumed from morning until night with executing heavily scripted courtships, writing occasional short poems, comparing scents and colors, executing calligraphy for appearance rather than anything that might be said, going on excursions to hear the sound of cuckoos, judging color combinations, or participating in elaborate court ceremonials. While knowledge of Chinese poetry and classics was appreciated, abstract reasoning and extended argument were not. One was expected to display learning in a casual manner that amounted to embellishment rather than substance. Evidence of good taste conforming to exact rules and standards was a virtual substitute for morality and was considered superior to complex thought.

The major setting for Heian aristocratic life was a type of dwelling called shinden-zukuri, developed in the Heian period and adapted to tastes and needs of its privileged residents.

Shinden means "hall for sleeping." The master lived in the central hall, the shinden, which faced a garden and courtyard to the south. Extending to the sides were corridors or verandas with other living quarters (fig. 26.18). Although no examples have survived, the style has been recovered from literature and painted scrolls of the time; it exerted much influence on later Japanese domestic and public architecture.

Although the shinden style was based on strictly symmetrical Chinese models, much of what can be said about it applies to traditional Japanese architecture in general, both sacred and secular.

Construction was entirely in wood, with cypress-bark shingles for roofing and reed matting (tatami) for floors, which meant that such buildings were fragile and vulnerable to fire. As in virtually all Japanese architecture, the structural system is post and lintel, with non-load bearing walls that can be removed. The post-and-lintel structure necessitated division of the building into bays whose sizes could be regulated with screens or sliding doors, although care was taken that such modular possibilities did not get out of hand and undermine a sense of proportion. The modular approach favored horizontal rather than vertical space, so Japanese buildings normally consisted of one story.

Fig. 26.18 Sketch of a Heian period *shinden-zukuri.*

Internal fluidity also extended to the outside. Paper screens on runners could slide to the sides so the interior seemed to merge with the outdoors. A garden, no matter how small, was essential to Japanese dwellers. The shinden of a wealthy individual would have an extensive garden. Post-and-lintel construction meant commitment to rectilinear forms at right angles without curves or arches. Natural surfaces in the shinden style were simple, understated, and undecorated, but it is well to recall that Japanese taste also accepted ornamentation that included elaborate wood carvings, gold leaf on walls, and even the use of lacquer and mother-of-pearl, all of which could be found in some Buddhist temples, most palaces, and wealthy private dwellings.

A visual suggestion of what it was like to live in such a dwelling has survived in the form of a painting called the *Genji Scroll* (fig. 26.19). As we look down, as though poised above an open ceiling, three women attired in handsome robes, long black hair streaming down their backs, are occupied with music and books. How one should look in Heian society was rigorously specified. The women shaved their eyebrows and painted them in higher on the forehead. A head of jet-black hair was allowed to grow to the ankles and was considered a major standard of feminine beauty. Robes were worn in numerous layers and had to exhibit accepted taste in their exposed combinations of texture and color. Failure to measure up in a public setting could ruin a reputation. Dress was as

Fig. 26.19 A section from the *Tale of Genji Scroll,* hand scroll, color on paper, twelfth century.

important as behavior. Makeup and clothing also had erotic implications. A sleeve draped from the window of a palanquin was enough to excite a gentleman's interest.

Expectations for fastidious appearance and ritual comportment were just as demanding for men as for women. The social position of women declined in later feudal times. Perhaps only in ancient Minoan civilization on Crete did women have so much personal freedom, despite all the rules, and such a range of creative opportunity as they did in Heian Kyoto. The aristocratic women pictured in the *Genji Scroll* and immortalized in Heian literature were literate, cultivated in the arts, and often learned. They could write poetry and prose, play musical instruments, debate effectively with men, and paint, all the while engaged in complex sex games with male courtiers.

The vocabulary of Heian aesthetics can be gleaned from Murasaki's *The Tale of Genji* and Shonagon's *Pillow Book*. The overriding idea, as we have seen, is mono no aware, sadness experienced as things, people, and relationships pass away. The melancholy arose from genuine love of an unstable world in which little escaped fading or dropping suddenly into oblivion. This sensibility did not seek truth or goodness beyond the fragility and beauty of those things that please the senses and touch the heart. The beautiful was viewed as both true and good. The fragility of beauty was part of its charm.

Art was intimately associated with relationships—endless notes passed back and forth in fine calligraphy, embellished with transitory flowers of the season tastefully arranged, gorgeous fabrics to delight sight and touch, and poetry recited from memory or contrived

spontaneously on the spot. Lives that were brief demanded a continuous flow of surprises and ingenuity. Dullness, vulgarity, bad timing, sloppiness, and uninspired imagination were enemies of the good life.

A surviving example of this intricate aesthetic is the early twelfth century *Ishiyama-gire,* two poems from the collection written in elegant ink-calligraphy on paper decorated with silver, gold, various dyes, and plant forms (fig. 26.20). Placement of color, texture, plant motifs, and calligraphy on the paper is asymmetrical. The title the piece refers to is a temple where a collection of eleventh-century poems in five-lines were kept. The paper itself is an elaborate construction that qualifies as a minor work of art. The expert, highly rhythmic calligraphy with continuous lines sets out with bold strokes and modulates into thinner ones toward the end.

The two poems from the *Ishiyama-gire* collection, composed by an elev-

Fig. 26.20 *Ishiyama-gire*, ink on silver, gold, and dyed paper early twelfth century.

enth century courtier, were transcribed onto the lavishly designed paper by a twelfth century courtier. Paper, poetry, and calligraphy interact with one another to provide a unique experience of refined pleasure. The poems are expressive of mono no aware. The first to the right reads: "The loved one / I could meet yesterday / is gone today— / wafted away / like mountain clouds." The second to the left reads: "Although I accept / that to live is indeed like this / it is only because / a certain person has died / that I am so deeply grieved."[61]

Heian aesthetics had two main sources: Buddhism, with its doctrine that all things pass away, and Shinto, with its view that nature's objects and creatures are sacred. For Buddhism the approach to impermanence is psychological and metaphysical. In the first instance, attachment to change is an error of the mind that leads to suffering and rebirth. In the second instance, philosophical analysis in the Mahayana schools was lavished on the nature and dynamics of the dharmas, categories of change (e.g., body, sensation, perception) whose essence was judged to be emptiness. In that frame of reference, there is not much room for an aesthetic when the goal is complete detachment from phenomena.

The Japanese view of impermanence is that things may pass away, but while they are in full bloom—a flower, a full moon, a piercing insect cry, the brilliant plumage of a bird, the sound of rain on a pond—they have value and deserve attention, and they reflect a different kind of beauty when they begin to fade. No other civilization was ever quite so enamored with ordinary things destined for decay. Daily experience governed by refinement and purity of taste is rare in the modern world. If excesses of Heian aesthetics are put aside, an admirable core of sensibility to well-made things and forms remains.

The Zen Aesthetic

No other Buddhist sect influenced art as much as Zen. This includes painting, calligraphy, theater (Noh), the tea cult (chanoyu), flower arranging (ikebana), poetry (haiku), architecture (the shoin style), and gardens. Clustered specifically around the ritualized drinking of tea were architecture, painting, calligraphy, ceramics, and gardens. As we have seen, Zen became the spiritual training ground for success in martial arts, especially swordsmanship and archery. At the heart of these influences was an aesthetic inspired by Zen called shibui, which means quiet, suggestive, unselfconscious simplicity embodied in natural materials shaped into clear, modest forms. Activities can also express shibui if they are cultivated with unobtrusive selflessness and tranquility. Objects, environments, and actions infused with shibui were aids to meditation and cultivated a sensibility linked with the Buddhist idea of emptiness, the goal of detached enlightenment beyond all conditioned states.

Zen fused with the native tradition of reverence for nature and its particular objects. This collaboration of old and new was expressed as a taste for things small, simple, intimate, and natural rather than big, complex, imposing, and artificial. Aged, rough hewn, misshapen objects were preferred to those that were new, shiny, and perfect. Out of this complex of taste and preference emerged the ideas of wabi and sabi. The meaning of the former is not far removed from that of the latter, and in some ways they are interchangeable. What both imply is an active appreciation of poverty and incompleteness. The idea of poverty does not mean wretched, abject destitution, but rather a condition of deficiency that arouses admiration and affection.

Wabi applies to a more general environment affected by time and to ephemeral lives associated with it. An ancient temple garden can have wabi, and it is correct to speak of Basho's "wabi life." The quality at work is being old and flawed in a spirit of self-sufficiency and contentment, a dignified poverty in tranquil abandonment. A good example is the Golden Pavilion in Kyoto, built by the last Ashikaga shogun as a private villa. He directed that it become a temple after his death. The structure was destroyed by fire in 1950. Within a few years it was rebuilt on the same plan with gold leaf decoration (fig. 26.21). Discerning viewers of the new, gleaming structure found it sadly lacking in wabi. The former building was rich not only in its patina of age, but also had associations with the past and had been frequented by men and women, mostly dead and gone, who enjoyed its quiet elegance, maybe participated in a tea ceremony, or engaged in meditation. Hovering about the first pavilion was an aura of quiet deficiency (fig. 26.22). Discriminating viewers said that in a hundred years or so the building will regain its original depth of feeling and visual power. Here is a verse that expresses the mystique of wabi: "Among the weeds, growing along the wall / The crickets are hiding, as if forsaken, / From the garden wet with autumnal showers."[62]

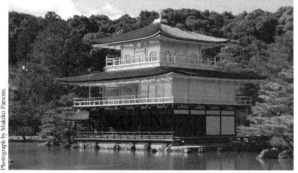

Fig. 26.21 Kinkaku-ji (Golden Pavilion), Kyoto. 1398, rebuilt version, 1964, after 1950 fire.

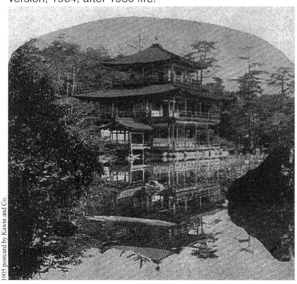

Fig. 26.22 Kinkaku-ji (Golden Pavilion), Kyoto, original, 1398, before 1950 fire.

If the aesthetic of simplicity, deficiency, and loneliness is focused on specific objects, sabi is a feeling of appreciation for them. Wear and desolation in ordinary things of life endow them with character and interest. Imperfection that invites abandonment strikes deeply into the human psyche, since all things not only pass away, but also commonly do so in stages of decay and decline. Must everything be new and polished? Are chipped but still usable teacups that have been around for generations to be discarded? Can we not take pleasure in what is old and even withered? Along these lines, a fourteenth-century writer explains sabi: "Are we only to look at flowers in full bloom, at the moon when it is clear? . . . There is much to see in young boughs about to flower, in gardens strewn with withered blossoms."[63] In sabi there is a lingering trace of aware, the Heian feeling of melancholy at the passing of beautiful things, but the difference with sabi lies in extending affection

to the imperfect thing itself. The influence of Zen is that the Buddha nature resides in the humblest objects and activities.

The spirit of shibui and the sensibility conveyed by things endowed with wabi and sabi are at odds with anything flashy, loud, or superficially novel—the latest fashion in clothes, utensils, or adornments. Shibui as understatement contrasts with things gaudy (iki) and vulgar (hade) whose hallmark is overstatement. Things with shibui, however, must not be confused with things merely dull, sober, and colorless (jimi), which are attempts at shibui that fall short.

These ideas about fitness and beauty in objects, from teacups to kimonos to architecture, extend to gardens. The building of gardens originally came from China but, in time, became a fusion of Shinto reverence for nature and Zen-inspired understatement for the Japanese. The greatest example is the garden at Ryoan-ji, a Zen temple of the Rinzai sect near Kyoto. The garden, designed by Soami (painter, art critic, artistic advisor to the shogun) consists of raked sand and some thirteen rocks of various sizes, a wall on two sides, and a viewing pavilion on the inside quadrant (fig. 26.23). Basic principles of Japanese aesthetics in evidence are natural materials, asymmetry, and above all a field of open space accented by the stones. Depending on the time of day and individual perceptions, the rocks can be islands rising from the sea or mountains above the clouds. An unobtrusive disposition of simple materials promotes tranquillity of mind in the Zen Buddhist spirit when contemplated.

Mature Japanese architectural ideals and forms for residential buildings had common denominators drawn from the Heian shinden style, a later shoin (literally, a "writing hall") style that derived from a small room or alcove used by the abbot of a temple monastery and

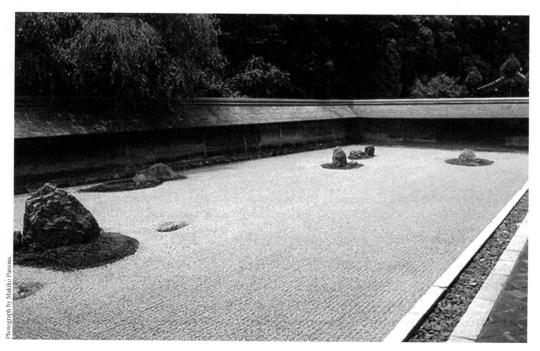

Photograph by Makiko Parsons.

Fig. 26.23 Soami, rock-sand garden at Ryoan-ji, Kyoto, fifteenth century.

later applied to a type of house, and the influence of Zen understatement and proximity to nature found in the teahouse. The basic synthesis included post- and lintel-construction, natural materials (unpainted wood, plaster, paper), modular organization of space, removable walls in the form of sliding doors (fusuma) and paper screens with wooden lattice reinforcement (shoji), tatami matting for floors, a tokonoma for displaying art and flowers, an open transition from interior to exterior, and a garden organically connected to the dwelling.

Fig. 26.24 Japanese house in the *shoin* style opened for the summer.

These features, which obey the spirit of shibui as well as our five aesthetic preferency, including irregularity and open space, were found in most residential dwellings. In Figure 26.24 the magnitude of open space makes the structure look light and even tenuous. The interior of Shoren-in, a more elaborate residence of a former abbot of the Tendai sect of Buddhism, looks out on an exensive garden designed by the same Soami who did the garden at Ryoan-ji (fig. 26.25). The openness of interior space to the outside creates a unity with the garden, accented and echoed by natural materials in the room that convey an atmosphere of shibui (fig. 26.26).

Fig. 26.25 Shoren-in and view of garden from the inside, Kyoto. Present buildings date from 1895.

Moving up in scale, the Katsura Imperial Villa, built between 1620 and 1624, merely has more buildings and a larger garden. The shibui spirit is present everywhere, as is the influence of the Zen-inspired teahouse. The main landscape feature is the huge walking garden overlooked by several teahouses (fig. 26.27). Numerous buildings

Fig. 26.26 Shoren-in main building, Kyoto.

Fig. 26.27 Katsura Imperial Villa, Kyoto, seventeenth century.

are made from wood and other organic materials. Like the shinden style of Heian aristocrats, many rooms can be opened up to look out on the grounds. Like the shoin style, rooms have sliding screens and a fresh, open, uncluttered look (fig 26.28).

The aesthetic principles of shibui achieved fullest expression in the cult of tea (chanoyu) and all the arts supporting it. Tea drinking was introduced from China in the time of Prince Shotoku. It became prevalent after the twelfth century when Eisai, founder of the Rinzai sect, cultivated the plant and introduced it to Zen monasteries. He praised its medicinal values and effectiveness in keeping monks awake for meditation without intoxication. Gradually tea drinking was systematized among daimyo and samurai as a fashionable thing to do, along with attending affable gatherings in the Heian tradition to compare and judge teas by taste.

In due time, tea became the center of an elaborate ritual perfected and propagated by a Zen priest, Sen no Rikyu (1522–1591), who swam against the social current and rejected class distinctions in the ceremony. He formalized the use of implements (kettle, cups, tea whisk, tea caddy, water ladle, tea scoop, etc.) in a simple thatched cottage with a tearoom ten-feet square (room for about five people) approached along an austere garden path. His tearoom is reminiscent of priest Kamo no Chomei's "hut ten-feet square" in the twelfth century. The front to Rikyu's teahouse is approached by an irregular stone-path from a modest garden. Most teahouses have an entrance gate, a room for belongings, a sheltered waiting arbor, and a stone basin for rinsing hands and mouth. The approach is full of reminders that nature's elements sacrifice for the guest's comfort: selfless stones on the path submit to being trod upon, and water in the basin accepts the task of removing impurities. Buddhist reminders of life's transience include an outdoor privy as a

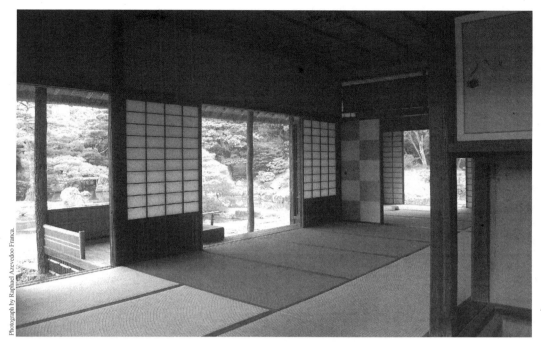

Fig. 26.28 Katsura Imperial Villa view from the Ko-shoin, seventeenth century.

reminder of the body's changing states. A three-and-a-half-foot entrance door to the tea hut obliges a guest, whatever his or her status, to stoop on entering in a voluntary act of humility. The approach to a teahouse may be viewed as pilgrimage route leading to a place of spiritual climax. Merely seeing a teahouse and its interior fails to convey the full magnitude of an experience that begins at the entrance gate and ends when the host says farewell after the ceremony.

The interior of Rikyu's teahouse, with its tokonoma for painting, calligraphy, and flowers of the season, epitomizes the wabi of undecorated plainness.[64] The interior is undecorated, unfinished, and mostly bare except for objects introduced for a gathering. The setting and the ceremonial objects are imperfect and asymmetrical—the refined "poverty" of Zen—so that guests might complete them in imagination. What had previously been simple enjoyment of a drink becomes a ceremony shaped by the aesthetics of shibui for appreciating beauty and tranquility in small things, like the sound of water boiling gently in a kettle, disciplined movements of a tea master at work, the sight of old utensils, and the ritualized sipping of green tea from an old, flawed ceramic cup.

The philosophy of tea is harmony (wa), a sense of communion with nature and people, respect (kei), thanks for graciously plain surroundings, beautiful utensils, fellow guests, and the tea master's hospitality, purity (sei), a spirit of cleanliness within and without, and tranquility (jaku), a condition of inner stillness cultivated by the first three qualities. While these qualities are the spirit of tea within the thatched hut, the idea is to extend them to humanity and the world once the ceremony is ended. The quality of purity clearly has roots in Shinto with its zeal for ritual cleanliness. A tea master is obliged to see that every corner and surface of the teahouse is free of dust and grime, a physical metaphor

for cleansing one's mind. On the other hand, cleanliness does not mean only scrubbing. A disciple once failed to satisfy a tea master with repeated efforts to cleanse stepping-stones. Finally, the master showed him how by shaking a few branches of a maple tree so a discreet pattern of fallen leaves dotted the stones.

This pursuit of Zen-inspired simplicity was called wabi cha (the wabi of tea). Rikyu became tea master in the court of Toyotomi Hideyoshi (1536–1598), the commoner who became a general and unified Japan before his death in the last decade of the sixteenth century. Unfortunately for Rikyu, Hideyoshi's preference in a tea ceremony was garish display, especially a heavy use of gold leaf on the walls of the teahouse and on implements as well, which resulted in disagreements with his austere tea master. Tension between them was aggravated when a detractor accused Rikyu of complicity in a plot to poison Hideyoshi with tea. Rikyu was ordered to commit suicide and did so after a farewell tea ceremony with close friends, in which he gave away all his implements, except his own cup, which was shattered.[65] After Japan was unified the ceremony continued to be practiced as part of the "dual way" that became the foundation of daimyo culture—martial arts combined with peaceful arts like scholarship, calligraphy, and the cult of tea.

The Urban Aesthetic

Among powerless commoners a rival and highly popular new aesthetic emerged in the booming towns and cities. The growth of towns and cities after the unification of Japan, stimulated by the shogun's hostage policy of "attendance in turn," fostered a culture unique to townsmen called ukiyo, once a Buddhist term meaning "sorrowful." The new meaning was "floating world," which retained Buddhist overtones of uncertainty and impermanence but came to suggest whatever is fashionable or up-to-date. In due time there were floating world stories (ukiyo-zoshi), art (ukiyo-e), and hosts of floating world men and women whose obsession with money and pleasure created a colorful universe parallel to that of daimyo and samurai.

Between 1688 and 1703 (called the Genroku era), ideas about the meaning and purpose of life deviated sharply from the austere values of the ruling class. The aesthetic of ukiyo defined and expressed the best life in remarkably worldly terms easily understood in the modern world. Once the new way of living and thinking got started, it continued to the end of the eighteenth century and laid part of the groundwork for Japan's modernization after 1867.

Prominent centers of ukiyo sensibility were Edo (now modern Tokyo), capital of the Tokugawa shogunate, Kyoto, the old imperial city, and Osaka, a center of business and commerce. Townsmen were commoners (tradesman, artisans, and merchants) with no political power or social status, which afforded real advantages. Being ignored and marginalized in a class-ridden scheme left them free to pursue wealth, consumerism, and pleasure. Since the country was at peace after unification, thousands of samurai had no active military duties. Still armed with the long and short sword, their military training became ritualistic over time. More than 200 daimyo were kept busy pleasing the shogun and competing with one another for status in Edo, where they built mansions as sumptuous as their incomes (measured in bushels of rice) would support.

In principle, samurai and daimyo were supposed to scorn comfort, money, and plea-

sure. Their traditional values were frugality, discipline, and hardship patiently suffered. Instead of a life filled with color and delicious sensations, they were expected to be content with sobriety and self-denial. The emergence of town life and its culture of the floating world changed all of that. Samurai were irresistably attracted to forbidden pleasures and indulgences that flourished in cities and towns. The rice stipends they received to support them and their families proved inadequate for all the things and services they wanted, and this had unforseen economic consequences.

A money economy developed in the hands of merchants and tradesmen, who insisted on payment in cash rather than rice. Eventually, merchants came to control the rice market, fixed prices, and reduced many unsuspecting samurai to indebtedness. The situation became so bad that a few hard-pressed individuals abandoned samurai status and moved to towns in search of work and careers in the floating world. Others borrowed heavily to pay gambling debts and fees to glamorous courtesans in pleasure districts like Yoshiwara in Tokyo and Shimabara in Kyoto. Samurai love affairs with forbidden women, which juxtaposed obligation (on) and duty (giri) with feeling (ninjo), sometimes offered no exit but double suicide (shinju), a popular theme in floating world literature and drama, backed up by numerous real life occurrences.

Confucianism had become the state doctrine. The emphasis in social and family relations was on obedience, filial piety, and detachment from unseemly emotion. Husbands were not to show open affection for their wives, who in turn were to manage home and children quietly and otherwise stay out of sight. In the ukiyo stories the Confucianists come off as stuffed shirts and moralizing pedants. In the same breath, however, men were encouraged to let off steam in pleasure quarters licensed by the government, providing they did not become attached to pleasure women and "accomplished persons" known as geisha.

The same dilemmas faced sons and daughters of merchant families. There was no polite society in which men and women from different social levels mixed freely. Marriage was regulated by the family patriarch, and home life remained strict, especially for women. Men from all walks of life were able to seek release and relaxation in theaters, teahouses, restaurants, and brothels, but only if they did so with discretion and protected the family name. As a result, human nature and desire being what they are, tensions between duty and feeling inevitably demoralized adventurous young men, and occasionally women, who dared to stray from the rules governing society.

An urban society dominated by courtesans, actors, merchants, tradesman, and straying samurai offered an array of characters and colorful images to be captured by talented artists. A culture of materialism, money-making, gaiety, and sensuality was recorded by writers like Saikaku and illustrated by painters and block-print illustrators. The writers focused on sexually wayward men and women, the follies and pretenses of townsmen, Buddhist priests, and samurai, and the swiftness with which disaster could overtake success. The chief visual medium was the block print, first in black and white, then in polychrome color, which lent itself to mass production and distribution at low cost. The affordable print became an ingenious, vivid record of the floating world's denizens and their shifting fortunes. Thousands of prints were sold and pinned on walls, collected in books, and even used to decorate pillars and posts. Although the artist usually got the credit, four kinds of talent were needed to make a successful print: the artist, the woodcarver, the printer, and the publisher.

on other hardwoods

The first three were apprenticed, in their teens, to a master. For a carver, the apprenticeship might last ten years. The artist drew a design on strong paper with brush and ink. The carver pasted the drawing on a block of wild cherry and carved away portions around the ink lines, leaving a "key block." After 1743, prints from the key block went back to the artist, who made notes indicating color. Blocks other than the key block were used for a print with multiple colors. The key block was printed first, then the color blocks. The job of the printer was to see that image and colors registered properly, which meant attention to the dampness of the paper, the right amount of color on a block, and the best degree of pressure used to rub the paper with a bamboo-sheathed circular pad (the baren) to register the image underneath. (fig. 26.29). The publisher would then market and sell prints pulled from the blocks. Throughout the creation of a marketable print, collaboration was key.

Fig. 26.29 Stages in the preparation of a block print.

Drawing by Vincent DiMattio.

This adroit mixture of art, technology, and business recorded vividly the urban floating world of actors, courtesans, townsmen, pleasure quarters, theaters, teahouses, and beauty spots frequented by amorous couples and pleasure seekers. Contrasts with the aristocratic "dual way" of daimyo and samurai could not have been greater. From their lofty perch in the social system—with its culture of Noh drama, tea ceremony, and Chinese style painting—popular art of the townsmen was held in contempt, which explains in part why so many block prints found their way to Europe and America in the nineteenth century. Moreover, urban popular art was not shared by the peasant majority, who labored without hope of participation in sophisticated urban pleasures.

Favorite subjects of block print illustrators, whose work went by the name ukiyo-e (floating world pictures), included the colorful world of Kabuki theater with its violent action, fabulous costumes, all-male performances, and melodramatic plots; actors of the moment who might be glorified or satirized; and beautiful, well dressed, sought-after courtesans in their pleasure quarters (figs. 26.30, 26.31).

Fig. 26.30 Toshusai Sharaku (active 1794–1795), *The Actor Tanimura Torazo*, Polychrome Woodblock Print, 1794.

Fig. 26.31 *Three Known Beauties*, ukiyo-e by Utamaro.

In these block prints some characteristics of Japanese drawing stand out that mirror received wisdom about sources of visual beauty. The Kabuki scene resorts to Western style perspective, but on the whole this technique is avoided, and space is indicated by overlapping forms in two dimensions on a single plane. The expressions of actors are exaggerated, which suited conventions of their profession, but normally faces are depicted without expression, which was considered a proper and expected control of emotion. In Japanese drawings there are no shadows, which were considered unessential because unreal. Faces are drawn halfway between full-face and profile to show all the features. There is no fussiness about bodily proportions. In all of this the block print artist accepts the limitations of his medium and his skill to produce accessible, visually charming effects. These popular illustrations were not considered art by Japanese painters; nor did illustrators seem to think of them as serious creations.[66] With some exceptions, they were produced self-consciously for the moment, for profit and

reputation. Illustrators and writers collaborated effectively because their human subject matter was the same.

But the block print had other possibilities beyond human comedy. The block-print tradition produced two artists capable of rendering landscapes in that medium with aesthetic qualities comparable to ink painting. So we end by juxtaposing views of nature from three sources—traditional ink and court painting along with two masters of the block-print landscape, Hiroshige and Hokusai.

For centuries, landscape had been the province of painters using brush and ink. The most reknowned figure was the fifteenth century master Sesshu Toyo, whose ink paintings— scrolls, album leaves, and screens—set the highest standard of achievement for unadorned landscape (fig. 26.32). Influenced by Chinese ideas of visual fitness—movement of the brush and spirit of the object—and Zen Buddhism, Sesshu's treatment of rocks in black ink was especially admired. The irregularity of design and the prominence of space in *Winter Landscape* adhere to enduring principles of Japanese aesthetics. The shoguns patronized several schools of painters to decorate their palaces and castles (fig. 26.33). An example on a minor scale is Korin's *Willows,* a sumptuous work of colors over gold leaf appealing to men of wealth and power, a marked contrast to the austerity of Sesshu's landscape, although Korin's work also has movement and spirit amidst the visual luxury.

Two block print artists, Hiroshige and Hokusai, were also painters, but they preferred prints to explore nature. Among all the print artists, who usually depicted people and urban scemes, they were the finest exponents of landscape. Both men exemplify basic preferences of Japanese art, reflect the Shinto reverence for nature and its creatures, and convey the spirit of landscape done with ink on paper or silk as images of the mind. The two prints below were produced about the same time,

Hiroshige's *53 Stages of the Tokaido* (the Pacific shore route from Kyoto to Edo) is a remarkable series of landscapes that retains all the traditional Japanese passion for na-

Fig. 26.32 Sesshu Toyo (1430–1506), *Winter Landscape,* ink on paper.

Fig. 26.33 Ogato Korin, *Willows,* colors over gold, paper mounted on silk, folds indicating it was an incense wrapper early eighteenth century.

Tokyo National Museum.

MOA Museum of Art, Atami, Shizuoka, Japan.

ture and its changing elements. One of them, *Clear Winter Morning in Kameyama,* shows a group of people, their hats visible at the bottom of the wind-blown pines, trudging upward to Kameyama Castle, a military fortification that also accommodated travelers (fig. 26.34). The season is winter, although Hiroshige was there in summer, so the scene covered with snow is an image from his mind. Lying beyond the steep slope are other mountains and the glow of morning in an expanse of space. He conveys the bite of natural elements and fading distance with humans aptly subordinated as well as any Chinese album leaf or even a segment of hand scroll (cf. figs. 18.43 and 18.44). Hiroshige's vision transcends any notion of mere "illustration."

Fig. 26.34 Utagawa Hiroshige, *53 Stations of the Tokaido: Clear Winter Morning in Kameyama,* Polychrome Wood Block Print, 1833–1834.

The same can be said about Hokusai's scene of two figures crossing a suspension bridge, from his "famous bridges" series (fig. 26.35). Although the men are in the foreground, they are dwarfed by the rocky landscape, and their vulnerability is emphasized by the precariousness of the bridge, which seems uncrossable. Below them, the valley drops away invis-

Fig. 26.35 Katsushika Hokusai, *Famous Bridges of Various Provinces: The Suspension Bridge Between the Provinces of Hida and Etchu,* Polychrome Wood Block Print, 1834–1835.

ibly, and a huge peak lifts up on the right. In the distance, a vast peak rises above the clouds, and flocks of birds carry the eye off into remote space. This work is even more an image of the mind than Hiroshige's because Hokusai was never there to see the bridge and its setting.

Notes

1. Hajime Nakamura, *Ways of Thinking of Eastern Peoples: India, China, Japan, Tibet*, edited by Philip Wiener (Honolulu: East-West Center Press, 1964), 347–348.

2. Quoted in Daisetz T. Suzuki, *Zen and Japanese Culture* (London: Routledge and Kegan Paul, 1959), 72.

3. Nakamura, *Ways of Thinking of Eastern Peoples*, 409.

4. Ibid., 575 ff.

5. Donald Keene (ed. and comp.), *Anthology of Japanese Literature: From the Earliest Era to the Mid-Nineteenth Century* (New York: Grove Press, 1995), 94.

6. Her literary devices of anticipation and build up, effective repetition of settings, situations, and relationships, and masterful, evocative use of imagery are discussed and illustrated in Ivan Morris, *The World of the Shining Prince: Court Life in Ancient Japan* (Baltimore, MD: Penguin, 1964), 277–281.

7. Shikibu Murasaki, *The Tale of Genji*, trans. Edward G. Seidensticker (New York: Alfred A. Knopf, 1981), 437..

8. Ibid., 41.

9. Ibid., 675.

10. Ibid., 810, 813.

11. Morris, *World of the Shining Prince*, 208n.

12. Quotations are from Ivan Morris's translation of *The Pillow Book of Sei Shonagon* (New York: Columbia University Press, 1992), sections 14, 42, 45, 123, 125, 128, 165, 172, 185.

13. Translated by Kenneth Rexroth, in Keene, *Anthology of Japanese Literature*, 193, 195, 196.

14. Quotations from Keene, *Anthology of Japanese Literature*, 197–212.

15. Miyamoto Musashi, *The Book of Five Rings*, trans. William Scott Wilson (Tokyo: Kodansha International, 2002), 47.

16. Ibid.

17. Ibid., 97–98.

18. Ibid., 135.

19. Ibid., 145.

20. As Suzuki explains: "When things are performed in a state of 'no-mind' (*mushin*) or 'no-thought' (*munin*), which means an absence of all modes of self- or ego-consciousness, the actor is perfectly free from inhibitions and feel nothing thwarting his line of behavior." Suzuki, *Zen and Japanese Culture*, 147.

21. Matsuo Basho, *The Narrow Road to the Deep North and Other Travel Sketches*, trans. Nobuyuki Yuasa (New York: Penguin, 1966), 28.

22. There are detailed maps in *Narrow Road to the Deep North*, 145–147.

23. In Harold G. Henderson (trans. and commentary), *An Introduction to Haiku: An Anthology of Poems and Poets from Bashō to Shiki* (New York: Doubleday Anchor, 1958), 30. Here is an alternative translation by Keene: "Stricken on a journey, / My dreams go wandering round / Withered fields" in Donald Keene, *World Within Walls: Japanese Literature of the Pre-Modern Era, 1600–1867* (New York: Hold, Rinehart and Winston, 1976), 119. Keene warns that nothing is so hard to translate as a *haiku*.

24. Henderson, *Haiku*, 20. The Japanese is: "Furuke ya / kawazu tobikomu / mizu no oto," seventeen syllables in three sections, or in literal translation: "Old pond / frog/ jump-in / water sound." Keene translates the haiku as follows: "The ancient pond— / A frog jumps in. / The sound of water." *World Within Walls*, 88.

25. Suzuki argues that Bashō is conveying his own satori (enlightenment) thorough the haiku and not just an imitation of it. *Zen and Japanese Culture*, 240–244. I disagree. Once satori is achieved there is presumably nothing to be said about it, but Suzuki is right to point out that a haiku expresses an intuition and not abstractions or arguments.

26. Henderson, *Haiku*, 18.

27. The other three were Buraku (puppet theater), Kyogan ("wild words"), comic interludes between Noh plays, and Kabuki, melodramatic or action-filled tales with colorful male actors in elaborate costumes and makeup. Bunraku and Kabuki were popular in the urban "floating world" culture of the Tokugawa era.

28. For detailed commentary on Noh and its tradition, see the introduction to Arthur Waley, *The NO Plays of Japan* (New York: Grove, n.d.).

29. Quoted in Wm. Theodore de Bary, et al. (compilers), *Sources of Japanese Tradition* (New York: Columbia University Press, 1958), 285.

30. Ibid., 292–295.

31. Keene, *World Within Walls*, 200.

32. Howard Hibbett (trans.), *The Floating World in Japanese Fiction* (London: Oxford University Press, 1959), 179.

33. Ibid., 159.

34. Ibid., 205.

35. Keene, *World Within Walls*, 217.

36. Hibbett, *Floating World*, 114 ff.

37. Quoted in Nakamura, *Ways of Thinking of Eastern Peoples*, 435.

38. Quoted in de Bary et al., *Sources of Japanese Tradition*, 141–142.

39. Ibid., 243.

40. Quoted in Daisetz T. Suzuki, *Manual of Zen Buddhism* (London: Rider, 1950), 106–107.

41. On the *koan,* see Philip Kapleau (ed.), *The Three Pillars of Zen: Teaching, Practice, Enlightenment* (Boston: Beacon, 1965), 64–65, 186.

42. Quoted in de Bary et al., *Sources of Japanese Tradition*, 253.

43. Ibid., 255.

44. Ibid., 349.

45. Ibid.

46. Ibid., 357.

47. Ibid., 355.

48. *The Manyoshu: One Thousand Poems* (New York: Columbia University Press, 1965), 215.

49. Joseph Campbell provides a sympathetic account of what Shinto is about in *The Masks of God*, volume 2: *Oriental Mythology* (New York: Viking, 1962), 474–479, from which my account has profited.

50. Quoted in de Bary et al., *Sources of Japanese Tradition*, 272.

51. Ibid., 268.

52. An accessible summary of Japan's mythical origins can be found in George B. Sansom, *Japan: A Short Cultural History*, rev. ed. (London: Cresset, 1946), chapter II.

53. Quoted in de Bary et al., *Sources of Japanese Tradition*, 274, 279.

54. Quoted in Nakamura, *Ways of Thinking of Eastern Peoples*, 393.

55. Ibid., 352.

56. *Manyoshu* (various trans.), 19, 44–45.

57. Quoted in Nakamura, *Ways of Thinking of Eastern Peoples*, 356.

58. These overarching characteristics, or preferences, are the framework for Stephen Addis, with Audrey Yoshiki Seo, *How to Look at Japanese Art* (New York: Harry N. Abrams, 1996).

59. Henderson, *Haiku*, 51.

60. My recommended account of Japanese painting—its materials, aesthetics, and schools—is an older work by Henry P. Bowie, *On the Laws of Japanese Painting: An Introduction to the Study of the Art of Japan* (New York: Dover, n.d.).

61. Quoted in Addis and Seo, *How to Look at Japanese Painting*, 80.

62. Quoted in Suzuki, *Zen and Japanese Culture*, 285.

63. de Bary et al., *Sources of Japanese Tradition*, 287.

64. A couple of flowers chosen for modest, temporary display in a tokonoma is the art of chabana, which is distinguished from ikebana, or flower arranging, an art involving more complicated manipulation of blossoms in greater numbers and variety.

65. Kakuzo Okakura, *The Book of Tea,* edited by Everett F. Bleiler (New York: Dover, 1964), 63–65.

66. Bowie, *On the Laws of Japanese Painting*, 24–27. In modern times, Japanese attitudes toward prints have become more favorable.

PART V
A SUMMING UP

What can be learned from the traditional ways of India, China, and Japan? Perhaps most conspicuous is their shared longevity, although there are differences. Of the three, China had the longest run as a centralized empire, and except for several centuries of disunity, governed consistently by the same ideas and social institutions. Japan also had a long run as a traditional civilization from the sixth to the nineteenth centuries, with a similar pattern of social and political stability. India, although without enduring empires or centralized regimes before Mughal times (except perhaps those of the Mauryas and Guptas), is notable for the long reign of Hinduism as a way of life, even into modern times. In all three, parallel common threads ran through the centuries. Meaning and purpose were shaped by hierarchy, a carefully articulated vertical distribution of power and status. Tradition was revered for what had been done and said in the past. Harmony was a high ideal to be achieved by respecting hierarchy and accepting human subordination to nature. A notable shared outlook was toleration. In all three civilizations it was possible to embrace multiple points of view with respect to meaning and purpose without persecution. The one conspicuous element of cross-fertilization that bound the three civilizations together was Buddhism.

27

India

Before the Muslim invasion and conquest of north India in the ninth and tenth centuries C.E., components of civilization emerged over a long and obscure timeline from about 1500 B.C.E. to 1200 C.E. Conspicuous markers are: (1) Sanskrit-speaking Aryan invaders

who destroyed the Indus River civilization and brought with them the Vedas, a pantheon of gods whose names and functions survived in later mythology, and practices of worship that became part of Hinduism in later times; (2) the emergence of priestly Brahmanism focused on ritual and with a monopoly on the sacred Vedas; (3) resistance to Brahman priests by forest mystics claiming direct access to ultimate reality, recorded in the Upanishads, and by Buddhism and Jainism, major religious movements that rejected Vedic authority altogether; (4) the emergence of a four-class system, supplemented over time by a multitude of castes, all defined by the kind of work people did as determined by dharma, karma, and reincarnation.

Jainism rejected Vedic authority and developed doctrine and a way of life stressing reverence for life (ahimsa). For a Jain the world is full of souls (jiva) whose injury causes an inflow of karmic matter that encrusts the human soul and holds it down. The goal of life is to prevent further inflows of karmic matter and free the soul from karmic dross already accumulated. This can be done only by not harming other souls, a necessary consequence of existence, which requires breathing, eating, drinking, and movement. Consequently, the highest ideal for Jains is starvation and immobility, which explains why the movement had relatively few adherents. Once free of karma, the soul rises to the summit of the universe for an eternity of tranquil bliss. Jain cosmology, with its endless cycles of creation and destruction, was adopted by Buddhism and Hinduism. This conception of cyclical change as the framework for unceasing reincarnation encouraged detachment from the constraints of material existence.

Buddhism emerged about the same time as another unorthodox sect that repudiated the Vedas. The original message of Buddha is the universal condition of suffering (old age, sickness, and death), an unavoidable consequence of impermanent existence that entails karma and reincarnation through unending cycles of time. Release from this trap of impermanence and suffering is to stop clinging to existence. The mechanism of release is an eight-fold path of understanding, intention, three stages of moral discipline, and three stages of meditation, the culmination of which is the detachment from clinging called Nirvana.

This Doctrine of the Elders proved too rigorous except for men and women (Buddhism was gender neutral) inclined to membership in the Buddhist order and a life of monastic isolation. In response there emerged a salvationist form of Buddhism, Mahayana (the big raft that carries all to "salvation"), which emphasized reliance on the merit and inspiration of a Bodhisattva (enlightened being) who postponed Nirvana to assist all sentient beings trapped in the web of impermanence. In Mahayana doctrine a multitude of Bodhisattvas inhabit the universe, a number of whom preside over paradises awaiting true believers. Unlike early Buddhism, Mahayana philosophers indulged themselves in elaborate speculations about being and non-being, which the Buddha warned are no help on the path to Nirvana.

Hinduism resulted from a series of compromises with religious sects that opposed early Brahmanism. The outcome was a scheme of four ends of life and four stages of life which made room for withdrawal from the world and transcendental experience, while also preserving family and civic life and the authority of Brahmans, who were foremost within the class system. Hinduism absorbed the monastic ideal of Buddhism; the cosmology and major principles of Jainism, especially the idea of endless cycles of creation and destruction and reverence for life; and the mysticism of the Upanishads.

The compromises of Hinduism reached a maximum number of people by approving many roads to salvation and enlightenment. The most common road was worship of particular gods and goddesses—Shiva, Vishnu, Deva, the Mother Goddess, Krishna—an incarnation of Vishnu—and so on. Numerous objects of worship appealed to every kind of temperament and level of intellect. The most radical path was complete withdrawal from human society and its obligations to seek oneness with Brahman, the final reality beyond all distinctions and rebirths. Proof that compromise succeeded is that Buddhism and Jainism lost adherents and went into decline.

By the sixth century C.E. core works of Indian literature were in place, divided by Hindus into four groups, depending on source and status—revelation (e.g., Vedas), human tradition (e.g., *The Law of Manu*), the orthodox (sacred Hindu texts), and the unorthodox (Buddhist and Jain texts). In Hinduism, philosophy was confined to a half-dozen systems that acknowledged authority of the Vedas while speculating freely about nature and man. The most influential of the systems was Vedanta, which emphasized the ultimate oneness of existence in Brahman. In the whole body of literature, whether Hindu, Buddhist, or Jain, is found all the major ideas that govern the life and thought of traditional India.

Two big ideas are karma and reincarnation, the belief that behavior and commitments in this life determine status and consciousness in the next life. Reincarnations go on indefinitely, bound to eternal cycles of creation and destruction, until an individual achieves release from the wheel of rebirth by severing worldly attachments.

Dharma is a third idea, the network of duties and obligations that bind an individual to class, caste, community, and family. Dharma varies depending on a person's gender and status in the class-caste system. The core teaching is that living faithfully by the rules and expectations of dharma, spelled out in authoritative texts and tradition, will assure collectively a harmonious human world in tune with the gods and nature, and favorable reincarnation for the individual.

Traditional India had secular elements, but on balance the civilization was dominated by religion and enveloped by a complex mythology. The gods were organized on a principle of assimilation. A number of minor deities were identified as incarnations of a major god or goddess. Most literature had a direct or indirect religious purpose and usually featured divine beings. Numerous gods and goddesses with their different attributes and powers allowed a range of choices to individuals who chose the path of worship over the paths of knowledge and action mentioned in the *Bhagavad-Gita*, and most Hindus were, and are, devoted to Shiva or Vishnu. All Hindu imagery is based on the principle of darshana, which means seeing the divine in an image while being seen by the god or goddess who takes up "residence" in it. Hindu sculpture, painting, and architecture required adherence to rules of proportion and ornamentation that would persuade divinities to be present.

Proper worship and acknowledgment of the gods required temples, shrines, and images. Art was the handmaiden of religion, but its creators were not "artists" in the modern sense—acting as individuals motivated by aesthetic and commercial purposes. Sculpture, painting, and architecture honored the gods and provided vehicles for their spiritual presence. Craftsmen produced it according to rules, standards, and methods supplied by tradition. For Hindus, a sculptural image or temple required heavy ornamentation before a god would take up residence. Blank surfaces were incomplete and therefore unsuitable for divinity.

Architectural forms consisted of stupas for relics of the Buddha, cave temples excavated from solid rock for Buddhist worship, which were also used by Hindus, at least one great temple carved from a cliff to simulate a freestanding structure, and two major styles—northern and southern—of freestanding temples. Temple architecture was at its best between the seventh and the twelfth centuries. Hindu temples are still in heavy use.

Apart from the power and beauty of Indian literature, art, and architecture, once the symbolism and religious background are understood, enduring contributions of Indian civilization are techniques to discipline the mind and achieve detachment from the vagaries of nature and life. Buddhist and Hindu meditation are powerful instruments for controlling and redirecting impulses of mind and body. In the realm of mind culture, myths are put aside, along with attachments to self and personality.

Contrasts with the West could not be more striking. In contemporary America there is an ongoing preoccupation with personal and group identity that finds its way into books, art, university courses, and social movements. The advanced stages of Buddhist meditation are designed to blunt and finally eliminate personal and group identity, even to the extent of not using the first-person pronoun "I" to describe what may be going on with mind, body, others, or the world. Instead of saying "I have an itch," one says, "There is an itch." Instead of "I know you," one says, "That object is known." The secular idea that the individual is the basic unit of society has its theological counterpart in the Christian idea of "soul" and personality surviving through eternity. From the Buddhist and Hindu perspective, such an approach to meaning and purpose is an illusion to be overcome by detachment from the everyday, empirical self.

For dilemmas of the modern world and its high-energy societies, driven by ideals of production and consumption, beset by pervasive environmental disruption and exploitation of energy resources, and, in the West, by solipsistic individualism, Buddhist and Hindu ideas about self-discipline and control of desire invite a thoughtful hearing. Finding a middle ground between the radical detachment of the Hindu holy man and the compulsive attachments of worldly consumers might be a regimen for people wanting more control over their inner lives despite lack of control over external events.

28

China

Like India, Chinese civilization has a long history of some 3,500 years. Unlike India, a foundation for political and cultural unity emerged fairly early and endured, with a break of some 300 years, until modern times. For centuries China had all the material advantages needed to support a large population in a vast land. A great historical question is how such unity and longevity were achieved and sustained. A rough answer lies in China's cultural dominance in East Asia, material self-sufficiency, an intensive agricultural system, an

ideographic written language, and a dynastic system of succeeding regimes that looked to the past. An explanation in the realm of ideas is the dominance of men with shared views on man, nature, and society, and the impact of Confucianism on virtually every aspect of government, society, and thought.

The fragmented 800-year Chou era produced most of the ideas by which traditional China was guided until modern times. The most important bodies of thought were complementary opposites—Confucianism and Taoism. The message of Confucius was one of moral self-cultivation and service to rulers on behalf of the people. The message of Lao-tzu and Chuang-tzu was identification with the spontaneous forces of nature and withdrawal from entangling social commitments. Other ideas articulated were the Mandate of Heaven—the rationale for later dynastic change—and the cosmological principles of yin and yang and the Five Elements, both of which affected art and architecture as well as philosophy. The Five Classics and Four Books associated with Confucius, which were the substance of the imperial examination system, also made their appearance. The most impressive art form to survive was the ritual bronzes of the Shang period that later became secularized. After the Sung dynasty, connoisseurship in bronzes was a passion of Confucian gentleman, inspired by reverence for the achievements of the past and the association of bronzes with ancestor worship.

After many years of warfare between separate feudal states during the extended Chou period, the aggressive border state of Ch'in, organized under the realist philosophy of Legalism for war and conquest, defeated its rivals and unified the country in 221 B.C.E., an event that marked the beginning of imperial China. During the next 2,000 years the dynastic system rolled on almost unbroken. Between the Han and Sui dynasties Buddhism successfully established itself against heavy odds. Thereafter Chinese might be, and usually were, Confucians, Taoists, and Buddhists without discomfort. Meanwhile, ancestor worship was the prevalent form of diffused religion in the absence of a "church" dominated by a centralized clergy.

A hierarchical class system emerged and sustained itself with no changes—the emperor and his family, scholar-officials, peasants, artisans, and merchants. Conspicuously missing from the ladder of status were religious and military figures. The ruling class rested its case on knowing right from wrong, which was not the function or destiny of other groups in the class system. Class structure reflected the triumph of Confucianism as the state ideology, which stressed social harmony based on status and respect for tradition. The distinction was between those who work with their brains and know what is right, the Confucian scholar-gentry, and those who work with their hands to do specialized work, essentially everyone else. Scholar-officials were near the top because they passed through at least the first stage of the imperial examinations, the chief avenue to status and worldly success.

Their cultural task was to provide moral example and benevolent service by advising the emperor and attending to the welfare of everyone else. The mature Confucian view of the state was that the emperor ruled, with the advice and assistance of his virtuous bureaucracy, as the harmonizer of Heaven, Man, and Earth. The political and social ideal was harmony, which meant everyone knowing and keeping a preassigned place. The Confucian view of man and the world was cement that held traditional China together.

The role of an ideographic written language in Confucian success cannot be underestimated. Calligraphy became an essential skill for the scholar-gentry and in due time

was elevated to a fine art that became the centerpiece of Chinese art for centuries. A key to achievement in the examinations and calligraphy was extended to landscape painting. Many scholar-gentry turned to landscape painting as an outlet for aesthetic, quasi-philosophical, and personal expression, relying on materials and skills of calligraphy, and established a tradition that flourished for 900 years. Landscape painting was influenced by Taoism, the spontaneous spirit acting without acting, Buddhism, with its notion of voidness, and Confucianism, respecting tradition as a repository of greatness. All other "arts" such as jade, lacquer, sculpture, ceramics, and architecture were the work of people considered specialists, not artists. Nevertheless, these "lesser arts" were vehicles of symbolism and ideas about nature. Landscape painting and its Confucian influences helped consolidate the identity of the scholar-gentry as a ruling class.

The gap between Confucius and his later followers is considerable. Mencius was aggressive in criticizing rulers and advanced the idea of man's natural goodness. Hsun-tzu took the Legalist tack that man is naturally evil, which excluded him from the later Confucian canon, but embraced the idea of cultivation to achieve virtue. His skepticism and criticism of traditional practices like divination and ideas like the Mandate of Heaven were not well-received. Confucianism underwent two great overhauls in the Han and Sung dynasties, to an extent that would have puzzled Confucius.

In the Han period, Tung Chung-shu took the moral ideas and linked them to yin-yang and one classical book, the *Spring and Autumn Annals*, in an elaborate system that justified the Chinese monarchy and set forth a means of predicting the future through the reading of portents and anomalies (shooting stars, earth tremors, and so on). The collapse of the Han included his philosophical system, a version of Confucianism rejected because it did not save the dynasty.

The second great synthesis, Neo-Confucianism, emerged after Buddhism had become an intimate part of the culture. Buddhist ideas directly or indirectly influenced the ideas and language of Confucianism from the thirteenth century to the end of the dynastic system. The Sung dynasty thinker Chu Hsi argued that everything in the world has a nature, called li, that emanates from a Great Ultimate, an undifferentiated source of reality (the Buddhist influence), and that Confucian virtues define the nature of man. His version of Neo-Confucianism was a successful, enduring vindication of imperial authority and the role of the scholar-gentry in sustaining it. The greatest achievement of these ideas, however, was to consolidate the idea that men with "evaluating minds" who distinguish right from wrong are the finest flowers of civilization.

Tradition and symbolism were dramatically expressed in architecture. Although the designers and builders had inferior artisan status, they created imposing ensembles like the Forbidden City and the Temple of Heaven in Peking. Chinese architecture brings together a cluster of ideas about nature (yin and yang, the Five Elements, Taoism, Confucianism) orchestrated by techniques of feng shui (wind and water) to harmonize conspicuously visible human works with forces and principles governing relations of Heaven, Man, and Earth.

Traditional Chinese civilization is gone, and much of what remains is under siege in modern China. Patriarchy and hierarchy are much out of fashion in the West, but it is clear that such arrangements in China provided legitimate authority, group solidarity, and a ritual sense of order that sustained a long, creative history. While social ideals

strengthened the family at the expense of the individual, constraints were no worse than those found almost everywhere on the planet until recent times, with perhaps qualified exceptions in ancient Crete, classical Greece, and imperial Rome. In the modern Western world, it can and has been argued that unfettered individualism has exacted a high price from community solidarity and sustainable relations with nature.

As global human population continues to double every few decades and the number of older people multiplies, the traditional Chinese way of order, harmony, mutual respect, and care for parents might seem attractive to industrialized societies. There is evidence that modern China, in an environmentally disastrous rush to become a great power, and facing the unprecedented challenge of managing a population of 1.6 billion projected for 2130, has begun to rediscover Lao-tzu and Confucius after rejecting both under Mao Tse-tung (Mao Zedong).

Chinese intimacy with nature and a traditional regard for plants and animals as sources of beauty, inspiration, and symbolism rather than exploitation and profit was inspired in large part by an economic system based on agriculture that brought most Chinese close to land, forests, and waters. In the modern world, industrialization, urbanization, and technology have alienated millions from nature, including the Chinese. It is now possible to live something like a "virtual" life with cell phones, television, movies, and computers, with little or no connection with the natural world. Even the change of seasons can be evaded in artificial environments. This anti-ecological way of life is spreading with technology and industry. Air-conditioned skyscrapers now spring up in desert environments like Dubai as well as on the fringes of rain forests. New cities are springing up throughout China and devouring the countryside.

Contemporary materialism and its instruments are on a roll and already producing self-inflicted wounds—climate change, pollution of scarce water supplies, deforestation, desertification, depletion of fisheries, contamination of the air people breath, destruction of entire species of plants and animals, and so on. China's traditional idea that nature is an organism in which all parts interact for mutual benefits is remarkably in tune with the findings of modern biology. It is not possible to establish a new cultural framework in an industrial context with ideas like yin and yang and the Five Elements, but a shared belief in nature as a unity, and in humanity as a benign part of it, is an insight of old China awaiting persuasive revival. Chinese landscape painting and a traditional architectural ideal in tune with land, water, and sky are salutary reminders of how an idea of harmony based on relational thinking had a centuries-long run. Possibly it will again.

29

Japan

In all of human history no people absorbed the elements of civilization more swiftly, receptively, and creatively than the Japanese. Prior to the sixth century C.E., Japan was an interesting Neolithic society without writing, sophisticated ideas, or advanced forms

of architecture and art (the monumental "keyhole" tombs in the Yamato heartland are not architecture). The dominant religion was Shinto, a form of nature worship focused on ritual and purification rather than ideas. By the seventh and eighth centuries, through the agency of Buddhism and the pervasive influence of China, great temples and palaces were being built, a centralized monarchy and bureaucracy were formed, books of poetry and history were produced, exquisite sculpture was fashioned, and ideas about nature and government on Chinese models flourished.

The role of Buddhism in this transformation was fundamental. Temples built by the thousands served not only scholarship and religion but supported many social needs like schools and orphanages. Most of the important sects that would enrich thought and influence art for centuries were already established. Buddhists became advisors to emperors. The Buddha was invoked to justify and strengthen the centralization of state power. The shops of artisans were humming and turned out innumerable images of Buddhas and Bodhisattvas. In the early stages of this cultural deluge from China, forms and ideas were copied slavishly. By the ninth century the Japanese began to find a distinctive voice and adapted the new trappings of civilization to their temperament, preferences, and traditions. A second intellectual gift from China was the ethical and political teachings of Confucianism, already nearly a thousand years old in China, which found a place in Prince Shotoku's historic Twelve-Article Constitution in the seventh century. Shinto yielded to the prestige of Buddhism by identifying with its gods and practices. Major Shinto shrines adopted Chinese architectural forms imported with Buddhism.

The first clear evidence of an emerging, distinctive culture after 200 years spent domesticating Buddhism and Confucianism was the refined, enclosed culture of the Heian period. Centered in Kyoto at the imperial court, an aristocracy of elegant men and women lived off estates in the countryside managed by others. Within the confines of court life and its elaborate protocols, status defined by kinship was a pervasive reality that absorbed energy and required personal watchfulness.

Life was intensely ceremonial, not just at court but also in relationships. Lovers were expected to write beautiful letters of solicitation, appreciation, and farewell, embellished with expensive, cunningly folded paper adorned with perfume and flowers. Much attention was given to dress in subtle colors on gorgeous fabrics. Literacy was high and included women, who pioneered vernacular Japanese in several literary forms while men continued to write in Chinese.

Buddhist ideas about impermanence were sublimated into the sentiment of mono no aware, which conveys a melancholy but not wholly unpleasing sense of passing and loss. That sentiment dominates a great work of literature, *The Tale of Genji*, by a brilliant court lady who put an aesthetic, positive sense of impermanence on the map of Japanese sensibility. Other common terms of aesthetic consciousness were miyabi, a sense of graceful, refined stylishness, and okashi, a smiling response to things that bring delight and pleasure.

The legacy of Heian culture was an enduring sensitivity to small things, an acute awareness of colors, smells, textures, and sounds, an affinity for moods in the world of nature conveyed by shifting moonlight, the calls of birds, the rustling of leaves, or water rippling and tumbling in rivers and streams. Movement toward art on a more intimate scale was reflected in architecture by the villa-monastery Byodo-in, with its fine image

of Amida Buddha. This delicate society of aesthetically preoccupied aristocrats became increasingly vulnerable as they lost control of the rural estates that supported them. A rising class of rude warriors on whom they depended for protection became their undoing as they seized control of the country.

A breakdown of centralized government and the emergence of feudal institutions in the twelfth century, dominated by samurai authority and ideals, went through three phases. At first samurai were loyal to one man who overthrew and succeeded to imperial rule, then to individual lords, the daimyo, during the long period of civil war, and finally to the Tokugawa clan when the country was unified. The military office of shogun paralleled the imperial seat in Kyoto, which was retained but kept at a distance and confined to ceremonial functions. While institutions and ideas changed, the past was seldom abandoned, a distinctive trait of Japanese civilization. In the first two stages of feudalism, the dominant influence on art and ideas was Zen Buddhism, which was imported from China in the thirteenth century.

Zen emphasis on aloofness from scriptures and doctrines, a master-disciple relationship as a temporary condition of enlightenment (satori), simplicity of life, the discipline of meditation, and closeness to nature as a valued manifestation of Buddhist reality appealed to the samurai on several levels and paralleled in some ways the warrior code of Bushido. Communion with nature was reinforced by traditional Shinto beliefs and practices. In time, Zen came to influence poetry, painting, gardens, architecture, and martial arts, especially swordsmanship and archery. Zen priests became influential advisors to daimyo and shoguns. The fullest expression of Zen philosophy in art was the idea of shibui, which implies sophisticated simplicity, understatement, suggestiveness, and responsiveness to things old and forlorn. The aesthetic of shibui found its most elegant realization in the tea ceremony (chanoyu), which reached maturity in the sixteenth century by coordinating a number of major and minor arts from architecture to ceramics.

With unification of the country under the Tokugawa Shoguns after 1600, Zen Buddhism receded in importance for the rulers, who preferred to cultivate Confucianism as a body of ideas best suited to managing a feudal kingdom at peace. Confucian ideals of study and self-cultivation were also useful for controlling and redirecting the warlike character of the samurai. While they continued to wear two swords as a mark of superior status, there were no more wars to fight. There arose the "dual way" of the warrior, who kept in practice with martial arts, and the man of peace, who cultivated scholarship and calligraphy. Thus Confucian scholars were more in evidence in the courts of daimyo and shoguns than Zen priests, although the tea ceremony remained a fixture among the ruling class, again showing the preference of Japanese temperament for preserving and reorienting the past rather than sweeping its familiar landmarks away.

More than 200 daimyo lords were kept harmless and under surveillance by a system of "attendance in turn" at the capital city of Edo (modern Tokyo). When a daimyo lord was not personally in attendance, family members were kept on hand to assure compliance by the great lords. This comprehensive hostage scheme obliged daimyo and their retainers to be in regular transit to and from Edo from the remotest corners of Japan. In Edo they needed suitable accommodations for a large retinue as well as the means to maintain mansions and castles in their domains. The result of these unending processions and periodic residence in Edo was rapid urbanization and the emergence of a money

economy dominated by townsmen, men and women with no political power or social status. Their role was to provide services, goods, and entertainment.

With no public responsibilities, and viewed with aloof disdain by their samurai masters, they were free to pursue money and pleasure in a continual whirl of worldliness. Extraordinary wealth was possible as townsmen developed a money economy and exploited hapless daimyo and samurai dependent on stipends of rice but wanting expensive gratifications afforded in the bustling cities. Occasionally material success was flaunted indiscreetly, and the punishment imposed by shogunal authority was ruthless confiscation of the offender's possessions.

By 1700 a new type of urban culture called ukiyo was flourishing. Ukiyo, the "floating world," included pleasure quarters and teahouses in the big cities, a new kind of visual art, mass-produced block prints, popular stories and novels about character and entanglements of men and women, and colorful forms of theater that produced celebrities. Common themes in art, literature, and theater were greed, love, conflicts of duty and feeling, and cautious contempt for the ruling samurai, who were drawn into perilous, costly adventures in pleasure despite warnings and prohibitions from the shogun.

This third aesthetic flowing from ukiyo presaged in some respects the secularization and modernization of Japan in the nineteenth century, especially the intense commercialization of urban life. The idea of a floating world, however, also retained the ancient Buddhist view that existence is a sea of impermanence in which lives and ambitions arise and vanish in what seems a moment. Buddhist sunyata (emptiness) was objectified and embraced in the whirling uncertainties of life among courtesans, actors, illustrators, merchants, moneylenders, hangers on, adventurers, charlatans, tradesmen, illicit lovers, and impoverished samurai defectors. This bygone culture of impermanence with its passions for money, consumption, entertainment, and pleasure has much in common with the ethos of contemporary industrial civilization, but without its disturbing impact on resources: pollution of air, water, and soils; decimation of life forms; and loss of intimate feeling for nature.

published in 2002 / resources are from first half of 20 and 2nd century / many from 1900s - 60s!

For Further Reading

The literature in English on traditional Indian, Chinese, and Japanese ideas and art is immense. In German and French it is just as copious. This bibliography, organized by topic, contains works in English, or translations from other languages, that were used to write this book. Most of the sources are accessible to a curious non-expert wanting to pursue deeper study. The bibliographical items are annotated to give readers a better grasp of their contents.

IDEAS

India

Akira, Hirakawa. *A History of Indian Buddhism from Sakyamuni to Early Mahayana.* Honolulu: University of Hawaii Press, 1990. A scholar's approach to understanding Buddhism through historical exposition and analysis.

Anderson, Carol. *Pain and Ending: The Four Noble Truths in the Theravada Buddhist Canon.* Richmond, UK: Curzon Press, 1999. An intelligent account of early Buddhist teaching.

Conze, Edward. *Buddhist Thought in India: Three Phases of Buddhist Philosophy.* Ann Arbor: University of Michigan Press, 1967. Published originally by George Allen & Unwin in 1962, this volume is a detailed exposition from a critical perspective of Buddhist ideas in India. The authoritative 293 pages of text and detailed notes are scholarly to a fault.

Embree, Ainslie T. *Sources of Indian Tradition, vol. 1.* 2nd ed. New York: Columbia University Press, 1988. A compendium of major texts in translation by prominent scholars, supplemented by commentary from the editor.

Eck, Diana L. *Darśan: Seeing the Divine Image in India.* 3rd ed. New York: Columbia University Press, 1998. An informed discussion in ninety-two pages of Hindu worship as seeing the gods and being seen by them. There are notes, a short bibliography, a pronunciation guide, and a huge number of technical terms, but also a glossary.

Finegan, Jack. *The Archeology of World Religions: The Background of Primitivism, Zoroastrianism, Hinduism, and Jainism.* Princeton, NJ: Princeton University Press, 1952. A reliable, compact exposition of basic history, doctrines, and literature convenient for reference. The author refers in the text to eighty-seven black and white illustrations compiled in the back. The chapter on Hinduism, for example, is sixty pages.

Guenon, Rene. *Man and His Becoming According to the Vedanta.* Trans. Richard Nicholson. New York: The Noonday Press, 1958. This is a very difficult book, maybe more so than the *Vedanta Sutras* or Shankara's *Crest Jewel of Discrimination,* but it is a major interpretation of Vedanta that justifies some time and effort.

Nakamura, Hajime. *Ways of Thinking of Eastern Peoples: India, China, Japan, Tibet, Japan.* Revised English translation edited by Philip Wiener. Honolulu: East-West Center Press, 1964. Profound and informative.

Radhakrishnan, Sarvepalli. *Indian Philosophy.* 2 vols. New York: Macmillan, 1923. Exhaustive and not always easy to follow, but Radhakrishnan was a well-educated man who understood a lot of Western thought and could use it to clarify Indian ideas. He is definitely an advocate of Indian thought and wants to persuade Western scholars skeptical about whether Indian systems are truly "philosophy."

Radhakrishnan, Sarvepalli, and Charles A. Moore (eds.), *A Source Book in Indian Philosophy.* Princeton, NJ: Princeton University Press, 1957. The most convenient and extensive anthology of texts in translation with commentary.

Rahula, Walpola. *What the Buddha Taught.* New York: Grove Press, 1959. The best general introduction to Hinayana teaching and practice in eighty-nine pages. Rahula's approach is to stress Buddhism as a systematic form of "mind culture." There is a short bibliography and full glossary of technical terms.

Shankara. *Crest Jewel of Discriminaiton.* Translation and introduction by Swami Prabhavananda and Christopher Isherwood. Hollywood, CA: Vedanta Press, 1947. A readable translation that can be compared with the selection in Radhakrishnan and Moore's anthology.

Zimmer, Heinrich. *Myths and Symbols in Indian Art and Civilization.* Edited by Joseph Campbell. New York: Harper Torchbooks, 1962. First published in 1946. A 221-page distillation of Zimmer's two-volume work, *The Art of Indian Asia.* His discussion of symbolism is keyed to seventy black-and-white illustrations. This readily accessible volume is probably the best introduction to Indian art and iconography.

———. *Philosophies of India.* Edited by Joseph Campbell. Princeton, NJ: Princeton University Press, 1956. Perhaps the best book on Indian thought. Vastly informative and persuasive. The author takes his reader to the core of difficult ideas with excellent detail and a full explanation of Sanskrit terminology.

China

Bodde, Derk. *China's Cultural Tradition: What and Whither?* New York: Holt, Rinehart, and Winston, 1957. This brief, clear roundup of traditional Chinese ideas, institutions, and practices is by one of the great twentieth century Sinologists.

Chai, Ch'u, and Winberg Chai. *Confucianism.* Woodbury, NY: Barron's Educational Series, 1973. A clear, sensible, and helpful survey of Confucians and Confucianism, with

background, major figures, and doctrines, from the beginning to the modern age. The Confucian tradition is 2,500 years old. It is not at all easy to see the whole above the parts. This book makes a satisfactory attempt to do so without losing the details.

Chan, Wang-tsit (trans. and compiler). *A Source Book in Chinese Philosophy*. Princeton, NJ: Princeton University Press, 1963. A solid compilation, easy to follow, with helpful commentary on all the texts.

Chang, Carsun. *The Development of Neo-Confucian Thought*. New York: Bookman Associates, 1957. The opening chapter is an insightful comparison of Western and Chinese philosophy, and more specific comparisons are made in most succeeding chapters, which include, for example, Plato, Aristotle, Kant, Hegel, and Adam Smith.

Ch'en, Kenneth. *The Chinese Transformation of Buddhism*. Princeton, NJ: Princeton University Press, 1973. Helps to explain how Buddhism came to China.

de Bary, Wm. Theodore, and Irene Bloom (compilers). *Sources of Chinese Tradition from the Earliest Times to 1600*. Vol. 1. New York: Columbia University Press, 1999. An enormous range of Chinese literature filling 924 pages, but cumbersome to use. Translations are from various hands with commentary and notes.

de Bary, Wm. Theodore (ed.). *Self and Society in Ming Thought*. New York: Columbia University Press, 1970. A good place to become acquainted with the Confucian idealism of the Wang Yang-ming school.

de Bary, Wm. Theodore, and Irene Bloom (eds.), *Principle and Practicality: Essays in Neo-Confucianism and Practical Learning*. New York: Columbia University Press, 1979. Six of the nine essays in this volume deal with Neo-Confucianism in Tokugawa Japan.

Dumoulin, Heinrich. *Zen Buddhism: A History*. Vol. 1. *India and China*. New York: Macmillan, 1988. Useful for tracing and connecting major figures and schools of Zen.

Fung, Yu-lan. *A History of Chinese Philosophy*. Translated by Derk Bodde. 2 vols. Princeton, NJ: Princeton University Press, 1952–1953. There is nothing like it in circulation for Chinese thought; it includes numerous translated passages of original texts.

Gernet, Jacques. *Daily Life in China on the Eve of the Mongol Invasion, 1250–1276*. Trans. H.M. Wright. Stanford, CA: Stanford University Press, 1962. The original French publication date is 1959.

Graham, A.C. *Disputers of the Tao: Philosophical Argument in Ancient China*. La Salle, IL: Open Court, 1989. This 428-page book explores the full range of ancient Chinese thought through the Han Dynasty, with an emphasis on how disputes were carried out.

Graham, A.C. (trans.). *Poems of the Late T'ang*. Baltimore, MD: Penguin Books, 1965. One of the best collections of Chinese poetry, with an instructive introduction about problems of translation.

Henderson, John B. *The Development and Decline of Chinese Cosmology*. New York: Columbia University Press, 1984. The author is illuminating on Chinese correlative thinking, its origins, meanings, and vicissitudes.

Hsi, Chu, and Lü Tsu-Ch'ien (compilers). *Reflections on Things at Hand: The Neo-Confucian Anthology*. Translated with notes by Wing-Tsit Chan. New York: Columbia University Press, 1967. An anthology organized around the innovations of Neo-Confucian thought that entered the mainstream of Confucian doctrine through the writings of Chu Hsi, whose commentaries became mandatory for the imperial examinations.

Liu, James J.Y. *The Art of Chinese Poetry.* Chicago: University of Chicago Press, 1962. A full explanation of how the Chinese written language works in poetic diction and versification, the function of poetry, and what it meant in traditional Chinese culture.

Liu Wu-chi. *An Introduction to Chinese Literature.* Indiana, IN: Indiana University Press, 1966.

Munroe, Donald J. *The Concept of Man in Early China.* Stanford, CA: Stanford University Press, 1969. Major conceptions of human nature are explored in the crucial period for Chinese thought before political unification. See especially Part I, Section 5, "Some Chinese Concepts and Ways of Thinking and Feeling."

Newman, Richard. *About Chinese.* New York: Penguin Books, 1971. A short, lucid introduction to mysteries of the Chinese language.

Ronan, Colin A. *The Shorter Science and Civilization in China: An Abridgement of Joseph Needham's Original Text.* Cambridge, UK: Cambridge University Press, 1978. Original is more than 20 volumes, and Needham worked on the first 15 before his death. This abridgement consists of the first two volumes in the Needham series, which now runs to more than 20 volumes. While the main interest of this work lies in an attempt to explain why a science based on "laws of nature" did not develop in traditional China, much can be learned about Chinese ideas in general.

Shen, Zaihong. *Feng Shui.* New York: A Dorling Kindersley Book, 2001. A good introduction in 187 pages to principles and practices of feng shui; includes much discussion of yin-yang and five-elements thinking. The author practices feng shui and is both an architect and a cultural anthropologist. The book has a Chinese calendar, a section on animal signs, and a glossary.

Sirén, Osvald. *The Chinese on the Art of Painting: Translations and Comments.* New York: Schocken Books, 1963. From the Han to the Ch'ing dynasties, the writings of Chinese painters about their art and its technique, meaning, and purpose, with remarks by the author, modestly illustrated. Unfortunately there is no index, which makes the book hard to use.

Smith, Richard J. *China's Cultural Heritage: The Qing Dynasty, 1644–1912.* Boulder, CO: Westview Press, 1983. An expert survey of China's last dynasty. The chapters on language, symbolism, literature, thought, and art were useful for the present volume.

Spence, Jonathan. *The Death of Woman Wang.* New York: Viking Press, 1978. Confucian ideals and social reality in conflict in seventeenth-century China.

Watson, Burton. *Early Chinese Literature.* New York: Columbia University Press, 1962. An urbane, clear discussion of texts on rites, poetry, philosophy, and history through the Han Dynasty.

———. (trans.). *Chuang Tzu: Basic Writings.* New York: Columbia University Press, 1964. The most evocative translation of the great Taoist poet and philosopher.

———. (trans.). *Han Fei Tzu: Basic Writings.* New York: Columbia University Press, 1964. A fine and tangy translation of this ancient advocate of authoritarianism.

Welch, Holmes. *The Parting of the Way: Lao Tzu and the Taoist Movement.* Boston: Beacon Press, 1957. This compact 188-page book, with a short appendix on the *Tao Te Ching's* authorship, addresses early Taoist teaching in the first eighty-eight pages and devotes the rest of the volume to the history of Taoism, the "church" and its organization, and

later philosophical Taoism, which included the "pure conversation" school after the Han collapse, and Taoist thought after the third century C.E.

Wilhelm, Richard/Cary F. Baynes (trans.) *I Ching, or Book of Changes.* 2 vols. New York: Bollingen Foundation, Pantheon Books, 1950. A full translation of the text with an introduction.

Wright, Arthur. F. *Buddhism in Chinese History.* Stanford, CA: Stanford University Press, 1959. The best short treatment of the subject in 127 pages.

Wright, Arthur. F. (ed.). *The Confucian Persuasion.* Stanford, CA: Stanford University Press, 1960. See the essay by James Cahill on Confucianism in Chinese painting.

———. (ed.). *Studies in Chinese Thought.* Chicago: University of Chicago Press, 1953. See the Schuyler Cammann's essay on types of symbols in Chinese art and Derk Bodde's impressive essay on harmony and conflict in Chinese ideas.

Yang, C.K. *Religion in Chinese Society: A Study of Contemporary Social Functions of Religion and Some of Their Historical Factors.* Berkley and Los Angeles, CA: University of California Press, 1967. Most of this book deals with traditional China and covers just about all one might want to know about the subject.

Zürcher, Erik. *The Buddhist Conquest of China: The Spread and Adaptation of Buddhism in Early Medieval China.* 2 vols. Leiden, Netherlands: E.J. Brill, 1972. Monumental exposition of the subject.

Japan

Basho, Matsuo. *The Narrow Road to the Deep North and Other Travel Sketches.* Translation and introduction by Nobuyuki Yuasa. New York: Penguin Books, 1966. A short volume (143 pages) on haiku poetry and the experiences of a Zen monk during journeys on foot, starting in 1684. The introduction to Basho's life and types of short poems, chiefly haiku, is excellent. Haiku by other poets are also represented.

Blyth, R.H. *Haiku: In Four Volumes.* Vol IV, *Autumn–Winter.* Tokyo: Hokuendo, 1952. Blyth made the study of haiku his life work (other main interests were Chinese landscape painting and the music of Johann Sebastian Bach). In 366 pages the author has selected hundreds of haiku across time by numerous poets. He provides extensive interpretation and commentary. All the poems appear in the original Japanese, English transliteration, and his translation.

De Bary, Wm. Theodore, and Donald Keene (compilers). *Sources of Japanese Tradition.* New York: Columbia University Press, 1958. This 906-page volume is the best source for original documents in translation relating to Japanese history and culture from the beginnings to the modern period. Each section begins with a chronology of events. All the selections are introduced by useful commentary. The first 600 pages were consulted for the present volume.

Duus, Peter. *Feudalism in Japan.* New York: Alfred A. Knopf, 1969. This compact volume of 116 pages traces the course of Japanese feudalism from the estate system of the Heian period to the abolition of feudal privileges in the early Meiji era. There is a short bibliography for each of the five chapters and a chronology.

Henderson, Harold G. (trans. and commentary). *An Introduction to Haiku: An Anthology of Poems and Poets from Basho to Shiki.* New York: Doubleday Anchor, 1958. For

haiku, this is the place to begin. A brief first chapter explains lucidly what a haiku is and all the poems (185 pages) appear in transliterated Japanese, along with a literal translation and an interpretive translation. One can see clearly the problems of choice facing a translator. Basho is the showpiece author, but other important haiku poets are represented as well.

Hibbett, Howard. *The Floating World in Japanese Fiction*. London: Oxford University Press, 1959. This is still the best single-volume on Genroku, the era in which floating world culture flourished. The commentary and analysis are informative about literature, block prints, theater (Bunraku and Kabuki), minor arts, the social setting, and the life of townsmen (chonin) in a bit more than 200 pages. There are substantial selections from the writings of Saikaku and Kiseki.

Ike, Nobutaka. *Japan: The New Superstate*. San Francisco: W.H. Freeman, 1974. Although focused mainly on contemporary Japan, this volume is succinctly informative about the formative role of Japanese village life in shaping the character of men and women both past and present.

Kapleau, Philip (ed.). *The Three Pillars of Zen: Teaching, Practice, Enlightenment*. Boston: Beacon Press, 1965. This volume, some 351 pages, contains numerous texts not readily available elsewhere with introductory comments before each section. In the back of the book are illustrations of various zazen postures, the ten ox herding illustrations with verses and commentary, and a glossary of Zen and Buddhist terminology.

Keene, Donald. *World Within Walls: Japanese Literature of the Pre-Modern Era, 1600–1867*. New York: Hold, Rinehart and Winston, 1976. An authoritative survey and analysis of haiku, fiction, drama, and waka in 580 pages. An appendix contains summaries of plays. There is a glossary of individual authors and technical terms.

———. (ed.). *Anthology of Japanese Literature From the Earliest Era to the Mid-Nineteenth Century*. New York: Grove Press, 1955. This anthology is actually two volumes in one, divided into the early period to 1868 and the Meiji period onward, with 880 pages and a brief bibliography at the end of each section. Many translators are acknowledged.

Kitagawa, Joseph M. *On Understanding Japanese Religion*. Princeton, NJ: Princeton University Press, 1987. This 338-page volume begins with an extensive chronology of Japanese religion. The bulk of the volume addresses the early ethos of Japanese religion, the relation of religion to the state, Shinto, and Buddhism, with closing chapters on religion in modern Japan.

LaFleur, William R. *The Karma of Words: Buddhism and the Literary Arts of Japan*. Princeton NJ: Princeton University Press, 1983. A helpful study of how Buddhism influenced Japanese literature.

The Manyoshu: One Thousand Poems. New York: Columbia University Press, 1965. The original collection of poems numbered more than 4,000, representing some 450 poets, and is a valuable source for Japanese life and beliefs in the seventh and eighth centuries. This collection was translated by a committee of scholars and revised by the poet Ralph Hodgson. *Manyoshu* means "Collection for a Myriad Ages." There is a preface by Donald Keene, an informative introduction, biographical notes, and a chronological table.

Miyamoto Musashi. *The Book of Five Rings.* Translation and introduction by William Scott Wilson. Tokyo: Kodansha International, 2002. This translation of Miyamoto's classic on principles of swordsmanship applicable to life includes a striking black ink portrait by him of "Bodhidharma Crossing the Yangtze River on the Branch of a Ditch Reed" (p. 147).

Moore, Charles A. (ed.). *The Japanese Mind: Essentials of Japanese Philosophy and Culture.* Honolulu: University of Hawaii Press, 1967. This 313-page anthology includes fifteen essays on various aspects of Japanese thought, all by Japanese authors with the exception of Moore. The present writer made use of Miyamoto on theory and practice, Sakemaki on Shinto, and Nakamura, Furukawa, and Kosaka on the individual in Japanese thought and society.

Morris, Ivan. *The World of the Shining Prince: Court Life in Ancient Japan.* Baltimore, MD: Penguin Books, 1964. A comprehensive account of Heian society and culture. The "shining prince" refers to Genji, the hero of Lady Murasaki's landmark novel. The 329 pages include chapters on politics, social structure, religion, superstition, court people, ideals of beauty, and the lives of women, especially Murasaki and her *Tale of Genji.* With more than 100 pages of extensive notes, there are also six appendices, including genealogical tables, the bureaucratic ranking system, details of architecture and dress, illustrations of how letters were folded, some comments by Murasaki on the writing of fiction, and a useful glossary. The volume concludes with a bibliography.

Murasaki Shikibu. *The Tale of Genji.* Translation and introduction by Edward G. Seiden-sticker. New York: Alfred A. Knopf, 1981. A complete translation in 1,090 pages.

Nakane, Chie. *Human Relations in Japan.* Tokyo: Ministry of Foreign Affairs, 1972. This short volume of eighty-six pages is helpful in understanding the dynamic of Japanese personal and group relations in a vertically oriented society, which has not changed that much from traditional times.

Okakura, Kakuzo. *The Book of Tea.* Edited and introduction by Everett F. Bleiler. New York: Dover Publications, 1964. This classic little book on chanoyu (tea ceremony), only sixty-five pages long, was originally published in 1906. The editor has performed a valuable service by discretely cleaning up many errors in the original edition, which apparently had no editorial oversight and was left uncorrected by the author. Successive printings included all the errors, so the present version is the best to consult. See the Afterward for details relating to this textual problem. The editor provides a helpful commentary in an introduction. The book has seven sections on the philosophy of tea, schools of tea, the influence of Taoism and Zen, the tearoom, the role of art and flowers, and various tea masters. The book is an early plea for the West to better understand the East.

Piggott, Juliet. *Japanese Mythology.* London and New York: Hamlyn Publishing, 1969. The seven chapters review and conveniently summarize Japanese mythological themes from various sources, including the *Kojiki* and *Nihongi,* with illustrations, many of which are hard to find elsewhere. There is an excellent index.

Sanford, James H. *Flowing Traces: Buddhism in the Literary and Visual Arts of Japan.* Princeton, NJ: Princeton University Press, 1992. A useful survey.

Sansom, George B. *A History of Japan.* 3 vols. London: The Cressett Press, 1959, 1961, 1964. This extensive, detailed history of Japan includes much material on culture as

well as politics, economics, and social matters. The first volume goes to 1333, the second to 1615, and the third to 1867. There are many good illustrations.

————. *Japan: A Short Cultural History.* Revised edition. London: The Cresset Press, 1946. This classic 537-page volume takes the reader from beginnings to the breakup of Tokugawa feudalism in the first half of the nineteenth century, although the latter subject is covered in only one chapter and some thirty pages. The cultural material—art, literature, religion, ideas, etc.—is presented in a political and social context throughout. Each chapter begins with a chronology of events. There are nineteen plates, fifty-five drawings, and a foldout sketch map of Japan at the end showing major cultural sites in very small print. The illustrations are good, but there are not enough to support Sansom's detailed descriptions of art and architecture.

Suzuki, Daisetz. T. *Manual of Zen Buddhism.* London: Rider, 1950. In addition to texts by Chinese and Japanese Zen masters, this 187-page anthology includes line drawings of Buddhas, Bodhisattvas, Arhats, protecting gods, various historical figures, and Shubun's Ten Ox-herding Pictures illustrating the path to enlightenment. Each drawing is accompanied by a nine-line poem that explains what is going on. Also included are ten paintings on the same theme with a somewhat longer Chinese commentary on each of the stages.

————. *Zen and Japanese Culture.* London: Routledge and Kegan Paul, 1959. This book was published originally in Japan in 1938 with the title *Zen Buddhism and Its Influence on Japanese Culture.* In twelve chapters and five appendices (440 pages), the author discusses Zen Buddhism in its relation to art, Confucianism, the samurai, swordsmanship, haiku, the cult of tea, and nature. The sixty-four illustrations, four of which fold out, are generally good, and many are hard to find anywhere else.

Waley, Arthur. *The NO Plays of Japan.* New York: The Grove Press, nd. Waley translates twenty plays and summarizes a number of others out of the 800 that survive (300 before the seventeenth century). His forty-page introduction provides a scholarly but accessible discussion of No history, philosophy, major authors, acting techniques, staging methods, and much more.

ART

India

Blurton, T. Richard. *Hindu Art.* Cambridge, MA: Harvard University Press, 1993. Instructive on Hindu cults and their relations to art, with much fascinating detail. The volume is beautifully illustrated with 144 images in color and black and white.

Chola: Sacred Bronzes of Southern India. London: Royal Academy of Arts, 2006. An exhibition catalogue with many contributing scholars and superb color images, many of which are close-ups that reveal details usually not visible. There is a detailed map of what southern India looked like between 850 and 1250, a useful glossary of terms, and a bibliography.

Craven, Roy G. *Indian Art: A Concise History.* New York: Thames and Hudson, 1976. Good on art, weak on ideas (245 pages). The 200 illustrations are clear and sharp.

Coomaraswamy, Ananda K. *The Dance of Shiva: On Indian Art and Culture.* New York: The Noonday Press, 1957. A densely executed classic worth having on one's shelf.

————. *History of Indian and Indonesian Art.* New York: Dover Publications, 1985. A pioneer work and still authoritative, with 400 illustrations. Most pages are littered with technical terminology, so it is not an easy book to read. First published in 1927.

Deheja, Vidya. *Indian Art.* London: Phaidon, 1997. The obvious virtue of this hefty book is 277 splendid color illustrations. It is also good on ideas and mythology as well as art and architecture. There is a glossary of terms relating to art, architecture, and mythical figures, a good map of art sites, a chronology, and a bibliography.

Kinnard, Jacob N., *Imaging Wisdom: Seeing and Knowing in the Art of Indian Buddhism.* Richmond, UK: Curzon Press, 1999. A perceptive work.

Michell, George. *Hindu Art and Architecture.* New York: Thames and Hudson, 2000. This attractive survey includes ideas, mythology, history, art, and architecture in 211 pages. There are 186 illustrations, 77 in color, all of high quality. The illustrations are referred to in the text on each page with numbers in the margin. There is a site map and a bibliography. The index serves as a glossary for mythological figures and technical terms.

————. *The Hindu Temple: An Introduction to Its Meaning and Forms.* Chicago: University of Chicago Press, 1977. The most authoritative short (182 pages) account of Hindu temples, but so detailed in its discussion of individual caves and structures that the trees tend to obscure the forest. The author addresses patronage, construction, uses, and symbolism. A map indicates temple sites, and there is a useful bibliography.

Rowland, Benjamin. *The Art and Architecture of India.* Baltimore, MD: Penguin Books, 1953. An authoritative work with many useful floor plans and nearly 200 fine black-and-white illustrations.

Wu, Nelson I. *Chinese and Indian Architecture: The City of Man, the Mountain of God, and the Realm of the Immortals.* New York: George Braziller, 1963. A brief but informative 48-page volume with 161 illustrations.

Zimmer, Heinrich. *The Art of Indian Asia: Its Mythology and Transformations.* Completed and edited by Joseph Campbell. 2 vols. Princeton, NJ: Princeton University Press, 1955. These huge volumes are the best place to see and experience a range of Indian art, mostly architecture and sculpture, in 614 good black-and-white photographs that fill volume two, keyed to discussion and interpretation—historical, aesthetic, mythological, and iconographical—in volume one.

China

Buhot, Jean. *Chinese and Japanese Art with Section on Korea and Vietnam.* Translated by Remy Inglis Hall from the French and edited by Charles McCurdy. New York: Frederick A. Praeger, Publishers, 1967. An informative survey in 332 pages, with much unexpected detail, illustrated with 65 line drawings and 46 black-and-white images. There is a concluding parallel chronology for major historical events of the countries included, and a section called "analytical table" that gives the reader a bird's eye view of what the author covers in various domains of art. Not much discussion of ideas.

Bussagli, Mario. *Chinese Bronzes.* Translated by Pamela Swinglehurst from the Italian. New York: Paul Hamlyn, 1966. An accessible, well illustrated, compact, 154-page account of Chinese bronzes, including sculpture, from Shang times to the T'ang dynasty.

Cahill, James. *Chinese Painting*. Lausanne, Switzerland: Skira, 1960. With nearly 100 superior color plates to accompany authoritative commentary in a little more than 200 pages, the volume addresses major periods, schools, and individuals in landscape painting, but also includes figure, flower, and bird painting, from the Han to the Ch'ing periods. Individual works are analyzed in a detail that is not always easy going, but the author has a knack for describing details of a painting that helps one "read" visually what is going on.

————. *The Compelling Image: Nature and Style in Seventeenth Century Chinese Painting*. Cambridge, MA: Harvard University Press, 1982. The Charles Eliot Norton Lectures at Harvard for 1979, this volume discusses the struggle and agonizing of scholar-gentry over stylistic choices as landscape painting entered its later phase of development in the late Ming and early Ch'ing dynasties. The author challenges the common view that Chinese painters avoided representation of specific places. The good black-and-white illustrations include photographs of historic places that attracted artists. There are thirteen color plates.

Cameron, Alison Stillwell. *Chinese Painting Techniques*. New York: Dover Publications, 1968. The best "do it yourself" book on calligraphy and painting for the beginner, which has all that is needed to get started with brush, ink, ink stone, and paper. The drawing examples are her own. The daughter of General Joseph Stillwell, who achieved fame in the Burma-China theater of World War II, she studied painting for many years in Peking.

Chinese Album Leaves in the Freer Gallery of Art. Washington, DC: Smithsonian Institution, 1961. Thirty-two plates with basic facts and short commentary.

Fisher, Robert E. *Buddhist Art and Architecture*. New York: Thames and Hudson, 1993. An informative survey of Buddhist art and architecture in India, China, Japan, and elsewhere in 201 pages—not counting bibliography, maps, and index—with 179 quality illustrations in color and black and white. The color images of Buddhist painting from Ajanta and Tunhuang are especially fine.

Fong, Wen C. (ed.). *The Great Bronze Age of China: An Exhibition from the People's Republic of China*. New York: Alfred a Knopf and the Metropolitan Museum of Art, 1980. This volume contains the best wide range of color illustrations available of Shang and Chou bronzes. The 386 pages also include sections on tombs of the Former Han period and the First Emperor's terra cotta army near Sian, only a fraction of which has been excavated.

Fong, Wen C. et al. *Images of the Mind*. Princeton, NJ: The Art Museum, Princeton University, in Association with Princeton University Press, 1984. This outsized volume of 504 pages contains many images from the collection of the Princeton Art Museum with much illuminating commentary by the collaborating authors. For such an ambitious volume, the quality of black-and-white images of landscape painting is generally poor.

Hutt, Julia. *Understanding Far Eastern Art: A Complete Guide to the Arts of China, Japan and Korea—Ceramics, Sculpture, Painting, Prints, Lacquer, Textiles and Metalwork*. New York: E.P. Dutton, 1987. The volume is poor on ideas, good on art forms, and excellent on materials, processes, and techniques. It is copiously illustrated.

Jenyns, Soame. *A Background to Chinese Painting*. New York: Schocken Books, 1966.

There are chapters on the influence of religion, the role of calligraphy, imperial patronage, technique and materials, landscape and figure painting, and the use of bird, flower, and animal motifs, with forty black-and-white illustrations. In this volume one can find a rare discussion of fake paintings, their types, and how they were made.

Keswick, Maggie. *The Chinese Garden: History, Art, and Architecture.* London: St. Martin's Press, 1978. Includes contributions and conclusions by Charles Jencks. A 216-page volume well illustrated with plans, maps, and images of famous gardens, many of them in the form of landscape paintings. The range includes origins, types, materials, uses, and meanings. An appendix lists, with commentary, thirty-two historical gardens open to the public in China.

Kwo Da-Wei. *Chinese Brushwork: Its History, Aesthetics, and Techniques.* Montclair, NJ: Alanheld & Schram, 1981. A fine treatment of technique with the brush, styles of calligraphy, and schools of painting in less than 200 pages. The quality of the volume's numerous illustrations is uneven. Those depicting calligraphy and its techniques are effective. The black-and-white landscape reproductions are frequently dull and washed out.

Lai, T.C., *Understanding Chinese Painting.* New York: Schocken Books, 1980. The organization of this book is unusual. There is no extended book-like text. Rather the many black-and-white illustrations of varying quality are accompanied by brief, but informative commentary ranging from a few pages to a short paragraph to a few lines on basic principles, composition, perspective, and symbolism. Several opening pages illustrate types of brush strokes, which are taken from *The Mustard Seed Garden Manual of Painting* (see Sze Mai Mai below). There is a section in which inscriptions on a number of works are translated. Three appendices comment on essentials of painting, standards of excellence, and provide quotations from well-known painters. There is no index and no bibliography.

Liang Ssu-cheng. *A Pictorial History of Chinese Architecture: A Study of the Development of Its Structural System and the Evolution of Its Types.* Edited by Wilma Fairbank. Cambridge, MA: The MIT Press, 1984. This volume is indispensable for a close study of traditional Chinese architecture. In some 200 pages it surveys structural systems; evidence of timber frame building from pre-Buddhist times and from cave temples; timber frame building from 850 to 1912 C.E.; and Buddhist pagodas and a variety of other structures, such as tombs, bridges, terraces, and gateways. The many illustrations include detailed drawings from historical sources and rare photographs of ancient buildings, the oldest being the main hall of the Buddhist temple Fo-kuang Ssu in Shansi Province (857 A.D.). There is a glossary of technical terms with Chinese characters and transliterations, a pronunciation guide (Wade-Giles), and a bibliography.

Liu, Lawrence G. *Chinese Architecture.* New York: Rizzoli International Publications, 1989. This physically large volume (awkward to handle) has many first-rate color illustrations and a generally full discussion of traditional Chinese architecture. Due attention is given to forms, materials, technique, and symbolism, although more could have been done with the layout and symbolism of the Forbidden City.

Loehr, Max. *The Great Painters of China.* New York: Harper and Row, 1980. In 325 pages the author surveys major painters from "the rise of pictorial art" to the Ch'ing dynasty,"

with 185 mostly poor black-and-white illustrations. Commentary is far superior to the quality of the images. A distinctive feature of the book is that individual painters are discussed in chronological order from dynasty to dynasty, with biographical detail hard to find elsewhere. The volume is well-documented.

Mather, Richard. "Landscape and Buddhism." In *The Confucian Persuasion*, edited by Arthur Wright. Stanford, CA: Stanford University Press, 1960. Although Taoism is the major influence on landscape painting and gardens, Buddhism should not be forgotten.

Rowley, George. *Principles of Chinese Painting*. Princeton, NJ: Princeton University Press, 1959. A superior work on Chinese landscape aesthetics with real philosophical depth. The illustrations are black and white and of variable quality.

Selection of Masterworks in the Collection of the National Palace Museum. Republic of China, 1973. The National Palace Museum is in Taipei. This brief volume includes 150 items with commentary in English and Chinese. We learn from the introduction that the collection consists of more than 600,000 items, including nine categories of art objects (59,138), six categories of painting and calligraphy (15,893), thirteen categories of rare books and documents (152,408), and ten categories of other documents (392,811).

Shen Zhiyu (ed.). *The Shanghai Museum of Art*. New York: Harry N. Abrams, 1981. A brief paragraph comments on each of the 246 items, which include ceramics, bronzes, paintings, calligraphy, and handicrafts. All of the illustrations are in excellent color.

Sickman, Lawrence C.S. (ed.). *Oriental Art, Series O, Section II, Early Chinese Art*. Cambridge, MA: The University Prints, n.d. Useful by limited.

Sze Mai Mai (trans. and ed.). *The Mustard Seed Garden Manual of Painting, Chieh Tzu Hua Chuan*, 1679–1701. Princeton, NJ: Princeton University Press, 1956. This famous work is a facsimile of an 1887–88 edition. *The Mustard Seed Garden* is a 621-page compendium of theory, painters, schools, motifs, styles, techniques, materials, and working illustrations with accompanying advice on how to paint, trees, rocks, figures, plants—all assembled encyclopedically from China's long history of visual art. The work was published originally in two volumes as *The Tao of Painting*. The present volume is the second of the original. The first one, which was Sze's commentary, can be had in a Vintage paperback, *The Way of Chinese Painting*. As a "do-it-yourself" guide, this volume falls short and the beginner is better off (short of a live teacher) with Alison Cameron for detailed instruction (see above).

Sullivan, Michael. *The Arts of China*. Revised edition. Berkeley, CA: University of California Press, 1977. A good shorter chronological review of Chinese art and theory in 267 pages from earliest times to the present, with 303 maps and illustrations.

———. *Symbols of Eternity: The Art of Landscape Painting in China*. Stanford, CA: Stanford University Press, 1979. An authoritative survey of Chinese landscape painting from the Han dynasty onward in 191 pages with 115 illustrations (only a few in color). A chronological survey puts individual painters and the development of aesthetic theory in a manageable historical perspective, explaining who influenced whom. Comment on individual works is uniformly excellent.

———. *The Three Perfections: Chinese Painting, Poetry, and Calligraphy*. 2nd revised edition. New York: George Braziller, 1999. This well-illustrated volume of eighty-three pages is a highly accessible effort to explain what and why Chinese wrote on

paintings. The relationship of poetry, calligraphy, and painting are discussed briefly but lucidly. Many of the poems and colophons that appear on paintings in the volume are translated.

Tregear, Mary. *Chinese Art*. Revised edition. London: Thames and Hudson, 1997. A reliable chronological history of Chinese art with slight attention to ideas, amply illustrated with good images in color and black and white.

Van Briessen, Fritz, *The Way of the Brush: Painting Techniques of China and Japan*. Rutland, VT: Tuttle Publishing, 1998. A volume of 329 pages, translated from German, which discusses in detail materials, methods, and styles of painting in China and Japan, their similarities and differences, with 284 illustrations, mostly in black and white. Especially useful are three appendices: one on Chinese terms for subject matter, materials, techniques and methods, principles, and styles; a second provides a chronology by historical period of major painters with their dates; and a third defines symbols that appear in art. Although published in the late 1990s, the author uses Wade-Giles transliterations instead of Pinyin throughout.

Watson, William. *Art of Dynastic China*. New York: Harry N. Abrams, Inc., 1981. An impressive volume of 622 pages with 184 very large color images of the highest quality, supplemented by 508 black-and-white images organized according to region. Part I is on The Evolution of Style, Part II is on The Image as Document, Part III is on The Principle Archeological Sites, and Part IV is on Principle Painters and includes chronology and bibliography. All the images are exhaustively documented. There is a section on architectural drawings and wall reliefs.

———. *Style in the Arts of China*. New York: Penguin Books, 1974. An intelligent 119-page discussion of stylistic origins and changes in Chinese art. The volume's historical and stylistic chronology is especially useful. The 146 black-and-white illustrations of artifacts are accompanied by commentary on their stylistic features. The author details influences on Chinese art that flowed from Central Asia and even beyond along the silk route.

Weidner, Marsha (ed.). *Flowering in the Shadows: Women in the History of Chinese and Japanese Painting*. Honolulu: University of Hawaii Press, 1990. A tribute to previously unknown or unmentioned women artists in traditional China and Japan in ten essays, by an assortment of scholars. All the illustrations are black and white.

——— (ed.). *Views from Jade Terrace: Chinese Women Artists, 1300–1912*. Indianapolis, IN: Indianapolis Museum of Arts, 1988. With eighty illustrations, most in color. There is an index of existing or reproduced paintings of women.

Whitfield, Roderick. *In Pursuit of Antiquity: Chinese Paintings of the Ming and Ch'ing Dynnasties from the Collections of Mr. and Mrs. Earl Morse*. Princeton, NJ: The Art Museum, Princeton University, 1969. An exhibit catalogue to which a number of people contributed. The numerous illustrations are mostly black-and-white and address both painting and calligraphy. In the back all the artists are listed with their names in Chinese characters.

Willetts, William. *Chinese Art*. 2 vols. New York: George Braziller, 1958. These volumes are an erudite mine of information about materials, techniques, and styles relating to jade, bronzes, lacquer, silk, sculpture, ceramics, calligraphy, painting, and architecture. The author also includes bridges as art. The pagination is consecutive from one volume

to the next, for a total of 754 pages. There are numerous line drawings, plates in black and white, a chronology, and a bibliography.

Williams, C.A.S. *Outlines of Chinese Symbolism and Art Motives: An Alphabetical Compendium of Antique Legends and Beliefs as Reflected in the Manners and Customs of the Chinese.* New York: Dover Publications, 1976. First published in 1941, this 462-page volume includes many symbols found in Chinese religion, philosophy, daily life, and art worthy of browsing, as well as research.

Weng, Wan-go, and Yang Boda, *The Palace Museum, Peking: Treasures of the Forbidden City.* New York: Harry N. Abrams, Inc., 1982. This outsized volume (317 pages) contains images of art and architecture not easily found elsewhere. The Forbidden City is a vast museum with extensive holdings of bronzes, ceramics, painting, calligraphy, lacquer, and much besides. The city itself is a museum of architectural forms, well represented here in good color photography, which includes the Ch'ien-lung garden in the rear. There are cutaway drawings and elaborate plans to show the layout of the Forbidden City and its major buildings.

Yee, Chiang. *Chinese Calligraphy: An Introduction to Its Aesthetic and Technique.* 3rd edition, revised. Cambridge, MA: Harvard University Press, 1973. This pioneering book was first published in 1938. In addition to an account of origins, principles, styles, composition, and connections with other forms of Chinese art, there is detailed treatment of brushstrokes, how to produce them, and how judge them. Calligraphy is extensively illustrated in black and white along with twenty-two plates.

———. *The Chinese Eye: An Interpretation of Chinese Painting.* Bloomington: Indiana University Press, 1964. A more personal treatment of the subject than most, in 231 pages. This writer found the chapters on painting and literature and painting and philosophy useful. The illustrations are few and mostly lackluster.

Japan

Addis, Stephen, with Audrey Yoshiki Seo. *How to Look at Japanese Art.* New York: Harry N. Abrams, 1996. An informative work of 134 pages organized around six clear principles of Japanese aesthetics. The six chapters deal with ceramics, sculpture, calligraphy, block prints, and gardens.

Alex, William. *Japanese Architecture.* New York: George Braziller, 1963. An informed, very short book (48 pages) with 154 black-and-white illustrations with notes. This is probably the most reliable abbreviated introduction to Japanese architecture.

Baker, Joan Stanley. *Japanese Art.* Revised edition. New York: Thames and Hudson, 2000. A straightforward chronological approach to the art of Japan in 208 pages, with 167 illustrations in color and black and white. A brief but authoritative work especially strong on painting and calligraphy, somewhat less so on sculpture, and weak on architecture. While historical landmarks are noted, the treatment of ideas, even those relating to aesthetics, is sketchy.

Bowie, Henry P. *On the Laws of Japanese Painting: An Introduction to the Study of the Art of Japan.* New York: Dover Publications, n.d. This book resulted from lectures delivered by Bowie in 1911 after many years of studying calligraphy and painting in Japan. By art he means painting. The 105 pages of text are accompanied by 66 black-

and-white illustrations, a number of which deal with the technique of rendering forms like trees, rocks, and birds.

Cahill, James. *The Lyric Journey: Poetic Painting in China and Japan.* Cambridge, MA: Harvard University Press, 2002. Much light is shed on poetry in painting.

Fister, Patricia. *Japanese Women Artists, 1600–1900.* New York: Harper and Row, 1988. The women represented painted landscape, people, geisha scenes, plants, and animals, and did remarkable calligraphy. There is a bibliography, mostly in Japanese.

Kato, Shuichi. *Form, Style, Tradition: Reflections on Japanese Art and Society.* Berkeley: University of California Press, 1971. A collection of essays that delivers acute insights.

Nishi, Kazuo, and Kazuo Hozumi, *What is Japanese Architecture? A Survey of Traditional Japanese Architecture with a List of Sites and a Map.* Translated, adapted, and with introduction by H. Mack Horton. New York: Kodansha International, 1983.

Paine, Robert Treat, and Alexander Soper. *The Art and Architecture of Japan.* Baltimore, MD: Penguin Books, 1955. Authoritative for traditional Japan with excellent drawings and sketches of architectural forms and ensembles, with nearly 200 black-and-white illustrations.

Saunders, E. Dale. *Mudrā: A Study of Symbolic Gestures in Japanese Buddhist Sculpture.* Princeton, NJ: Princeton University Press, 1985. First published in 1960 by the Bollingen Foundation. The detail in this 195-page study is prolific, and the author's account of mudras, asanas, attributes, postures, and thrones shows how Japan used and modified the iconographic tradition that came to it from India through China and Korea. There are twenty-six black and white illustrations and many line drawings. Up front there is a pictorial index of mudras.

Sen, Shositsu. *Chado: The Japanese Way of Tea.* New York: Weatherhill. 1979. The author is a Grand Master of the Urasenke School of Tea. The 182 pages cover history, philosophy, layout, and symbolism of the teahouse, gardens, implements, kinds of tea and refreshments, ritual of preparation, and etiquette at every stage of the tea ceremony. There are numerous quality illustrations, many in color.

Shimizu, Yoshiaki, and Carolyn Wheelwright (eds.). *Japanese Ink Paintings.* Princeton, NJ: The Art Museum, Princeton University. Distributed by Princeton University Press, 1976. The catalogue of an extensive exhibition of Japanese ink painting from the Muromachi period (1333–1573) assembled from various American collections. Nothing quite like it is available. The numerous black-and-white images are accompanied by extensive commentary. The images include ink renderings of landscape, flowers, birds, animals, bamboo, religious figures, and calligraphy. There is a section on seals and signatures of artists, a chronological chart, and a bibliography of sources in Japanese, Chinese, and Western languages.

Shoten, Kadokawa (ed.). *A Pictorial Encyclopedia of the Oriental Arts.* Vol. 2. *Japan.* New York: Crown Publishers, 1969. This volume will not be easy to find. It contains 168 very superior color and black-and-white images of sculpture, painting, and some architecture. The scope is Heian and Kamakura periods. It was compiled from the oriental section of the Encyclopedia of World Art, also published by Crown. The collection opens with a complete description of each of the pieces and their location, followed by an informative seventeen-page essay.

Smith, Bradley. *Japan: A History in Art.* New York: Simon and Schuster, 1964. The virtue of this 295-page volume is the predominance throughout of painting. There are some images of sculpture but virtually none of architecture and other arts. The images of painting are large, sometimes with oversize details, all in color, which makes their study much easier than trying to make out small-scale versions found in most art books. Each section is prefaced by a useful parallel chronology of history and art. At the end there is a short bibliography and a list of all artifacts by historical period.

Swann, Peter. *A Concise History of Japanese Art.* Tokyo, New York, and San Francisco: Kodansha International, 1979. An excellent, usefully documented survey in 317 pages, with 177 illustrations of mostly inferior quality. The author is helpful with the identification of stylistic shifts in the various arts and their relationship to Chinese counterparts. His visual analyses of artifacts are perceptive and detailed.

Watson, William (ed). *The Great Japan Exhibition: Art of the Edo Period, 1600–1868.* London: Wiedenfield and Nicolson, 1981–1982. A sumptuously illustrated (412 images in color and black and white), instructive journey across some 250 years of Japanese art.

Yoshikawa, Isao. *Japanese Stone Gardens: Appreciation and Creation.* Tokyo: Graphic-sha Publishing, 1992. The text of this volume is in Japanese and English. In each chapter, the Japanese text comes first followed by a separate English translation. The numerous high-quality illustrations, both color and black and white, including many fine drawings, are accompanied by informative comments in English as well as Japanese.

General Works

Basham, A.L. *The Wonder That Was India: A Survey of the Culture of the Indian Sub-Continent Before the Coming of the Muslims.* New York: Grove Press, 1954. Now a classic, and the finest exposition of traditional Indian civilization in all its aspects. Impressive erudition is carried lightly, and every page is illuminated with fact and generalization. The only drawback is illustrations of mostly indifferent quality.

Campbell, Joseph. *The Masks of God.* Vol. 2. *Oriental Mythology.* New York: Viking Press, 1962. See the stimulating chapters in Part Two on the mythologies of India, China, and Japan, which make good use of archeological as well as literary sources. The discussions of Buddhism and Shinto are especially fine.

———. *The Mythic Image.* Princeton: Princeton University Press, 1972. A lavishly illustrated exploration of worldwide mythical themes. See especially Chapter 2 on the "world mountain."

Cavendish, Richard, and Trevor O. Ling (eds.). *Mythology: An Illustrated Encyclopedia.* New York: Barnes and Noble Books, 1992. Informative chapters on Hinduism, China, and Japan, among other cultures. There are many illustrations with explanatory captions, as well as lists of major mythical figures.

Cottrell, Leonard. *The Great Within.* London: Faber and Faber, Ltd., 1941. A highly readable account of foreigners in China and their formal reception in the Forbidden City.

Frankfort, Henri, et al. *Before Philosophy: The Intellectual Adventure of Ancient Man.* New York: Pelican Books, 1949. The classic statement about mythopoetic

thinking with examples drawn from the Ancient Near East but applicable to any civilization.

Fraser, J.T. (ed.). *The Voices of Time: A Cooperative Survey of Man's Views of Time as Expressed by the Sciences and the Humanities.* 2nd ed. Amherst: University of Massachusetts Press, 1981. The helpful essays in this volume are by Nakamura (India and Japan) and Needham (China).

Hucker, Charles O. *The Traditional Chinese State in Ming Times, 1368–1644.* Tucson: University of Arizona Press, 1961. A compact 85-page topical account of the Ming dynasty with documentation. Accessible political, economic, and social background for ideas and art.

Jaffrelot, Christophe. *The Hindu Nationalist Movement in India.* New York: Columbia University Press, 1993. The best documented account of Hindu nationalism, its origins, and rise to power.

Keay, John. *India: A History.* New York: Grove Press, 2000. A detailed, well-written, accessible recent history that sorts out the complexities of India's teeming, chaotic, sprawling past.

Koller, John M. *Oriental Philosophies.* New York: Charles Scribner's Sons, 1970. A short but clear exposition of Brahmanism, Hinduism, the Six Classical Systems, Buddhism (including Zen), Confucianism, Taoism, and Neo-Confucianism. There is nothing on Jainism.

Langer, Suzanne. *Philosophy in a New Key: A Study in the Symbolism of Reason, Rite, and Art.* Cambridge, MA: Harvard University Press, 1942. Useful to this book are Chapters 2, 4, and 10. She argues that "'Artistic truth,' so-called, is the truth of a symbol to the forms of feeling—nameless forms, but recognizable when they appear in sensuous replicas" (p. 213).

Mann, Susan. *Women's and Gender History in Global Perspective: East Asia, China, Japan, Korea.* Washington, DC: American Historical Association, 1999. A pamphlet-size work (sixty pages) that contains a fuller account of the condition of women in China and Japan in the traditional period than is available in the usual historical narratives.

Mitchell, Donald W. *Buddhism: Introducing the Buddhist Experience.* Oxford, UK: Oxford University Press, 2002. In 360 pages the major historic forms of Buddhism—Indian, Chinese, Tibetan, Korean, Japanese, Southeast Asian, and modern—are discussed in considerable detail. Useful bibliographies concluding each of the eleven chapters suggest how extensive the literature is on the history, beliefs, and practices of Buddhism. There is a glossary of technical terms.

McArthur, Meher. *Reading Buddhist Art: An Illustrated Guide to Buddhist Signs and Symbols.* London: Thames and Hudson, 2002. An informative survey of 31 Buddhist figures sitting, standing, and lying; their attributes and ritual objects; symbols; Buddhist sites; and more in 203 pages, including 304 illustrations, maps, and a glossary of technical terms.

Munsterberg, Hugo. *Dictionary of Chinese and Japanese Art.* New York: Hacker Art Books, 1981. The alphabetical entries take up 352 pages and are informative about artists, artifacts, techniques, and historical landmarks.

Panofsky, Erwin. *Studies in Iconology: Humanistic Themes in the Art of the Renaissance.* New York: Harper & Row Publishers, 1962. First published in 1939, the discussion

of iconography and its relation to meaning in the introduction is applicable to any civilization.

Schapiro, Meyer. "Style." In *A Modern Book of Esthetics: An Anthology*, edited by Melvin Rader. New York: Holt, Rinehart and Winston, 1962. An illuminating account of what style is and how it works.

Spear, Percival. *A History of India: From the Sixteenth Century to the Twentieth Century.* Vol. 2. New York: Penguin Books, 1990. The companion volume to Romila Thapar, with the same fault of academic density, but containing a great deal of useful information.

Spencer, Theodore. *Shakespeare and the Nature of Man.* 2nd ed. New York: Collier Books, 1966. An excellent source for comparing European ideas of cosmic correlation in the Renaissance with Chinese ideas at about the same time.

Steadman, John M. *The Myth of Asia: A Refutation of Western Stereotypes of Asian Religion, Philosophy, Art and Politics.* New York: A Clarion Book, Simon & Schuster, 1969. A perceptive review of doubtful and misleading characterizations of so-called Asian culture that discourages one from making facile generalizations about ideas and art.

Thapar, Romila. *Early India: From the Origins to A.D. 1300.* Berkeley and Los Angeles: University of California Press, 2004. Good for consultation but not for easy reading—heavily academic in tone and language.

Selected Websites

Online Museum Resources on Asian Art

http://afemuseums.easia.columbia.edu/cgi-bin/museums/search.cgi
Columbia University hosts this comprehensive, annotated guide to nearly 100 museums with Asian art collections online, with search options for size of collection or regional focus and extensive links to supplementary and topical materials.

General

Asian Art Museum

http://www.asianart.org
This San Francisco museum holds one of the most comprehensive collections of Asian art in the world. The online collection is keyword-searchable.

Freer Gallery of Art and the Arthur M. Sackler Gallery

http://www.asia.si.edu/collections/default.asp
The Smithsonian Institution's Freer Gallery of Art and Arthur M. Sackler Gallery contain some of the most important holdings of Asian art in the world. Thousands of objects from the collections may be viewed online.

http://www.asia.si.edu/exhibitions/online/buddhism/default.htm
This gallery guide focuses on items related to Buddhism.

Internet Sacred Text Archive

http://www.sacred-texts.com/index.htm
This site provides the English-language translations of hundreds of texts from ancient India, China, and Japan, including texts related to Buddhism, Confucianism, Hinduism, and Taoism.

Kyoto National Museum

http://www.kyohaku.go.jp/eng/syuzou/index.html
This site features a selection of Masterworks from China, Japan, Korea, and South Asia, plus an online searchable database of artworks and artifacts held by the Kyoto National Museum.

Metropolitan Museum of Art: Works of Asian Art and the Heilbrunn Timeline of Art History

http://www.metmuseum.org/works_of_art/asian_art
This is a database of the Asian art collections at the Metropolitan Museum of Art in New York.

http://www.metmuseum.org/toah/
The Heilbrunn Timeline of Art History includes coverage of East Asia and South and Southeast Asia.

India

Digital South Asia Library

http://dsal.uchicago.edu
This site, a project of the Center for Research Libraries and the University of Chicago, has links to a variety of Internet-based South Asian and Indian resources.

The Huntington Archive

http://huntingtonarchive.osu.edu/index.php
Ohio State University's John C. and Susan L. Huntington Photographic Archive of Buddhist and Asian Art contains thousands of original slides and photographs.

China

CAFA Art Museum, Art Collections

http://www.cafamuseum.org/en/AllCollections
The CAFA Art Museum in Beijing has ancient works of Chinese art in a variety of media.

Hong Kong Museum of Art: Chinese Art and Antiquities Collections

http://www.lcsd.gov.hk/CE/Museum/Arts/english/collections/collections.html
This site includes brief introductions to the collections and a collection databank.

National Art Museum of China (NAMOC), Collections

http://www.namoc.org/en/Collection/Highlights/Fine_Arts/index.html
This site is organized by type of artwork.

Japan

E-Museum: National Treasures & Important Cultural Properties of National Museums, Japan

http://www.emuseum.jp/top?d_lang=en
The e-museum features a searchable database of Japanese art and historical artifacts.

The Virtual Museum of Japanese Arts

http://web-jpn.org/museum/menu.html
This site is organized by type of art or cultural activity.

Index

Page numbers in *italics* indicate illustrations

Vishnuites, 66
Voidness, Buddhist idea of, 236

Wabi, in Zen aesthetic, 246–247, 248
Wabi cha (wabi of tea), 252
Wade-Giles system of written language, xi
Wang An-shih (Wang Anshi), 137–138
Wang Chien (Wang Jian), 184
Wang Ch'ung (Wang Chong), 130, 136
Wang Hsi-chih (Wang Xizhi), 164
Wang Hui, 184
Wang Meng, 176, *178*, 182
Wang Shih-min (Wang Shimin), 184
Wang Yang-ming, 129, 191n96
Wang Yuan-ch'i (Wang Yuanqi), *184*, 184,
 185
Warring States Period, 106, 107, 108
Water, in Five Elements, 97, 98
Way (Tao), 104, 107, 108, 130
Wen Ching-ming (Wen Jing-ming), 93
Western society, individualism of, 34,
 264
Wheel (chakra) symbol, 7
Woman Who Spent Her Life in Love, The
 (Saikaku), 217–218
Women
 in Chinese society, 95–96, 198
 dharma instructions for, 55
 in Hindu mythology, 60–62, *61*
 in Japanese society, 11, 201, 244–245,
 253
 representation in religious settings,
 40
Wood, in Five Elements, 97, 98
Woodblock prints, Japanese, 253–256,
 254, 255

Written language, x–xi
 Chinese, x, 88–92, *89, 90*, 113, 198, 265
 Japanese, x, 198–199, 238
Wu Chen (Wu Zhen), *173*, 182

Yamato clan, 197
Ying Yu-chien (Ying Youjian), *178*
Yin-yang
 in architecture, 147, 154
 in art, 141, 146, 178
 in Chinese cosmology, 97, 98, 173, 204,
 265
 in gardens, 157
 in landscape, 173, 175
 male/female, 95
 symbol of, *7*, 7, 98
 and Tao, 108, 131
Yoga
 karma, 27
 Sankhya, 27, 28–29
Yomeimon Gate, Toshogu Shrine, 236, *237*
Yoni, 60, *61*
Yoritomo, Minamoto, 200
Yoshitoshi, Tsukioka, 236, *238*
Yuan dynasty, 85, 168, 173, 182, 192n129
Yumedono chapel, Horyu-ji, Nara, *240*, 240
Yung-lo (Yongle), 151

Zazen meditation, 223
Zen Buddhism, xi, 4, 204
 aesthetic of, 210, 246–250
 influence of, 269
 and samurai values, 200, 222, 269
 sects of, 118, 119, 222–224
 and tea ceremony, 250–252, 269
Zimmer, Heinrich, xiii n1

About the Author

Kenneth R. Stunkel is professor of history at Monmouth University, New Jersey. He received a doctorate in history from the University of Maryland and also holds a master's degree in philosophy. He teaches undergraduate and graduate courses in European and Asian history. He was a Visiting Fellow at Princeton University for two years to study engineering and architecture for non-specialized students. He has traveled extensively in Europe and Asia. For a year he taught Chinese history and oriental philosophy for the University of Maryland overseas program in East and Southeast Asia.